2013
CARNEGIE
INTERNATIONAL

2013 CARNEGIE INTERNATIONAL

Curated by
Daniel Baumann,
Dan Byers,
Tina Kukielski

Ei Arakawa/Henning Bohl,
Phyllida Barlow, Yael Bartana,
Sadie Benning, Bidoun Library,
The Collection, Nicole Eisenman,
Lara Favaretto, Vincent Fecteau,
Rodney Graham, Guo Fengyi,
Wade Guyton, Rokni Haerizadeh,
He An, Amar Kanwar, Dinh Q. Lê,
Mark Leckey, Pierre Leguillon,
Sarah Lucas, Tobias Madison,
Zanele Muholi, Paulina Olowska,
The Playground Project, Pedro Reyes,
Kamran Shirdel, Gabriel Sierra,
Taryn Simon, Frances Stark,
Joel Sternfeld, Mladen Stilinović,
Zoe Strauss, Henry Taylor,
Tezuka Architects, Transformazium,
Erika Verzutti, Joseph Yoakum

CARNEGIE MUSEUM
OF ART

ONE OF THE FOUR CARNEGIE MUSEUMS OF PITTSBURGH

To
Jane Haskell (1924 – 2013)
Artist and Friend

2013 CARNEGIE INTERNATIONAL

Daniel Baumann, Curator
Dan Byers, Curator
Tina Kukielski, Curator

Amanda Donnan, Assistant Curator
Lauren Wetmore, Curatorial Assistant

CARNEGIE PRIZE AND FINE PRIZE JURY OF AWARD

Lynne Cooke
Andrew W. Mellon Professor, Center for Advanced Study in the Visual Arts,
National Gallery of Art, Washington, DC
Curator of the 1991 *Carnegie International*

Douglas Fogle
Independent curator and writer, Los Angeles
Curator of the 2008 *Carnegie International*

Mark Francis
Director, Gagosian Gallery, London
Curator of the 1991 *Carnegie International*

Madeleine Grynsztejn
Pritzker Director, Museum of Contemporary Art, Chicago
Curator of the 1999 *Carnegie International*

Laura Hoptman
Curator, Department of Painting and Sculpture, Museum of Modern Art, New York
Curator of the 2004 *Carnegie International*

Woody Ostrow
Carnegie Museum of Art Board Member

Alice Snyder
Carnegie Museum of Art Board Member

Lynn Zelevansky
The Henry J. Heinz II Director, Carnegie Museum of Art

Major support for the *2013 Carnegie International* has been provided by the A.W. Mellon Charitable and Educational Fund, The Fine Foundation, the Jill and Peter Kraus Endowment for Contemporary Art, and The Henry L. Hillman Fund. Additional major support has been provided by The Friends of the *2013 Carnegie International*, which is co-chaired by Jill and Peter Kraus, Sheila and Milton Fine, and Maja Oeri and Hans Bodenmann.

The Lozziwurm playground was made possible by a generous gift from Maja Oeri and Hans Bodenmann.

Major gifts and grants have also been provided by The Andy Warhol Foundation for the Visual Arts, Jill and Peter Kraus, Ritchie Battle, The Fellows of Carnegie Museum of Art, Marcia M. Gumberg, the National Endowment for the Arts, The Pittsburgh Foundation, Juliet Lea Hillman Simonds Foundation, Bessie F. Anathan Charitable Trust of The Pittsburgh Foundation, George Foundation, Huntington Bank, Wendy Mackenzie, Betty and Brack Duker, BNY Mellon, The Broad Art Foundation, and Nancy and Woody Ostrow.

Additional support has been provided by Pittsburgh Audi Dealers, GlaxoSmithKline Consumer Healthcare, Bernita Buncher, Peter J. Kalis and Mary O'Day, Daniel and Beverlee Simboli McFadden, Walter A. Bechtler Foundation, the Tillie and Alexander Speyer Fund, Fort Pitt Capital Group, The Japan Foundation, New York, EQT Corporation, K&L Gates, LLP, Sueyun and Gene Locks, Schneider Downs Wealth Management Advisors, Tata Consultancy Services, Wells Fargo Advisors, Isabel and Lee Foster, Etant donnés: The French-American Fund for Contemporary Art, Embassy of Colombia, Artis, Bobbie Foshay, Barbara and Aaron Levine, Lyn Ross, Pro Helvetia Swiss Arts Council, Asian Cultural Council, The Henry John Simonds Foundation, and David and Susan Werner Philanthropic Fund of the Jewish Federation of Greater Pittsburgh.

FOREWORD

In 1895, when Andrew Carnegie opened the Carnegie Institute, he rejected the practice of so many wealthy American patrons of the time, declaring that he would not travel throughout Europe to acquire a collection of old master works for its art gallery. Rather, the director of his gallery was to present an annual exhibition of the best in international contemporary art and buy works from that show, building a collection of "the old masters of tomorrow" (the phrase may be apocryphal but the idea is accurate). In so doing, Carnegie created the first institution in the United States with a strong focus on contemporary art.

His *Carnegie International*, inaugurated in 1896, has had different names and taken different forms over its 117 years but, in spirit and fact, it has continued to this day. For well over half a century it and the Venice Biennale (founded less than a year before it) were the only ongoing shows of this kind in the world. Over the last decades international surveys of contemporary art have proliferated worldwide, but the *Carnegie International* remains one of the few in North America, and the only one that has, in significant part, built a collection.

As a newly minted museum director whose task it was to appoint a curatorial team for the next iteration of this august exhibition, I was remarkably fortunate to encounter Daniel Baumann in Basel, Switzerland, Tina Kukielski at the Whitney Museum of American Art in New York, and Dan Byers under my nose in the contemporary art department at Carnegie Museum of Art. It was nothing short of a miracle not only to have found these very smart, very savvy individuals, but also that they worked together so harmoniously as a team. I think they collaborated so well because of the shared values that are eloquently expressed in their introduction to this book. I asked them, in order to create an exhibition with some specificity — and some heart — to consider the city of Pittsburgh, the museum, and our history as they conceived the show. They embraced that notion, melding a genuine engagement with this locality with the most broadly international exhibition we have yet produced. The resulting exhibition enhances our understanding of the complex, joyful, and often fraught moment in which we live.

I am very grateful to Daniel, Dan, and Tina for their hard work, thoughtfulness, intellectual rigor, and visual acuity. The Board and staff of Carnegie Museum of Art are indebted, as well, to all of the participating artists, and to our very generous donors and lenders, all of whom have understood the importance of the ongoing *Carnegie International* endeavor and made this exhibition possible.

 — Lynn Zelevansky
 The Henry J. Heinz II Director
 Carnegie Museum of Art

Table I. Classification of Games

	AGÔN (Competition)	ALEA (Chance)	MIMICRY (Simulation)	ILINX (Vertigo)
PAIDIA Tumult Agitation Immoderate laughter	Racing Wrestling } not regulated Etc. Athletics	Counting-out rhymes Heads or tails	Children's initiations Games of illusion Tag, Arms Masks, Disguises	Children "whirling" Horseback riding Swinging Waltzing
	Boxing, Billiards Fencing, Checkers Football, Chess	Betting Roulette		Volador Traveling carnivals Skiing Mountain climbing Tightrope walking
Kite-flying Solitaire Patience Crossword puzzles *LUDUS*	Contests, Sports in general	Simple, complex, and continuing lotteries*	Theater Spectacles in general	

N.B. In each vertical column games are classified in such an order that the *paidia* element is constantly decreasing while the *ludus* element is ever increasing.

* A simple lottery consists of the one basic drawing. In a complex lottery there are many possible combinations. A continuing lottery (e.g., Irish Sweepstakes) is one consisting of two or more stages, the winner of the first stage being granted the opportunity to participate in a second lottery.

Originally published in Roger Callois, *Les jeux et les hommes* (Paris: Librairie Gallimard, 1958); reprinted from *Man, Play, and Games* (New York: Free Press of Glencoe, 1961).

The idiosyncratic work of Roger Callois (1913–1978) combined sociology, philosophy, and literary criticism to examine humanity in terms of play, games, and the sacred.

INTRODUCTION

DANIEL BAUMANN, DAN BYERS, TINA KUKIELSKI

We met in 2010 to figure out the most important US exhibition of new international contemporary art. And how to get along. Dan had been living in the Pittsburgh neighborhood of Polish Hill for a year; Tina came from Brooklyn in 2011 and found a house in the Lawrenceville neighborhood; and Daniel made frequent visits from Basel until he moved here with his family in summer 2012. There were ambitions, decisions to be made, and conflicts to be worked out and benefited from. We dismantled an exhibition that traditionally has consisted of a heroic list of names, future stars, or potential "old masters of tomorrow," and added other parts, reshuffling the deck. We decided to present new voices rooted in history, a sense of place, and play, defined in various ways. The *2013 Carnegie International* is guided by a shared passion for the individual and the extraordinary; it reflects a love of art that celebrates dissonance and beauty, and makes space for artworks that stay in touch with the everyday, in all its extremes and mundanities, its contradictions and excessive expectations.

You hold part of this journey in your hands. The catalogue opens with the artists' works, and with the expression of the ways we've thought through their contributions. The *2013 Carnegie International* comprises thirty-five artists from nineteen countries: Ei Arakawa/Henning Bohl, Phyllida Barlow, Yael Bartana, Sadie Benning, Bidoun Library, Nicole Eisenman, Lara Favaretto, Vincent Fecteau, Rodney Graham, Guo Fengyi, Wade Guyton, Rokni Haerizadeh, He An, Amar Kanwar, Dinh Q. Lê, Mark Leckey, Pierre Leguillon, Sarah Lucas, Tobias Madison, Zanele Muholi, Paulina Olowska, Pedro Reyes, Kamran Shirdel, Gabriel Sierra, Taryn Simon, Frances Stark, Joel Sternfeld, Mladen Stilinović, Zoe Strauss, Henry Taylor, Tezuka Architects, Transformazium, Erika Verzutti, and Joseph Yoakum.

Despite social media, the Internet, and our global information economy, it still makes a difference if you live in Tehran, a village near Kraków, Johannesburg, or Los Angeles. Yet all of the artists in the exhibition, while working from and within a local context, translate their views into pictures, sculptures, concepts, or installations that can travel and be accessed and understood by a broad audience. Carnegie Museum of Art in Pittsburgh offers, through the *Carnegie International*, a unique and recurring platform for these voices, and it is our pleasure to make them heard, knowing that listening is not always the easiest thing to do. But contemporary art is more than trophies on the wall, assets in a portfolio, or a conquest stored away in a safe. It takes a high form of troublemaking to transform our thinking, if not our lives—"for a better future," as Los Angeles artist Frances Stark recently put it. Some might find such intentions embarrassing and idealistic. Forty, fifty years ago, art was meant to change the world and utopia was just around the corner. In the end, it wasn't there, so the desire for redemption shifted toward theories and their promises. The 1980s came and went, a decade marked—for some—by deconstruction, simulation, postmodernism, and nightlong discussions about Derrida, Lyotard, Barthes, Benjamin, and the end of history. The art market crashed soon after, in the early 1990s, only to resurrect itself around 2000 stronger than ever. It is normal and good that grand ideas die and ambitious theories fade. Yet it is unsatisfying to be left with a dominant popular conception that art finds its sole expression of power in the monetary realm.

While organizing the *2013 Carnegie International*, once in a while we confessed to each other that we do what we do because we are convinced that art makes life better. It was almost a secret. And now we've decided to come out, here and now. We love art because it is a troublemaker that changes our thinking and even our lives. This was one of the reasons we added troublemakers to the catalogue itself. They are here to complete the artists' voices and ours, to sustain or break the rhythm of the book, and to push beyond the limits of this exhibition. You will find a very engaged, sorrowful text by Carnegie museum director Gordon Bailey Washburn from 1961, unaware of the transformations the 1960s were about to unfurl; an inspiring scheme

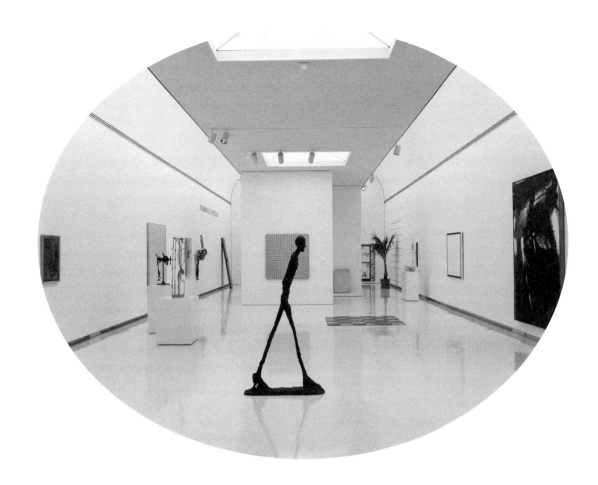

FIG. 1
Installation view of modern and contemporary galleries, Carnegie
Museum of Art, June 2013

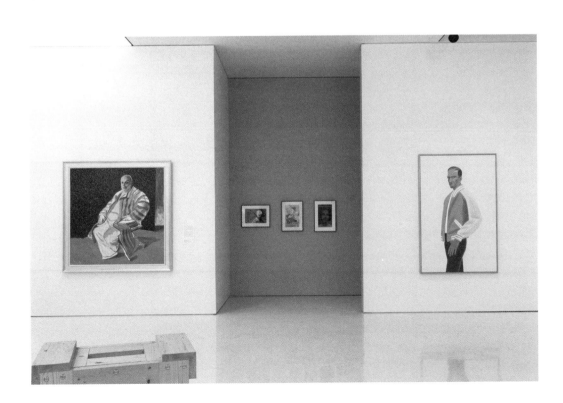

FIG. 2
Installation view of modern and contemporary galleries, Carnegie
Museum of Art, June 2013

recreational gathering in which Israeli men with SUVs and pickups meet on the arid coastal sand dunes outside Tel Aviv to demonstrate their driving prowess to a crowd of spectators. The men take turns scaling the most abrupt slopes, often at perilous angles that threaten to capsize their vehicles. As a fragment torn out of narrative context, *Kings of the Hill* offers itself to symbolic extrapolation and universal significance: though not explicitly related to the Israeli-Palestinian conflict, the aggressive absurdity of the activity may be seen to represent the senseless single-mindedness and territorial rapacity of perpetual war.

Recently Bartana has taken on a less passive role in her videos, shifting from anthropologist to provocateur. Her epic trilogy *...And Europe Will Be Stunned*—composed of the films *Mary Koszmary* (*Nightmares*; 2007), *Mur i wieża* (*Wall and Tower*, 2009), and *Zamach* (*Assassination*; 2011)—imagines the rise of the fictional Jewish Renaissance Movement in Poland (JRMiP). Led by a charismatic young radical played by Sławomir Sierakowski (founder of *Krytyka Polityczna* [*Political Critique*] magazine and actual leader of the Polish New Left), the JRMiP seeks the return to Poland of three million Jews displaced during the World War II era. Weaving actual statements and actions into a fictionalized narrative, Bartana's trilogy traces the JRMiP from its beginnings, with Sierakowski delivering a moving speech (written by him with activist Kinga Dunin) in the dilapidated National Stadium in Warsaw, to the construction of a full-scale kibbutz on the site of the Warsaw Ghetto, to Sierakowski's (symbolic) assassination and funeral service.

Like *Summer Camp*, the trilogy addresses themes of homeland and belonging, evoking historical cycles of expulsion and the ramifications of the "right of return."[6] And yet, Bartana's trilogy telescopes time, channeling the utopian zeitgeist of the Socialist era to open up new interpretations and fresh possibilities in the present, suggesting that living together should be tried, in answer to both the lingering anti-Semitism in present-day Poland and the ongoing Israeli-Palestinian conflict. Both works open the door to empathy, to seeing oneself in the Other.

—Amanda Donnan

1. Arata was divided in 1967 when the State of Israel annexed half of the village—along with other Palestinian lands to triple the size of Israeli territory—creating a disputed border zone of nearly constant construction and destruction. See Galit Eilat, "Non-Zionist Propaganda," in *Yael Bartana: Short Memory*, ed. Sergio Edelsztein and Klaus Biesenbach (Tel Aviv: Center for Contemporary Art, 2008), 105.
2. Ariella Azoulay, "'Come Back! We Need You!' On Yael Bartana's Video Works," in *Yael Bartana: Short Memory*, 36.
3. Moshe Ninio, "On *Kings of the Hill* and Some Other Video Vignettes by Yael Bartana," in *Yael Bartana* (Ostfildern, Germany: Hatje Cantz, 2008), 26–27.
4. See Sergio Edelsztein, "Utopias and Historical Reversibility: Yael Bartana's New Works," in *Yael Bartana: Short Memory*, 25–30.
5. Ninio, "On *Kings of the Hill*," 25.
6. A principle of international human rights that gives refugees the right to return to their homeland, it is invoked to give all people of Jewish descent the right to obtain Israeli citizenship. Palestinians, too, as people from the land that is now Israel, have demanded the same right as part of any peace negotiations, though it has consistently been denied. See Sascha Crasnow, "Politics of Space and Belonging and the Right of Return," *Hyperallergic.com*, January 2, 2012, http://hyperallergic.com/44020/yael-bartana-and-europe-will-be-stunned/.

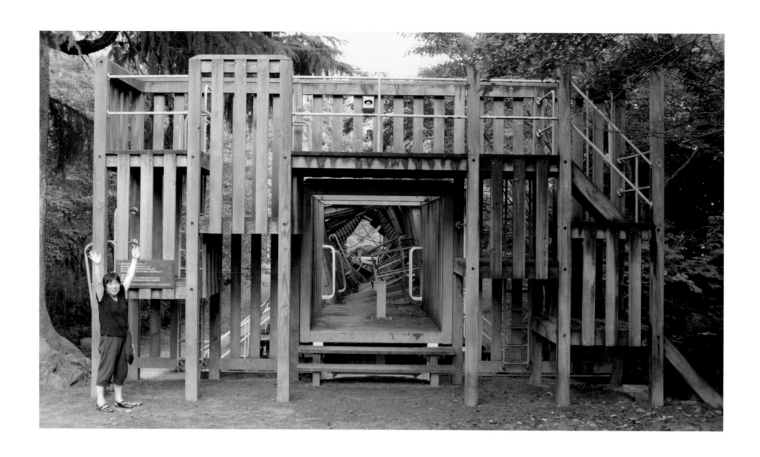

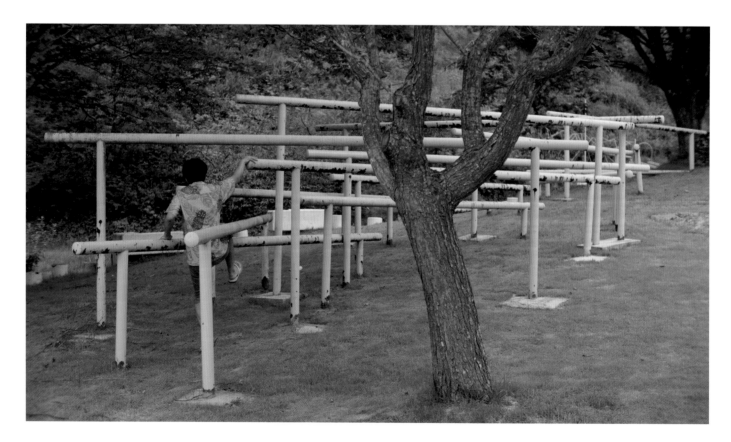

Ei Arakawa location research for *Helena and Miwako* 2012 Courtesy of the artist
Top: Tunnel Gururin by Mitsuru Senda, Iwaki, Fukushima, Japan
Bottom: Ryozen Children Village by Mitsuru Senda, Date, Fuskushima, Japan

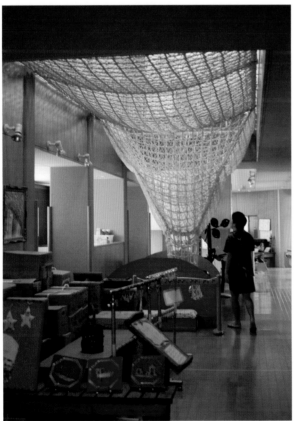

Ei Arakawa location research for *Helena and Miwako* 2012 Courtesy of the artist
All: Houtoku Kindergarten by Mitsuru Senda, Iwaki, Fukushima, Japan

Ei Arakawa location scouting for *Helena and Miwako* 2012 Courtesy of the artist
Top left: Adventure Playground at Hanegi Play Park, Tokyo, Japan
Top right: site of Reversible Destiny at Yoro Park by Shusaku Arakawa and Madeline Gins in Gifu, Japan
Bottom: Fuwa Fuwa Dome at Showa Kinen Park by Takano Landscape, Tachikawa, Tokyo, Japan

Ei Arakawa and Henning Bohl stills from *Helena and Miwako* 2013 cat. no. 1

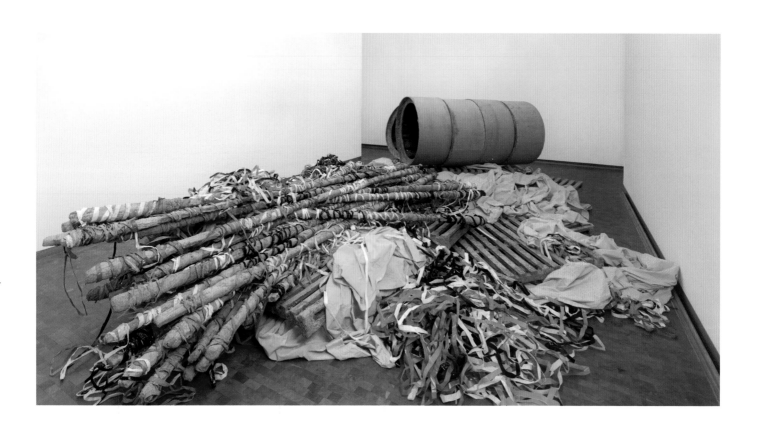

Phyllida Barlow installation view of *untitled: pallettestarpaulinscylinder* 2011 in the exhibition
Before the Law at Museum Ludwig, Cologne, Germany, 2011

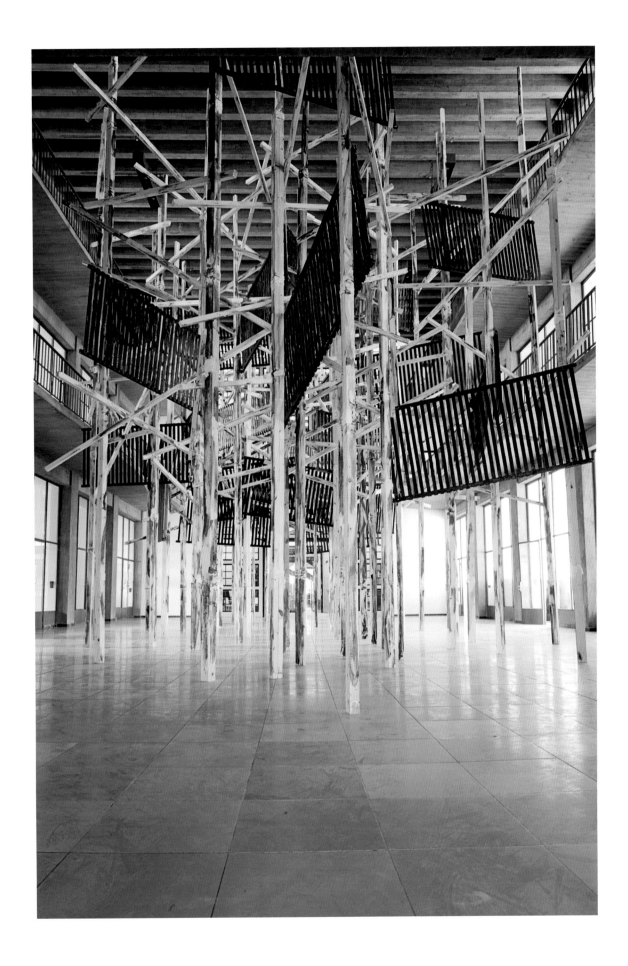

Phyllida Barlow installation view of *untitled: structure* 2011 in the exhibition *Cast* at Kunstverein Nürnberg, Nuremberg, Germany, 2011

Sadie Benning details of *Locating Centers* 2013 cat. no. 12

Bidoun Library installation view of Bidoun Library in Cyprus 2012–13 cat. no. 13

Bidoun Library selection of books from Bidoun Library Courtesy of Bidoun Library

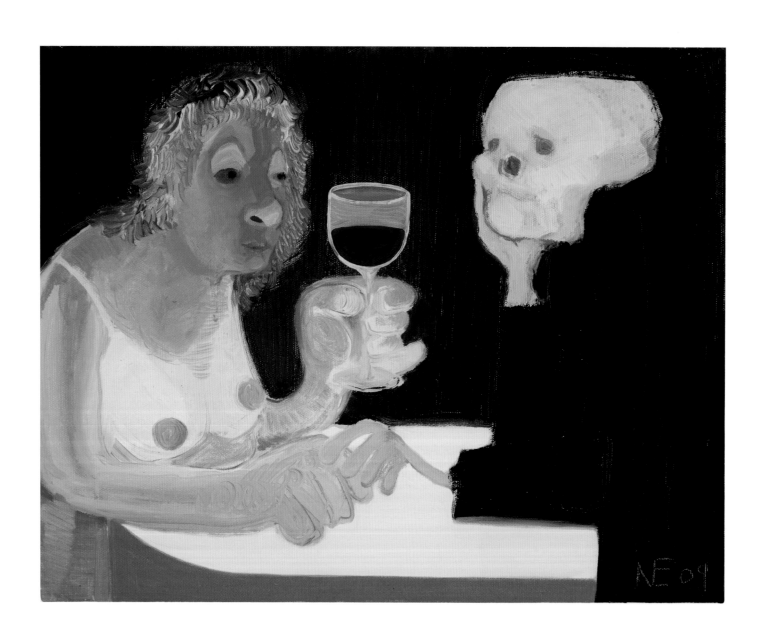

Nicole Eisenman *Death and the Maiden* 2009 cat. no. 28

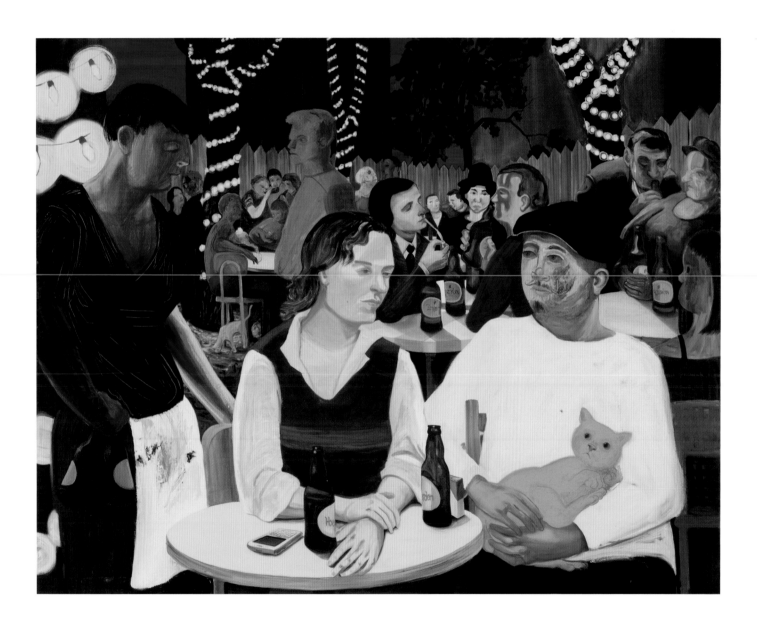

Nicole Eisenman *Beer Garden with Ulrike and Celeste* 2009 cat. no. 27

Lara Favaretto *Un Ruisseau d'Or* 2012 iron road plate and silk 98 ⁷⁄₁₆ x 80 ¾ x ⅝ in. (250 x 205 x 1.5 cm) Private collection

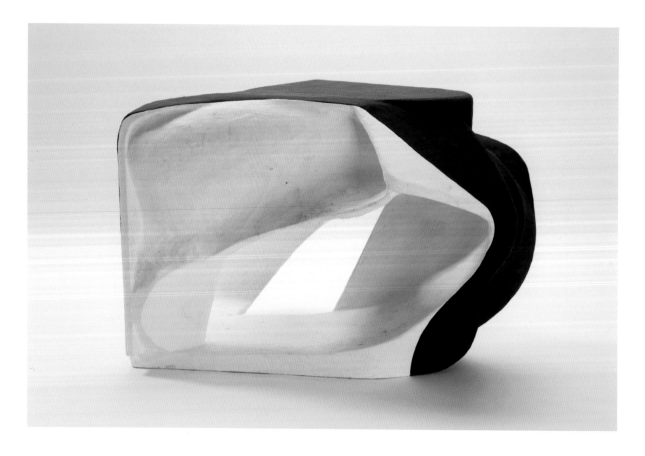

Vincent Fecteau *Untitled* 2008 cat. no. 48
Vincent Fecteau *Untitled* 2008 cat. no. 47

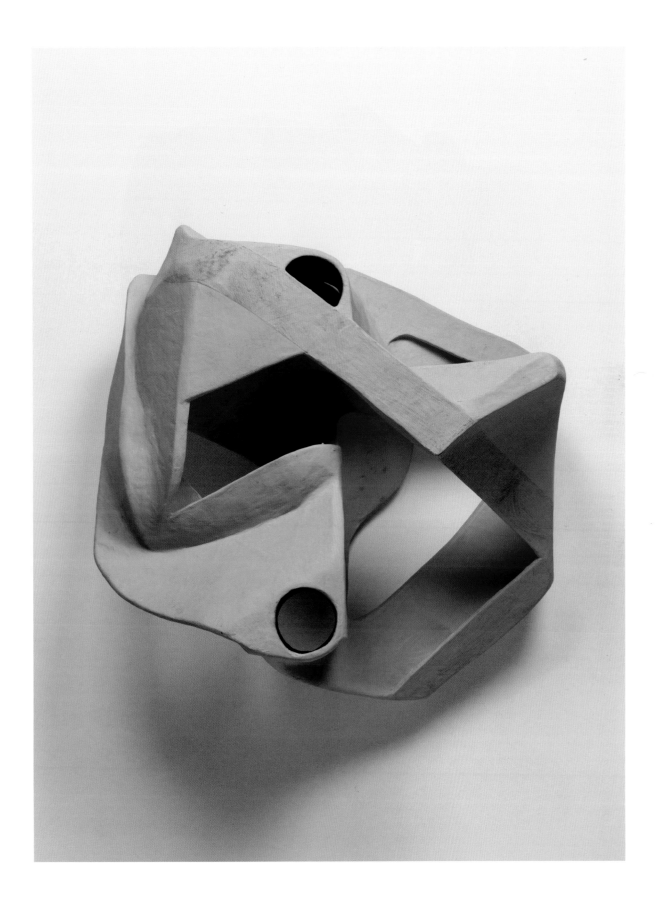

Vincent Fecteau *Untitled* 2010 cat. no. 50

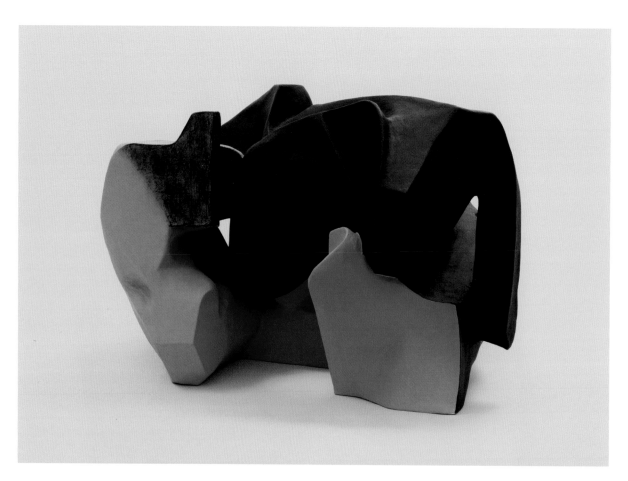

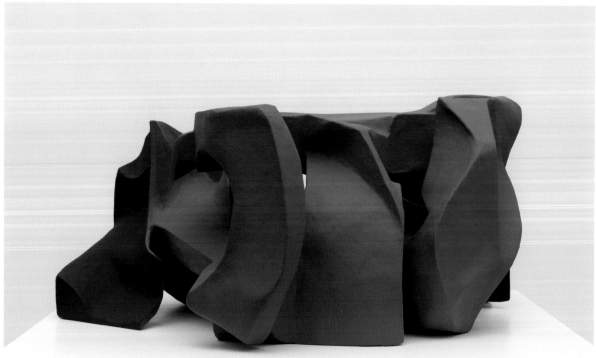

Vincent Fecteau *Untitled* 2012 cat. no. 53
Vincent Fecteau *Untitled* 2012 cat. no. 54

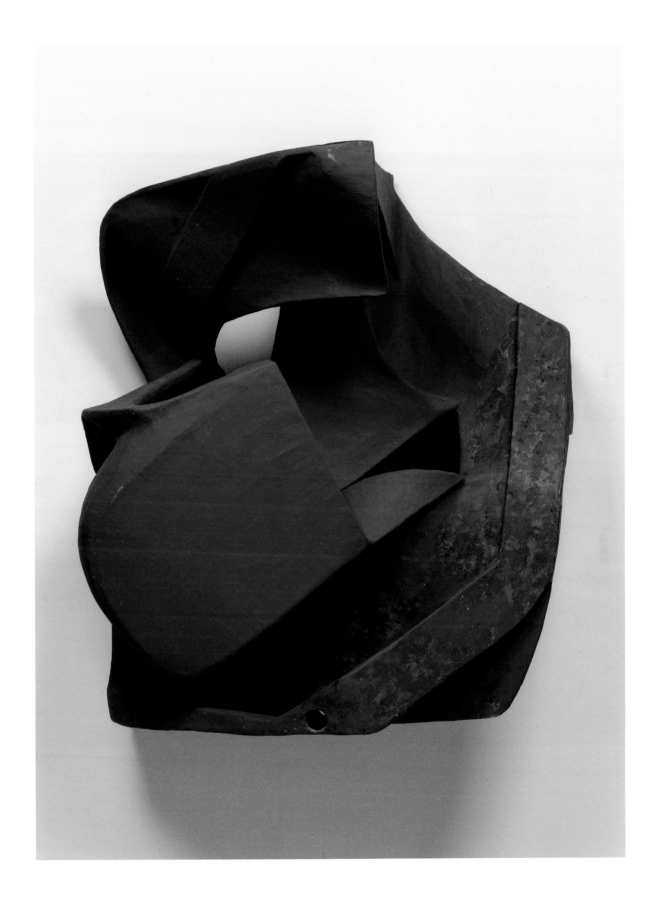

Vincent Fecteau *Untitled* 2010 cat. no. 49

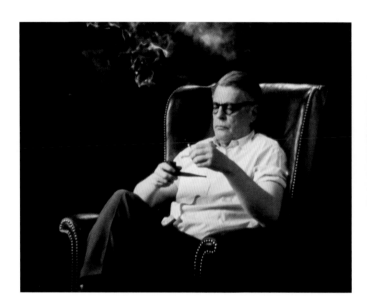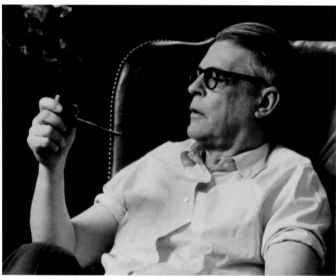

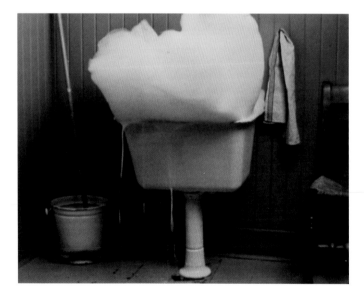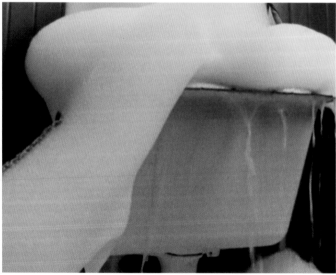

Rodney Graham stills from *The Green Cinematograph (Programme 1: Pipe smoker and overflowing sink)* 2010 cat. no. 56

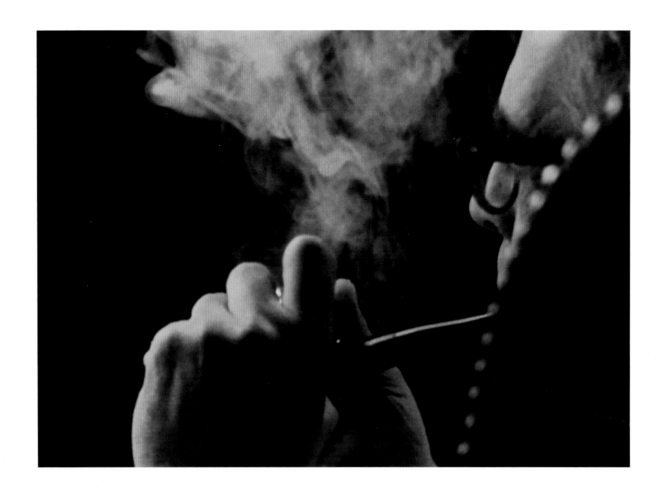

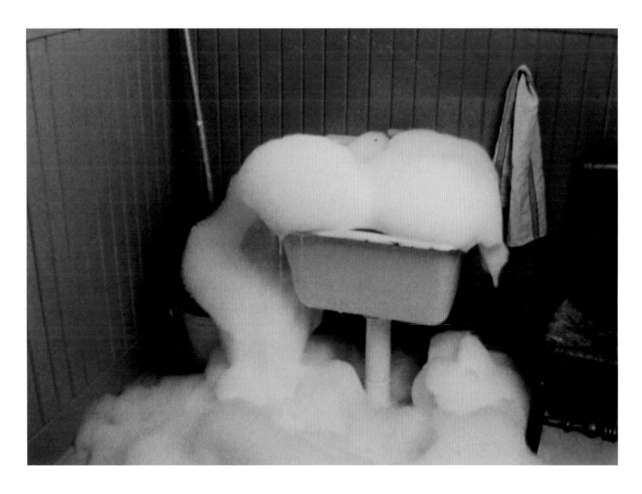

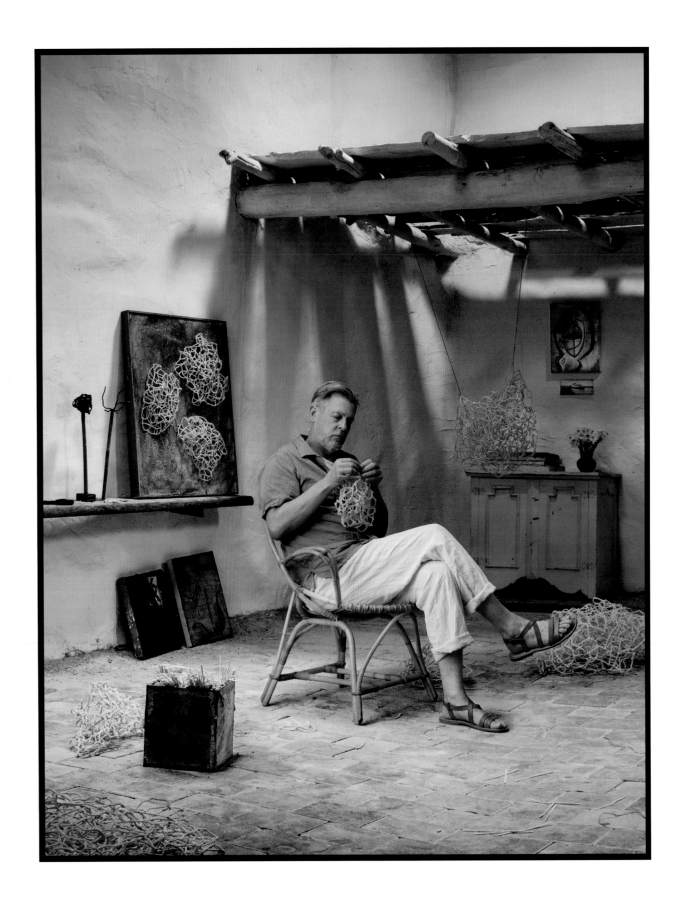

Rodney Graham *The Pipe Cleaner Artist, Amalfi, '61* 2013 cat. no. 57

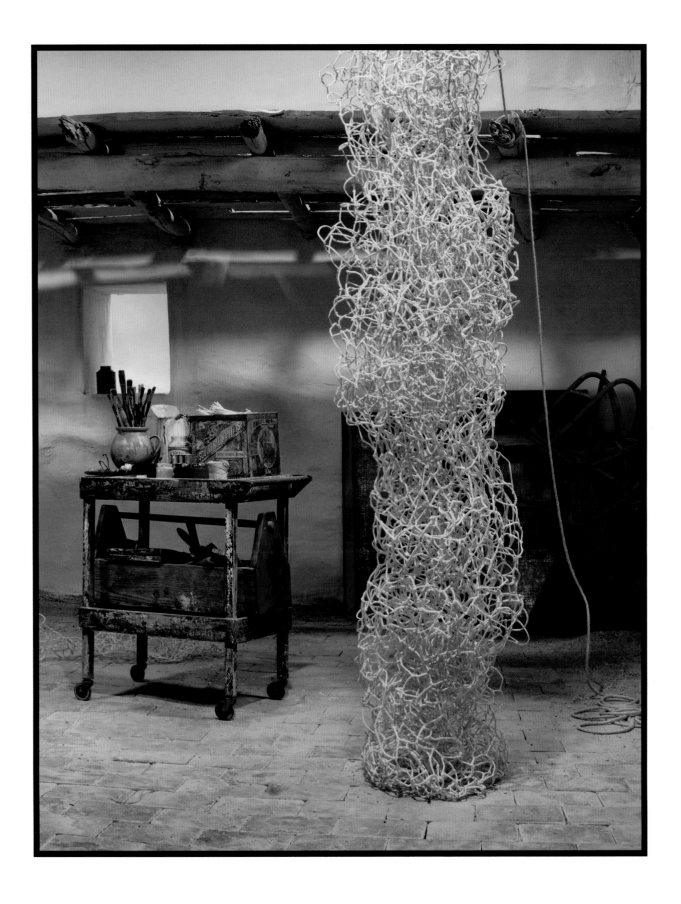

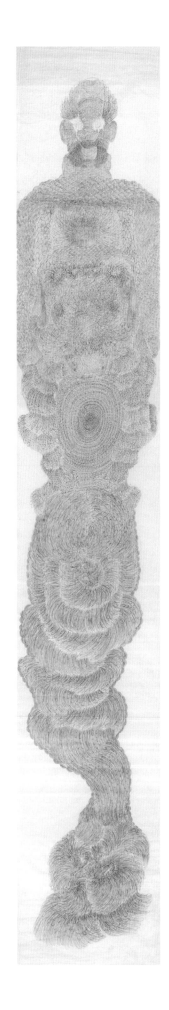

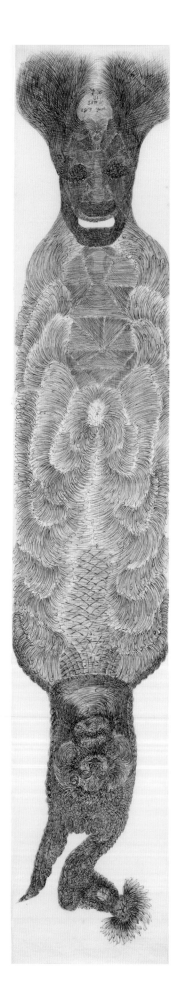

Guo Fengyi *Image of Tortoise and Snake* 2004 cat. no. 62

Guo Fengyi *Fuxi* 2006 cat. no. 64

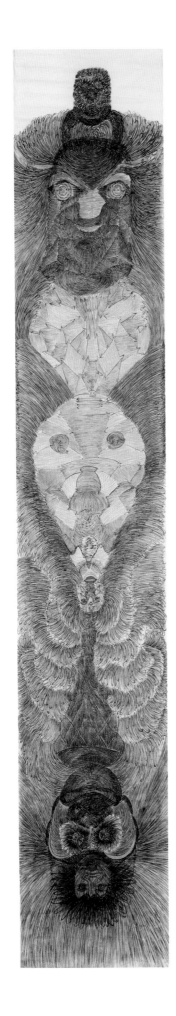

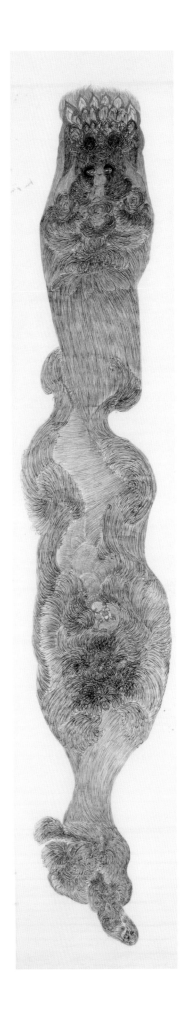

Guo Fengyi *Shaodian* 2006 cat. no. 65

Guo Fengyi *Di^pam!kara* 2007 cat. no. 66

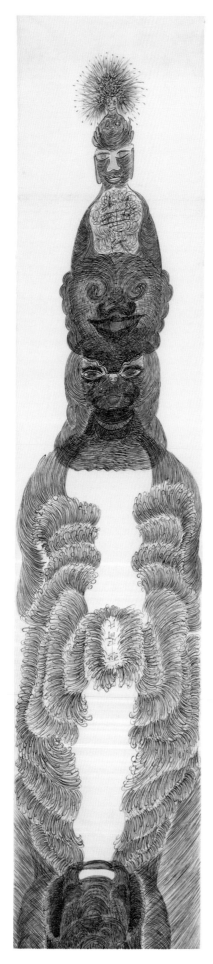
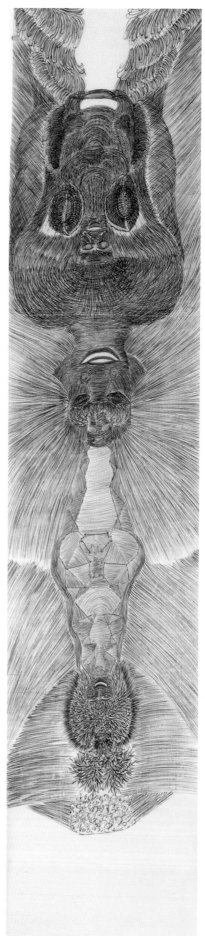

Guo Fengyi *Huaxu Family* 1996 cat. no. 60

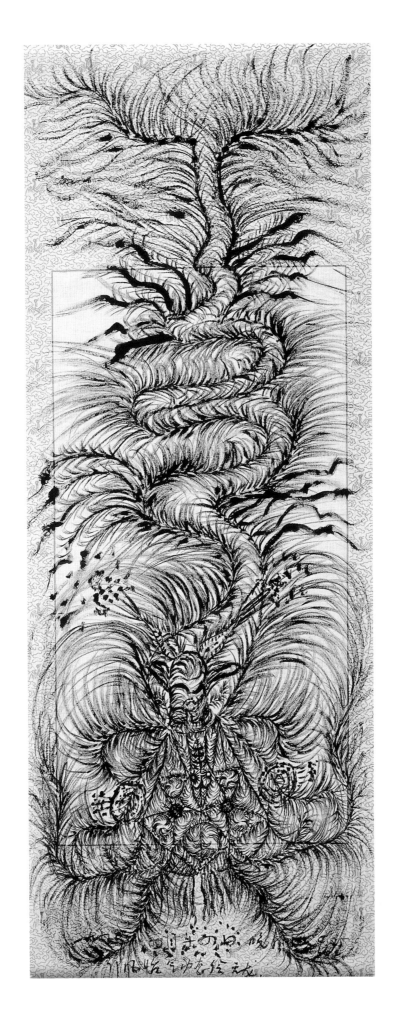

Guo Fengyi *Heavenly Dragon* 1990 cat. no. 59

WADE GUYTON

BORN 1972, HAMMOND, INDIANA
LIVES AND WORKS IN NEW YORK, NEW YORK

Since they first met in 2003 for the exhibition *Context, Form, Troy* at Vienna's Secession, Wade Guyton and Daniel Baumann have entertained a discussion about art and the expectations attached to it. The following interview was conducted via email.

* * *

DANIEL BAUMANN — Standing in front of one of your paintings, I see a painting, right?

WADE GUYTON — This one. That could be considered a painting, sure.

DB — For many of your works, you fold the canvas vertically, stick it into a large professional Epson printer, and push the "print" button on your computer. If the canvas gets stuck, you have to pull. Sometimes the printer does unexpected things: the print head might leave traces on the canvas or it might have problems delivering the right amount of ink. Once the canvas is through, you turn it and print the other half. Sometimes you repeat this process and print over the same canvas again. You use abstract motifs; you might send a black surface or a colored line to the printer, or sometimes flames. How do you produce the motifs?

WG — Oh, there are different ways. Sometimes the image is "drawn" in Photoshop, other times it has been imported or scanned from something in the world—a book or a piece of paper. Other times it is typed.

DB — It is a conceptual, seemingly laid-back approach to painting. You never touch a brush or even paint. Sometimes the concept gets troubled by the machine, the printer, which stumbles, stutters, and fails. Do many canvases fail?

WG — Well, the works record their own process and sometimes there are troubles, yes. And like many things that don't hide their history, sometimes they don't look so good or they make us uncomfortable. But over time, one's mind might change. Or maybe things eventually find their place in the world. So maybe there are tons of failures—it sure looks that way around here now, doesn't it?

DB — So standing in front of one of your paintings, I see a painting that isn't a painting. It lies to me. At the same time, it is transparent; it records its own making and embraces its affiliation with Conceptual art, Minimalism, and the grand traditions of abstract art and Color Field painting. These are among the beloved achievements of American art, and yet your work seems suspicious of their ambitions, their search for perfection and the absolute, which, in your case, is stymied by the printer's stuttering.

So there is a disenchantment, and the painting lies, even as it speaks the truth. There is some humor there. Is it Tennessee (where you grew up) laughing at New York?

WG — Ha! There probably is some laughter at New York going on there, but I'm part of New York too, so I'm being laughed at also, and the paintings aren't jokes. This idea of lying is interesting. I'm not sure exactly what the lie is, but I do sense that people have a feeling of being lied to. Some people—like you—are interested in the lie, and others get irritated that the truth they expect or believe in isn't being respected.

DB — For many, art is a refuge for the authentic and the truthful, and we expect it to behave with a certain integrity. This is the contract modernism worked out in opposition to what it perceived to be the lies of academia and the ingenuousness of eclecticism. Still today, the relationship between the artwork and the viewer is based on this fundamental contract. Your paintings (which are not paintings) break with this contract.

WG — Maybe the route to truth today isn't necessarily through truthfulness.

DB — Well, I prefer "understanding" to "truth." So yes, your paintings do a great deal to batter my usual reception of an artwork. There is quite a bit of disillusionment going on, which is always welcome. It's done elegantly, in a calm way and without anger. Beyond this, there is a will for or interest in composition evident in the paintings—a desire that they hold up formally. What for?

WG — I think this is a side effect of the natural form of the works. Most of them are rectangular, because that is the format of the printer, and just tall enough to get into my elevator. And because they are all folded to increase the print area, there is always a center axis: a bilateral symmetry or asymmetry, like a body. Information is present and absent. And the "image" is in varying degrees of completion. So these things create what seems to be a composition. When I install them, they often have a relationship with the space around them: for example, when I exhibited them [in 2011] at the Villa Francesca Pia, the second space that the Galerie Francesca Pia temporarily rented in Zurich. Maybe this is part of the illusion?

DB — Yes, they looked like abstract paintings, actually *were* abstract paintings, but became tools to change the perception of the space. Villa Francesca Pia was formerly used by Kornfeld Gallery & Auctions, all Gilded Age rooms, but marked by a hefty 1970s renovation. The paintings didn't hide it; in fact, it was the opposite. They created this kind of brothel atmosphere out of these domestic spaces that went commercial. It was abstraction meeting the shabby. So your paintings are less abstract and autonomous than they look at first. They open themselves up to the outside and are conditioned by seemingly irrelevant, yet relevant, things such as the dimensions of an elevator or the size of the printer. The outside world forces its way in, visibly and literally, in a way that is as ridiculous as it is strangely touching. They allow the mess called "everyday

life"—that thing from which abstract painting always wanted to escape—to spill in. Maybe this is what was going on at the Villa Francesca Pia show. They were no longer paintings hanging on walls, but rather paintings hanging in a room and making that room visible and coherent as a clear entity. But what do you mean by "Maybe this is part of the illusion"?

WG — I mean the illusion of "composition." I think viewers have a desire for composition, or for things to work themselves out formally—even if the elements of a work aren't formal or worked out. It's an illusion produced more from the desires of a viewer than from the work of art itself.

DB — But composition is not just a projection on the part of the viewer; it has autonomy. As a viewer, I want to face something. If it is too hermetic, it doesn't need me; it's self-sufficient. If it is too loose, I don't even see it. It's not just an illusion produced by a desire; it isn't solipsism, but quite the opposite.

WG — Exactly—it's like a focusing mechanism. It is a necessity.

ROKNI HAERIZADEH

BORN 1978, TEHRAN, IRAN
LIVES AND WORKS IN DUBAI, EMIRATE OF DUBAI, UNITED ARAB EMIRATES

While on a trip to Paris for a gallery exhibition of his work in 2009, artist Rokni Haerizadeh received a call from a friend in Tehran warning him and his brother, also an artist, not to return: their work had been seized from a private collection in Tehran. Haerizadeh has not returned to Iran since, although his paintings, drawings, and animations draw heavily on the painterly traditions of Persia. In his animation *Just What Is It that Makes Today's Homes So Different, So Appealing?*, Haerizadeh transforms found media imagery of protest, disaster, and violence from the 2009 Iranian demonstrations into fairy tales of sensual delights, where human heads of protestors and newscasters alike are replaced with those of animals. A more recent animation, *Reign of Winter*, debuting at the *2013 Carnegie International*, takes on the subject of the British royal wedding. The following interview took place in January 2013 via email and Skype with the artist in Dubai, where Haerizadeh and his brother now live. The text immediately below is a collaboration between Haerizadeh and the writer Nazli Ghassemi, who also is responsible for the translation of the artist's responses from Farsi.

* * *

Outcry and mayhem, sound of gunshots, people escaping, buildings on fire and smoky streets blend in with the steam rising from a hot cup of tea, aromatizing the senses in the air around the kitchen.

Clean and fresh out of the shower, towel in hand, drying your private parts, peeking at the dead bodies rolling out from under the rubble in an earthquake.

Eyes wide open, mouth agape, nibbling on your organic savory crisps, staring into Gaddafi's half-open mouth. Passing by a kindergarten, seeing the children in the playground, an eerie chill running down your spine—fright engulfed.

These invasive images introduce strangers into the secure privacy of our homes as they barge in, violating the most intimate moments of our lives.

* * *

TINA KUKIELSKI — Your previous works, the portfolio of watercolor and gesso drawings that make up *Fictionville* (2009–ongoing) and the animation *Just What Is It that Makes Today's Homes So Different, So Appealing?* (2010–11), made use of protest imagery from the news and other online media. Not coincidentally, you were working on these projects as the Arab Spring erupted. How did that affect the work? Did it change or alter your subject or the tone in any way?

ROKNI HAERIZADEH — I've been questioning the role of the spectator and his or her ethical stance as a consumer of media images for the past few years. Looking through the carnage of my accumulated archive of images, I began to detect the rhythm of a "system," one that has turned us into numb spectators of violence. The theatrical display of violence in this system is seen everywhere, regardless of the location (Syria, Egypt, London) or the occasion (a wedding, a protest). Whether it be the coverage of uprisings around the world, a gathering of political leaders at a forum or a royal wedding, or a pop star's funeral, the system is there wiping away one phenomenon with another.

We are consumers who, through viewing the repetitious images, indulge in a certain voyeuristic fulfillment as passive onlookers with a distorted (misplaced) moral gauge. We have become inured to the violence of our times.

The why and the how of this current "spectator" state of being interest me. I pervert the archived pictures, taking the images and the scenes away from the conventional moral codes.

TK — This may be a simplistic question, but why paint humans with animal heads? Are there references to fairy tales and folklore in your work, or is there a contemporary source for these bestial explorations?

RH — Instead of getting consumed by the intended moral or immoral message of the original scene, I turn my attention to the negative (empty) spaces and the margins of the pictures. I mutate humans into animals to highlight our basic instincts. The beast heads are inspired by anthropomorphic characters in fairy tales, ancient fables, and satirical plays that become vehicles for frank expression.

TK — For your new animation, *Reign of Winter* (2012–13), you chose to use imagery from the British royal wedding of Prince William and Kate Middleton. Why?

RH — I've always been fascinated by rituals and their corresponding choreography of movements. And in my view, the arcane hysteria disguised within elaborate ceremonies asserts a system of dualities. A royal wedding is the ultimate manifestation of this: man and woman, old and new, poor and rich, nature and city, trees in a cathedral, car and carriage, royalty and commoners.

TK — When you were studying art in Iran, how important was the tradition of Persian miniatures to you as an artist? How did you choose the title for this work?

RH — The poem "Reign of Winter" by Akhavan Sales, which often plays as a soundtrack to my thoughts, seemed to fit this project. It describes the bitter-cold cruelty of winter, and the colorless existence of those left outside at the mercy of the elements. There is a certain pathos in this poem, which captures the breath on the streets; it reflects the spirit of our times. Hossein Alizadehand later composed the music, and the song is performed by Mohammed Reza Shajarian.
I carry within me the sensitivities of the culture I've grown up in, and so, yes, the relationship between literature and image in Persian paintings has had a strong influence on me and it's something I explore in my works. In this project, I have brought language and image together again to watch them mate, wondering where they will lead me: from a poem to a soundtrack, which may then be reduced to a sound, or a noise, and perhaps ultimately lead to silence.

TK — Your work has been described as "ruthless criticism in the spirit of creative play." Do you agree with this assessment?

RH — I agree if:

"ruthless" is describing an unidentifiable state beyond morality or immorality — a power felt in an ocean wave or a bolt of lightning.

"creative" means free-flowing and unpredictable like the waves of a gem-filled ocean, always roaring.

"play" is a swing between comedy and tragedy — unruly, unyielding, playfully devoid of affirmation or condemnation. With no winners or losers. Shunning all mortal logic — eager to destruct. Always present.

In my view, art should provoke. It must employ cruelty, which is an inherent quality of life. If this cruelty is ignored, then art becomes just another manipulated plaything.

TK — Who or what influences you?

RH — We have surrounded ourselves with a spectrum of amusing "whos" (humans, pets, and beasts) and "whats" (objects of artistic and nonartistic worth, a film archive, a book library, a home-grown garden, etc.). So the "what" in question may be anything from a mouse caught by the house cat, to a drawing by an artist, to a film. And the "who" may be a film director, or an artist, or a dog's love for someone or something.

HE AN

BORN 1970, WUHAN, HUBEI, PEOPLE'S REPUBLIC OF CHINA
LIVES AND WORKS IN BEIJING, PEOPLE'S REPUBLIC
OF CHINA

In He An's *What Makes Me Understand What I Know?* (2009), two names are repeated several times, spelled out in Chinese characters by combining fragments of neon light-box signs. One name, that of the artist's father, He Taoyuan, consists of three characters; the other, Miho Yoshioka, the name of a favorite Japanese adult-video actress, is four characters long. Over the course of a year, He and a group of collaborators stole the neon characters from cities all over China. The original installation repeated both names nine times; three of those sets are presented in the *2013 Carnegie International*.
What Makes Me Understand What I Know? abruptly combines a number of references to people, places, and things: the artist's familial relationship with his father and his anonymous yet intimate relationship with a pornography actress; the alienating urban spaces under hyper-development in China; and memories of home from the artist's new, adopted city of Beijing. The installation is rough and lawless, though not overtly aggressive. Instead, it is

hopelessly emotional and "warm," in the words of its maker. It reflects the specific conditions of contemporary China, and the texture of urban life—the opportunity, anonymity, and visual cacophony—experienced by hundreds of millions of people there. The raw material—stolen light-box signs—is made possible by the abundance of cheap, quickly produced (and hence quickly replaced) signage that accompanies urban population and economic growth, and the acceleration of services and businesses that populate the streets and floors of buildings. The speed of that growth and the dark gaps left behind in the development of cities—where buildings disappear and reappear, streets are lit and then darkened—create a kind of vulnerable emptiness. Gaps, over-crowded spaces, darkness, and harshly lit passages all appear blank before and after their appropriation by business, allowing for the projection of subjective ownership by those people who pass through. As He has noted,

> The development of cities is happening so fast to the point that you can leave a place and the memories won't be there when you come back.… Mainly, I think I feel grief and indignation. I have no idea what to do with the environment that I live in; all of these emotions cannot fit into one solid place. As to the act of stealing the signage, the consequences have been considered, but it isn't so bad … it is a sense of playing a game like kids; it's a rebellious act made from my frustration of the city. It's a small voice from a nobody, and an attempt to connect with the city.[1]

The artist started using illuminated signs in 2000, and the material is specific to the context of newer Asian cities, such as Shenzhen, formed only in 1980 as part of China's creation of "special economic zones." North of Hong Kong, Shenzhen has seen the investment of billions of dollars, attaining a rate of growth almost unseen in China's accelerated economy. "At the time," He says, "Beijing was yet to have as many neon lights as Shenzhen—Shenzhen being so close to Hong Kong. I feel that the lights from various cities are actually different.… At the time, Wuhan wasn't as developed as Shenzhen. You could feel that especially at night; the whole emotions of the city were different. Shenzhen is what really drew me towards these lights, of course Shanghai as well."[2] *What Makes Me Understand What I Know?* carries the texture and atmosphere of those cities. The character of the light boxes (and occasional neon tube) is very different from the allusions to American vernacular signage and advertising one finds in Bruce Nauman's work, or the abstracted, industrial quotation in a Dan Flavin sculpture. In He's collage of artificial surfaces, the work forms and re-forms the names and their associations, producing evocative combinations and adjacencies. Curator, critic, and artist Colin Chinnery has compared He's art to that of Jack Pierson, whose work comes from "a sculptural sensibility, where the formal beauty of each letter complement[s] each other to create strict compositions of shape, color, and meaning. He An's word compositions reflect more directly the aesthetic environment they came from—a confused and arbitrary mixture of kitsch and practical sensibilities. Whereas Pierson's formal devices distance his word sculptures from their original public settings, He An's work brings their setting into the exhibition hall."[3]

In the context of the *Carnegie International*, that means introducing the banally chaotic glow and hum of an ultramodern (rather, contemporary) city such as Shenzhen into the one-hundred-year-old marble halls of a museum built by an American industrialist. For US audiences, the sight of these words carries a sense of recognition—we are accustomed to seeing Chinese characters on signs and products. But just as recognizable is the increased sense of familiarity itself of encountering this foreign language in our environment (think of Ed Ruscha's Tool & Die paintings, which translate English industrial signage into Asian characters to comment on the passing of homegrown industry to the globalized, cheap-labor economy of the day). We are overly familiar with news stories of a rapidly industrialized, highly polluted China and the new cities that rise up alongside factories. (Pittsburgh around the turn of the nineteenth century might be a familiar analogue.) Whether or not one is able to understand the language in He's installation, one can make out the repitition of elements—of Chinese characters—which are actualized differently in each set of names. Facing the repetition and the seemingly random combination of elements, one immediately grasps the associations with street life and the anonymity of cities; even without knowing the meaning of the words, one has access to the underlying sense of emptiness in the work.

As He notes, "interestingly, the Zen concept of 'emptiness' differs from the Daoist [Taoist] concept of 'emptiness.' The Daoist 'emptiness' is closer to physical emptiness and quite objectified. For instance, Daoism tells us, the emptiness one faces in nature, in a forest or on the beach, is one's rapport with it. Yet the emptiness of Zen is two-dimensional, like silence in a black hole that entails one's hopelessness."[4] He's work exists between these two notions of emptiness: on the one hand, the condition made manifest by the materiality of the characters and the physicality of their gathering, and on the other, the numbing void created by the repetition of names (of those absent) and the atmospherics of the anonymous, disembodied light.

He An's project can be understood as tapping into extant reservoirs of feeling, meaning, and experience—at once obsessive, banal, superficial (built from surfaces), playful, light, and anarchic. The mantralike repetition of names brings absent people closer, and the liberation of the Chinese characters from their original purpose realigns and reforms them in the visual field. Once you start looking for (and stealing) some motif or object, you see it everywhere. One imagines, in the artist's eyes, Shenzhen or Wuhan literally lit up by glowing constituent character fragments that spell out names across great distances.

—Dan Byers

1. He An, interview with Josef Ng, in *I Am Curious Yellow, I Am Curious Blue* (Beijing: Tang Contemporary Art, 2011), 47.
2. Ibid., 46.
3. Colin Chinnery, "I am Curious (He An)," in *I Am Curious Yellow*, 14.
4. Quoted in "Production of Space, a Conversation between He An and Dong Bingfeng," in *I Am Curious Yellow*, 34.

Wade Guyton *Untitled* 2011 Epson UltraChrome inkjet on linen 84 x 69 in. (213.4 x 175.3 cm) Courtesy of the artist

Wade Guyton *Untitled* 2012 Epson UltraChrome inkjet on linen 84 x 69 in. (213.4 x 175.3 cm) Courtesy of the artist

Wade Guyton installation views of exhibition at Villa Francesca Pia, Zurich October 25–December 3, 2011

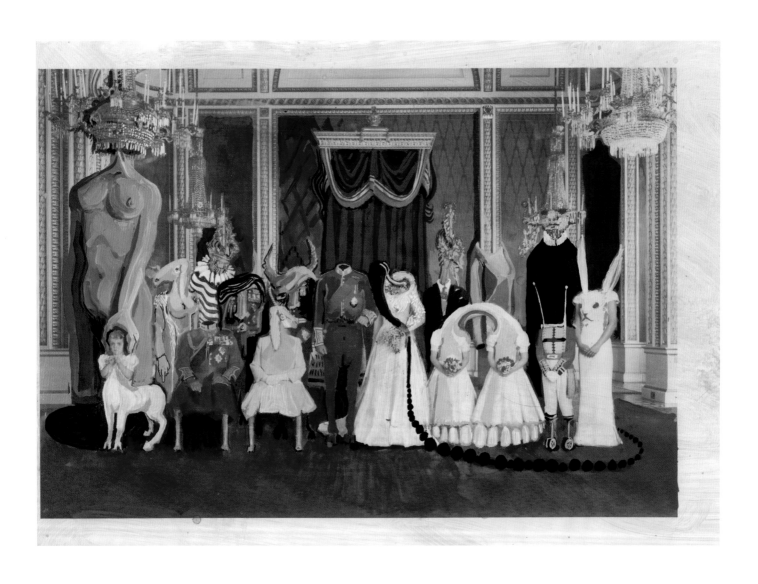

Rokni Haerizadeh *My Heart Is Not Here, My Heart's in The Highlands, Chasing The Deers* 2013 cat. nos. 79–103

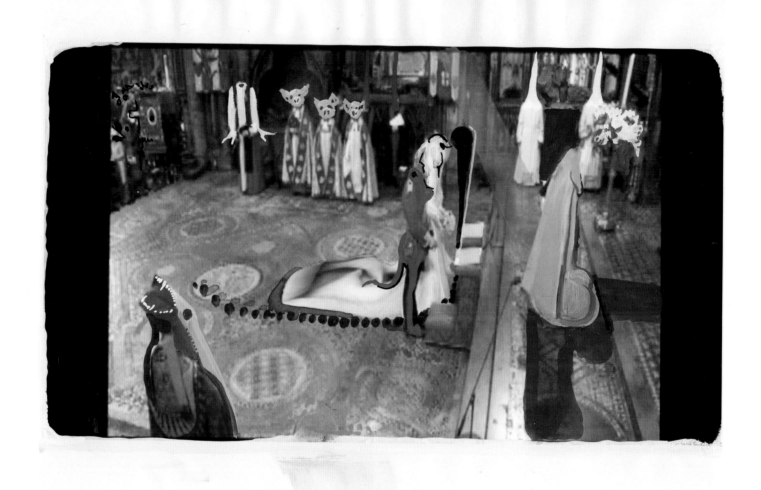

Rokni Haerizadeh *My Heart Is Not Here, My Heart's in The Highlands, Chasing The Deers* 2013 gesso, ink, and watercolor drawing on printed paper 11 ¹³/₁₆ x 15 ¾ in. (30 x 40 cm) Courtesy of Gallery Isabelle van den Eynde, Dubai, and the artist

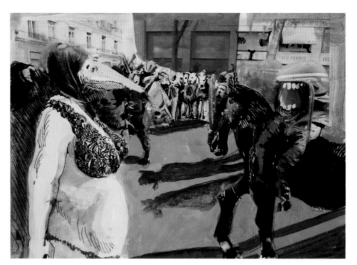

Rokni Haerizadeh selections from *Adrenaline Runs in Armpits* 2011 cat. no. 74

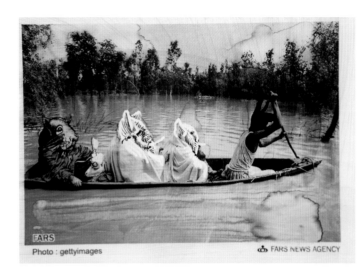

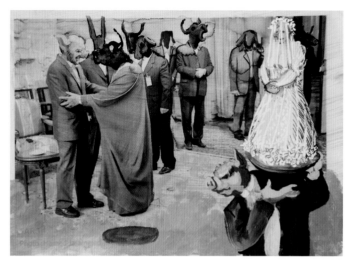

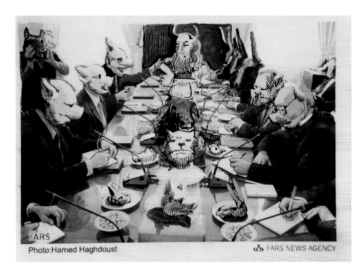

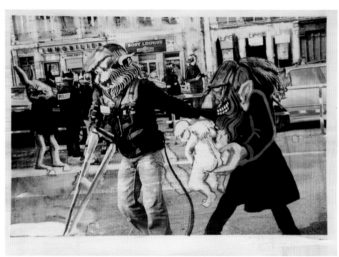

Rokni Haerizadeh selections from *Go Find a New Bed* 2011 cat. no. 76

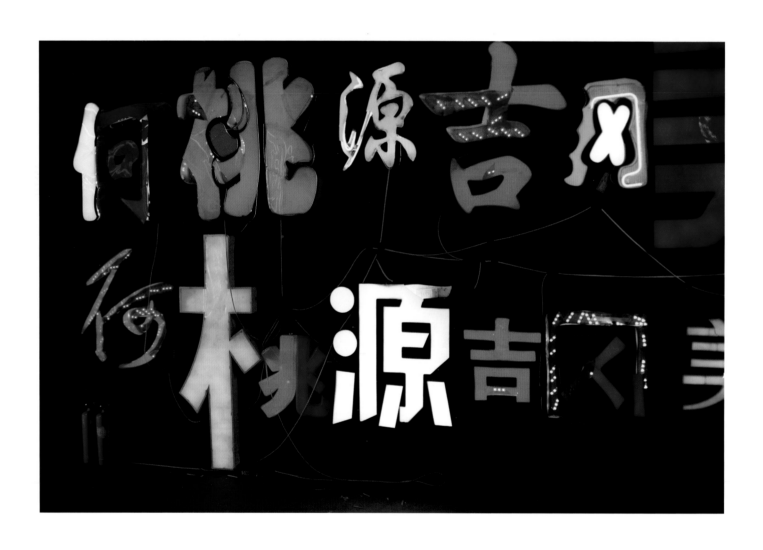

He An details of *What Makes Me Understand What I Know?* 2009 cat. nos. 104–6

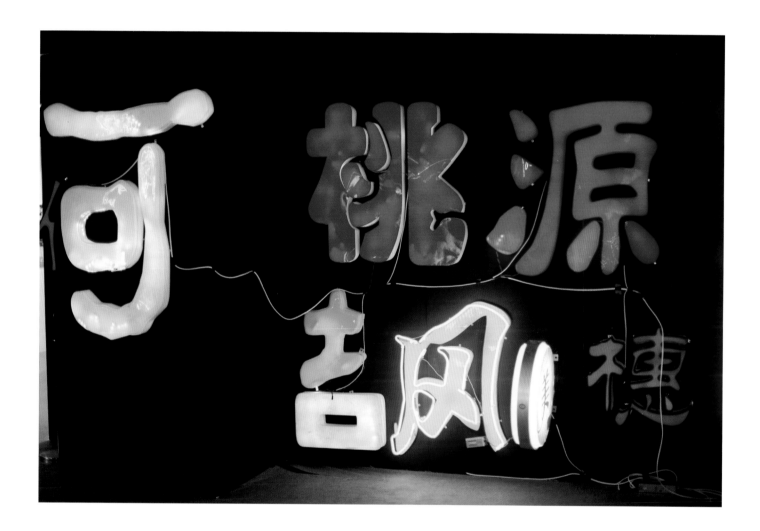

He An details of *What Makes Me Understand What I Know?* 2009 cat. nos. 104–6

AMAR KANWAR

BORN 1964, NEW DELHI, INDIA
LIVES AND WORKS IN NEW DELHI, INDIA

Amar Kanwar's films and installations address trauma, history, and conditions of conflict through experimental, often poetic, narration and documentary forms. Many of his works deal explicitly with the Indian Subcontinent, while others address zones of conflict and violence in neighboring countries, often mixing historical footage, personal testimony, and lyrical cinematography. While a voice of protest, he routinely examines the complex historical, psychological, ethical, and emotional origins and consequences of violence.

* * *

DAN BYERS — You write quite beautifully in the Documenta 13 catalogue about the situation in Odisha, the landscape pictured in your film *The Scene of Crime* (2011). Specifically, you describe how during the last fifteen years "several mountain ranges, tracts of wilderness, and agricultural lands have been sold or leased to mining cartels and other corporations for commercial use" and how the film portrays an "experience of landscape just prior to erasure." Importantly, local groups have recently staged a series of successful actions in resistance to these destructive and corrupt land grabs. What is the current state in the region, between activists and the corporate and governmental interests? Is the landscape shown in the film now gone?

AMAR KANWAR — Everything is still bitterly contested in a daily war that fluctuates on the ground, in police stations, and in courtrooms. If acquisition is resisted for too long, then the local population is worn down by arrests, violence, bribes, and propaganda. If acquisition seems to have failed, then other methods to squeeze people out are used. One way to evict a resisting community, for example, is to encircle the village with toxic effluent or dust to make the region uninhabitable. Perhaps the best answer to your question is in this public letter, released on January 11, 2013, by anti-POSCO [a multinational steel-manufacturing company] villagers. Here is an [unedited] extract:

Dear Friends, In the mid-night of 9th January, the police filled in two vehicles entered into the Dhinkia Village secretly in order to arrest Mr. Babaji Charan Samantary aged about 65 years, of Dhinkia village in false cases. However, once our villagers became aware about it, they readied for defense. The vehicles went away. Mr. Samantary who worked as postmaster in Dhinkia for 28 years, was suspended on 14/12/2007 on the ground that he was not willing to give his land for the proposed POSCO project. Despite of the suspension, Mr. Samantary voluntarily continued his work and delivered the post everyday, for about 7 – 8 months. However, around July, 2008, the bag of post was not sent, and since then the basic service delivery like post office has been arbitrarily closed in the Dhinkia village and villagers are not receiving any letter to their area. From 9th January 2013 evening onwards, the government has deployed 10 platoon of polices near to our villages. We came to know that the government is bringing another 8 platoons of police to deploy today. Apprehending the police operation at any time, the villagers are united and erected barricades, refusing entry to outsiders to their village. Both men and women have kept a strict vigil 24 x 7 and disconnect all the village connecting road to Dhinkia and Govindpur village. Kindly circulate this mail widely. In Solidarity, Prashant Paikary, Spokesperson, POSCO Pratirodh Sangram Samiti.

DB — I realize that this issue of absence and disappearance applies to the people as well as to the landscape, and with equally dire consequences. This destructive, aggressive, illegal behavior vividly illustrates the strategies to eliminate people who are indigenous to the region, and seems to represent the great cost of the growth of Indian urban centers and of international economies. Can you tell me more about the situation of indigenous peoples in the area?

AK — How do you answer that question briefly? We have been witnessing a systematic disenfranchisement of the indigenous people for a very long time now. In the past decade, the destruction of their forests, water, livelihoods, and homes has become even more severe, swift, and brutal. It seems impossible to answer without rage or sorrow, but perhaps even those two emotions are not permitted, valid, or useful anymore. Presenting data also seems meaningless, as the reality of this process is quite obvious. At times, though, it is still hard to comprehend how a nation, a class, a government can continue to destroy nature and lives with such arrogance. For you in America, this is perhaps a familiar story, maybe done and over with. There is a scene of crime in India, certainly, but there is one in America too. There is another answer as well: people are fighting back all over, with everything they have, regardless of the outcome. They are fighting as large organizations, in networks, or even just within small hamlets. With petitions, with mass demonstrations, with their children, with books and stories, or with guns.

DB — It is a familiar story here in the United States, and for many of us it can seem like a trauma from the past. But conversations such as this one (and works such as *The Scene of Crime*) remind us, viscerally, that we still live with this—in this country, considering the situation of Native Americans, or the systemic racism that pervades the structural forms of society and government. The profound impact of the physical and environmental conditions on both urban and rural poor comes to mind as well. And this makes me think about your 2010 film *A Love Story*, not only its location on the outskirts of a major city (New Delhi), but also the narrative that unfolds in it. How does that film relate to *The Scene of Crime*?

AK — There are many relationships. It is very difficult to understand the meaning and scale of this destruction. Both films search for a way to comprehend this vast, multilayered process of loss and separation.

It sometimes seems to me that it is only in the deep core of separation that one can comprehend the meaning of compassion. In order to enter this core, perhaps we need to slip into a state of mind where we can momentarily see the bareness of the image, of human beings, of the inner life of nature.

A moment within a series of migrations, *A Love Story* expands, contracts, and distills time and the image. Sequentially, cyclically, and simultaneously, it becomes the companion, the prelude, and the post-script to *The Scene of Crime*.

DINH Q. LÊ

BORN 1968, HÀ TIÊN, KIEN GIANG, VIETNAM
LIVES AND WORKS IN SAIGON, VIETNAM

Light and Belief: Sketches of Life from the Vietnam War (2012) is composed of one hundred drawings and paintings made by Vietnamese men and women serving as artist-soldiers on the communist side of the Vietnam War. Gathered and presented by Dinh Q. Lê, these images are accompanied by his documentary film featuring interviews with the artists and animated vignettes of their lives and work. This collective narrative illuminates an oft-overlooked perspective on what is also known as the *Kháng chiến chống Mỹ* or "Resistance War Against America."

The paintings and drawings are for the most part sketchbook-sized. Some present quick and loose reportage of a conflict as it unfolds, while others are meditations in times of repose, rendering life around the edges of war in fine pen-work and sweeping watercolors. Most poignant are the portraits; resembling passport photographs or family snapshots, they are records of individual lives and were often kept in a soldier's pocket to be passed on to family members should he or she die in combat. In Lê's documentary, the artists (Lê Lam, Quách Phong, Huỳnh Phương Đông, Nguyễn Thụ, Dương Ánh, Vũ Giáng Hương, Nguyễn Toàn Thi, Trương Hiếu, Phan Oánh, Kim Tiến, and Minh Phương) speak with humor, candor, and a great deal of pride about the political and cultural history of their country.

The *2013 Carnegie International* marks the first showing of *Light and Belief* in the United States, following its only other presentation, which was in Germany as part of Documenta 13. In this interview, Lê speaks about the impetus and function of this body of work, as well as his own relationship to the Vietnam War.

* * *

DINH Q. LÊ — The impulse for me to create this project was to argue for the place of these artists who have been overlooked for years in the context of the Vietnam War and Vietnam's cultural history. This is the work they felt they had to do. One of them, Lê Lam, talks about how it would have been ridiculous, in the middle of fighting a war, for artists to examine modernity or to paint nudes and flowers. In light of the context of where they were and what they were doing at that time, I felt this work was important.

The title refers to the artist-soldier Le Duy Ung. Three different people tell his story in the film. According to these stories, he picked up a camera that an enemy soldier had dropped, held it to his eye, and was shot and blinded by a bullet that went through the lens. In one account, he uses the blood from his wounds to paint a portrait of Ho Chi Minh. The portrait actually exists and is in the Vietnam Military History Museum in Hanoi. Under the image of Ho Chi Minh, painted in blood, is the phrase, written in Vietnamese, "Light and Belief. I pledge my youth to you."

LAUREN WETMORE — Had you heard Le Duy Ung's story before starting this project?

DQL — No, but when we were working on the film and interviewing the artists, they kept repeating his story. We were fascinated by the idea that he had become something of a legend, but also wanted to use his story as a way to remind the audience that these artists are talking about history and that these memories are so fragile, so malleable.

LW — At the same time, the artists in the film often talk about how the drawings were very concrete documentation of people's lives and their experiences during the war.

DQL — Yes. The drawings also acted as journals for the artists, a kind of diary. Another way of looking at them is that the artists thought they were going to use these sketches as the basis for paintings when they came back from the war and had an opportunity to work in their studios again. They thought they would create a grand narrative of the war. But when they came back, the country was in such a mess economically that most of them never had the opportunity to follow through with the paintings they had envisioned. Also, after the war, a lot of people, Vietnamese and others, just didn't want to see any more images about the war. As a result, all these drawings sat dormant in cabinets and bookshelves in the artists' houses.

LW — What led you to start investigating these drawings and to seek out the artists who made them?

DQL — I had seen some of the drawings at museums in Ho Chi Minh City, and was always struck by how beautiful they are. Not only in terms of technical proficiency but in how they represent the very beautiful, sad, and melancholy scenery of the war. Also, they have no sense of violence. That was something I found really interesting. For a long time I

assumed this was due to a directive from the communist government—that artists had been told not to record violence because the leaders didn't want those images getting back to the artists' hometowns and lowering the morale of the people. I have struggled with this myself, because my work has dealt a lot with the Vietnam War, and I also have avoided depicting the horrific aspects of war. Talking with the artists really opened my mind. When I found out that there was no such directive from the government, that they were just doing it on their own, I began to look at the drawings differently. It was then that I decided to start collecting them and interviewing artists for the film.

LW — Did any of the artists not want to speak about their experiences?

DQL — A couple of artists didn't want to talk about it, but it was more a question of trust. They weren't sure how we were going to use their story. They worried in part because we are still living under a communist government in Vietnam, and some of them felt that if we misused their stories, they might get into trouble.

LW — Did they ever ask you about your own memories of the war?

DQL — Not so much. I think they look at me as a member of the young generation, and many of them assume that we don't have any memory of the war.

LW — Why is that? The war has clearly had a large impact on your life and your practice.

DQL — I think it's because the Vietnam War is so complicated; it was a civil war on the one hand, between the north and the south, between democracy and communism, and then on the other hand, it was a war between America and Vietnam. Many see it as a war between imperialist America and a very poor, small nation in Asia. Being from the south, I look at it more as a civil war. In many ways, the Vietnam War led to the war between Vietnam and Cambodia. All of these events have had a tremendous effect on my life and my family's life. Eventually, we all left Vietnam and ended up in America, where I was met with a completely different way of looking at the war. So, I am constantly trying to understand it in a more complicated way. That is why, over the years, I keep working.

MARK LECKEY

BORN 1964, BIRKENHEAD, ENGLAND
LIVES AND WORKS IN LONDON, ENGLAND

In a 1969 interview for *Playboy* magazine, famed media theorist Marshall McLuhan spoke about the trajectory of modern society, envisioning a retribalized future of "mythic integration" in which "magic will live again." "Our whole cultural habitat," McLuhan contended, "which we once viewed as a mere container of people, is being transformed by [TV, radio, and computers] and by space satellites into a living organism.... The day of the individualist, of privacy, of fragmented or 'applied' knowledge, of 'points of view' and specialist goals is being replaced by... [a] simultaneous, 'all-at-once' world in which everything resonates with everything else as in a total electrical field."[1] Though society has not yet attained the shared consciousness that McLuhan foresaw, we are more connected than ever before—to each other and to our machines, which increasingly mediate our interpersonal relationships and have themselves become more relatable, more human. Consider, for example, "proactive" phones that decipher our desires,[2] websites that use predictive analytics to generate targeted advertisements, and smart refrigerators that recognize our voices and suggest personalized recipes. These objects have returned us to what Mark Leckey calls "an enchanted world full of transformations and correspondences, a wonderful instability between things animate and inanimate ... mental and material."[3]

Leckey is an artist whose work in sculpture, sound, performance, and video explores the affective power that objects, images, and brands exert on us, as focal points of desire and totems around which identities take shape. His breakout video *Fiorucci Made Me Hardcore* (1999) is a collage of found footage and audio samples that tracks three decades (1970s–90s) of British subculture, from Northern Soul through the Casuals and Acid House Rave. The video functions as a eulogy to the passions and rituals of the disenchanted working-class kids—the artist included—who united around dance music and clothing styles such as those popularized by the Italian fashion house Fiorucci. His ongoing series *BigBoxStatueAction* (2003–present) pairs a monumental stack of speakers (also exhibited independently under the series title *Sound Systems*) with an existing sculpture of equal stature, usually by an iconic artist such as Henry Moore or Jean Arp. As a surrogate for the artist, the *Sound System* "speaks" to the sculpture in a mash-up language of sampled music and found sounds, apparently in the belief that the sculpture will awake from its aloof stasis and divulge its secret object thoughts.[4] *GreenScreenRefrigeratorAction* (2010–present), a performance that features the artist in communion with a Samsung "smart" fridge that electronically tracks its contents, approaches the notion of mystical human–object exchange most explicitly. Seeking to empathize with the fridge, in this performance the artist drinks "coolant" and cloaks himself in a green cloth that allows him to disappear into the green-screen backdrop behind the fridge, becoming one with the object in a visual-electrical field.

Leckey's contributions to the *2013 Carnegie International* continue his interests in totemic brands,

surrogate machines, and correspondences between the actual and the virtual. In keeping with McLuhan's vision of the future, they problematize the notion of "point of view" and seek to amplify a sense of simultaneity and dislocation. Leckey's video installation *Pearl Vision* (2012), like his *Sound Systems*, centers on a sound machine— in this case, a simple Pearl Vision snare drum—through which the artist communicates by way of "rhythmic pulses of information" akin to computer code.[5] The drum appears in a three-minute video projection wherein the camera pans around its silver shell in close-up; we see the artist, wearing bright red pants and a white T-shirt, straddle the drum and strike it, flick the "throw-off" switch open and closed, and bob his Sony-earphoned head to the beat. This is foreplay, set to a throbbing electronic voice-beat: "On, Off, On, Off…" The human-machine intercourse climaxes as the artist's thighs are again reflected in the surface of the drum, but this time, sans red pants. A drum-stick quickly tickles the vent hole, and the silver surface merges with artist's skin.

Leckey's *Made in 'Eaven* (2004) similarly revolves around a silvery object of desire: a Jeff Koons stainless-steel "balloon" bunny, a potent if somewhat ridiculous symbol of reified value. The short silent film traces a trajectory around the reflective sculpture, which appears on a pedestal in the center of an empty room recognizable to initiates as Leckey's longtime studio on Windmill Street in London. As the bunny is brought close in a series of smooth zooms and pans, a troubling realization dawns: there is no camera reflected in its hyper-real surface. The image is a digital fabrication transferred to 16mm film. Within the image, both the bunny and the artist (the camera's "eye") dissolve into screen-space, the walls of Leckey's oft-represented studio standing in for his presence.

This disembodied communion with an inanimate object echoes Maurice Merleau-Ponty's theories on the sensual perception of things, in which we experience "the complete expression outside ourselves of our perceptual powers and a coition, so to speak, of our body with things."[6] This coition with an object occurs for the viewer in physical space, too, in relation to the magical flickering presence of the film projector, whirring away in the shadows, seemingly alive. For the *Carnegie International, Made in 'Eaven* is found at the end of a snaking path through Carnegie Museum of Natural History's gem and mineral display, among cases of jewels in the vaultlike Wertz Gallery. Discovered in succession with electronic didactics in which, at the push of a button, one can make crystals glow and rocks speak (by way of an auditory radiation detector), Leckey's installation underscores a sense of magical interconnectedness and the surreality of contemporary experience.

—Amanda Donnan

1. Eric Norden, "The Playboy Interview: Marshall McLuhan," *Playboy*, March 1969. Accessed online at http://www.nextnature.net/2009/12/the-playboy-interview-marshall-mcluhan.
2. Apple's iOS program Siri is "proactive, so it will question you until it finds what you're looking for." http://www.apple.com/ios/siri.
3. In 2013 Leckey curated an exhibition for Hayward Touring called *The Universal Addressability of Dumb Things*, which includes artworks, artifacts, and mechanical objects. Addressing the concept of "techno-animism," the exhibition is something of a contemporary redress of McLuhan's theory. Quoted text appears on the web page for the exhibition: http://www.southbank-centre.co.uk/find/hayward-gallery-and-visual-arts/hayward-touring/future/the-universal-addressability-of-dumb-things.
4. See also *March of the Big White Barbarians* (2006), a video slide-show of London's "alienating and alienated" public sculptures with a soundtrack "hymn" performed by Leckey and his Jack Too Jack bandmates; http://www.youtube.com/watch?v=OCNn-ZOm-oc.
5. Gary Carrion-Murayari, "The Body Is a Machine," in *Ghosts in the Machine* (New York: New Museum and Skira Rizzoli, 2012), 16.
6. As quoted by Kirsty Bell in "Cinema-in-the-Round," *Camera Austria*, May 2008, 10.

THE SCENE OF CRIME
Amar Kanwar

It is always possible to be able to distinguish between each breath, to be able to *perceive* every single inhalation and exhalation. It is also possible that this may happen without a reduction in the speed or rate of breathing. The precision of this perception about a recurring ordinary event can dramatically impact the awareness of one's own existence, a unique unity with the self emerges, finite and infinite time are experienced together, and all senses seem to transform. Words sound different, every touch becomes special, new smells are experienced, all relationships change, and in a while, the world can be recognized anew.

In the same way it is possible to distinguish between each look, but can this be done without a reduction in the speed or rate of looking? Will the experience of the separation of each glance also result in a separation of the *perception of* what each glance is looking at? If that were possible, then would these distinct perceptions dramatically alter our awareness of our own existence and transform the way we see the world around us? Would we then begin to see anew that which lies within each image and each object? Would a spectrum of inner narratives then emerge? Would the fluidity of these narratives give us a unique insight into the temporariness around us?

In 1999 I began filming the resistance of local communities in the state of Orissa [since 2011 called Odisha] to the industrial interventions taking place there. In 2010 I returned again, but this time to film, in particular, the *terrain* of this devastating conflict. Almost every image in this film lies within specific territories that are proposed industrial sites and are in the process of being acquired by the government and corporations in Odisha. In this war by the state against its own land and people, *The Scene of Crime* is an experience of the battleground and the personal lives that exist within a natural landscape.

The Scene of Crime was filmed in the proposed project areas, all in Odisha, of the POSCO steel plant complex in district Jagatsinghpur; the bauxite mining and alumina plant of Sterlite Industries [a principal company of Vedanta Resources] in the Niyamgiri hills; the Vedanta University and resort complex of Sterlite Industries in district Puri; and Tata Steel and other companies in the Kalinganagar Industrial Complex in district Jajpur.

The Scene of Crime is also central to a larger multimedia installation titled *The Sovereign Forest* along with a constellation of moving and still images, texts, books, pamphlets, albums, music, objects, seeds, events, and processes. *The Sovereign Forest* is inspired by a search for the possible answers to the following questions. How are we to understand the conflict around us? How are we to understand crime? Is legally valid evidence enough to understand the meaning and extent of a crime? Can "poetry" be presented as "evidence" in a criminal or political trial? Can it create a new and valuable perspective about the crime? What is the vocabulary of a language that can talk about a series of simultaneous disappearances occurring across multiple dimensions of our lives? How can we see, know, understand, and remember these disappearances? How can we look again?

With overlapping identities, *The Sovereign Forest* continuously reincarnates as an art installation, a library, a memorial, an open school, a film studio, an archive, and a proposition for a space that engages with political issues as well as with art. With a call for the collection of more "evidence," *The Sovereign Forest* is permanently installed and open for public viewing in Bhubaneswar, Odisha, India.

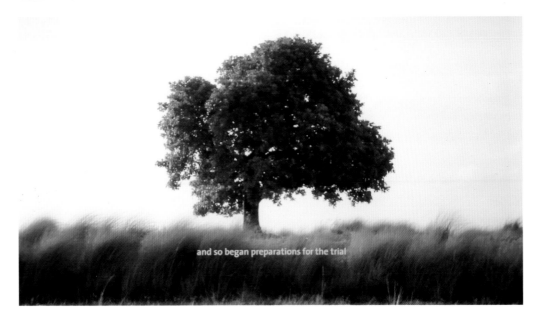

and so began preparations for the trial

Amar Kanwar stills from *The Scene of Crime* 2011 cat. no. 107

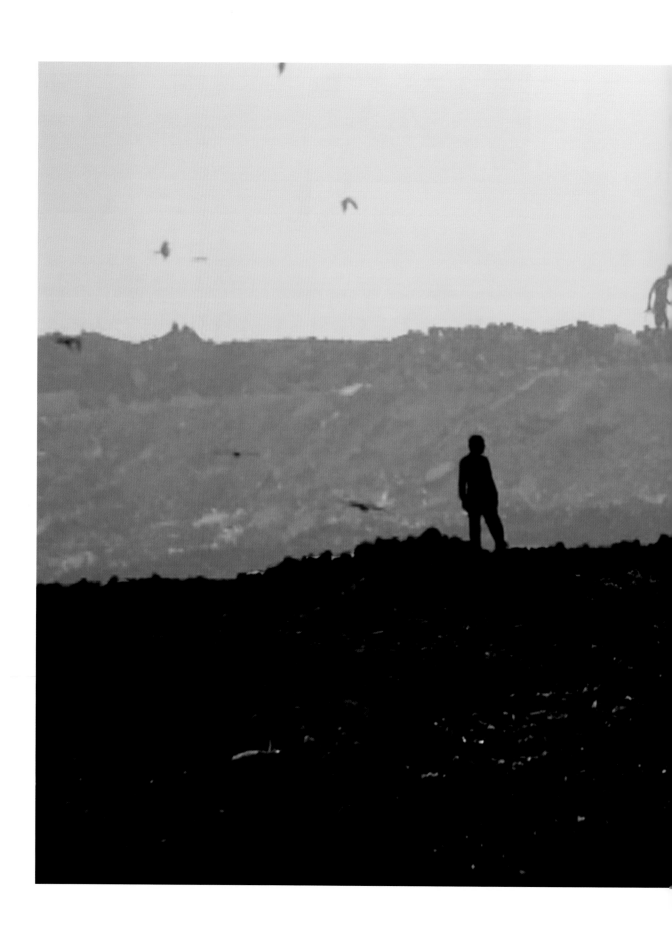

Amar Kanwar still from *A Love Story* 2010 cat. no. 108

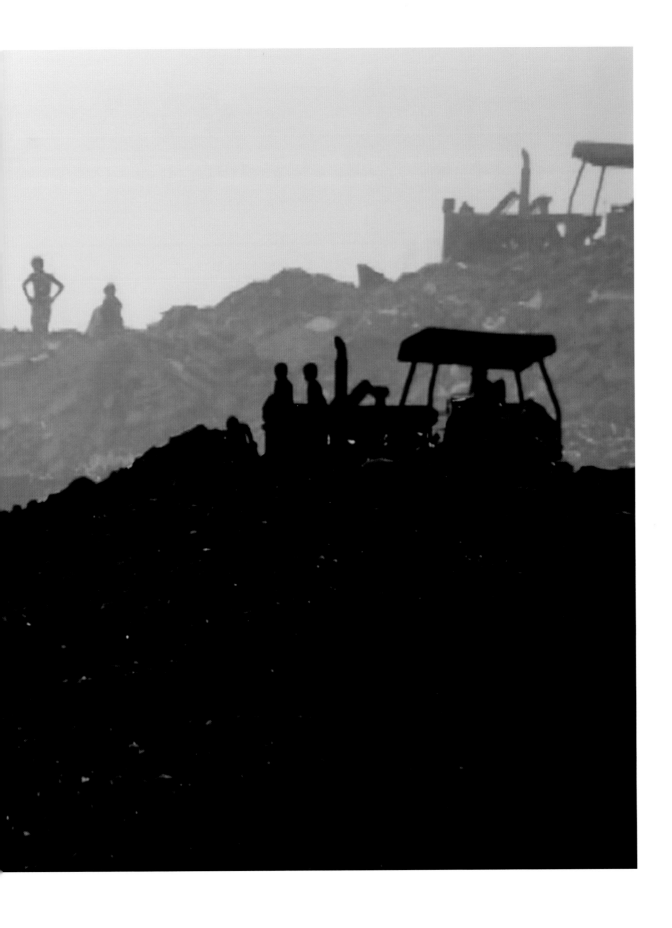

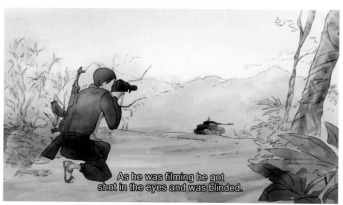

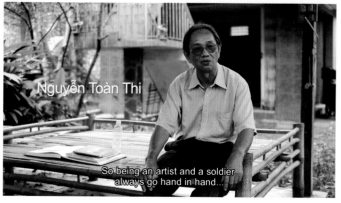

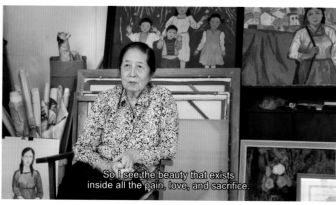

Dinh Q. Lê stills from *Light and Belief: Sketches of Life from the Vietnam War* 2012 cat. no. 109

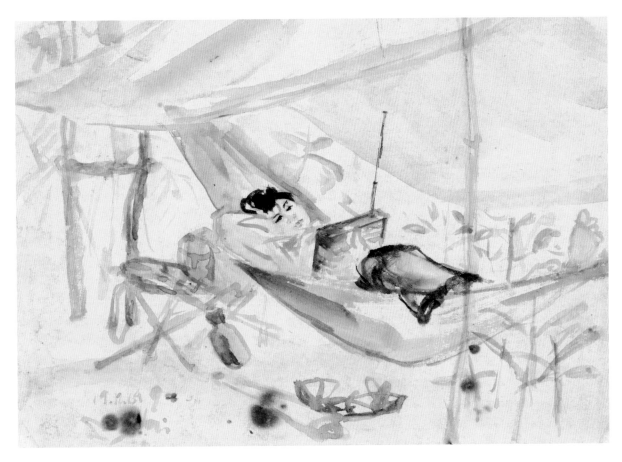

Quách Phong *Khong Ten (Untitled)* 1964 watercolor on paper 6 ½ x 9 ⁵⁄₁₆ in. (16.5 x 23.6 cm)
from Dinh Q. Lê *Light and Belief: Sketches of Life from the Vietnam War* 2012 cat. no. 109

Dương Ánh *Dân Quân Thanh Hóa* 1966 watercolor on paper 10 ½ x 12 ⅜ in. (26.7 x 31.5 cm)
from Dinh Q. Lê *Light and Belief: Sketches of Life from the Vietnam War* 2012 cat. no. 109

Trương Hiếu *Untitled* 1972 pen on paper 11 ½ x 5 ⁵⁄₁₆ in. (29.5 x 13.5 cm)
from Dinh Q. Lê *Light and Belief: Sketches of Life from the Vietnam War* 2012 cat. no. 109

Vũ Giáng Hương *Untitled* 1965 watercolor on paper 10 ¹³⁄₁₆ x 15 ⅜ in. (27.5 x 39 cm)
from Dinh Q. Lê *Light and Belief: Sketches of Life from the Vietnam War* 2012 cat. no. 109

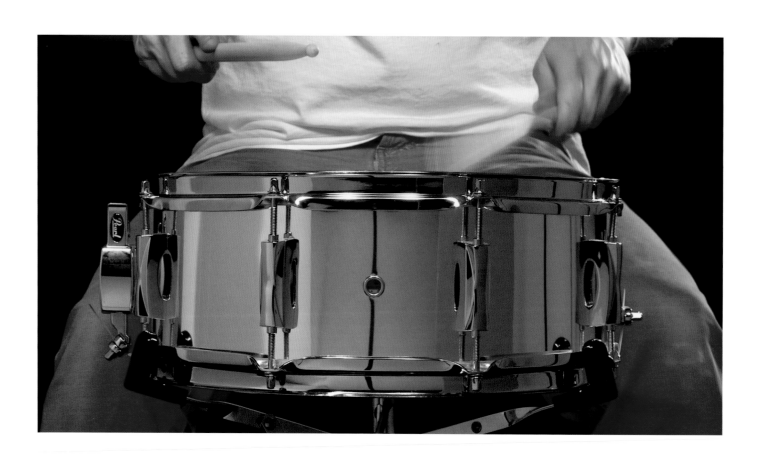

Mark Leckey stills from *Pearl Vision* 2012 cat. no. 111

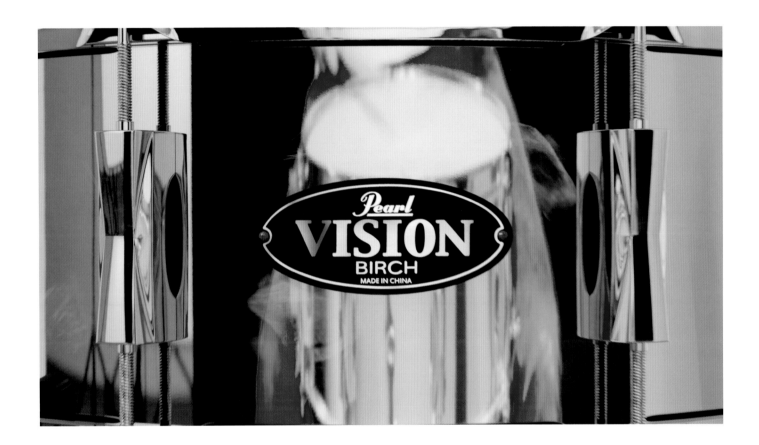

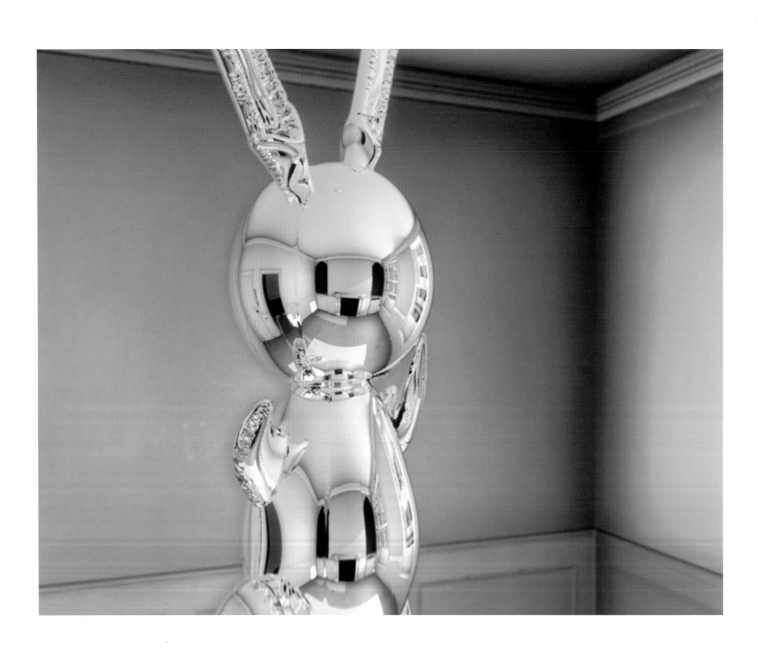

Mark Leckey stills from *Made in 'Eaven* 2004 cat. no. 110

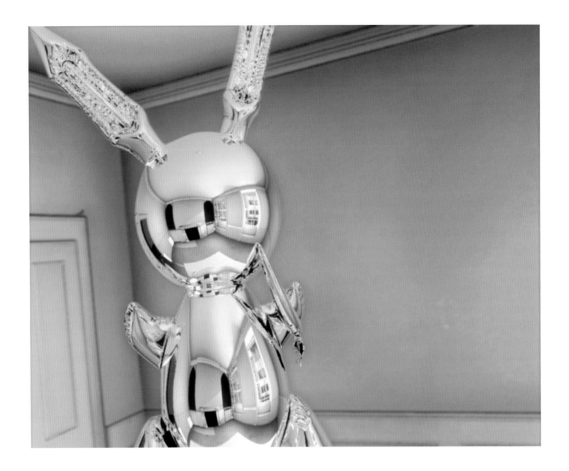

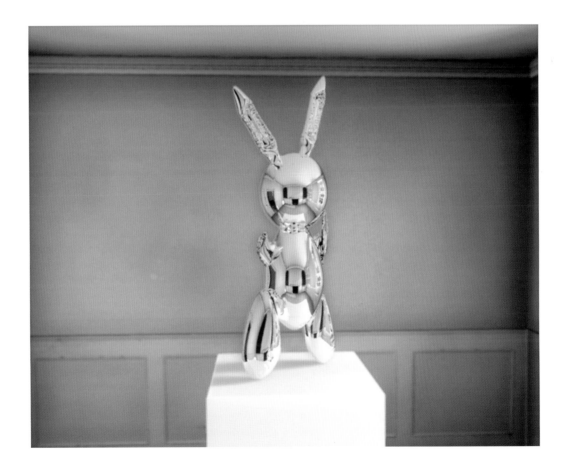

PIERRE LEGUILLON

BORN 1969, PARIS, FRANCE
LIVES AND WORKS IN BRUSSELS, BELGIUM

Pierre Leguillon studied art at the Sorbonne in Paris, and in the early 1990s began working as a curator and critic, publishing the one-page journal *Sommaire* between 1991 and 1996, and writing for the *Journal des Arts, Art Press*, and *Purple*. In 1993 he began to use his own photographs, taken while traveling or visiting exhibitions, to create slide-shows, or "Diaporamas."[1] Like a vaudeville artist, Leguillon traveled around the world presenting his slide-shows to various audiences and transforming the slide-lecture format into a precise, poetic, and witty form of performance art. For the *2013 Carnegie International*, he premieres two new vitrine installations: *A Vivarium for George E. Ohr* and *Jean Dubuffet Typographer (diorama)*. The former occupies a large diorama case and includes thirty ceramic objects by the famous "mad potter of Biloxi," George E. Ohr (1857–1918), arranged around a wooden "tree" structure with a printed photographic surface.[2] The latter transforms an existing wall case in Carnegie Museum of Natural History's Hall of Botany into a panorama of printed material—books, posters, announcement cards, and pamphlets—created by renowned French artist and entrepreneur Jean Dubuffet (1901–1985). Leguillon also presents his acclaimed slide-show performance *Non-Happening after Ad Reinhardt* as a special one-time event.

* * *

AMANDA DONNAN — Your work often plumbs art history or the culture around art and its reception, looking at the way artists are "flattened" into caricatures of themselves or are made into products. What drew you to the three artists that you investigate in the *International?*

PIERRE LEGUILLON — My work is often about art history because this is the field I know best. If I were to speak about history with a big "H," it might be more dangerous in some way, but I'm interested in the broader implications or issues surrounding these historical figures. In the case of Dubuffet and Reinhardt and even Ohr, I use them as characters that have been constructed in history but leave aside the narrative; I go back to the actual objects, erasing the fiction. The project on Dubuffet is not about Dubuffet's artwork; it's more about typography and handwriting. And of course *Non-Happening after Ad Reinhardt* is to some extent about taxonomy. He developed a subjective, pre-Google system of classification; he had 10,000 slides that he photographed all over the world, and he classified them by different geometric shapes, body parts, etc. Most of them are art objects, but you also have things that are not from the arts field, and he mixed them together in his slide presentations to convey a personal point of view, and to show that there is no evolution in art. Ohr is likewise not the main subject of *A Vivarium for George E. Ohr*; it's more about industry and design. Ohr had a factory workshop

and was producing quite intensively, always making a mark on the bottom of the pots. At first he was using metal [moveable-type letters] to sign his work, which he borrowed from the printer in Biloxi, and then began signing them by hand because the people who bought his pots wanted this mark of "authenticity." People began to ask him to sign his pots "like checks," as he said, so he did. All of these projects are also about techniques, about how industry was transformed from the nineteenth century to the present and how we once again have a new revolution where things can be customized for each of us in some way by ourselves, by hand, etc. My interest is not in speaking about the past but in what these figures can tell us about today.

AD — Ohr called his pots his "babies," and he had this very eccentric self-presentation; part of your interest in him is the idea that his DNA is in these pots, and if you have one, you have a piece of the artist.

PL — Exactly. And he always said it was the product of an artist and unique: "No two are alike," he was fond of saying. So there is that aspect, and there is the aspect of self-promotion. [In *A Vivarium for George E. Ohr*] I'll use all these photos he made to promote himself and his particular brand. This can be related to Dubuffet's strategy of promoting himself through his handwriting, titles, and slogans. With Dubuffet you also have this ambivalence between original and copy, because all his printed material appears to have been written by hand. They look handmade, but they are all multiples.

AD — Of course this was part of his Art Brut style—it continues the notion found in his paintings that he was an expressive conduit for a more natural or primitive way of seeing, outside the culturally tutored aesthetic of academic art. So the handwritten look makes sense, but ironically it was a very calculated, self-promotional move.

PL — Yes, as an image, it was somehow completely fake. Sometimes he did ten different poster designs with the same "handwritten" text, with very small changes between them, and then he would print the one he preferred. Or he would write the text by hand and then stick in a small piece of paper to change one letter only, so it looks to be done in a rough, fast way but it's exactly the contrary. And here you can see another relationship with Ohr, because when he collapsed his thin ceramic pots, even though it looks like a mistake, he was of course in control of it and then he fired them that way. It's just a game of going against the rules and then the mistake becomes the rule, but in a very precise way. The "mistake" becomes a signature style. This figure of the artist bound up with advertising and self-promotion is very important and very contemporary to me; it's a genealogy that includes Duchamp, Yves Klein, Piero Manzoni, and Andy Warhol (who was, by the way, a collector of Ohr pottery).

AD — You were telling me that you want to display Ohr's pots in a casual manner that suggests the nonchalance of zoo

animals lounging in their cages. Is displaying Ohr's pots and Dubuffet's printed materials in natural history diorama cases a distancing strategy—a way to throw people off so they have a more intellectual engagement with these things?

PL — Yes, I hope so. I want to break with the conventions of showing documents or art objects in vitrines, and to think of the objects instead as live specimens. When I do projects in museums, I am bringing new collections into other collections, like introducing a radical particle—an organism in an organism. And what I will do at the Carnegie is similar because I will remove the [Ohr] pot from the vitrine in the decorative arts galleries and recontextualize it in another kind of space, which will change people's perception of the piece. It is important for me, too, that the displays be very playful. In the Dubuffet film, when you see me handling and playing with the paper materials, I really felt like a child or an animal myself—as if a monkey found them and didn't know what to do with them. It's one way to show that you can repossess your own history just by changing the way you look at objects, beyond language and theory, and to look at how manipulating objects can translate into a specific form of knowledge.

1. Leguillon's website includes digital versions of many of his slide-shows. See http://www.diaporama-slideshow.com.
2. Leguillon's interest in the relationship between the Diaporama and the Diorama dates to 2003, when he presented "Slideshow Diaporama/Diorama" at the Musée d'Histoire Naturelle in Nantes, France.

SARAH LUCAS

BORN 1962, LONDON, ENGLAND
LIVES AND WORKS IN LONDON, ENGLAND

The practice of sculpture historically has been dominated by muscles and men, even into the twentieth century. But the latter half of the century brought a notable shift in the visibility of women sculptors, with, among other things, the "discovery" of Louise Bourgeois and the still-growing admiration of Eva Hesse's career. On a broader scale, it became apparent in the popular yet critical film *Camille Claudel* from 1988, which pictured that nineteenth-century

artist's troubled relationship with legendary sculptor Auguste Rodin as representative of a woman artist under pressure from a patriarchal society. Today, some of the most convincing and intriguing contributions in the field of sculpture come from a new generation of artists such as Trisha Donnelly, Rachel Harrison, and Rachel Whiteread (all featured in previous *Carnegie International* exhibitions), Nicole Eisenman (see pages 48–49), and Erika Verzutti (see pages 195–96). Their emergence goes hand in hand with an ongoing reassessment of the history of sculpture that is bringing to attention artists such as Phyllida Barlow (see pages 31–32), Lygia Clark, Isa Genzken, Yayoi Kusama, Senga Nengudi, and Alina Szapocznikow.

Within this narrative, the work of Sarah Lucas can be understood as a bridge between the (re)discovery of previously overlooked artists and the contemporary practice of a younger generation. Lucas started her career in the early 1990s in the context of the now-famous Young British Artist (YBA) movement. The achievement of this group was to combine ambitious art with an irreverent, corrosive, and self-conscious attitude informed by the politics, music, and subculture of the 1980s. I remember seeing their work and being thrilled; it was my generation talking to me through art, the same way that musicians had spoken to me through music. For the last twenty years, Lucas's works have predominantly been perceived within the context of YBA and a certain "bad girl" attitude. Her sculptures have been understood as metaphors of sex and death; lauded for exploiting the language of "ordinary" things; loved as visual and crude puns; and described as funny, sad, sexy, and foolish.

In 2009 Lucas began to produce a series of new sculptures entitled *NUD*, consisting of tights stuffed with cotton and wire by which they can be intertwined to look like elaborately knotted legs and arms. Displayed on precisely composed plinths, they refer less to subculture than to a modernist sculptural tradition represented by artists such as Henry Moore and Barbara Hepworth, or Constantin Brancusi (for the unconventional use of the pedestals). There is a classy seriousness here—with no funny or flashy moments, no visual puns or "bad girl" gestures as in earlier works such as *Wanker* (1999). Quite unexpectedly, the *NUD*s focus on gravity (both physical and mental), on materiality, contortion, and composition, while at the same time keeping up with a relaxed and casual handling of both material and history.

A big part of the immediate appeal of Lucas's work stemmed from her bold use of iconic images derived from popular culture and our fantasies: genitals and cropped body parts, food and cigarettes, and the uncanny aspects of so-called everyday life. While the iconic and sometimes violent nature of such imagery inevitably captures our attention, the artist's use of flabby, malleable, and cheap materials does the opposite: it makes the objects appear disposable, detached, and almost negligent. This is true for the *Bunny* series, started in 1997, including *Ace in The Hole* (1998), which shows a group of four exhausted stuffed figures sitting in sexually suggestive positions on chairs, headless and thus literally absent-minded. It is equally true for Lucas's use of cigarettes to create portraits and to build shoes, breasts, vacuum cleaners, and garden gnomes. The cigarette is the perfect image of desire, destruction, and disappearance: you suck it, inhale it, burn it, and throw it away.

The recent *NUD*s go beyond the image and the poignant metaphor; they allow us to see Lucas's work anew, and push us to think more generally about sculpture and why some of the most interesting sculptors today are women. Historically, one of the core tasks of sculpture has been the transformation of the human body into an object. For centuries, this transformation was executed by men, who developed the visual language for how a body is apprehended and sculpted. The history of sculpture is the history of this coding by the masculine eye. The images used by Lucas reflect this coding and part of its formation, which also explains their success and uncanny attraction: we are confronted with powerful tropes. The material the artist uses, however, works against the trope. By expressing indifference through flabbiness, distance through irreverence, and contempt through corrosion, the material separates itself from the image to become what it is: a body. One can therefore argue that, if traditionally sculptors transform the (female) body into an object, Lucas and other women artists today are, importantly, transforming the object into a body.

—Daniel Baumann

TOBIAS MADISON

BORN 1985, BASEL, SWITZERLAND
LIVES AND WORKS IN ZURICH, SWITZERLAND

Tobias Madison's work revolves around a never-ending process of coding, decoding, and recoding. This produces all sorts of things, including drawings, films, benches, performances, music, sculptures, lamps, concerts, texts, gatherings, and paintings. It is an activity taking place in a world that relies on digital codes as they increasingly define today's products and processes. Not only are these codes present in our cell phones, bank cards, and robot-cut jeans, but they are responsible for every fruit and vegetable that comes to our table thanks to software-based logistics. Madison embraces this development—loops it, perverts it, forms and performs it. After all, culture is coding, and art is language. This requires a broad knowledge of the languages that rise up around and codify various cultural enterprises and define identity, which Madison acquires by constantly exposing himself to the glories and miseries of the very languages he uses and is defined by.

In 2005, at the age of twenty, Madison, along with Emanuel Rossetti (born 1987) and Dan Solbach (born 1987), founded the publishing enterprise Used Future in Basel, Switzerland, one of numerous collective efforts that would mark his practice. A platform for realizing fanzines, booklets, and posters with friends, Used Future was a way to collaborate with artists on book design, printing, and distribution. In 2008 Madison and Rossetti, then attending the Zurich University of the Arts, and Solbach, a student at the Basel School of Design, founded (together with me) the exhibition space New Jerseyy, in North Basel, dedicated to presenting the work of artists, designers, and filmmakers and experimenting with the language of exhibition and display. In 2011 Madison was part of a collective of artists and art historians who established AP News, a DIY movie theater in Zurich that holds weekly film screenings and serves as a bookshop, a production enterprise, and a testing site for all sorts of performances and experiments.[1]

Madison showed his first artworks, a film and folded carbon-copy papers, in 2007 in an exhibition in Tbilisi, Georgia. These and subsequent works are, more than anything, snippets of a much larger practice that encompasses and intertwines curating, writing, publishing, filmmaking, exhibiting, producing, and performing. Most of these efforts, moreover, are done in collaboration with others, including artists Mathis Altmann, Ruedi Bechtler, Emil Michael Klein, Kaspar Müller, Ken Okiishi, Emanuel Rossetti, and Jan Vorisek; art historian Fatuma Osman; curators Martin Jaeggi and Mélanie Mermod; fashion designer Simon Burgunder; and musicians Stefan and Sergei Tcherepnin. These collaborations—rather than emerging as a critique of traditional notions of authorship—arose from shared pleasures, experiences, and discussions and evolved in response to the participants' mutual need for action and space.

Within a few years, they taught themselves the languages of publication, promotion, exhibition, performance, and film; in the process, they began to critically reflect upon the growing cultural industry, the all-consuming art world, and the powerful art market. Earlier in their lives, during their "careers" in tagging and graffiti bombing, Madison and others had already attempted to undermine these same processes of commodification, deriding what established itself as "street art."

Though the languages and codes that organize our lives are obviously useful, they are equally limiting. In the art world, where works need to be produced, marketed, and sold, a possible mode of revenge is to play with expectations: to code the code, to loop the loop—even, or especially, if this includes looping and recoding yourself. This is what happened with Madison's project for the *2013 Carnegie International*. In October 2012 the artist held a weeklong after-school workshop at Carnegie Museum of Art with a group of eighteen students aged seven to thirteen from the town of Wilkinsburg, in the Pittsburgh metropolitan area. The goal was to produce collectively an abstract film in which light, sound, image, and space would be the main actors. Madison had made two similar films a few months before, in Zurich and in Toronto, and this was meant to be part three. The artist worked with educators Ashley Andrykovitch and Juliet Pusateri, artist Tom Sarver, and filmmaker David D'Agostino, in addition

to the children. Nothing worked the way he had expected—
or, one might say, everything worked the way it was meant
to. The children didn't follow the code and didn't speak the
language that Madison had developed in his previous
projects; there was more anarchy, freedom, and surprises
than anticipated. The artist ended up with a mass of foot-
age and sound recordings that seemed impossible to
integrate into a coherent whole. That is the status of the
project at the time of this writing. Whatever its final form,
Madison's work will certainly request the visitor's active
participation—mental, physical, or both—to complete it.

This may be precisely the motivation behind Madison's
efforts to generate form and undermine experiences. What at
first glance seems to be a rather hermetic activity for friends
and insiders is in fact a serious, chaotic, yet inclusive carving
out of a space for action and interaction that pushes through
conventional structures and boring modes of thinking.

—Daniel Baumann

1. AP News and New
Jerseyy are still active; Used
Future stopped its activi-
ties in 2011 after publishing
forty-nine titles.

MONDAY SEPT 30, 2013, 4PM **THE PROMISE OF THE SCREEN**
LEON A. ARKUS LIBRARY **PRESENTS**
CARNEGIE MUSEUM OF ART

A CMA ALL-STAFF EVENT
CELEBRATING THE INSTALLATION OF THE
2013 CARNEGIE INTERNATIONAL

PHOTOGRAPHY EXPERT
AURÉLIEN MOLE

EDITING
ADRIEN FAUCHEUX

MANUAL

ASSISTANT EDITOR
OLIVIER STRAUSS

CAMERA
JULIEN CREPIEUX

OF

A PRODUCTION OF
MUSÉE DE L'ÉLYSÉE, LAUSANNE

PHOTOGRAPHY

POSTER
WAYNE DALY

2013
CARNEGIE
INTERNATIONAL

PHOTOS
JOHN PHILLIPS; SELF-PORTRAITS;
CIRCA 1940

COURTESY THE JOHN
AND ANNA MARIA
PHILLIPS FOUNDATION

BY PIERRE LEGUILLON

Pierre Leguillon *The Promise of the Screen: Manual of Photography* 2011 / 2013
poster designed by Wayne Daly, photographs by John Philips 31 ½ x 23 ⅝ in. (80 x 60 cm) Courtesy of the artist

**2013
CARNEGIE
INTERNATIONAL**

**A Vivarium for George E. Ohr
by Pierre Leguillon**

**Starring Ceramics from
the Collection of
Carolyn & Eugene Hecht**

**Carnegie Museum of Art
Pittsburgh**

**October 5, 2013 –
March 16, 2014**

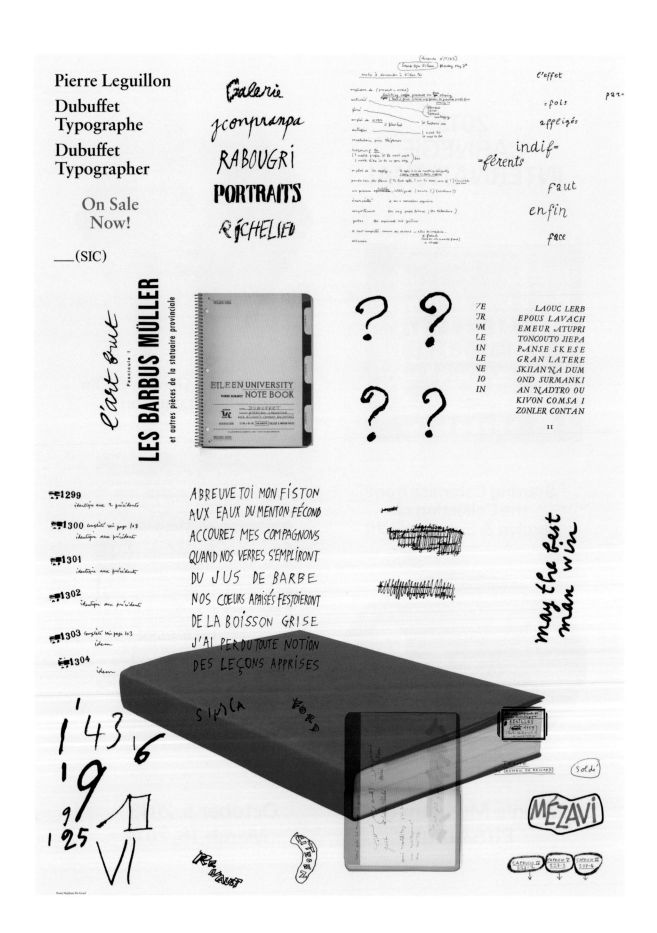

Pierre Leguillon *Jean Dubuffet Typographer* 2013
poster designed by Stéphane De Groef 32 11/16 x 23 5/8 in. (83 x 60 cm) Courtesy of the artist

Ad Reinhardt at Colonial Williamsburg, Virginia, USA, 1962. Photo Anna Reinhardt, courtesy of the Ad Reinhardt Foundation, New York. Poster: Wayne Daly

NON-HAPPENING
AFTER BY
AD REINHARDT PIERRE LEGUILLON

8 NOV 2013, 6PM, CARNEGIE MUSEUM OF ART,
PITTSBURGH. WITH LYNN ZELEVANSKY

Pierre Leguillon *Non-Happening after Ad Reinhardt* 2010/2013
poster designed by Wayne Daly, photograph by Anna Reinhardt 31 ½ x 23 ⅝ in. (80 x 60 cm) Courtesy of the artist

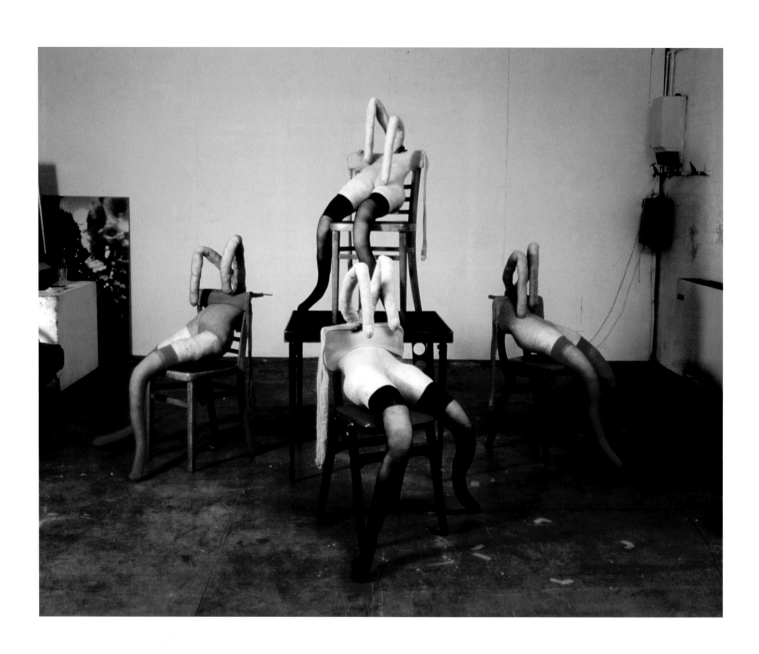

Sarah Lucas *Ace in The Hole* 1998 cat. no. 115

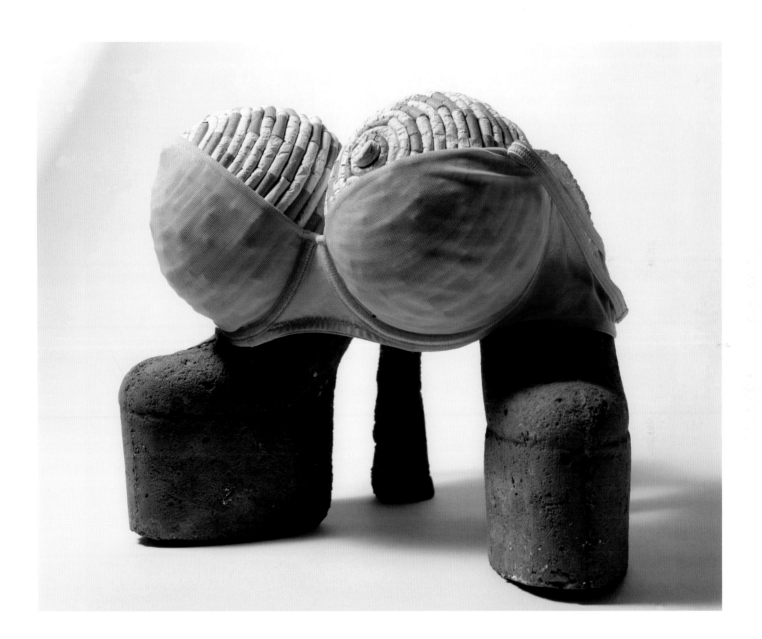

Sarah Lucas *Stars at a glance* 2007 cat. no. 117

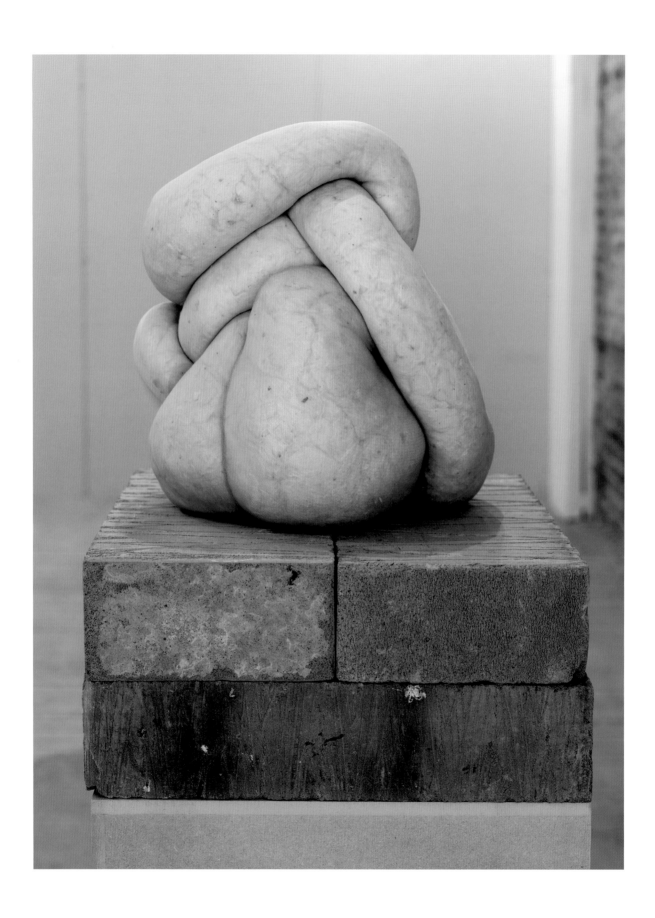

Sarah Lucas *NUD 11* 2009 cat. no. 119

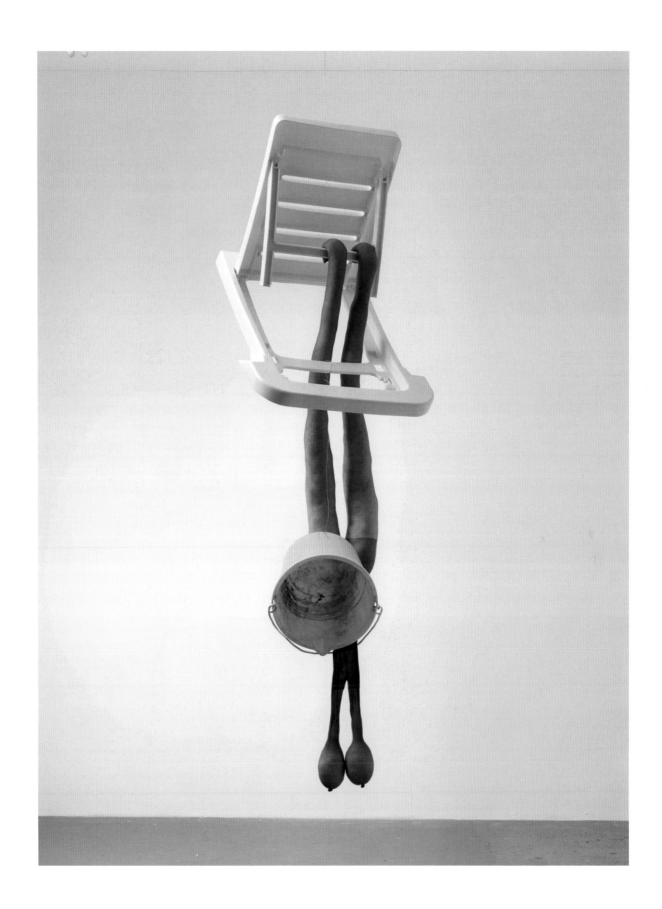

Sarah Lucas *Loungers #3* 2011 cat. no. 120

Tobias Madison process documentation for the making of *Workshop* 2012–13
in collaboration with the Neighborhood Youth Outreach Program and St. Stephen's Church, Wilkinsburg, Pennsylvania cat. no. 127

P. Olowska 2012

"Torcik"

Paulina Olowska *Cake* 2010 cat. no. 176

Paulina Olowska *Cardigan Jedrek* 2010 cat. no. 177

Pedro Reyes *Disarm (Mechanized)* 2012–13 cat. no. 180

Pedro Reyes *Disarm (Aquafone)* 2012–13 recycled metal 52 x 28 ¾ x 24 ⅜ in. (132 x 73 x 62 cm)
Courtesy of the artist and Lisson Gallery, London

Pedro Reyes *Disarm (Double Psaltery)* 2013 cat. no. 181

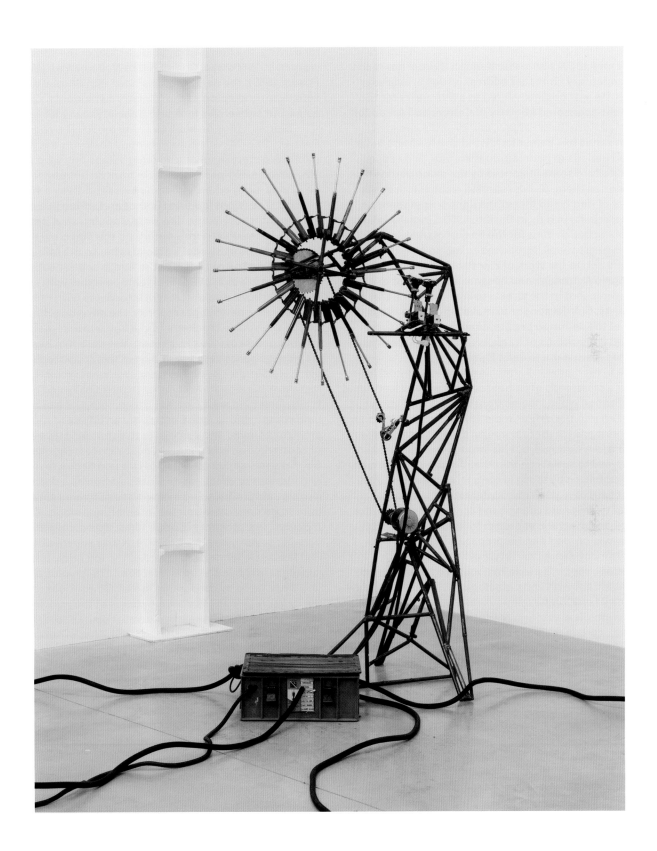

Pedro Reyes *Disarm (Sentinel)* from *Disarm (Mechanized)* 2012–13 cat. no. 180

KAMRAN SHIRDEL

BORN 1939, TEHRAN, IRAN
LIVES AND WORKS IN TEHRAN, IRAN

Since the mid-1960s filmmaker Kamran Shirdel has made bold documentary films that address issues of everyday life in Iran. He was originally hired as a filmmaker for the government-sponsored Ministry of Culture and Art under Mohammad Reza Shah Pahlavi, and over the decades Shirdel at times has been blacklisted and his films have withstood periods of banning, confiscation, and censorship, ironically in some instances by the same parties that commissioned them. Shirdel studied architecture at the University of Rome and film at the Centro Sperimentale di Cinematografia in Italy in the late 1950s, initially taking a job dubbing Italian films for the Iranian market. It was in Rome where he was introduced to Italian Neo-Realist filmmakers and to the work of Pier Paolo Pasolini and Michelangelo Antonioni, and became accustomed to a style of filmmaking shot in the streets using nonactors. Like the Neo-Realists, Shirdel sought to make films that reflected subjects of the common people; as such, his films have influenced generations of Iranian New Wave filmmakers from Abbas Kiarostami to Jafar Panahi.

Back in his homeland after his schooling, Shirdel found himself at a crossroads of cultural production and fast-paced industrialization when income from oil production brought great wealth into the nation in the 1970s. Shirdel's first film was a short made for the first Iranian domestic car on the market, the Iran National, but his interests as a filmmaker quickly spread to social conditions and causes, subjects not so easily embraced by those in command under the Shah.

To consolidate power and integrate the nation in the face of widespread change and economic growth, the Shah took an autocratic approach to rule, usurping the media, television, and film for propagandistic purposes. The government-sanctioned style of film was mostly documentary, shot in a mode that idealized the Shah and was in alignment with state ideologies. Because of Pahlavi-enacted civil laws, Shiite religious restrictions, and strict social customs, it was taboo to portray women (especially if unveiled), certain religious ceremonies, and any negative aspects of Iranian culture or its people, past or present.[1]

As a documentarian, Shirdel was especially interested in these subjects, as they were true to the reality he witnessed around him. Two of his early films were sponsored under the Ministry of Culture by the Women's Organization of Iran, nominally headed by Princess Ashraf Pahlavi (the Shah's twin sister). At the same time, Shirdel was making a third film called *Tehran Paitakhte Iran Ast* (*Tehran Is the Capital of Iran*; 1966–79), which because of its critical view of the White Revolution caught the attention of Iranian authorities and was quickly confiscated and banned. The filming and editing of *Qaleh* (*The Women's Quarter*; 1966–80), one of the films commissioned by Princess Pahlavi, was halted as a result. Fourteen years later, in 1980, with some footage lost, Shirdel finally edited *Qaleh*, making a dedication in the film's opening credits: "To those who perished in their innocence." Like most of his films at the time, *Qaleh* intercuts moving and still imagery. Footage of a classroom scene in which a female teacher takes dictation before a group of women students is the counterpoint to a series of candid and desperate interviews with prostitutes, shown in still photographs by Kaveh Golestan taken in humble living quarters of Tehran's red-light district, Qaleh. With the exception of one final interview with a middle-aged woman who eventually found her way out of the brothel to sell oranges for a living, the film portrays a dark view of the condition of women in 1960s Iran. Compared to *Nedamatgah* (*Women's Prison*; 1965), the only commissioned film Shirdel would complete by keeping to the Ministry's standards, *Qaleh* is a lyrical but subversive look into a society ready for reform.

Shirdel's film *An shab ke barun amad* (*The Night It Rained*; 1967–74) was commissioned to document a highly publicized story involving a young village boy who purportedly saved a 200-passenger train from an imminent crash on a rainy night when a flood had washed away a segment of track. *The Night It Rained* is shot and edited in a meta-documentary style: the film slate clapping shut between takes is left visible; commentary on the film crew recurs throughout; and Shirdel's official letter to the Ministry reporting on the progress of the film is self-reflectively read aloud in voice-over. This is compounded with the use of news articles and on-camera interviews with railway employees, a newspaper reporter, the governor, the chief of police, the village teacher, and the boy himself—each with varying points of view; as a result, Shirdel's film highlights warring perspectives at the heart of this supposedly heroic act. Here Shirdel shows mastery over what would become known as his signature style, both technically and conceptually, including such cinematic techniques as fast zooms, bold compositions, quick edits, and artful use of music, ambient sounds, and voice-over to communicate a mood of contradiction and distrust. These devices, coupled with Shirdel's trademark blending of fact and fiction to ironic and humorous effect, made his reputation as a documentarian, arguably influencing a new wave of Iranian cinema just prior to its positioning on the international stage. *The Night It Rained*, like most of his other films, was confiscated and banned; seven years later, in 1974, it was shown once in a film festival in Tehran and awarded the top prize, but it was subsequently banned until after the 1979 Revolution.

Frustrated by censorship in Iran, Shirdel looked to the larger region in his documentaries of the mid-1970s, exploring subjects in nearby Kuwait, Fujairah, and Dubai. In *Pearls of the Persian Gulf: Dubai* (1975), Shirdel outlines the growth of the emirate and tracks its infrastructural development through interviews with Sheikh Maktoum bin Rashid Al Maktoum, the then ruler, and his younger brother and Dubai's current leader, Sheikh Mohammed bin Rashid Al Maktoum. As a marker of a former moment in the emirate's accelerated history, it is—like most of Shirdel's films—as shocking today as when it was first released.

—Tina Kukielski

1. Hamid Naficy, *A Social History of Iranian Cinema, Volume 2: The Industrializing Years, 1941–1978* (Durham, NC: Duke University Press, 2011), 73–74.

GABRIEL SIERRA

BORN 1975, SAN JUAN NEPOMUCENO, COLOMBIA
LIVES AND WORKS IN BOGOTÁ, COLOMBIA

I. TIME

The Hall of Architecture, opened to the public in 1907, was part of Andrew Carnegie's expansion of the original Carnegie Institute building, a public library and museum completed in 1895. A self-made man, Carnegie amassed an enormous fortune in the steel industry and, according to the tenets of monetary redistribution laid out in his 1889 article "The Gospel of Wealth," he spent the latter part of his life establishing charitable institutions dedicated to the promotion of community and cultural betterment. The creation of the Hall of Architecture was motivated in part by the popularity of plaster casts in late nineteenth- and early twentieth-century museums, and Carnegie was particularly interested in bringing likenesses of European masterworks to the people of Western Pennsylvania. "If they cannot go to the objects which allure people abroad," he stated, "we shall do our best to bring the rarest of those objects to them at home." [1]

The Hall of Architecture contains 150 individual plaster casts and is itself modeled after the Mausoleum at Halicarnassus (one of the seven wonders of the ancient world). The collection includes a cast from a Roman copy of a fourth-century BCE Greek bust of Zeus presently located in the Vatican Museums in Rome and, notably, one of the largest architectural casts ever made: that of the west facade of the twelfth-century Abbey Church of Saint-Gilles, measuring seventy-five feet long and thirty-eight feet high. The cumulative effect of these object groupings is a disorienting sense of simultaneous agreement and disagreement. For instance, the cast of an Ionic column from the Mausoleum at Halicarnassus abuts a scaled-down version of itself, which functions as one of the structural elements within the space.

II. SPACE

Formally trained in both architecture and design, Gabriel Sierra creates sculptural interruptions within the coherence of built environments; these interventions are concerned not only with aspects of constructed forms but with the psychic condition they produce, "when physical qualities become an atmosphere," as the artist describes it. [2] His interest in temporality as a function of space was particularly evidenced in 2011, when he cut out a large swath of gallery floor from the Musée d'Art Contemporain de Lyon

and propped it up as a wall across the room. The title of this work, *Untitled, day as a gap in the middle of the night*, reflects Sierra's obsession "with the idea of time and its complexity, and how culture represents duration in different disciplinary fields, such as architecture." [3]

An earlier work, *Untitled, Bilancia Calendar* (2009), took as its starting point a perpetual calendar designed in the late 1950s by Enzo Mari, himself referencing slide rulers and other measuring tools used by architects and engineers to calculate conversion scales. Mari's calendar employs three lengths of wood (indicating dates, days, and months, respectively), which can be independently manipulated back and forth through a central viewfinder to represent the exact date. Sierra's version replaces the days of the week with a gray scale, the numbered dates with random colors, and the names of the months with color-wheel hues. Though its intended use may seem obscure outside the elegantly ambiguous logic of Sierra's work, the resulting device presents a continually expanding and contracting abstraction of time through shade and color.

III. COLOR

Brightly painted walls are traditionally a common feature of architectural displays. The west cast court of the Victoria & Albert Museum in London, for example, boasts deep red-purple walls, the same color they were painted for the opening of the courts in 1873. The history of the Hall of Architecture's walls is less straightforward. Carnegie consulted experts to assist not only in the selection and placement of the casts but also in the overall look of the Hall. Henry Watson Kent was an invaluable agent in this process, contracted on the strength of his 1900 pamphlet *The Horace Smith Collection of Casts of Greek and Renaissance Sculpture: A Brief Statement of the Cost and Manner of Its Installation*. Under the heading "Color of Walls," Kent had suggested "a fine dark bronze green." [4] At the Carnegie, however, John Beatty (the museum's Director of Fine Arts at the time) disagreed with Kent, advising the use of a "subdued gold" for the Hall of Architecture. [5]

Eighty years later it was discovered that something of a bargain had been struck between Beatty and Kent. While conducting research toward a planned refurbishment of the Hall, Franklin Toker, a professor of Art and Architecture at the University of Pittsburgh, found that the original wall color had been a muted shade of green. This hue was replicated in the 1980s restoration, and remained the same until Sierra's chromatic intervention for the *2013 Carnegie International*. By painting the walls purple and interspersing various modular plinthlike forms among the complex object relations in the Hall of Architecture, Sierra unconsciously brings about Toker's unheeded suggestion that the walls be painted a bold color, as "the integrity of the room demands that the real architecture be separated from the fictive architecture by color and light." [6]

IV. LIGHT

Purple is an invention of context. Colors that a contemporary eye might identify as blood-red or royal-blue have, in other times and places, and by way of various modes of preparation or display, been identified as purple. Take, for instance, the history of Tyrian purple, so named after the Phoenician dye-makers of Tyre. In the fifteenth century BCE, they brought the process of making purple dye to Greece after being shunned by Phoenician society because

147

of the unsavory practicalities of their trade, namely, the liberal use of urine for ammonia in the dye-making process.[7] Roman myth purports that Heracles discovered the source of the color after seeing that his dog's mouth had been stained purple after eating shellfish along the eastern Mediterranean coast.

Indeed, the colorant derives from a liquid found in the glands of two types of shellfish: *Thais haemastoma* and *Murex brandaris*. Upon extraction and exposure to the elements, this white substance becomes the rich red-purple hue that adorned the vestments of powerful religious and monarchical individuals of antiquity. The source and process of making Tyrian purple was lost amid the chaos of Constantinople's fall in 1453, only to be discovered again in 1856 by the French zoologist Félix Henri de Lacaze-Duthiers. Walking along the seashore, he observed a fisherman whose clothing had been marked by the liquid from a broken *Thais* shell. In the sunlight, Lacaze-Duthiers watched the stain gradually transform from white, through yellow, green, and blue, to become purple over time.

—Lauren Wetmore

1. Presentation of the Carnegie Library to the People of Pittsburgh, with a Description of the Dedicatory Exercises, November 5, 1895. Quoted in Mattie Schloetzer, "Andrew Carnegie's Original Reproductions: The Hall of Architecture at 100," *Western Pennsylvania History*, Fall 2007, 39.
2. Gabriel Sierra, email to the author, January 3, 2013.
3. Gabriel Sierra, interview with Ruba Katrib, "Customized," *Mousse* 28 (April 2011): 103.
4. Henry Watson Kent, *The Horace Smith Collection of Casts of Greek and Renaissance Sculpture:*

A Brief Statement of the Cost and Manner of Its Installation (Springfield, MA: City Library Association of Springfield, 1900). The Horace Smith Collection is housed in the library in Springfield, Massachusetts.
5. Letter from John Beatty to James Wall Finn, May 15, 1906.
6. Franklin Toker, "The Hall of Architecture, Museum of Art, Carnegie Institute: A Feasibility Report on the Restoration of the Rooms and Its Casts," June 1983, 18.
7. Philip Ball, *Bright Earth: Art and the Invention of Color* (New York: Farrar, Straus and Giroux, 2002).

TARYN SIMON

**BORN 1975, NEW YORK, NEW YORK
LIVES AND WORKS IN NEW YORK, NEW YORK**

Taryn Simon's aesthetic, as described by Salman Rushdie, "is one of stretching the limits of what we are allowed to see and know, or going to the ambiguous boundaries where dangers—physical, intellectual, even moral, may await."[1] Her artistic medium consists of three elements: image, text, and graphic design. Recent projects include a web-based work in collaboration with Aaron Swartz that interrogates cultural differences and similarities (*Image Atlas*; 2012); an archive mapping the relationships among chance, blood, and other components of fate (*A Living Man Declared Dead and Other Chapters, I–XVIII*; 2011); and a catalogue of more than one thousand objects seized upon entering the United States at John F. Kennedy Airport over a five-day period (*Contraband*; 2010). In the following interview, Simon speaks about her most recent project, *Birds of the West Indies*, debuting at the *2013 Carnegie International*.

* * *

LAUREN WETMORE — What was the genesis of your preoccupation with the James Bond film franchise?

TARYN SIMON — I wanted to present a visual database of interchangeable variables used in the construction of fantasy. The title of this work, *Birds of the West Indies*, references the title of a 1936 taxonomy written by ornithologist James Bond. Ian Fleming, an active bird watcher living in Jamaica, appropriated the author's name for his novel's lead character, citing it as "ordinary," "brief," "Anglo-Saxon," and "masculine." This was the first replacement in a series of substitutions central to the evolution of the Bond narrative.

LW — Fleming himself was subjected to substitution by many different authors after his death in 1964. How did you see these initial replacements as indicative of a larger codex of fabrication?

TS — I was interested in the economic and emotional value generated by repetition in the construction of fantasy. In servicing the desires of the consumer, fantasy becomes formulaic, and repetition is required. Viewers demand something new, but only if it's essentially the same. A contract between Bond and the viewer binds the narrative to a certain set of expectations. Satisfying these expectations established Bond as a ubiquitous brand, a signifier to be activated with each subsequent novel and film. The resulting film franchise has reiterated its narrative since 1962 to unprecedented economic success.

LW — Your investigation into the Bond brand covers twenty-three films in which seven different actors have played the eponymous character over a period of fifty years. Yet, nowhere in the almost two hundred photographs that

make up your presentation does he appear. How have you been able to create such a comprehensive dissection of Bond-as-signifier without the inclusion of the character's iconic visual presence?

TS — I inventoried the women, vehicles, and weapons—constant elements in James Bond films between 1962 and 2012. These categories are rendered as essential accessories of the film's seductive, powerful, invincible Western male. Maintaining the illusions the narrative relies upon—an ageless Bond, state-of-the-art weaponry, herculean vehicles, and desirable women—requires constant replacements.

LW — There seems to be a correlation between what you describe as the formulaic construction of these films and the way in which much of your work seeks to create indexes, taxonomies, and an ordered presentation of information out of perceived disorder. And yet you often incorporate into these inventories the inevitable disruptions that arise. Have you had to contend with incompatibilities in the construction of this database?

TS — Time disrupts the inventory as the women confront an indelible fiction with nature's reality. The memory of Pussy Galore is very different from the portrait of an aged Honor Blackman.

The other disruptions are the empty portraits. In my past work, I've repeatedly gained access to forbidden and restricted sites—confronting divisions between public and private. The surprising thing was that in this work I met my greatest adversary or roadblock in the form of vanity. Ten women declined participation. The reasons they gave for their absences included not wanting to distort the perception of their fictional character, pregnancy, and a desire to disassociate from the character.

LW — You further explored this disassociation between the lived reality of the actresses and the fiction of their characters with a video component.

TS — The role of substitution takes a surreal turn in the video. In *Dr. No*, the first Bond film, Ursula Andress plays the role of Honey Ryder, one of the most memorable Bond girls of all time. It is little known that the voice of Honey Ryder belongs to Nikki van der Zyl. Ursula Andress was dubbed; her character that is so pored over and adored is a Lego construction, a Photoshop piece, an icon made up of fragments. The video presents Nikki reading all of Honey Ryder's lines from *Dr. No*. In the project, Ursula is invisible (she declined participation), yet her voice is finally visible.

LW — For your 2007 project *An American Index of the Hidden and Unfamiliar*, which looked at the maintenance of fantasy through the management of access to out-of-view spaces, Disney declined to participate. You've said that the fax you received from them, denying your request to photograph the underground facilities at Disneyland, proved more illustrative than the images themselves would have been. What did Ursula Andress's decision not to be pictured in the present suggest in relation to the overarching themes of the *Birds of the West Indies* project?

TS — Fiction influences, controls, and dominates people's behavior, into the smallest corners of their lives.

LW — Do you think that art can exist outside of fiction?

TS — A while ago, I photographed and wrote a text on the CIA's art collection. It consists of several Abstract Expressionist paintings from the Washington Color School. It's speculated that the CIA's interest in, and support of, Abstract Expressionism during the Cold War was to counter a more political and activating Soviet art. Abstract Expressionism in the years that followed became so valued culturally and economically throughout the world. We consider our responses to art to be individual and from the gut. In this work I was exploring if a "gut" or private brain-space can exist, or if everything is programmed.

1. Salman Rushdie, foreword to Taryn Simon, *An American Index of the Hidden and Unfamiliar* (Göttingen, Germany: Steidl, 2007), 5.

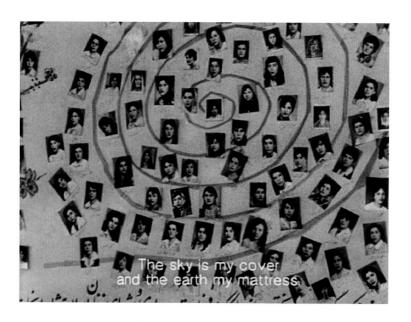

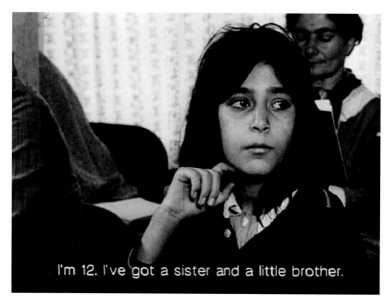

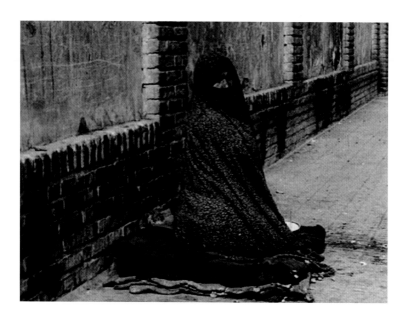

Kamran Shirdel stills from *Qaleh* (*The Women's Quarter*) 1966–80 cat. no. 185

Kamran Shirdel still from *Tehran Paitakhte Iran Ast* (*Tehran Is the Capital of Iran*) 1966–79 cat. no. 184

the film team returned to the village of
Lamelang to carry out its main mission –

So I quickly took off my jacket,
poured some kerosine on it and lit it

Kamran Shirdel stills from *An shab ke barun amad* (*The Night It Rained*) 1967–74 cat. no. 186

Kamran Shirdel stills from *Pearls of the Persian Gulf: Dubai* 1975 cat. no. 187

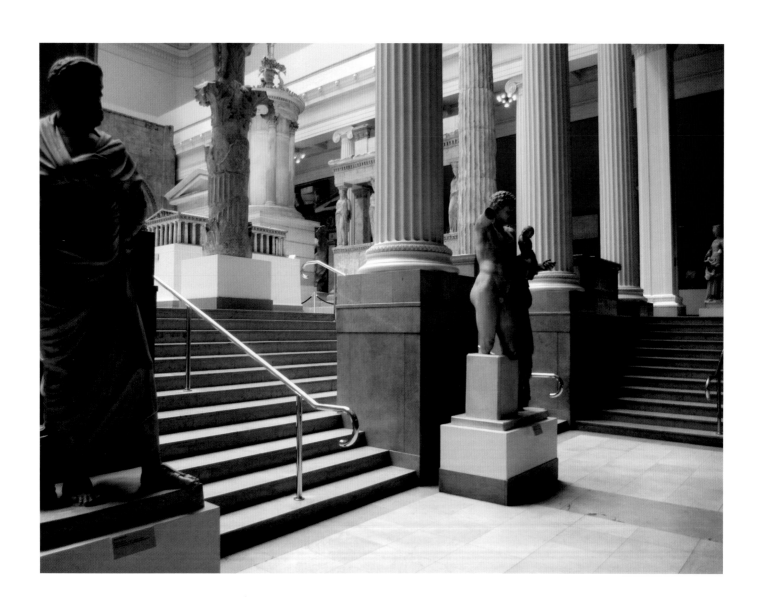

Gabriel Sierra sketches of *Untitled (111.111.111 x 111.111.111 = 12345678987654321)* 2013
installation for Carnegie Museum of Art's Hall of Architecture cat. no. 189

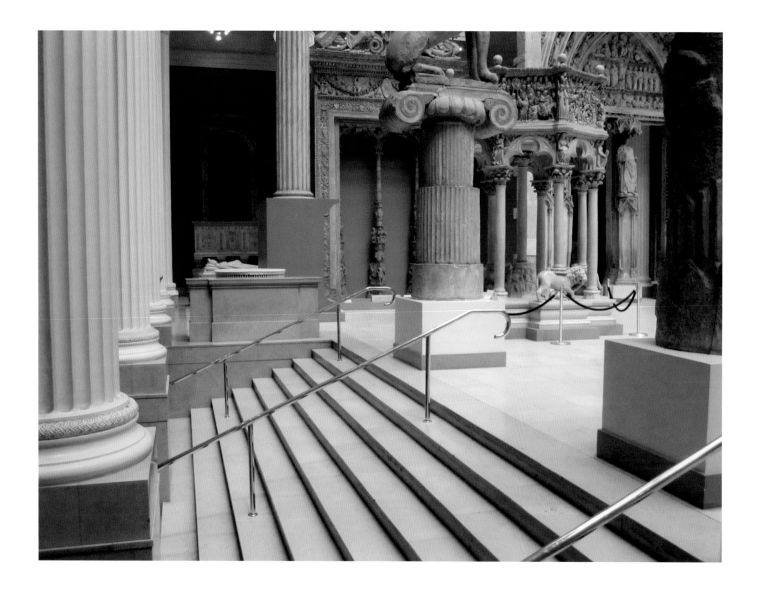

Gabriel Sierra sketches of *Untitled (111.111.111 x 111.111.111 = 12345678987654321)* 2013
installation for Carnegie Museum of Art's Hall of Architecture cat. no. 189

A.6 *Pussy Galore* (Honor Blackman), 1964

Taryn Simon details of *Birds of the West Indies* 2013 cat. no. 190

B.65 *Plutonium Rod and Case*, 1999

Taryn Simon detail of *Birds of the West Indies* 2013 cat. no. 190

FRANCES STARK

BORN 1967, HUNTINGTON BEACH, CALIFORNIA
LIVES AND WORKS IN LOS ANGELES, CALIFORNIA

Frances Stark is known to "play around with the idea of what is text in art" and to explore "the very intimate relationship between the reader and the writer."[1] Her work has taken the form of collages and posters, visual poems, large wall works, and pages for magazines or announcements. More recently, Stark has started to produce films, slide-shows, and audio pieces that are startling in their bold engagement with the outside world, with its beguiling contradictions and sometimes overwhelming expectations.

* * *

DANIEL BAUMANN — What happened? I understood your work to be words on paper combined with pictures: elegant, irreverent, sometimes hard to understand, also hard to read, then nasty and poetic, and funny too. Then, at the Venice Biennale in 2011, in a small space at the very end of the Arsenale, your digital animation film *My Best Thing* was projected. All of a sudden, the words talked and the drawings moved! We immediately connected with its ideas: the sex, the activism, the furor, the fantasies, and the horrible and ridiculous drama of our daily lives. People came out of this film amused, full of questions, even embarrassed. Is *My Best Thing* breaking with your past work? Is it a manifesto?

FRANCES STARK — Well it wasn't a sudden break; there were a few awkward performance experiments that led up to it. The manifesto germ in *My Best Thing* involves cultivating a pedagogical spirit out of the right combination of erotic desire and intellectual generosity in the face of the demand for quantitative productivity. In many ways, it was also about being free: free of obligations, free to get off, free animation software (Xtranormal), free love really. While "free love" may not be the motto I'd want to settle on, it does speak to our general problem of not affording to pay attention, and has led me to an awareness of how we are prone to squander our most readily available resource: "personal energy under personal control."[2]

DB — Previously, you would set up text on paper and install it in a space. Now, in *My Best Thing* and in the 2012 exhibition *Osservate, leggete con me* at Gavin Brown's enterprise, in New York, the words move as if walking away from the paper. Then you did that audio piece for a car, *Trapped in the VIP and/or In Mr. Martin's Inoperable Cadillac*, at Frieze Art Fair, New York, last year. In that work, you describe an encounter with a guy, Mr. Martin, in a park; seduction, knowledge, intellectual generosity, and personal energy under personal control all come into play again. It's a narration, but it found its way into reality, because Mr. Martin now sometimes works with you. As in *My Best Thing*, in which you are talking with online dates, you mess with fiction and reality, but now, it is more serious. You meet somebody, make a piece, a fiction, about the person, but now that person sits at your table. Are you fed up with fiction? Should fiction be more generous?

FS — First, to clarify, I don't actually work with Mr. Martin, but with Bobby, Martin's friend since childhood who did the recording. He's made himself at home in my studio for the past year—a very generous and generative apprentice.

Okay, so, the minute I sat down to reflect on fiction's potential for generosity, or lack thereof, one of the parakeets that lives in my studio flew out the front door—just like that, zip, right out the door, into the sky, across the horizon, goodbye. We named him Baby. And Baby's nonfictional escape prompts the question: How necessary is the cage when considering the metaphorical relevance of my birds, which actually live both on top of and inside their cage? (This is an image I conjure at the close of my movie *Nothing Is Enough*.) Was my bird's sudden and certain exit a crystal-clear message meant to alert me to the fact that I'm quite capable of freeing myself right now but I choose not to?

This is just one of the myriad little events that announces the straight-up "legibility" of daily life. Observations don't necessarily require translation into fiction; occurrences and their subsequent "reads" simply arise and coalesce in ways that invite close attention and consideration. Therein lie the potential narrative arcs to pursue, which have resulted in real material contributions to my work by men totally outside the realm of my presumed audience or student demographic. My latest sprawling work in progress, which I refer to as "Bobby Jesus," has taken shape in the studio by way of continuing my brazen pursuit of unlikely alliances.

Bobby—a self-described resident of "planet 'hood"—is the alias of Mr. Martin's friend I met through the Cadillac project. Because he was so responsive to my work, I opened my studio to him—young guys with little education and no jobs have a lot of free time. I offer him a quasi-MFA experience, that popular buffer against practical demands allowing people to "find themselves," so to speak. Bobby's grown into a remarkable student, model, apprentice, and guide. I use some peculiar infant Jesus clip art as the logo for the project; it stands not as a reminder of an immaculately conceived supernatural "savior" but for the stark reality of that persistent byproduct of sexual intercourse: an actual infant/future man. And as for Baby the bird, well, I suppose my door *is* often open.

1. Frances Stark, quoted in Leah Ollman, "The Mind and Art of Frances Stark," *Los Angeles Times*, December 26, 2010.

2. Ivan Illich, *Tools for Conviviality* (New York: Harper and Row, 1973), 12.

JOEL STERNFELD

BORN 1944, NEW YORK, NEW YORK
LIVES AND WORKS IN NEW YORK, NEW YORK

A pioneer of color photography at the time of its debut in the world of art in the 1970s, Joel Sternfeld is recognized among some of the best-known American journeyman photographers, including William Eggleston, Joel Meyerowitz, and Stephen Shore. Yet Sternfeld's attraction to nature — evident in his work at least since the 1990s — suggests connections to the somber, patient, and inquisitive images of black-and-white photographer Robert Adams, who for almost half a century has focused his lens on the changing landscape of the American West. The entirety of Sternfeld's *Sweet Earth* (2006), a series of photographs and accompanying texts that chronicle experimental utopias in the United States, takes place across the seasons, in regions as diverse as California's Mojave Desert, a roof garden in downtown Chicago, and the hills of Western Massachusetts. The tone across this compilation of controlled, purposeful, and alluring images is one of a casual exuberance for nature, beauty, life, and death.

Sternfeld envisioned *Sweet Earth* as a companion to his dystopian study on violence in America, *On This Site: Landscape in Memoriam* (1996). The artist earnestly writes about the 1990s moment that launched the two series, both also published as books: "As the world seemed to turn in unison to hyper-capitalism and large-scale urbanism, I wanted to point out that there were other models that might be considered."[1] After years spent obsessively and almost morbidly tracking news stories about thefts, murders, and other tragedies dating back as far as the John F. Kennedy assassination, Sternfeld set out across the country to photograph, when possible, the original sites of these brutal crimes, assembling a series of austere photographs for *On This Site* and accompanying them with textual descriptions that tell haunting tales of truths stranger than fiction. Following *American Prospects* (1987), his brilliant but unabashed look at the back roads of a postindustrializing United States, *On This Site* was a purge. The images are mostly eerie, empty landscapes and interiors. The moody series has something of the same slyness of the earlier photographs but leavened with a documentary style, enhanced by the accompanying text (also a popular approach among such artist-critics as Allan Sekula and Martha Rosler). Sternfeld began taking photographs for *Sweet Earth* in the 1980s and 1990s, and then focused on the subject full-time in the mid-2000s.

Sternfeld recalls his early enthusiasm for literary critic Van Wyck Brooks's 1936 book *The Flowering of New England*, a history of the intellectual and literary motivations that inspired the Transcendentalist movement. During the first wave of utopian enlightenment — coincident with Transcendentalism — six hundred different communities developed in the United States. These communities, active between 1810 and 1860, grew in response to the overwhelming pressures on urban areas during the Industrial Revolution and a new brand of religious and social extremism that sent followers to rural areas to seek alternative futures. The 1960s ushered in a second wave of communal living made popular by the counterculture hippie movement concentrated in states such as Virginia, New Mexico, Oregon, and California and flourishing in and around New England. Sternfeld's own relationship to this era can be seen through *Sweet Earth*'s earliest image, taken during a 1982 visit to the home of Helen and Scott Nearing, authors of *Living the Good Life*, a bible for back-to-the-landers in the 1960s. This photograph is ten years apart from the next earliest picture in *Sweet Earth*, but it is a foundational image. The third utopian wave that Sternfeld cites coincides with our present moment, as exemplified in today's popular interests in eco-villages, sustainability, and cooperative housing, the roots of which stretch back at least two decades.

Whether Sternfeld is examining a religious sect, a government assistance program, or an ecologically minded commune for nature-lovers, the tension between success and failure is a dominant theme across the series. The book's afterword breaks voice from the otherwise informative but neutral text panels throughout to ask, "How does one understand the fact that so many communities began with idealism and ended in ruin?"[2] Possible responses to this question align with the many moods of Sternfeld's photographs: irony, ecstasy, sadness, loneliness, controversy, and frequent abandon. Subjects include the American Shaker community whose history stretches back in this country to 1774, when founder Mother Ann Lee, after experiencing a revelation, brought a band of followers to New York from England. Yet because abstinence is a central tenet of the movement, there are fewer and fewer Shaker communities today. Other groups find ways to support themselves in a modern world: Twin Oaks, an "intentional community" in rural Virginia, sells handmade hammocks to retailer Pier 1 Imports; and at the experimental town of Acrosanti, founded by architect Paolo Soleri in the desert outside of Phoenix, residents sell handcrafted wind chimes and bells to visitors. Brushes with celebrity can bring momentary attention to a group, as when the planned community of Seaside, Florida — its pristine post office photographed by Sternfeld in 2004 — was chosen as the site for the filming of *The Truman Show* (1998), a cinematic satire on media manipulation.

Sweet Earth brushes against the ironic subjects and radical subjectivity frequently found in Sternfeld's earlier work, for example a photograph from *American Prospects* of a fireman buying a pumpkin while a house burns in the distance. Critic Andy Grundberg eloquently identified the subject of *American Prospects* as "a postindustrial, service-oriented society devoted to technology, consumer spending, personal narcissism, increasing unemployment, which masquerades as leisure time."[3] If the communities depicted in *Sweet Earth* share one common goal, it is their rejection of the *American Prospects* lifestyle. The subjects offer new ways, new possibilities, for living in the modern world. Sternfeld writes: "As the evidence of ecological ruin mounts, the world will come to value these communities and the storehouse of knowledge they have been quietly amassing about sustainability."[4] He holds strong views on global warming, and shot a body of work at the United Nations conference on the subject in Montreal in 2007.

Competing ideologies of individualism and collectivism at times get the best of Sternfeld's subjects, and irreconcilable differences force utopian communities to shutter.

Even so, there are shining moments when pragmatism prevails, and some good can be gleaned from these experiments. Even those communities that are now long gone (Black Mountain College in North Carolina, for instance, now turned into a Christian boys' camp) can, thanks to Sternfeld's keen eye, leave a lasting and irrevocable trace on our collective unconscious.

—Tina Kukielski

1. Joel Sternfeld, "Afterword," in *Sweet Earth: Experimental Utopias in America* (Göttingen, Germany: Steidl, 2006), 126.
2. Ibid., 127.
3. Andy Grundberg, "The Itinerant Vision," reprinted in the second edition of *American Prospects* (San Francisco: Chronicle Books, 1987), unpaginated.
4. Sternfeld, "Afterword," 127.

MLADEN STILINOVIĆ

BORN 1947, BELGRADE, YUGOSLAVIA (NOW SERBIA)
LIVES AND WORKS IN ZAGREB, CROATIA

Since the 1970s, Mladen Stilinović has practiced the poetic interrogation of power. "The subject of my work is the language of politics, i.e., its reflection in everyday life," he states. "The question is how to manipulate that which manipulates you, so obviously, so shamelessly."[1] Stilinović's omnivorous approach to art making—with major works in nearly all formal media, including drawing, painting, performance, video, photography, and text—is represented in the *2013 Carnegie International*'s succinct retrospective presentation. Fluent yet deeply colloquial, Stilinović's work contributes to numerous dialogues on culture and politics spanning Yugoslavian socialism, the capitalist diaspora, and contemporary globalism.

The artist's early years in the former socialist republic of Croatia directly influenced many of the ongoing preoccupations and strategies of his practice. Under the presidency of Josip Broz Tito, the Socialist Federal Republic of Yugoslavia was one of the founding nations, in 1961, of the Non-Aligned Movement. This international coalition upheld socialist values but remained neutral with regard to the extreme positions and policies of the Soviet power bloc. Arguably a "benevolent dictator," Tito espoused the goal of a "Third Way" of socialist governance that would provide an alternative to both Western capitalism and Soviet communism. This approach remained a force in Yugoslavia for nearly a decade after Tito's death in 1980, after which communism gave way to an unstable market economy, political unrest, civil wars, and Croatia's eventual separation in 1991.

This context differs from that of many Eastern European artists and intellectuals of the time. Even though Stilinović and his Croatian contemporaries experienced the relentless propaganda, pervasive censorship, and relative poverty that Miklós Haraszti has described as the "subtle means of constraint"[2] practiced by socialist governments outside of the Soviet Union, they were not persecuted for voicing political or social opposition. Stilinović, isolated from both state sponsorship and the commercially driven art world of Western Europe and the United States, was able to make and exhibit art that actively questioned his sociopolitical surroundings. The somewhat amateurish mien of Stilinović's aesthetic—his use of handwriting, collage, found objects, everyday materials, and self-publishing—could be attributed to a lack of resources and restricted communication with a wider creative community. Of greater significance are the ways in which these modes of production function as explicit strategies of critique on social, cultural, moral, and aesthetic values.

Stilinović has written poetry since childhood, and as a youth he cofounded and made experimental projects with the amateur film society Pan 69. In 1975 he visited the Belgrade Student Cultural Center's annual multiarts event *April Meetings*, heavily influenced that year by Fluxus and Conceptual art. Upon his return to Zagreb, he formed the Grupa Sestorice Autora (Group of Six Artists) along with his brother Sven Stilinović, Boris Demur, Željko Jerman, Vlado Martek, and Fedor Vučemilović. This group pioneered what would become known as "exhibition-actions": projecting films and slides onto the sides of buildings and displaying in-progress artworks in unexpected places, such as on city streets and on the banks of the Sava River.[3] These spontaneous happenings consciously subverted the dominant cultural-politic by insisting on transparent process and public discourse.

The destabilizing strategies developed by the Group of Six Artists, which called into question dominant ideologies of art making and display, would remain a major component of Stilinović's practice. Through the 1980s, he managed the independent, artist-run Extended Media Gallery in Zagreb, and to this day presents exhibitions of his artwork in his own home (though he has also exhibited widely, including at the 50th Venice Biennale and the 2007 Documenta). Where this spirit of creative dissidence is most evident is in Stilinović's humorous, ironic, and profoundly cynical take on ideological power as it is created by and maintained through the use of symbolism, systems of bureaucracy, and especially language.

Exploitation of the Dead (1984–90), a constantly rearranged cycle of more than one hundred individual paintings, drawings, texts, found objects, and photographs, is a rich example of Stilinović's philosophy and stratagem. Upon first consideration, this intricate montage seems to present a complex codex made up of a post–World War II art history, explicitly political symbolism, discarded everyday items, and documentary photography. Characteristically, Stilinović's organization of these ele-

ments is poetic rather than taxonomical. The repetition of abstractly appropriated and manipulated visible languages (flags, money, logos, slogans) disrupts the process by which imbued meaning can come to be experienced as inherent. "De-symbolizing," as Stilinović refers to this technique, attempts to transfigure co-opted symbols into instances of subjected interpretation. For example, by repeating and recontextualizing the color red throughout this installation, viewers are encouraged to simply see a color, rather than a representation of communism. In Stilinović's words, "If language (the color, the image, etc.) is possessed by ideology, I too want to become the owner of such a language."[4]

Over the years, as the political landscape has altered, Stilinović's practice has effectively encompassed an engagement with capitalism and globalism. "As an artist," he writes, "I learned from both East (socialism) and West (capitalism). Of course, now when the borders and political systems have changed, such an experience will be no longer possible. But what I have learned from that dialogue, stays with me."[5] His 1992 banner work *An Artist Who Cannot Speak English Is No Artist* combines the authoritative tone of socialist sloganeering with the DIY strategy of handmade protest banners to present a statement that, if read literally, is rankling if not absurd. Read as an indictment of the Anglo-Western dominance of a purportedly global art world, however, this banner has made a powerful statement when installed in major international art spaces. By focusing on specific yet shared features of life, such as language, food, labor, time, and currency, Stilinović's accessible tactics of dissidence and critique achieve an ongoing relevance.

—Lauren Wetmore

1. Mladen Stilinović, "Footwriting" (Zagreb: Studio of the Gallery of Contemporary Art, 1984), unpaginated.
2. Miklós Haraszti, *The Velvet Prison: Artists under State Socialism* (London: I. B. Tauris, 1988), 7. Here Haraszti refers specifically to Hungarian socialism; however, this language is apt for the Croatian context as well.
3. For more on the group's activities, see Branka Stipančić, "Some Aspects of Croatian Contemporary Art 1949–1999," in *Aspects/ Positions: 50 Years of Art in Central Europe, 1949–1999* (Vienna: Museum moderner Kunst Stiftung Ludwig, 1999).
4. Stilinović, "Footwriting," unpaginated.
5. Mladen Stilinović, "The Praise of Laziness," *Mladen Stilinović: Tekstovi/ Texts* (Zagreb: Mladen Stilinović, 2011), unpaginated.

Frances Stark installation view of *Osservate, leggete con me* 2012 Courtesy of the artist and Gavin Brown's enterprise

Frances Stark *Addressing Bobby Jesus on My Knees* 2013 Matte laminated inkjet print mounted on aluminum, framed Unique from a suite of 6
framed: 47 ½ x 35 ⅜ x 1 ¼ in. (120 x 90 x 3.2 cm) Courtesy of the artist and Gavin Brown's enterprise

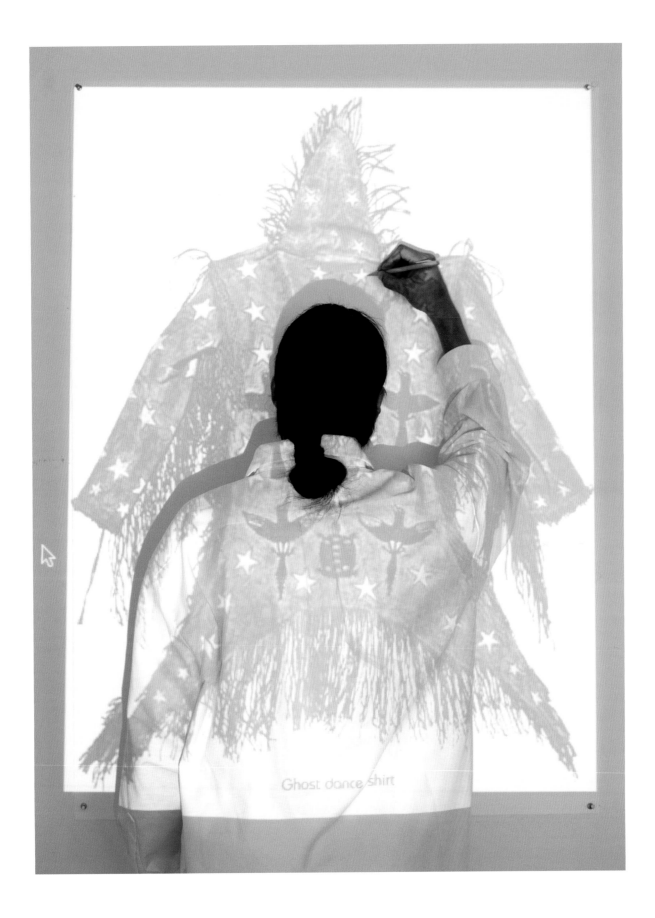

Frances Stark *Bobby Jesus with Bullet Proof Vest for Dancing the Round Dance Continuously* 2013 Matte laminated inkjet print mounted on aluminum, framed
Unique from a suite of 6 framed: 47 ½ x 35 ⅜ x 1 ¼ in. (120 x 90 x 3.2 cm) Courtesy of the artist and Gavin Brown's enterprise

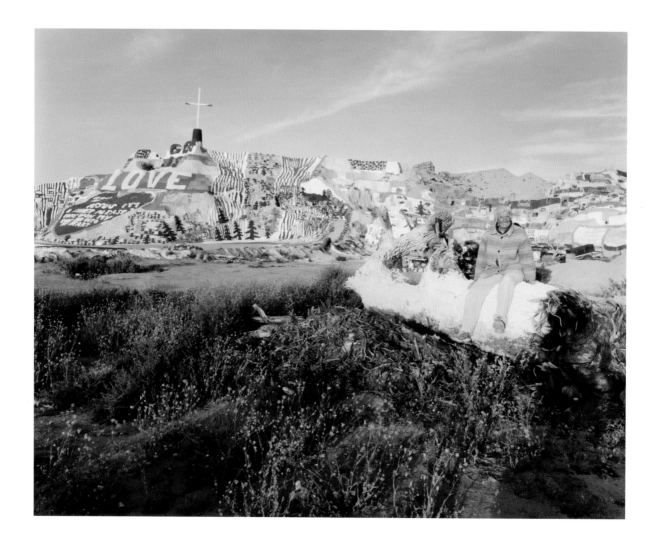

Leonard Knight at Salvation Mountain, Slab City, California, March 2005.

Leonard Knight's religious awakening occurred in 1967, when he was thirty-five years old. "One day by myself I started saying, 'Jesus, I'm a sinner. Please come into my heart.'"

Sometime afterward, Knight began to work on a hot-air balloon made from bed sheets, on which he planned to write "God is Love," as well as the prayer that had facilitated his conversion. This plan failed when the balloon could not get off the ground.

Not one to be discouraged in his quest to spread his newfound faith, Knight began creating Salvation Mountain from adobe and hay bales on the site of his balloon efforts. Visitors have donated some of the funds necessary to purchase the estimated one hundred thousand gallons of paint used to color the structure over the years; California paint stores have contributed the rest.

In 1994, local government authorities declared the mountain a "toxic nightmare" and drew up plans to have it carted off and buried in a nuclear waste dump in Nevada. Rallies by Knight's supporters, as well as his own test results proving that the site was non-hazardous, led the government to back down and allow him to continue building his shrine. He does so daily, except when graciously showing visitors around and giving them postcards inscribed with the Sinner's Prayer.

Because Knight considers it an obligation to personally greet each of the fifty to one hundred visitors who come each day, construction now depends on the help of volunteers. His latest project is a museum to house his own work and that of other artists.

Joel Sternfeld *Leonard Knight at Salvation Mountain, Slab City, California, March 2005.* 2005 cat. no. 209

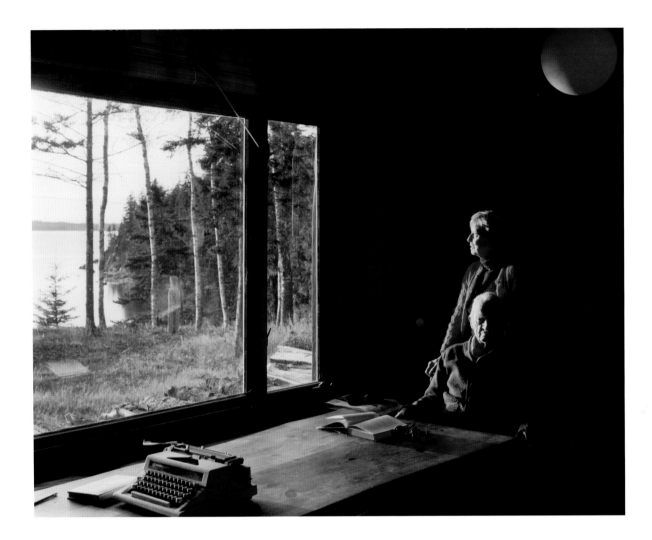

Scott and Helen Nearing at Forest Farm, Harborside, Maine, October 1982.

In the early years of the twentieth century, Scott Nearing's pacifist beliefs and antiwar activism caused him to lose two college teaching jobs. As a young professor of economics at the University of Pennsylvania, he wrote essays such as "The Great Madness and Oil and the Germs of War," asserting that the main purpose of the US military was "to guard the hundreds of millions of dollars…invested in 'undeveloped countries.'" He was put on trial under the Espionage Act of 1918 and, though he was acquitted, publishers began to refuse his work.

Out of these experiences came an utterly new one. In 1932, at the height of the Great Depression, as he was approaching fifty, he married Helen Knothe. Together they bought a run-down farm in Vermont for three hundred dollars, built their own home and eleven other structures out of stone, and eventually grew eighty percent of the food they ate. Without using any animal labor, they gathered maple syrup and sold it as a cash crop (they refused to gather honey because they believed it exploited the bees' work). Only one-third of each day was spent in what they referred to as "bread labor." The rest of their time was divided between community service, professional activities and recreation, particularly music making.

Nor were they lonely: the Nearings' door was continuously open to visitors who wished to learn from and participate in their simple life. To enter, one had only to be willing to work. And once again Scott published. *Living the Good Life: How to Live Sanely and Simply in a Troubled World* appeared in 1954, co-authored with Helen, and was followed by numerous other reflections on their homesteading life and beliefs. *Living the Good Life* proved consequential, becoming an Ur-text for the back-to-the-land movement of the 1960s.

In 1952, when Vermont grew too crowded for them, the Nearings moved to Maine and started the good life process all over again. It lasted until 1983 when Scott, aged one hundred, fasted to his death. Physically and mentally strong, the choice to end his life was a conscious one.

Defending himself at his espionage trial in 1919, Scott Nearing wrote: "The Constitution does not guarantee us only the right to be correct, we have a right to be honest and in error. And the views I have expressed in the pamphlet "The Great Madness" I expressed honestly. I believe they are right. The future will show whether or not I was correct."

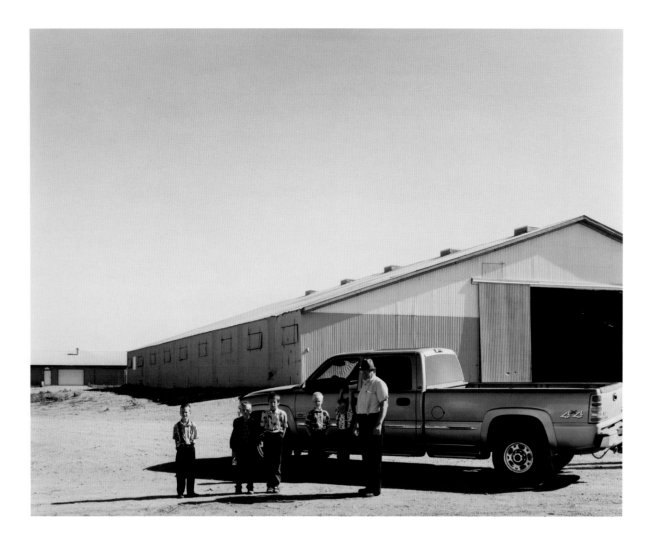

New Elm Springs Colony, Ethan, South Dakota, July 2005.

In 1516, Thomas More published *Utopia*. A year later, Martin Luther nailed ninety-five theses to a church door in Wittenberg. And in 1525 at a meeting in Zurich, the early Anabaptists repudiated infant baptism in favor of "true Christian" adult baptism. Among this most radical wing of the Protestant Reformation were the Hutterites, a sect which took its name from Jacob Hutter, an early leader. They believed strongly in pacifism, communal ownership of all goods and the separation of church and state.

For the next century, under the protection of Moravian nobles, the Hutterites grew prosperous and their numbers swelled to perhaps thirty thousand. But the sect, which throughout its history has been persecuted for its distinctive beliefs, was expelled from Moravia in 1622. After a century and a half of migration, they began to settle in Russia with a promise of exemption from military duty. When this privilege was withdrawn in 1871 they left, and a few years later settled in South Dakota.

Despite the hardships of their early years on the prairie, the Hutterites' numbers grew steadily until World War I. As pacifists, their young men resisted service but, with no conscientious objector laws in place, draft-eligible males were arrested. When two of them were tortured to death while in custody, the Hutterites hastily moved to Canada, under another promise of exemption from active duty.

During the dark days of the Great Depression, the state of South Dakota was in desperate need of tax revenue, and the highly successful Hutterites, whose colonies refused any form of state aid, were invited to reoccupy their former lands. Today, forty thousand Hutterites can be found throughout the western United States and Canada, where their remarkably successful communities adopt whatever modern technology they find useful, and live according to beliefs first embraced in 1525.

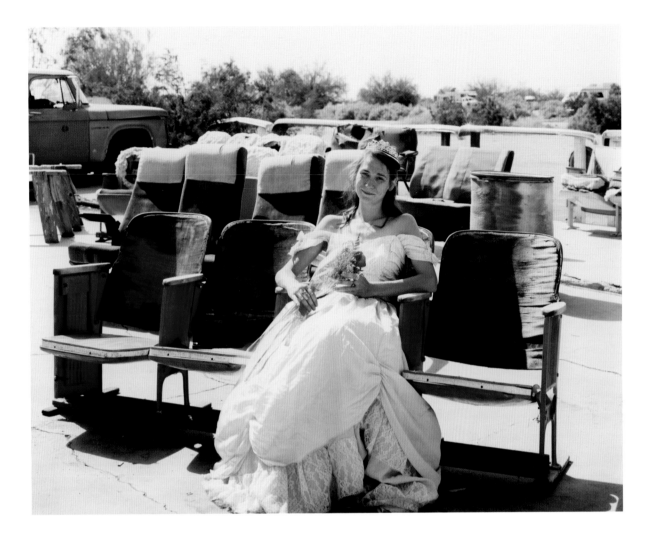

Queen of the Prom, the Range Nightclub, Slab City, California, March 2005.

When Camp Dunlap, a World War II Marine training facility near Niland, California, was closed in 1946, all of the buildings were completely dismantled, leaving numerous cement foundation slabs in the desert.

Almost as soon as the government abandoned the site, "snowbirds" (campers from northern states in recreational vehicles) began to winter on the slabs, even though no running water, electricity or sewage facilities were available. Today at least five thousand snowbirds arrive each winter, and a few have become permanent year-round residents, despite summer temperatures that can reach 120 degrees. The snowbirds come with motor homes costing half a million dollars and they come with tents.

Over the years, a true self-governing community has arisen, including a mayor, the Slab City Christian Church (in a trailer), the Lizard Tree Library (used paperbacks on an honor system), the Gopher Flats Country Club (gravel greens), the Oasis Social Club (combination meeting space/junkyard), a CB radio station (one half hour of purely local news, nightly at six p.m.) and the Range, an outdoor nightclub built by "Builder Bill," complete with stage, lighting, bar, communal outhouse and several rows of salvaged airliner seats. The Range takes its name from an active bombing range located a few miles away, which makes the sight and sound of F-16 sorties a part of life at the Slabs.

Moira, the Queen of the 2005 Prom at the Range, never got to go to her high school prom.

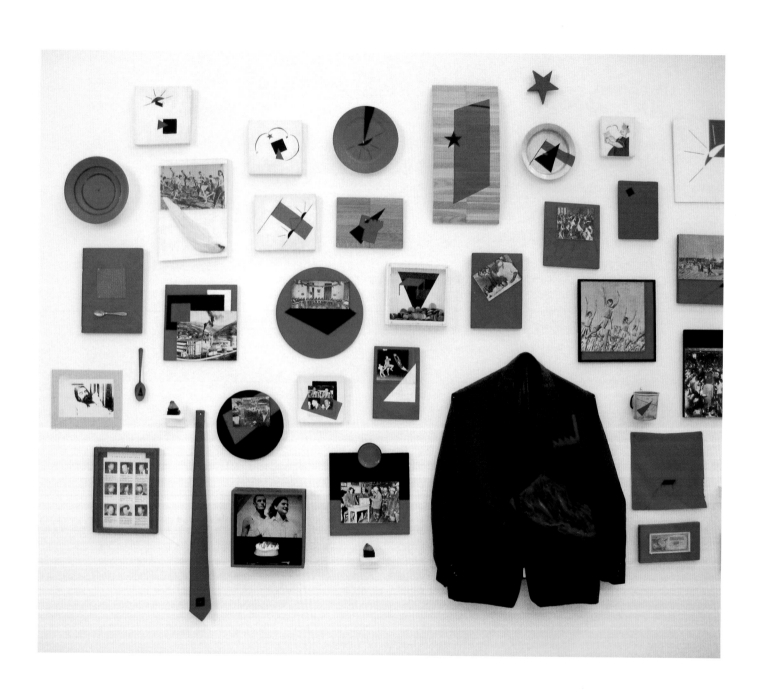

Mladen Stilinović installation view of *Exploitation of the Dead* 1984–90 cat. no. 233

accede PAIN

accelerate PAIN

accent PAIN

accentuate PAIN

accept PAIN

access PAIN

accession PAIN

accessory PAIN

accident PAIN

acclaim PAIN

acclimatize PAIN

accolade PAIN

accommodate PAIN

accompaniment PAIN

accompanist PAIN

accompany PAIN

accomplice PAIN

accomplish PAIN

accord PAIN

accordance PAIN

accordingly PAIN

according to PAIN

accordion PAIN

accost PAIN

account¹ PAIN

account² PAIN

accountant PAIN

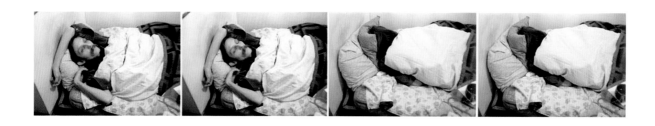

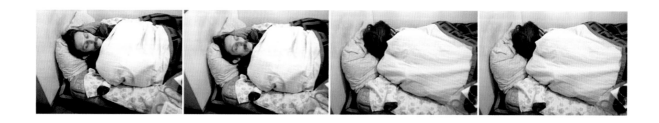

Mladen Stilinović *Artist at Work (for Neša Paripović)* 1978 cat. no. 229

Mladen Stilinović still from *Krumpira Krumpira* (*Potatoes Potatoes*) 2001 cat. no. 240

ZOE STRAUSS

BORN 1970, PHILADELPHIA, PENNSYLVANIA
LIVES AND WORKS IN PHILADELPHIA, PENNSYLVANIA

For more than a hundred years, until 1986, Homestead, Pennsylvania, was defined by the imposing presence of the Homestead Steel Works, the 430-acre flagship plant of Carnegie Steel Company (later US Steel). Long one of the world's largest steel mills, the Works was also the site of a pivotal event in American labor history: the 1892 Homestead Strike, in which twelve people died in a day-long battle between striking steelworkers and Pinkerton Detective Agency toughs hired by union-busting plant manager Henry Clay Frick. Although the workers claimed victory in the battle, the strike was ultimately unsuccessful; Frick, with Andrew Carnegie's blessing, effectively quashed the union at Homestead and other Pittsburgh-area mills, setting the labor cause back for several decades.[1]

Today, little remains of the Works, save the pump house on the Monongahela River where the Pinkertons came ashore and a monumental row of red brick smokestacks.[2] The defining feature of Homestead is now the Waterfront, a sprawling complex of big-box stores and chain restaurants built in 1999 in the footprint of the demolished plant. Meanwhile, a population of 3,000 residents—down from a peak of 20,000 in the 1920s—survives alongside. They and their town, a prism of shifting industrial landscapes, interconnected economies, and fluid identities, are the subjects and dedicatees of photographer Zoe Strauss's project for the *2013 Carnegie International*.

As of this writing, in the spring of 2013, Strauss has already begun to immerse herself in the community there, taking regular trips from her home across the state to walk around, meet people, and take pictures. For four weeks before and two weeks after the exhibition's opening, she'll live and operate a portrait studio in Homestead, likely in the building formerly occupied by a Woolworth five-and-dime store. Strauss will produce three prints of each portrait she takes of Homestead residents: one for the sitter, one for herself, and one for Carnegie Museum of Art, where the portraits will accumulate over the course of the project on the walls of a hallway off the main lobby; Homestead residents and union steelworkers will be given free admission during the run of the *International*. The artist's Homestead street photography will be hung alongside her portraits, joined by video projections of rivers in both Homestead and Wuhan, China, a present-day center of steel production, where the largest mill employs 80,000 workers. Footage from a Wuhan mill will also be on view on the windows and in the basement of the pump house, which sits at the far end of the Waterfront's main thoroughfare. The pump house projections telescope historical and contemporary sites of steel production, and underscore a sense of history lost in the development of such "everywhere and nowhere" places as the outdoor shopping center. The installation of photographs at the museum, on the other hand, highlights issues of access and representation, making space for a portrait gallery like one might find in the hallway of a family home.

Strauss's Homestead project marks something of a departure for the artist, who between 2001 and 2010 focused almost exclusively on her project "Under I-95," an epic, open-ended narrative in photographs "about the beauty and struggle of everyday life."[3] Imagined from the outset as a ten-year project, the I-95 concept centered on an annual, one-day exhibition of Strauss's street photography (in the form of color photocopies) on the concrete pillars under an elevated section of Interstate 95 in South Philadelphia. Based in an anarchistic will to reclaim a part of the city for its residents, the exhibition was hung without permits in the expansive pedestrian underpass, which is often traversed by locals en route to a shopping center on the other side of the highway. Strauss would set up a table and sell prints for five dollars each, and then leave the exhibition up at the end of the day for people to take away remaining prints as they liked. The artist assembled many of the photographs that appeared in the various iterations of I-95 in her 2008 book, which she provocatively titled *America*.[4]

As this title suggests, Strauss's project was something of a contemporary redress to Robert Frank's photo essay *The Americans* (1958), and focused on the unseen (or deliberately ignored) details of life at the lower rungs of the economic ladder. With sometimes startling candor and genuine empathy, she photographed people and places in her hometown of Philadelphia and beyond, capturing both heart-rending dejection and moments of joy, hope, and pride that transcend difficult circumstances. She has an equally keen eye for texts—signs, billboards, graffiti—within the constructed environment that aptly encapsulate shades of ambivalence, absurdity, and fear in post-9/11, boom-and-bust America.

Strauss gained significant art-world recognition over the course of the I-95 project, but has remained committed to an ethic of access and transparency, to work that is responsible to its subjects and aims to affirm the significance of their lives. Though she has been compared to Diane Arbus, Strauss approaches the people and places she photographs "more as a fellow traveler than as an outsider" driven by photojournalistic curiosity.[5] Her photography studio in Homestead affords her the opportunity to continue this aspect of her practice, giving greater agency to her subjects, who determine how they want to appear before the camera and, ultimately, to museum audiences. Although Strauss's Homestead project might begin with an interest in points of convergence between present and historical sites of production and consumption, with a growing awareness of the global interconnections that shape the local landscape and the conditions of our everyday existence, the project ultimately centers on the individual lives that have grown up around—thanks to, in spite of, or without—the Works.

—Amanda Donnan

1. See Les Standiford's book *Meet You in Hell: Andrew Carnegie, Henry Clay Frick, and the Bitter Partnership That Changed America* (New York: Broadway Paperbacks, 2006).
2. Carrie Furnaces 6 and 7, which were built in 1907 and produced iron for Homestead Steel Works until 1978, also survive on the opposite side of the Monongahela River, but are not within Homestead. The furnaces and pump house are maintained as historical sites by Rivers of Steel; see http://www.riversofsteel.com.
3. Zoe Strauss, quoted by Peter Barberie, "Under I-95," in *Zoe Strauss: Ten Years* (Philadelphia: Philadelphia Museum of Art, 2012), 54.
4. Edited by Steve Crist and published by AMMO Books, Pasadena, CA.
5. Barberie, "Under I-95," 131.

HENRY TAYLOR

BORN 1958, OXNARD, CALIFORNIA
LIVES AND WORKS IN LOS ANGELES, CALIFORNIA

Henry Taylor lets the world into his Los Angeles studio, and onto every surface and object there — cigarette boxes, bottles, furniture, and stretched canvases. He makes no sacrosanct distinctions between historical icons and the person sitting in front of him: people from the neighborhood might wander in and become the subject of a portrait alongside Eldridge Cleaver or a friend's son. Taylor's work is fast, rough, and voracious. All subjects of interest to him are painted into flat, heavily worked, and lively grounds; they are embedded and yet they jump off the surface. There is junk and beauty and history and most of all people — everywhere — conjuring all kinds of times and places and attitudes.

That Was Then (2013) shows a man standing on dirt against a bright blue sky; his pants are a complete mess of paint. It starts at the stomach with the loosely painted shirt and falls down the front of his body, to his knees, and on down to the gathered, liquid cuffs. The paint is viscous and thick, and describes itself better than it does the trousers, but it works. The other attention-grabbing element is the repeated racial taunt "boy," which gets cut off by the painting's edges, implying a continuous repetition, and yet frames the man, fixing him in place. The face of this *man* is old and tired, and he is looking down. A hand is clamped to his side, and a rough, jagged shadow clings to his feet. Boy. There is no doubt that this painting, as well as its companion work *Mary had a little… (that ain't no lamb)* (2013), is an evocation and indictment of a historically specific racism and a reflection of black experience in America. *That Was Then* wants to be completed with a corrective "This Is Now." Instead, it is left unanswered, grounded in a past–present continuum, expressed through the fresh, thick paint and matter-of-factness of the image.

African American subjects — past and present — populate many of Taylor's large paintings. And while the expressive brushstrokes, exaggerated (or generalized) features, and fragmented surroundings all signal emotional and psychological layers, the speed and surfaces of his works reveal a series of fluid exchanges: between snapshots, history, and present-day encounters; friends and strangers; and stuff that was found or remembered and then fixed into painting.

By mixing portraits of friends, strangers, and historical figures, Taylor creates a web of empathetic associations. History is about people, and the people around Taylor take on roles in history.

In *Eldridge Cleaver* (2007), the early leader of the Black Panther Party sits in profile, strangely fragmented, with a dim shadow around his head. His brilliant blue pants end too soon, and the chair is barely enough to hold him; yet he seems firmly planted, staring off resolutely even as the furniture legs (and his own legs) disappear. His eye, the cigarette, and two framed artworks on the wall behind him create a rhythm of white across the top of the painting. The interior takes on hues of nature: the floor a dirt brown, the walls a forest green. Even though the image was no doubt taken from a photograph, the scene belongs entirely to Taylor in the way it has been stripped down and then rebuilt in abstracted, generalized passages.

The way Taylor brings together fragments of bodies, places, and objects, and then makes it all work together (either in antagonism or coherence), extends to his use of language. A quick sampling of paintings finds a grab bag of themes and slogans, pulled from city walls, advertisements, and overheard conversations: "Henry," "Oh, Henry," "Peanuts," "Get," "Warning shots not required," "Denny's," "Spoon," "No Parking," "Human Hair," "She Mixed," "CORN BREAD," and "A+ A+ A+ A+ A+ A+" (which he wrote in black marker on the side of one of his canvases as it was being hung for an exhibition in Los Angeles). These phrases function as punctuating commentary on the actions and subjects depicted.

"Know what I mean?" is Taylor's constant refrain, appended to statements he makes, especially those of personal disclosure and some rather far-fetched claims. And his paintings invite a similar sense of invitation and inclusiveness. Taylor presents his characters and settings — whether family members hanging out on a couch, Jackie Robinson sliding into home plate, a drug-addicted homeless person, or kids playing in the street — as something recognizable from the viewer's own life experience. But the assumptions underlying the casual familiarity and uninhibited directness of his subjects are the challenge of his work.

—Dan Byers

TEZUKA ARCHITECTS

FOUNDED 1994, TOKYO, JAPAN
TAKAHARU TEZUKA AND YUI TEZUKA

Societal structures allow the communal to be greater than simply the aggregation of individuals. Paradoxically, perhaps, society can give individuality a home within a tolerant set or matrix of relationships. The relationship between the individual and the communal, between the human actor (or reactor) and the institution, between citizens and the state is the focus of much critical architecture informing the Western canon since the dawn of modernism.

Architecture with a capital A seems to embody and reify a prescribed, hierarchical, and rather rigid notion of society. Think of stereotypical images of the hospital, the courthouse, or the school. The work of Takaharu and Yui Tezuka offers alternatives to preconceptions of architecture, or of how architecture should look and perform. Since establishing their practice in Tokyo in 1994, the Tezukas have realized houses, schools, office buildings, and healthcare facilities that prioritize human activity and a sense of connection to the larger world.

Frank Lloyd Wright was one of the first to challenge how architecture works, to envisage how it might better benefit its users. Wright posited an organic architecture that used and expressed natural materials and systems of construction, and that situated the human being as a central player in a broader natural world of topography, light, and material finish. After 1945, in opposition to rapid industrialization and urbanization, architects such as Aldo van Eyck and colleagues in the international group known as Team 10 were inspired by both sociology and an admiration for vernacular structures. They proposed cellular and weblike buildings that emphasized communal use above static form.

The work of Tezuka Architects operates in this alternative lineage of modern architecture, a lineage that is less technocratic and that privileges human interaction, specifically between families (as demonstrated in their house projects) and between children (as evident in their kindergartens and schools). Such projects emphasize program over appearance, space over architectural language. There may be nothing so restrictive, limiting, or occluding as a normative facade.

The Fuji Kindergarten expresses with brio the Tezukas' interest in making spaces and places for people. Situated in the extended western suburbs of Tokyo and completed in 2007, the facility takes its name from the family that owns and manages the kindergarten. The Tezukas' response to the architectural brief and the site was to erect a single generous structure that is oval in plan and expands almost to the property boundary. The structure is one story high and virtually flat: the entire roof surface is accessible from open stairs and ladders that ascend from the interior through skylights so that the roof functions unexpectedly as a deck, running track, and playground in one.

It is this raised oval terrace that gives the building its principal and memorable image. It is of course a strong geometric shape. Animating this surface is the lively coming-and-going of the children: they pop up through skylights, chase each other around the track, and can even slide back down into the courtyard on a metal slide. Balustrades are made from skinny, vertical metal rods. According to the architects, surveys show that the children at the Fuji Kindergarten are eight times more active than Japanese children on average. Thus good design not only is beautiful and inventive but also helps stimulate healthy lifestyles.

The entire courtyard facade is made of glass panels that slide back, even on cool days, to open up the interior space to the shared outdoor space. Children not only run around on the roof, inventing their own games, but are engaged in more intimate study groups within the shelter of the building. Preexisting zelkova trees have been preserved, encased in small glassed-in patios and rising high above the roof deck. The necessary gaps between tree trunk and deck are simply covered by loose rope mesh on which more adventurous children walk and jump.

Furthering the sense—the reality—of the Fuji Kindergarten as an incubator and playground for all the senses, a second, smaller structure was completed in 2011 to one side of the main oval. This two-story pavilion for foreign-language classes encircles and almost wraps another mature zelkova tree. Much of the structure is open to the elements, sheltered by the great vegetal canopy overhead. In addition to the glazed segments allocated as classrooms, interstitial decks and ledges and gentle flights of stairs allow the children to colonize the pavilion to their own ends.

At the Fuji Kindergarten, children are encouraged to organize their activities free from the segregation of typical boxlike classrooms and enclosed corridors. The building opens out and up to embrace the natural world and a social space in which children take comparative control. Rainwater is collected via spouts from the roof and freestanding taps are clustered to encourage some understanding of mechanical and environmental services. Thus the work of Tezuka Architects encourages, through play and activity, the development of young citizens of a world in which nature and technology coexist.

—Raymund Ryan

Zoe Strauss *Blast Furnace Matriarchy, Braddock, PA* 2012 from the series *Homesteading* 2013 cat. no. 242

Zoe Strauss *Homestead at Night, Homestead, PA* 2012 from the series *Homesteading* 2013 cat. no. 242

Zoe Strauss *Erika at Work, Homestead, PA* 2013 from the series *Homesteading* 2013 cat. no. 242

Zoe Strauss *Facing Waterfront Mall from US Steel Building, Munhall/Homestead, PA* 2013 from the series *Homesteading* 2013 cat. no. 242

Zoe Strauss *Frick Park, Homestead, PA* 2012 from the series *Homesteading* 2013 cat. no. 242

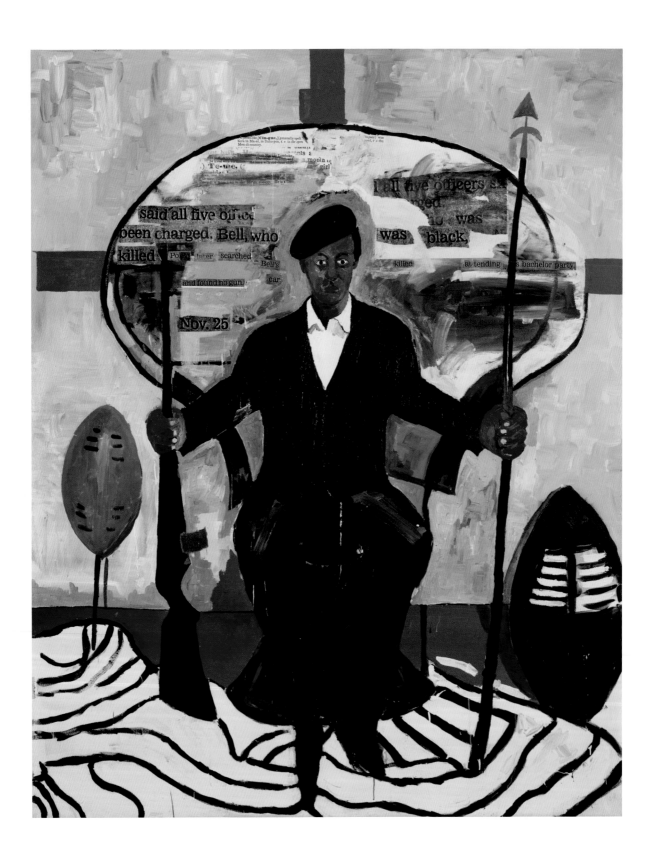

Henry Taylor *Huey Newton* 2007 cat. no. 245

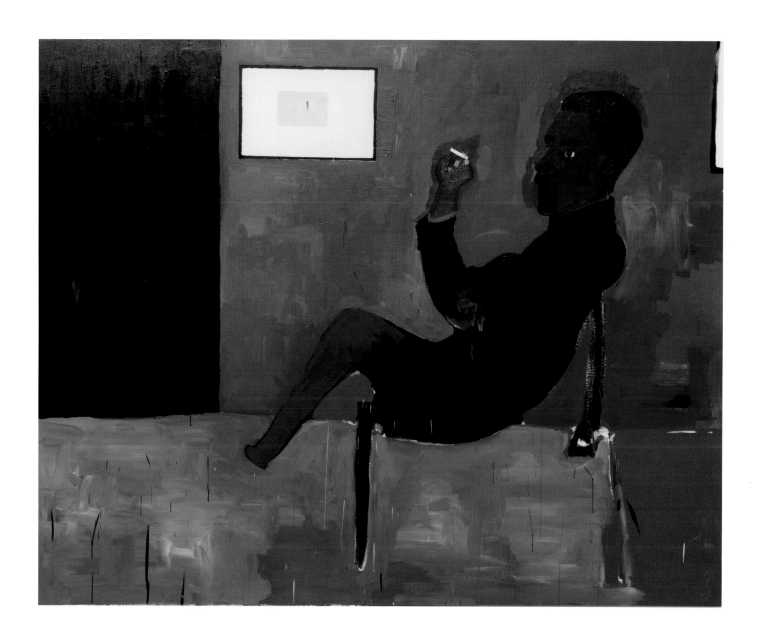

Henry Taylor *Eldridge Cleaver* 2007 cat. no. 243

Henry Taylor *That Was Then* 2013 cat. no. 251

Henry Taylor *Mary had a little... (that ain't no lamb)* 2013 cat. no. 249

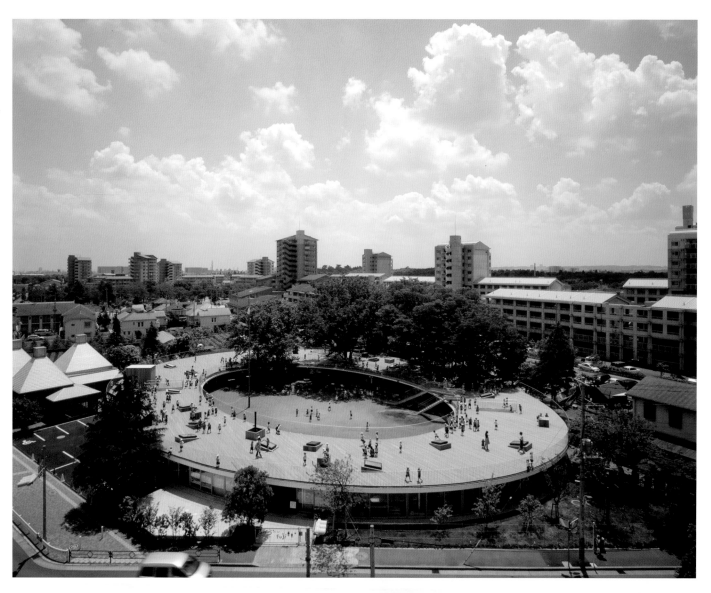

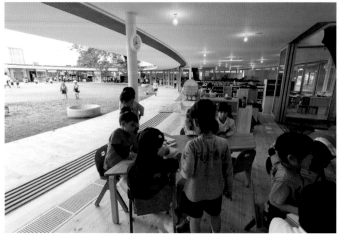

Tezuka Architects Fuji Kindergarten 2007 Tachikawa, Japan

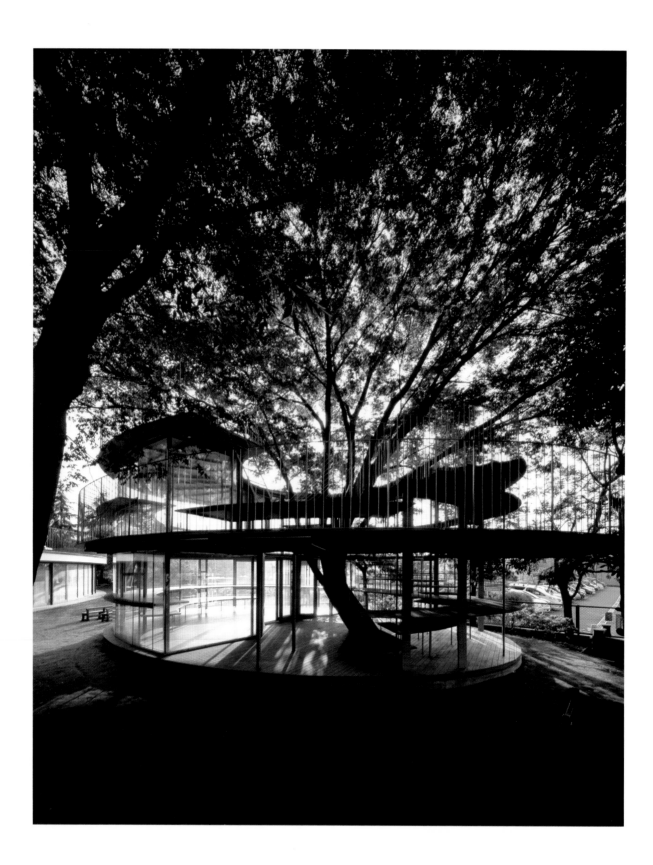

Tezuka Architects *Ring around a Tree* 2011 Tachikawa, Japan

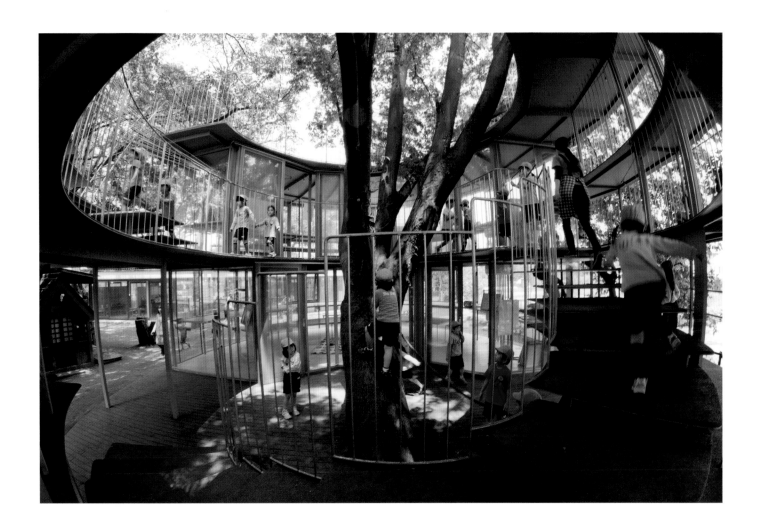

TRANSFORMAZIUM

FOUNDED 2007, NORTH BRADDOCK, PENNSYLVANIA
DANA BISHOP-ROOT, LESLIE STEM,
AND RUTHIE STRINGER

Transformazium's participation in the *2013 Carnegie International* reflects the exhibition's focus on an engagement with the city of Pittsburgh: to collaborate with leading contributors to Pittsburgh's cultural landscape and to participate in the significant history of its public institutions, many of which are indelibly linked by the Carnegie name. Originally referred to as the Edgar Thompson Works Library, and presented to the public as the Carnegie Free Library of Braddock, what is now known as the Braddock Carnegie Library was the first of many public libraries built in the United States by industrialist and philanthropist Andrew Carnegie. It was initially conceived of as an educational and recreational facility for employees of the Carnegie-owned J. Edgar Thompson Steel Works. The building opened in March 1889 with a collection of 2,153 volumes. By the start of the next year, that number had doubled, and circulation was at 18,738.[1] In addition to a library, this multiuse building housed billiards tables and public shower facilities in the basement, as indoor plumbing was not a common amenity at the time. In 1893 an extension doubled the size of the library and added a gymnasium, a swimming pool, a 964-seat music hall, and a two-lane duckpin bowling alley.[2]

The grandeur of the building and its facilities matched the prosperity of Braddock and the surrounding towns of North Braddock and Rankin through the 1950s and early 1960s. As the source of this prosperity—the steel industry—began to falter, so too did the population of Braddock and support for its public resources. The Braddock Carnegie Library was closed and slated for demolition in 1974, due to lack of funds for necessary maintenance. It was purchased for one dollar by the Braddock Field Historical Society, in a conservation effort led by then librarian David Solomon. That same year, the Braddock Carnegie Library Association (BCLA) was incorporated as a nonprofit organization; in 1983 they reopened the building as a single-room children's library. The BCLA has continued to work toward rejuvenating the building and expanding the role of the library in a greatly altered community, where more than a third of residents live below the poverty line.[3]

Since 2009 the BCLA has partnered with Transformazium to "develop and coordinate new creative learning programs and build relationships with regional cultural institutions."[4] Moving from New York City to North Braddock in 2007, Dana Bishop-Root, Leslie Stem, and Ruthie Stringer share interests and experiences in community agriculture, political and cultural activism, youth development, and education. They first came to Braddock at the suggestion of their friend and collaborator the artist Callie Curry (a.k.a. Swoon) to refurbish a local church Curry had purchased in 2007 as a live/work space. Transformazium quickly realized that their interests and efforts would contribute to the community more effectively in collaboration with the already vibrant engagement programs at the Braddock Carnegie Library.[5] This ongoing partnership has yielded many important projects. The Neighborhood Print Shop is a fully operational screen-printing studio, where residents of Braddock can learn to make prints for creative or entrepreneurial purposes; for instance, participants Nia Hogan, Kijuana D. Cummings, and Tiona Henderson have created a series of posters for the *2013 Carnegie International* apartment talks (see pages 318–28). The Resident Artist in Residence program has provided studio space and facilities as well as public engagement opportunities for established artists with ties to Braddock, including Tony Buba, LaToya Ruby Frazier, and Jim Kidd.

For the *2013 Carnegie International*, Transformazium continues this collaboration by creating the Art Lending Collection (ALC). Informed by institution-based precedents such as the Art Lending Library in the Jane Addams Hull-House Museum, Chicago, the ALC also looks to artist-run models such as the Art Lending Library in Seattle, and international examples such as Zoe Walker and Neil Bromwich's Art Lending Library in collaboration with Market Gallery for the 2012 Glasgow International Festival. Transformazium's ALC shares with these projects the goal of fostering an alternative model for experiencing art, one that provides access to otherwise overlooked audiences and generates a sense of community around intellectual and creative engagement.

The ALC includes works donated by other artists participating in the *2013 Carnegie International* as well as local and regional artists. Anyone with an Allegheny County library card is able to borrow the works and borrow a pass to Carnegie Museum of Art. Individuals from the community have been trained to work as discussion facilitators on location at the Braddock library. At the museum, a section of the main lobby features a space for visitors to hang works they have checked out of the ALC. For Transformazium, the ALC is a means to "expand discourse by including the perspectives of our patrons who are representatives of diverse cultural, educational, and class backgrounds."[6] ALC facilitators and visitors are encouraged to consider what social, cultural, and historical factors affect the way we value or evaluate artworks, and to question the voices that have historically been heard when assigning these values. The mobile nature of the pieces from ALC—be they in the Braddock library, at Carnegie Museum of Art, or in a patron's home—is intended to highlight through lived experience the significance of the question: "What is the relationship of an artwork to its context?"[7]

—Lauren Wetmore

1. George H. Lamb, *The Unwritten History of Braddock's Field* (1917; facsimile reprint, Bowie, MD: Heritage Books, 1999), 220.
2. "History of the Braddock Carnegie Library," www.braddockcarnegielibrary.org/history.
3. Based on census results form 2000 and 2010, 35 percent of Braddock residents live below the poverty line, as do 33 percent of the residents of North Braddock. Ruthie Stringer, "Braddock Carnegie Library Organizational Statement," typescript (2012). Carnegie Museum of Art artist files.
4. Ibid.
5. Dana Bishop-Root, Leslie Stem, and Ruthie Stringer, "Personal Canon," typescript (2012). Carnegie Museum of Art artist files.
6. Project statement, "The Art Lending Collection at the Braddock Carnegie Library," application to the Sprout Fund, typescript (2013), page 3. Carnegie Museum of Art artist files.
7. Quoted from a series of instruction questions in the Art Lending Collection Facilitator Learning/Teaching Binder (2012). Carnegie Museum of Art artist files.

ERIKA VERZUTTI

BORN 1971, SÃO PAULO, BRAZIL
LIVES AND WORKS IN SÃO PAULO, BRAZIL

When describing Erika Verzutti's work there is a tendency to make lists. "Heads, breasts, genitalia, vases, fruits, vegetables, animals and monsters,"[1] for example, or "Mickey Mouse, an eggplant, beach scenes, a swallow, a church, shrubbery and climbing vines."[2] Undoubtedly this impulse stems from the work itself: informal, dense, inherently elegant yet unabashedly crude. Installations composed through a process of seemingly unedited accumulation are in fact carefully delineated by their abundance of media, reference points, processes, accidents, and anecdotes. Loose but not disparate, Verzutti's self-sustaining environments enumerate their elements while also functioning as their container. A ceremonial attention to placement (taking into account both the physical practicalities of the gallery and the more esoteric elemental positioning of the space) is reflected in her venerative compositions. The prismatic strength of Verzutti's practice lies in the fecundity of a discrete object being equal to that of an intricate network of such objects.

Verzutti's new body of work for the *2013 Carnegie International* expands on her interest in revealing the beauty and symbolic power of common (both in the sense of low/undesirable and familiar/populist) objects. Just as a lattice of old paintbrushes bristling from a bronzed pineapple became the courtship display of an amorous peacock (*Pavão*; 2008) in *Pet Cemetery* at Galeria Fortes Vilaça, here a collection of tropical fruit is erected as a sharp totem of some implied ritual. Verzutti is known for her bronze and cement casts of fruit and vegetables; her use of the casting process as a means of object making can be read as metaphorical rather than utilitarian. The multiplicity inherent in the process of casting objects (the models, the off-casts, the discarded molds and materials) results in many layers of removal from the original form that felt the artist's hand, though each of those layers necessitates the very touch it seeks to obscure. In this way, a finished object holds within itself the knowledge of every cast that contributed to its final form.

The figurative and material links within a single object enable a reactive relationship to the creation of the whole installation in a process the artist describes as a progression, allowing her to "determine new shapes, new works,

sprouts." This "continue and expand gesture,"[3] as Verzutti names it, is one that she has employed before. It is seen in her collages of pastries expanded by watercolor drawings, such as *Crocante* (*Crunchy*; 2006), which bear a playful resemblance in tone and technique to Man Ray's collages *Nut Girls* (*Les Filles des Noix*; 1941). This two-dimensional layering is brought into sculptural proportions through a more topographical abundance akin to Mike Kelley's *Framed and Frame* (1999). Verzutti's more recent application of this reproductive gesture occurred with *Bicho de 7 Cabeças* (*7 Headed Monster*; 2010), where she invited seven artists to design a different head for one "body" she created—the heads and the body responding to one another throughout their respective processes of creation.

This understanding of an art object as a bodily container echoes the Neo-Concretist view of a sculpture as a "quasi-corpus," or "a being whose reality is not exhausted by the external relationships of its element; a being that can be deconstructed into parts for analysis but can only be fully understood through a direct phenomenological approach."[4] A mid-twentieth-century Brazilian movement, Neo-Concretism rejected mechanized and overly intellectual approaches to art making in favor of a sensual, intuitive relationship between the artist and the object whereby the work of art is seen as "being similar to a living organism."[5] Though Verzutti's work resonates with aspects of Neo-Concretism (as well as Tropicália), curator José Augusto Ribeiro has noted that her "relationship with previous art is not resolved in a pure and simple citation … references to art history are open and prospective, affective and analytic in a single blow."[6] Certainly, Verzutti's semi-abstractions exhibit none of Neo-Concretist Lygia Clark's early geometrics or her later explicitly participatory works. However, a connection between the two artists is found in their shared location— what Regina Célia Pinto, in her writing on Neo-Concretism, describes as "somewhere between nature and culture."[7]

Many elements of Verzutti's new installation move away from casting in favor of a more explicit veneration of nature through culture. For instance, *Cinco Ovos* (*Five Eggs*; 2013) presents several ovoid forms nestled into a platform of bronze held up by four wedges of mineral stone. This altar, when read alongside the slender vertical rope of *Egg Tower* (2013), makes manifest familiar themes of germination and reproduction previously elucidated by way of process. Still present are the anthropomorphic characters reminiscent of *Pet Cemetery* and the cast vegetation of *Batalha* (2010). The addition of shrinelike presentations as well as objects acting as texts or hieroglyphic tablets, such as *The Book of Gems* (2013) and *Lua* (*Moon*; 2013), augment a sense of ceremonial mystery. Upon entering her gallery one has the feeling of having stumbled upon a site of ritual, composed by way of Verzutti's idiosyncratic sacred geometry.

—Lauren Wetmore

1. José Augusto Ribeiro, *Antonio Malta and Erika Verzutti*, exh. brochure (São Paulo: Centro Cultural São Paulo, 2012).
2. Rodrigo Moura, "Indirectly, Flowers," in *Erika Verzutti* (Rio de Janeiro: Cobogo, 2007), 88.
3. Email to the author, January 9, 2013.

4. Ferreira Gullar, quoted in Frederico Morais, *Neoconcretismo: 1959–1961* (Rio de Janerio: Banerj Gallery, 1984), unpaginated.
5. Regina Célia Pinto, "Quatro olhares à procura de um leitor, mulheres importantes, arte e indentidade" (Four Views in Search of a Reader, Important

Women, Art, and Identity)
(master's thesis, Escola de
Belas Artes, Universidade
Federal do Rio de Janeiro,
1994), 415.

6. Ribeiro, *Antonio
Malta & Erika Verzutti.*
7. Pinto, "Quatro olhares
à procura de um leitor,
mulheres importantes, arte e
indentidade," 415.

JOSEPH YOAKUM

BORN 1890, ASH GROVE, MISSOURI
DIED 1972, CHICAGO, ILLINOIS

Joseph Yoakum, according to official records, was born in 1890 in Ash Grove, Missouri, though by his own account, he was born in 1888 on a Navajo reservation near Window Rock, Arizona.[1] The rest of his life story is similarly unsettled, an admixture of fact and fantasy, memory and legend. Yoakum was a storyteller who claimed to have traveled the world "four times over," crisscrossing North America, Europe, Asia, and Australia as a circus advance man, soldier, train porter, hobo, stevedore, and stowaway. He is said to have started drawing in 1962, when he was in his seventies, after he awoke one night inspired to record a dream of Lebanon. Thereafter, he made one or two drawings a day until his death on Christmas morning, 1972. Some are portraits of people he admired or identified with—the legendary steel driver John Henry, among others—but the vast majority are landscapes: intuitive, undulating scenes composed of sinuous lines, intricate patterns, and preternatural pastel tones. He labeled each of these with geographical and anecdotal details, claiming they were vistas he had glimpsed in his traveling days.

Yoakum, who alternately called himself a full-blooded "Nava-joe" or simply an "old black man," was of mixed heritage: his father was born in the Cherokee nation of Tennessee and his mother as a slave in Missouri, of mixed African American, Cherokee, and French American descent. Captivated by the exoticism of circus spectacles, Yoakum left home as a boy, around 1900, to work as a stable hand with the Great Wallace circus, having received only four months of formal education. He subsequently traveled with the Ringling Brothers and with Buffalo Bill's Wild West show, possibly touring Europe with the latter between 1902 and 1906, and eventually rising to the position of bill-poster with the advance department. After settling back in Missouri around 1908, marrying, and fathering five children, in 1918 Yoakum was drafted into the army and served in

France with the pioneer infantry. His wanderlust revived, he never returned to his family. Through the 1920s, back in the States, he hopped freight trains to various corners of the country and eventually stowed away on a ship bound for Perth, Australia. Once there, he said he found work on cargo ships headed for port cities in India, Singapore, Burma, China, and Japan.

By 1929 Yoakum had settled in Chicago. He remarried and worked a series of odd jobs—including janitor, foundry worker, and ice cream purveyor—until his retirement in 1946, when he was diagnosed with "chronic brain syndrome" (dementia) and admitted to the psychiatric ward at Hines Veterans Hospital. His wife died shortly after he was discharged in 1947, and Yoakum moved into a small South-Side storefront, where he subsisted on a meager veteran's pension. It was there that he was discovered in the summer of 1967, when Chicago State College anthropologist John Hopgood happened past and saw several drawings hanging in the window. Hopgood bought twenty-two drawings for $1.50 to $10 each, and showed them to Rev. Harvey Pranian of St. Bartholomew's church.[2] Soon after, Pranian displayed forty of Yoakum's drawings in the church coffeehouse, where they were seen by local writers, gallerists, and artists such as Leon Golub and Theodore Halkin.

Gallery exhibitions (the first in 1968 at Edward Sherbeyn Gallery in Chicago) and representation followed, but the relationships were uneasy and did not last long. Yoakum was not interested in the art world, and was skeptical of the intentions of most of its denizens, with the exception of the young artists known as the Chicago Imagists—particularly Jim Nutt, Gladys Nilsson, Roger Brown, Philip Hanson, and Christina Ramberg—and their teachers at the School of the Art Institute of Chicago, Ray Yoshida and Whitney Halstead. Attracted by the obsessive, fantastical quality of Yoakum's drawings and his status as a self-taught artist, the Imagists often visited the elderly artist in his studio and amassed some of the most significant collections of his work. In 1969 the Imagists included him in their first museum show, called *Don Baum Sez "Chicago Needs More Famous Artists,"* at the Museum of Contemporary Art, Chicago. Over the next three years, Yoakum was given several solo museum exhibitions, including one in the Penthouse Gallery at the Museum of Modern Art, New York (1971), and another in the "Projects" gallery at the Whitney Museum of American Art, New York (1972). Today his work is usually displayed in the context of folk and outsider art, but he remains an influential cult figure among a devoted cadre of "fine" artists and collectors: an "artist's artist" who created an entire world on his own terms. The *2013 Carnegie International* presents an opportunity to bring his work the broader recognition it deserves, and to widen the frame placed around it.

There is some disagreement as to whether or not Yoakum actually saw all the places he depicted, though the issue is really beside the point. Yoakum was like any seafarer or hobo, returning from the margins of the world and spinning yarns about what he had seen out there: the appeal of the story is in its sensational, almost (but not) impossible-to-believe quality, and the value is in the telling. Like that of other American "visionary" artists—Arthur Dove and Charles Burchfield among them—Yoakum's artwork is more about conveying the essence of nature and experience than it is about accurate description. He was a religious man for whom drawing was a process of

"spiritual unfoldment," a term he adopted from the teachings of Christian Science to describe the way a composition revealed itself to him in the course of its creation. For Christian Scientists, spiritual reality is the only reality and outward appearances are mere illusion; the goal is to see beyond the thing to the truth behind it.

Yoakum's drawings speak to his life and the era in which he came of age, recalling the visual tropes and compositions of posters, travel books, and postcards from the golden age of the railroad and the circus. His landscapes often have an anthropomorphic, double-image quality, in which rock formations take on animal and human features suggestive of the animistic beliefs of the Native American tribes with whom he so strongly identified. But perhaps what makes the drawings so interesting today is not what they say about the artist's particular biography, but the optimism and open, expansive sense of self they express. Yoakum had an experience of internationality and foreignness, discovery and wonderment, that is rare today, and he embraced all he saw—or heard or read about—as his own.

—Amanda Donnan

1. Derrel B. DePasse, *Traveling the Rainbow: The Life and Art of Joseph E. Yoakum* (New York: Museum of American Folk Art, 2001), 4–5. Other sources cite Yoakum's birth year as 1886, referring to another version of the artist's own narrative; but 1890 is, according to DePasse, the year listed on the artist's Social Security and military records. Depasse's book is the most thoroughly researched account of Yoakum's life and work to date, and was my primary resource for quotations and factual information, except where otherwise noted. Other sources include Jane Livingston and John Beardsley, *Black Folk Art in America, 1930–1980* (Washington, DC: Corcoran Gallery of Art, 1989), 163–65.
2. Norman Mark, "My Drawings Are a Spiritual Unfoldment," *Chicago Daily News*, November 11, 1967.

Braddock Carnegie Library
YOUR NATIONAL HISTORIC LANDMARK
A MARK OF THE PAST, A VISION FOR THE FUTURE,
A CENTER OF LIGHT + LEARNING FOR OUR EVERY DAY.

THE BOOK DIVE
A third space designated for used book sales, a cooperative, commercial kitchen, community organizing, connecting, small - scale performances, and sales of goods made in the Neighborhood Print Shop and Bathhouse Ceramic Studio . All proceeds will support the library building.

social/economy/self-guided education

ADULT LIBRARY CIRCULATION
Central circulation, has a diverse selection of books, periodicals, audio visual, public computers, as well as informed and helpful library staff connecting patrons to resources and resources to patrons.

LIBRARY OFFICE

ART LENDING COLLECTION
An international collection of artworks available for public circulation.

respect/inquiry/lifelong learning/resource development

INFORMATION EXCHANGE CENTER

A puppet workshop and public lending collection.

PUPPETS FOR PITTSBURGH + ALTERNATIVE LENDING COLLECTION

These collections will expand to include other alternative lending material.

BUILDING MAINTENANCE OFFICE

1st floor

Key:
Existing Use
Planned Use
Visualized Use

basement
BATHHOUSE CERAMIC STUDIO + POTTER'S WATER ACTION GROUP
A teaching and learning fully equipped ceramic studio with a research and design facility for ceramic water filter development.

CAPITAL CAMPAIGN GOALS:
- elevator + accessibility
- energy efficient windows & lighting
- expanded restrooms
- court yard masonry work
- updated heating, air and plumbing systems
- updated security system

Transformazium Proposed floor plan for Art Lending Collection addition to Braddock Carnegie Library 2013

NTER OF LIGHT
CENTER OF LEARNING

LOCAL HISTORY ARCHIVES + LEARNING ROOMS
This space will be open for the public to explore local history and artifacts.

inquiry/self-guided education

THE BRADDOCK ROOM

THE VAN WILLIAMS ROOM
public meeting room

THE KIDS' LIBRARY + TEEN ROOM
A safe & welcoming environment for children to explore, play, socialize, study, create, and learn. The Kids' Library provides a variety of programs & resources.

social/inquiry/self-guided education community education/cultural

THE ROTARY ROOM
This room is for library functions as a space for activities, celebrations and various gatherings. This room is also available for community rental.

social/cultural/ community education

BRADDOCK CARNEGIE MUSIC HALL INTERACTIVE HALL OF CULTURE & LEARNING
The seats & floor are in the process of undergoing renovations improving seating capacity & overall usability while preserving historic integrity.

This space is designated to become a learning center for technology based learning, exchanges and cultural programming. The library will conduct/schedule programming as well as continue to offer the hall as rental space.

social/economy/culture/community education

2nd floor

RESIDENCY & RESEARCH STUDIOS
These rooms will be used as small research rooms as well as studio spaces for the library residency programs.

inquiry/self guided education/cultural

THE NEIGHBORHOOD PRINT SHOP
A teaching and learning, cooperative print and design studio.

economy/inquiry/community education/cultural

THE GYM
Local youth-groups utilize the gym for indoor physical activity. Currently, this is a rental space. The gym is also used for large scale library functions.

social/economy/physical

RESTROOMS

3rd floor

The Neighborhood Print Shop (with Jim Kidd), 2012 Courtesy of Transformazium

Poster for Zoe Strauss apartment talk (July 10, 2012) by Tina Henderson Courtesy of Transformazium

Poster advertising the grand opening of the Neighborhood Silk Screen Studio, 2009 Courtesy of Transformazium

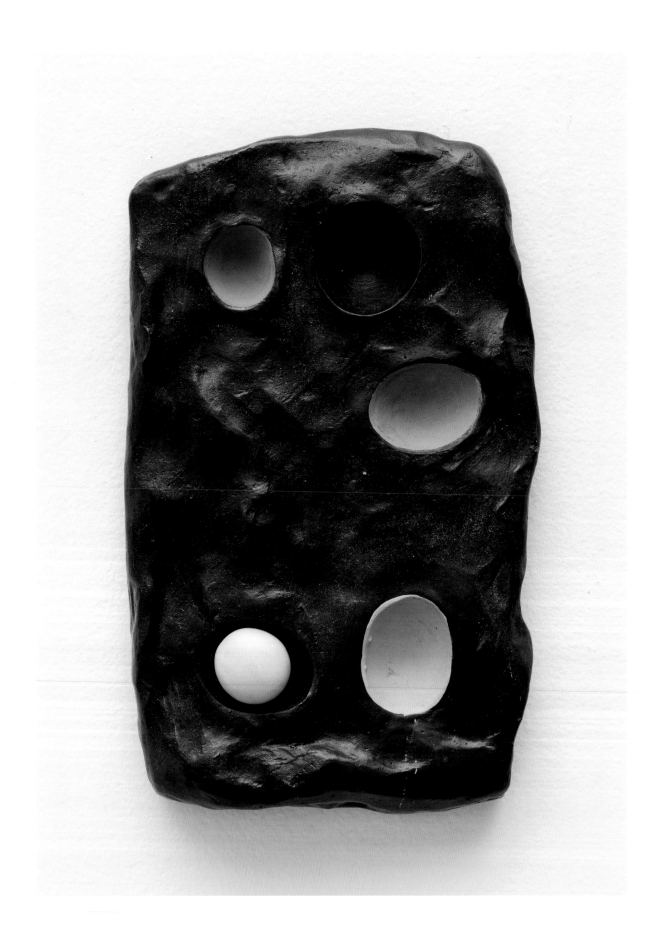

Erika Verzutti *Cinco Ovos* (*Five Eggs*) 2013 cat. no. 254

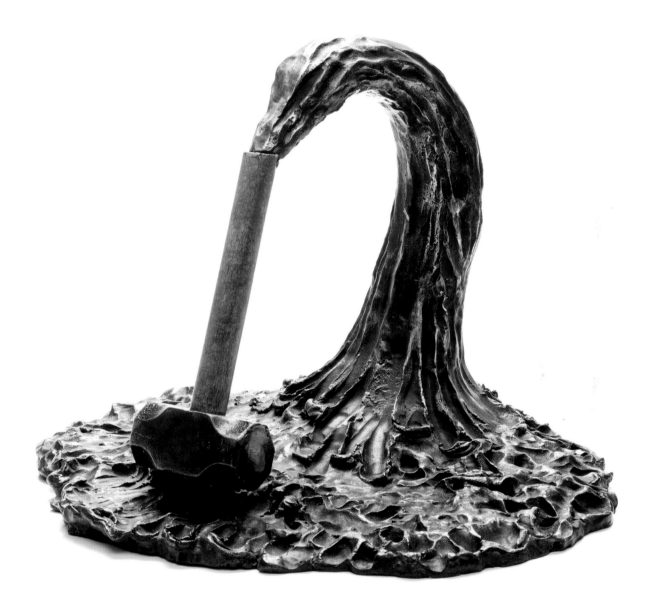

Erika Verzutti *Swan with Hammer* 2013 cat. no. 261

Erika Verzutti sketch of installation for Carnegie Museum of Art's Forum Gallery 2013

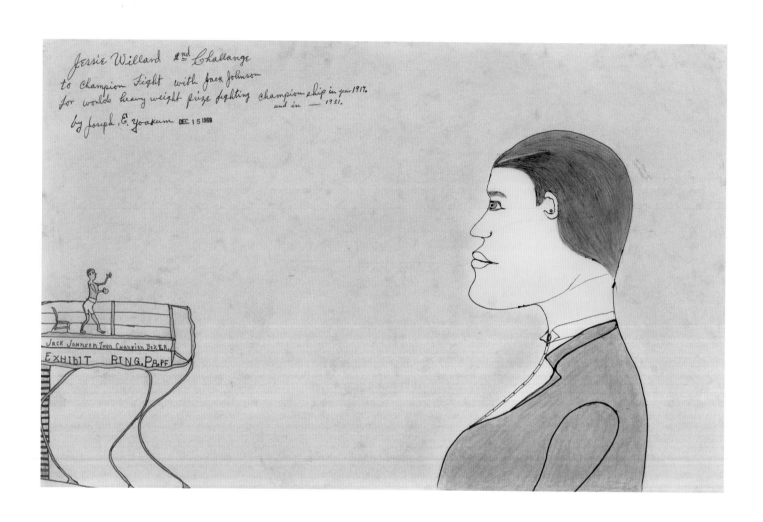

Joseph Yoakum *Jessie Willard 2nd. Challange to Champion Fight with Jack Johnson for worlds heavy weight
prize fighting championship in year 1917 and in 1921* December 15, 1969 cat. no. 299

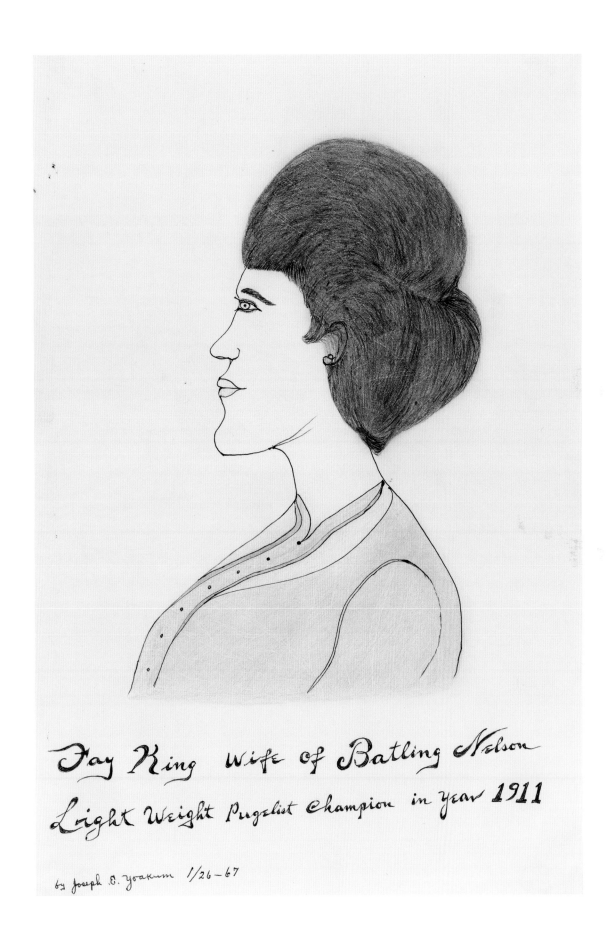

Fay King wife of Batling Nelson
Light Weight Pugelist Champion in year 1911

by Joseph E. Yoakum 1/26-67

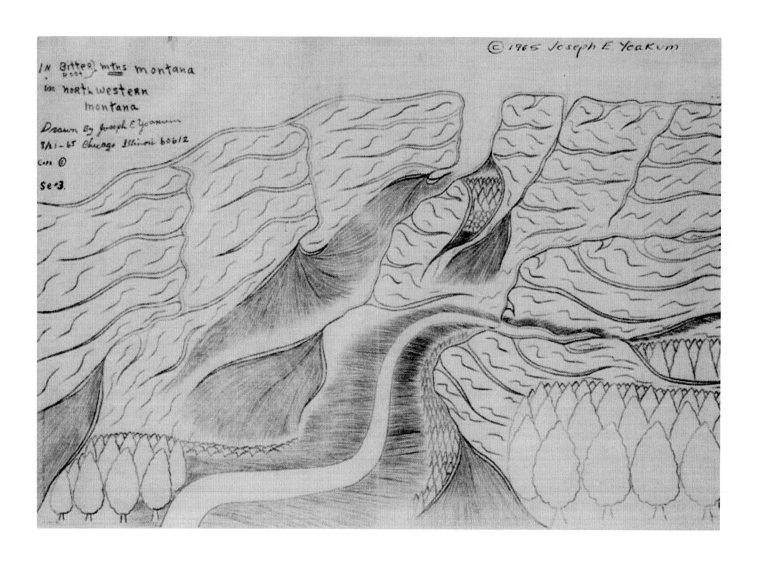

Joseph Yoakum *In Bitter Root Mtns Montana in Northwestern Montana* August 21, 1965 cat. no. 273

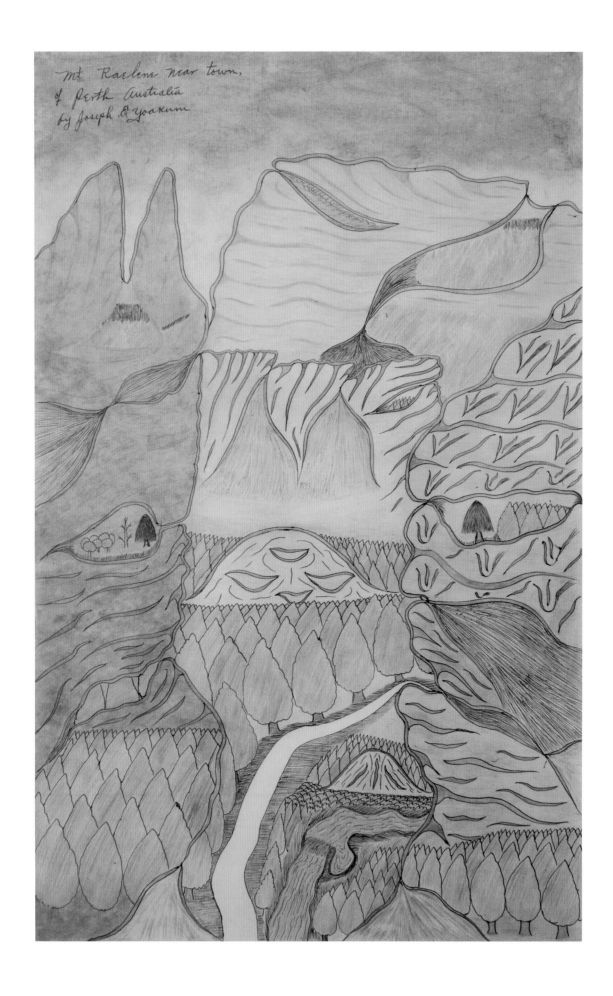

Joseph Yoakum *Mt. Raelene near town, of Perth Australia* n.d. cat. no. 315

Mt Demavend of Elburg Range
nearby Tehran Iran Euro Asia
by Joseph E. Yoakum

Joseph Yoakum *Mt Demavend* n.d. cat. no. 310

INTRODUCTION TO
THE 1961 PITTSBURGH INTERNATIONAL EXHIBITION OF CONTEMPORARY PAINTING AND SCULPTURE
(1961)

GORDON BAILEY WASHBURN

We often doubt if there has ever been a time in the life of man as desperate as ours. Our distress penetrates more deeply than at any previous age because it now includes an almost complete despair of ourselves. From prehistoric times we have struggled to master forces and elements in the external world as though these were the chief enemies to a life of order and happiness. Now we have come to understand that the greater enemy lies within our own nature as men and that, being built in, this opponent can neither be put under control nor expelled. Neither force nor cunning are [*sic*] of any avail, and we are forced to admit, with Sigmund Freud, that no one may consider himself a master in his own house.

This new awareness of our human predicament leaves us enfeebled even in the certainty of our own personal identity, let alone in our ability to fix and hold those aspects of reality that have heretofore seemed to exist as solid facts outside ourselves. To what truth, we ask ourselves, can we give our faith, to what reality offer credence? In this dilemma, we see no position more valid or more heartening than that of the artist. Rejecting the untenable role of "master" in order to work as the servant of his art, he seeks through the mystery of the creative act to find a unity of self that may resolve the apparent hopelessness of this position.

Many naive people have mistakenly thought that our contemporary artists attempt to reflect, as in a mirror, the sense of dissolution and chaos that all but overwhelms us. It is, of course, the contrary that is true. At all times it has been the aim of the creative artist to discover order, not to offer disorder, and today he consciously seeks to uncover this order in the hidden reaches of his innermost self. Of all living men, the artist is the most positive in his action, the most optimistic. Though, like the rest of us, he is skeptical of all conventional illusions relating to permanence, stability, and security, he is still firmly capable of an act of faith in approaching the task of his creation.

In this respect the New York school of *Action Painters* is well named, a work of art being the product of human action—of doing something constructive in a crisis when rationally there is "nothing left to do." Today, such performance of trust is one of the most serious human actions that is possible: the artist's claim of a self-contained unity by means of images drawn from within. Moreover, thanks to his moments of achievement, we who contemplate his art are allowed to share in these acts of self-recovery or self-realization. The evidence of his integrity, when he succeeds, assures us of the existence of our own, the wholeness of his imagery declaring—dare we claim it?—the reality of an inner or spiritual order.

Good works of art have always given men this assurance, but in our time confidence in ourselves and in all of our long-accepted attitudes has been so deeply shaken that we have been forced to employ other creative approaches. Discovering no clear picture of the self or the non-self (our inner and outer worlds having become equally elusive) we have lost faith in all historical positions. It has sometimes seemed as though we must start anew, with scarcely any help from the past. So it is that our art has had to encompass our new attitudes towards ourselves, each individual coming to terms as best he might with those strange and unaccountable forces that press from within, as well as with a physical world that is being totally revised by the development of science and industry.

Our contemporary artists' most universal discovery has been the requirement of a new humility. It is now widely recognized that the achievement of an integrated image will not be dependent upon an artist's calculations, nor yet upon his will. Writes Kazuaki Tamahashi: *An artist should not draw within his powers. He should attempt to draw only what he cannot draw with human powers. Drawing is an action of faith.*

The successful work of art will then seem to reach beyond the limits of his feeble intentions and to have been achieved by the aid of forces that are not his to command. This does not mean that he will have rejected his own intelligence or his technical gifts or that he will not modify through conscious thought what is revealed to him, but rather that he will have found a working partnership with forces that are stronger and truer than all his conscious designs or expectations. Klee, Picasso, Braque, Miro, and dozens of others have all testified in their works, as well as in their comments on them, to the necessity of this inward approach. They have declared that the final work of art could only be invoked or "found," being at best neither anticipated nor foreseen. "The history of the last hundred years," writes the British sculptor, Reg Butler, "suggests that art is increasingly becoming understood as some kind of involuntary, compulsive consequence of the state of being human."

Contemporary submission to "the mysterious centers of thought," as Gauguin called them, is novel only in having developed into a concerted direction of work. Artists of the past, both Oriental and Occidental, have recognized and welcomed these forces of psychic energy within the unconscious, but they have rarely if ever before been given the same oracular importance. New, too, is the willingness of the modern artist, like the modern scientist, to relinquish the world of appearances as his frame of reference. Just as the scientist develops a wholly abstract world of relations in his consideration of the nature of reality, so the artist—as with the late Jackson Pollock—may push abstraction beyond all direct references to the external world. Being himself a part of nature he can never leave his natural state of being, but he can and often does create forms that cannot be understood by an observer seeking references or comparisons between his image and external things. That is to say, his work may be no more or less naturalistic than a scientific law which is expressed in mathematical symbols.

Just as "the physicist used to borrow the raw material of his world from the familiar world but does so no longer," (Eddington) so with the artist, who is now inclined to borrow his images from the unfamiliar world of the unconscious. The producers of Cubist and post-Cubist abstractions still cling to analytic and descriptive elements, that is, to images derived from external forms in nature. But subsequent developments of abstraction are more severely conceived, representing visual crystallizations of psychic states that have been called up to consciousness and to revision. Offering us some aspect of the artist's essential self, the image is a work of self-revelation. In the process of producing it he finds himself an observer of his own performance, the image that develops under his hand being as much a discovery to him as later it will be to us.

Perceiving himself to be an inseparable part of the natural world, the contemporary artist offers himself as an organic medium through which its mysterious forces (though not subject to his command) can reveal themselves. Being part of his own field of perception, he willingly submits himself to the only role that becomes him from this human position. He rejects the vain and willful ego as a false master of the human situation turning instead to revelations of that deeper and more elusive self that has been called the "human spirit."

Thus modern man has sometimes been able to find himself through an artistic activity that reaches around and behind the rationalizing ego and deep into the hidden reaches of the self. It is this unique psyche that he reveals in his art, as directly as he experiences it and with no requirement of signs or symbols taken from the external world to

convey the content. Notes David Smith, the American sculptor, "[My] sculpture work is a statement of my identity."

If faith is a derivative of love, creative art must represent the life instinct opposing the death instinct in the duality of ultimate conflicts. But art at its greatest may go even farther by reconciling this conflict between life and death. For it would seem that when the life instinct prevails, a pressing function of the self is to synthesize and to reconcile. This harmony, the modern painter has discovered, is as much desired by the unconscious as by the conscious mind and may not be achieved unless the two are partners.

We are tempted to conclude, as have others before us, that human beings may find themselves and make their adjustment to the world through art. However, being keenly aware of the ambiguity of the human situation, contemporary artists are less inclined than ever to title their works, knowing no more than the observer what to call things or what, in fact, they are. A work of art like everything else in the world is given to us, and, what is more, it is given without a name.

Originally published in *The 1961 Pittsburgh International Exhibition of Contemporary Painting and Sculpture* (Pittsburgh: Carnegie Institute, Department of Fine Arts, 1961).

Gordon B. Washburn (1904–1983), director of the Carnegie Institute Department of Fine Arts from 1952 to 1962, was a central force behind the *Carnegie International* exhibitions at a crucial moment in the history of the institution. Washburn was global in his interests; his mark on the exhibition ended in 1961 with a particularly memorable spotlight on contemporary revolutions in Japanese art.

FIG. 1
Dijkstraat Playground, Amsterdam, 1954, designed by Aldo van Eyck, Amsterdam City Archives

AN OPEN FUNCTION

TINA KUKIELSKI

The playgrounds designed for children by architect Aldo van Eyck in the mid-twentieth century emphasized oblique angles and nonhierarchical combinations of forms meant to inspire spontaneity, spiraling movements, and meandering. These designs comprising simple blocks in different sizes and shapes for climbing and jumping have been described as "objects that are not anything in themselves, but which have an open function and therefore stimulate a child's imagination."[1] From 1947 to 1978 Van Eyck promoted an urban campaign to transform unused spaces across Amsterdam into public playgrounds (Fig. 1). Of the more than seven hundred playgrounds he designed for the city's public works office, many were built in the interstices between existing structures, and most were site-specific; the focal point was often a sandpit. Van Eyck challenged the deterministic approach to prewar urban planning, which favored large-scale, top-down plans that divided the functions of the city into separate zones. He valued experimentation, education, and play as both freedom and order, and called for a program sensitive to the emotional needs of the city's inhabitants. He has been called a "humanist rebel" for his promotion of human values and his insistence on participatory design.[2] It was in that same spirit that Robert Rauschenberg, in a 1968 speech before a meeting of the New York City Cultural Commission, presented a similar proposal: to build parks that would offer cultural activities in unused public spaces, what the artist called "tent sites" (see pages 229–31). Today, the name immediately conjures the temporary encampments of the Occupy Wall Street movement. That these ideas have had a long arc through art, urban design, and activism of the last half century is not surprising.

How to design as Van Eyck did, with "an open function," became a foundational question for the development of the *2013 Carnegie International* and provided the inflection in the collective voice of three curators. This exhibition began with a shared set of questions about our world, about exhibition making, and about the possibilities of art in our time. Debates ensued. From there themes emerged from the artworks and artists we pursued collectively and with conviction; new directions begot new directions. Together over time—through our conversations, inquiries, and examinations—these themes coalesced. We aspire to the following: that we embrace ideas of play in a serious way, and in terms closely connected to all the beauty and confusion of daily life both in Pittsburgh and beyond; that we give artists a platform—the museum—around which to convene and respond; and that we welcome inquiry and dissent.

As a way to give structure to this (open) system, we looked to Roger Callois (see page 17), the French social theorist who in 1958—while Van Eyck was still building playgrounds—published an influential sociological study of play.[3]

For Callois, aspects of play exist across a continuum with order, discipline, rules, and systems (*ludus*) at one extreme, and tumult, turbulence, improvisation, conviviality, and imagination (*paidia*) at the other. Discipline at the one end, improvisation at the other: these were the contours that were defined, interpreted, and revised in our ongoing conversations—at times consciously, at times not. The established order of a 120-year-old institution guided us, while the stuff of dreams and dissidence excited and incited us.

In the expanding field of contemporary art, curators face a daunting task. Even working as three instead of one, we struggled to locate points on a seemingly endless line of artistic production and distribution that now crisscrosses the globe, and expands via the Internet. It has been said many times before: we live in a world of data overload. To navigate this, we invested in the work of artists, and we let that commitment lead us: from an outsider artist with a delirious eye for worldly paradises, to a documentary filmmaker examining women's rights while under censorship, to a group of sculptors, mostly women, who have each found expressivity in the mundane. Like the Van Eyck playground, the *2013 Carnegie International* embraces spontaneity, nonhierarchy, and play, marked with the intention to depart from the everyday in creative ways. These are the terms alive in the world we see and experience around us, but also in the art that reflects and studies that world. If the artist of today has a mission, artist and writer Frances Stark might come closest to expressing his or her tacit resolve: "to devote [one's] talent to the service of an idea and perhaps lead us towards a better future."[4] The artists in the *2013 Carnegie International* reflect the hybridity, difference, openness, and dissonance we find evident in the cultural identities that make up our world.

THE MYTH OF THE BIENNIAL

The globalization of art in the last twenty years affects an exhibition such as the *Carnegie International* in two ways. One is no longer a surprise: there are more biennials and triennials worldwide than ever before, hence we are only one in an expanding field. It is a common belief today that such exhibitions are symptomatic of globalization made inseparable from capitalistic prosperity. Yet in coming together to work on the *Carnegie International*, we quickly landed upon the following question: why are there so few biennials in the United States? The United States is two and a half times the size of Europe, where there are now more than forty biennials, yet until the recent development of exhibitions such as Prospect in New Orleans and the New Museum's international triennial exhibition in New York, the *Carnegie International* was the only continuous exhibition of its kind in this country.[5] During some

1. Rudolf Herman Fuchs, foreword to Liane Lefaivre, Ingeborg Roode, and Rudolf Herman Fuchs, *Aldo van Eyck: The Playgrounds and the City*, ed. Liane Lefaivre and Ingeborg de Roode (Amsterdam: Stedelijk Museum, 2002), 7.
2. Liane Lefaivre and Alexander Tzonis, *Humanist Rebel: Inbetweening in a Postwar World* (Rotterdam: 010 Publishers, 1999).
3. Roger Callois, *Les jeux et les hommes* (Paris: Librairie Gallimard, 1958);

published in English translation as *Man, Play, and Games* (New York: Free Press of Glencoe, 1961).
4. Quoted in Henriette Huldisch and Shamim Momin, *2008 Whitney Biennial* (New Haven, CT: Yale University Press; New York: Whitney Museum of American Art, 2008), 3.
5. The Solomon R. Guggenheim Museum, in New York, ran its own program called the Guggenheim International every two years from 1956

to 1971. The Whitney Biennial, while predominantly an exhibition of work made in the United States, has in recent years on occasion brought in international artists. Site Santa Fe was inaugurated in 1995 with the mission of hosting an international biennial in the Southwestern United States; it eventually grew to host temporary exhibitions year round and has thus far held eight biennials of varying scope.

FIGS. 3–5
Lawrenceville apartment talks, 2011–13

periods, it barely survived. Does the lack of international exhibitions in this country reflect an avoidance of "First-World protagonism" as posited in touchstone global-view exhibitions such as *How Latitudes Become Forms*?[6] Does the biennial's intrinsic ties with tourism and travel promote its proliferation in Europe but stunt its growth in the United States? Does the lack exemplify an inherent isolationist retreat? These were questions considered early on as we—like an increasing number of our peers today—questioned the myth of cultural homogeneity supported in the rhetoric surrounding mega-exhibitions. As such, this exhibition at times sings polyphonically, but it also performs in discord.

Perhaps less expected is the other trick of globalization. With more biennials promoting a globalizing face and lingua franca for art, the local has ironically assumed new relevance. While globalization leads to more biennials, at the same time it reinforces local identification, instilling new emphasis on destinations, resources, and production closer to home. The danger, as some see it, is that biennials make pathetic or infrequent connections to local bodies and leave little impact on the cultural life of their host cities. Rauschenberg recognized the need for specificity as early as 1968 in that inspiring speech promoting parks: "All cultural activities should, I believe, be dependent on participation and involvement of the inhabitants in their specific localized environment. It is essential to break down the sense of exclusivity, foreignness, and imposed prestige of conventional attitudes about art." Most urgent to us in working on this exhibition were the emerging, rumbling voices from our immediate neighbors. From them we quickly recognized our task—which not coincidentally matched Andrew Carnegie's original decree—namely, to bring contemporary art to Pittsburgh. We tried things out almost immediately; since August 2011 an ongoing program of artist talks and events have taken place in an apartment space at 113 44th Street in the Pittsburgh neighborhood of Lawrenceville; more than seventy speakers have held court there, and shared countless six packs over lively conversation (Figs. 3–5).

In that same way, the *2013 Carnegie International* explores the possibility that the museum itself embodies a micro-history; it is for this reason that we looked to its collection as a backbone for our work as curators. Carnegie Museum of Art's collection is an accumulation of past experiences in concise form; it reflects the legacy of a 117-year-old exhibition in ways few biennial programs can. It names great artists on its roster. Assembled by people, it is admittedly flawed. Yet without this memory, we run the risk of repeating certain blunders. The archival impulse is growing in popularity among artists and curators; that this trend coincides with the global economic crisis of the last five years is worth considering. As curators become more attuned to their own vulnerabilities, economic or otherwise, and more aware of the erratic shifts of past and present, there is a new promise

6. *How Latitudes Become Forms: Art in a Global Age* was organized by Philippe Vergne at the Walker Art Center in 2003. The exhibition was notable as the first in a series of global-view exhibitions at the Walker that also included

Brave New Worlds organized by Doryun Chong and Yasmil Raymond. The exhibitions were notable for an openness to and curiosity about international art, and filling in where American institutions tended to leave off. As Vergne writes in

the catalogue (p. 20), "The minute one pronounces the words global art or global exhibition, one is already part of the problem, positioning oneself as the other, as a First-World protagonist, as a dominant signifier."

FIG. 6
Installation view of the 1961 *Pittsburgh International* exhibition

of transparency for the museum. This is not meant to be a narcissistic exercise.[7] We believe that the museum today is undergoing a redefinition of institutional character and behavior that we acknowledge and support. No longer simply a storehouse for art, the museum is both a hub for new information and a new means of communication. At the nexus of this transformation are new uses, new modes, and new means of production and distribution that welcome new terms for art.

THE CONFUSION OF LIFE

"Into an imperfect world and into the confusion of life [play] brings a temporary, limited perfection."

— Johan Huizinga, *Homo Ludens: A Study of the Play-Element in Culture* [8]

For cultural historian Johan Huizinga, "play" manifests as a social construction, appearing across disciplines and informing activities such as language, myth, and ritual. His 1938 study *Homo Ludens* was influential on Van Eyck's attitudes toward playgrounds and architecture, and inspired Callois's own investigations on the subject.[9] Huizinga's conception of the essential nature of the play

7. See Carlos Basualdo, "The Unstable Institution," *Manifesta Journal*, no. 2 (Winter 2003–Spring 2004): 50–61.
8. Johan Huizinga, *Homo Ludens: A Study of the Play-Element in Culture*, (Boston: Beacon Press, 1950), 7.

9. By some accounts, Callois saw Huizinga's definition of play as too limiting, for Huizinga focused only on the competitive aspects of play, whereas Callois defines play across four separate categories: *agôn* (competition), *alea*

(chance), *mimicry* (simulation or role play), and *ilinx* (balance or vertigo). In other ways, Callois found Huizinga too broad and sought instead to draw distinctions between play and the ritualistic aspects of the sacred.

FIG. 7
Joseph Yoakum, *U.S. Highway #19 From Miami Florida to New York City N.Y.,*
June 21, 1964, cat. no. 267

instinct and its importance to creativity funneled through various manifestations of art in the postwar period, arguably influencing CoBrA, the Lettrist International, and the Situationist International. The widespread influence of these avant-garde groups on post-1960s counterculture extends from outsider art, DIY, and punk rock to Occupy Wall Street and beyond, intersecting with a wide range of artistic impulses today.

Unconnected to any of the art movements of his own time, artist Joseph Yoakum started drawing in the 1950s with the simple desire to record a view of Lebanon, as he had recalled seeing it in a dream vision. Rocks and mountains hug the sky and flowing colorful streams crisscross a landscape made up of sinewy lines that multiply and spread across the page (Fig. 7). Yoakum's dreamscapes are, on the surface, as far away from the postwar avant-garde as they are from Mark Leckey's recent incantations in the digital realm, yet Yoakum and Leckey seem to share a worldview defined by a belief that all substances have divine power, contain a spirit, and breathe with life. For Leckey, "The more computed our environment becomes, the further back it returns us to our primitive past, boomerangs us right back to an animistic world view where everything has a spirit, rocks and lions and men.... Paradoxically cold autistic cyberspace takes us

back to an appreciation of sensuality."[10] Leckey's films and videos *Made in 'Eaven* (2004), circling around the avatar-like form of a digitally rendered Jeff Koons bunny, and the quasi-erotic *Pearl Vision* (2012), a self-portrait in which the artist, never quite in the frame, plays a snare drum, are both beautifully mundane and self-consciously sensual experiences that speak to the way humans live in a world increasingly mediated by technology. Upending our presumed relationship to the electronics and technology that inhabit and share our lives, Leckey's works occupy the space between, where the artist and the object/machine cross over, merge, and dissolve one into the other to become a third thing entirely: a network, a communion, a new being, a new myth (Fig. 8).

Other artists similarly remix the uneventful and the uncanny, as in Frances Stark's prosaic sexual exploits mediated by the culture of the Internet. Stark works in drawing, video, and writing, but is predominantly a text-based artist. The self-reflexivity of language provides a means for her to transmit her role as an artist into the very production of her work; it is in this process that deep feelings of ambivalence and doubt emerge. Pulling back the curtain on a parallel world, we discover a realm where inhibitions cease to exist and sexual innuendos and free-flowing thoughts prevail (Fig. 9).

10. Interview with Lauren Cornell,
"Techno-Animism," *Mousse
Contemporary Art Magazine* 37
(February–March 2013): 55.

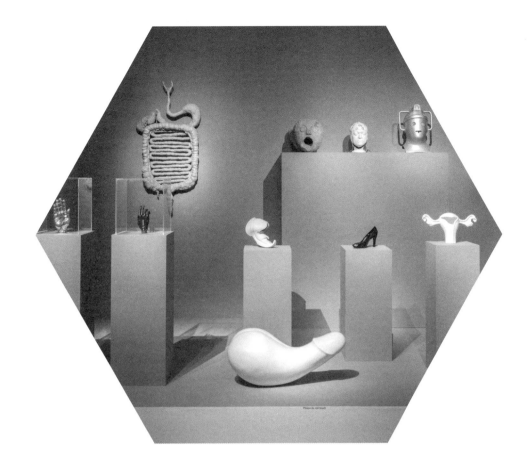

FIG. 8
Mark Leckey, *Universal Addressability of Dumb Things*, 2013, Hayward Touring

FIG. 9
Frances Stark, installation view of *Osservate, leggete con me*, 2012.
Courtesy of the artist and Gavin Brown's enterprise

Nicole Eisenman's inner life is similarly introspective and humorous—sentiments born out in the euphoria and turbulence of her paintings and sculpture.[11] Her works track and digest centuries of classical myth, ancient ritual, and visual history, testing the bounds of what is accepted and what is not, and what is expected and what is not (Fig. 10).

Much of human history is marked by the kind of persistent sexism addressed by numerous artists in the *2013 Carnegie International*. Most insistently, Sarah Lucas humorously plays with the erotic abstraction of the readymade in her feministic sculptural assemblages of found objects and mutated female forms. Chair legs become sexualized, tables turn into torsos, white plastic patio furniture transforms into hanging devices. Lucas's *NUD*s, bulbous abstractions that at once reference Louise Bourgeois's androgynous sculptural lairs and suggest Vincent Fecteau's spherical, cavernous sculptures, seduce with sex, flesh, and suggestive form (Fig. 11).

Androgyny and identity abound in the labored abstractions of Sadie Benning based on drawings the artist made with the quick swipe of an iPhone and then later transformed into hand-built paintings composed of layers of plaster and milk paint. Benning refers to these works as bodily "containers for the 'inside,'" and their sequence and mutation across forty separate panels suggests (human) transformation. Collective transformation is the stuff of Zanele Muholi's classically beautiful black-and-white portraits of lesbians from South Africa and beyond; these faces not only initiate but also insist on reconsiderations of cultural identity in today's world, casting new meaning for a worldview of Africa from both within and beyond its borders (Fig. 12). These are truly works of "self-revelation," to borrow a term from former Carnegie director Gordon Bailey Washburn's introduction to the 1961 *Pittsburgh International* catalogue (see pages 213–15). (His phrase still rings true today, although it is probably fair to say that the art he was responding to bore little resemblance to the work assembled here.) The *2013 Carnegie International* creates a model for making amid the hybridity we find in the world at large. Whatever the truth—knowable or not— these artists find diverse, playful, sensual, and serious ways to repurpose the confusion of life.

FIG. 10
Nicole Eisenman, *Fishing*, 2000, cat. no. 18

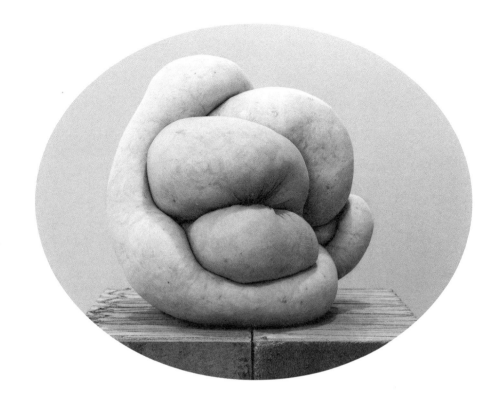

FIG. 11
Sarah Lucas, *NUD 10*, 2009, cat. no. 118

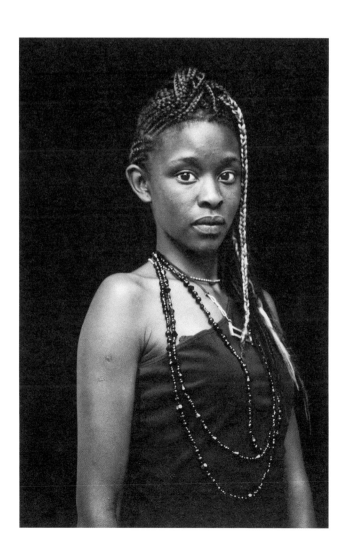

FIG. 12
Zanele Muholi, *Tinashe Wakapila, Harare, Zimbabwe*, 2011, cat. no. 146

FIG. 13
Yael Bartana, still from *Mary Koszmary* (*Nightmares*), 2007, cat. no. 7

Photo : gettyimages

FARS NEWS AGENCY

FIG. 14
Rokni Haerizadeh, selection from *Some Breath Breathes Out of Bombs and Dog Barks*, 2011, cat. no. 77

THE DISCIPLINE OF DISSIDENCE

"The Constitution does not guarantee us only the right to be correct, we have a right to be honest and in error. And the views that I have expressed in the pamphlet I expressed honestly. I believe they were right. The future will show whether or not I was correct, but under the laws, as I understand it, and under the Constitution, as I understand it, every citizen in this country has the right to express himself ... on public questions."

— Scott Nearing, *The Trial of Scott Nearing and the American Socialist Society* [11]

Joel Sternfeld, known for his series of images of utopian communities in the United States, photographed Scott and Helen Nearing in 1982, when the idea for his larger project was just beginning to take shape in his mind. By then, the Nearings were aging homesteaders famous for authoring *Living the Good Life* (1954), a guide that advocated a simple life of labor and leisure, rather than one motivated by monetary gain. Back-to-the-landers of the 1960s applied the Nearings' alternative theories throughout the United States, especially in New England, where the couple eventually settled. As early as 1915 Scott Nearing was already well known for having been fired from teaching economics at the University of Pennsylvania after an incendiary Marxist-inspired critique of capitalist wealth. In 1919 he defended himself in court against charges that he had obstructed military recruitment by disseminating a pacifist pamphlet in and around New York City. Sternfeld visited the couple some sixty years later, one year before Scott Nearing died at the age of one hundred. Nearing's wisdom as a young man is a timeless decree that demands repeating as a mantra indispensable to art. Artists today have the right to be honest, whether correct or in error.

Kamran Shirdel's film *An shab ke barun amad* (*The Night It Rained*; 1967–74) tested those waters in 1960s Tehran (Fig. 15). The film was commissioned to document a well-known story involving a young village boy who purportedly saved a 200-passenger train from a crash one rainy night when a flood washed away a segment of track. Shirdel traveled to the village of Gorgan to investigate the lore for himself and interview the supposed hero everyone was talking about. Piecing together the course of events as told from opposing viewpoints, Shirdel's film is both comic and serious, and delightfully full of contradictions. Everything hangs in the balance, and eventually we acquiesce; finding any real truth is impossible. *The Night It Rained*, like most of his other films, was confiscated and banned until 1974, when it was shown once in a film festival in Tehran, and subsequently banned again until after the Iranian Revolution. Shirdel's circumstances, working under the Shah's authoritarian rule in the 1960s and 1970s, represent an extreme, but his motivations are shared by many other contemporary artists. As Martha

Rosler, always a savvy commentator on our present moment, has noted, "Artists have the capacity to condense, anatomize, and represent symbolically complex social and historical processes." [12]

This assured ability to anatomize complexities holds true in the projects of a number of artists who take on some of the boldest, broadest, and most controversial topics of our day: from Pedro Reyes's wondrous mechanical instruments transformed from decommissioned weapons; to Taryn Simon's taxonomy of power, sexism, wealth, and weaponry in a series of photographs documenting the James Bond franchise; to Yael Bartana's films on cultural and religious displacement and the search for belonging (Fig. 13). Dinh Q. Lê's film *Light and Belief: Sketches of Life from the Vietnam War* (2012), told in an illuminated and illuminating documentary style that takes up the perspective of the Vietnamese soldiers, reanimates a now rather distant conflict whose repercussions are felt to this day.

Iranian artist Rokni Haerizadeh addresses the most pressing social phenomena of our day as he witnesses their broadcast on television, on YouTube, and in print from his home in exile in Dubai, zeroing in on violence, protest, and ritual as chronicled by the media (Fig. 14). He questions our complicity as disengaged spectators both of atrocity, as occurred during the Iranian demonstrations in 2009 or the more recent Arab Spring uprisings, and of spectacle, as with the media obsession surrounding the British royal wedding in 2011, watched by tens of millions around the world. One short animation by Haerizadeh is composed of thousands of beautifully bizarre drawings of fictitious worlds full of surreal mythic creatures—part human, part animal—fighting for survival, food, and sex. As mirrors on the personalities that we simultaneously fawn over and fight against, Haerizadeh's character-filled dramas express a harsh, complex, and exuberant planet.

These artists engage in the retelling of social histories as they truly are, as discursive systems susceptible to the fluctuations of time, experience, and belief. Fact and fiction merge and cross over; contradictions abound; success and failure are fantasized, played out, and abandoned as terms in and for themselves. The bold, brave dissidence of such artists is continuous, and assuming we grant its safe passage—correct or in error—it will forge the way to a better future for all.

11. Quoted in Joel Sternfeld, *Sweet Earth: Experimental Utopias in America* (Göttingen,

Germany: Steidl, 2006), 36.
12. Martha Rosler, "Take the Money and Run? Can Political and Socio-

Critical Art 'Survive'?," in *What Is Contemporary Art?* (New York: Sternberg Press, 2010), 134.

FIG. 15
Kamran Shirdel, still from *An shab ke barun amad* (*The Night It Rained*), 1967–74, cat. no. 186

PROPOSALS FOR PUBLIC PARKS
(1968)

ROBERT RAUSCHENBERG

You can't bring culture to people, you can only bring it out of them.

In time of change and crisis, the most important element is the people themselves. Therefore, I believe that all cultural activities should be designed to encourage the personal initiative and sense of responsibility in each individual, thereby creating and inspiring a sense of personal dignity, self-respect, and community spirit. All cultural activities should, I believe, be dependent on participation and involvement by the inhabitants in their specific localized environment.

It is essential to break down the sense of exclusivity, foreignness, and imposed prestige of conventional attitudes about art. The already existing cultural resources of the city should be utilized to develop a sensitivity that is essential to an understanding of art and to a basic revitalization of the senses, which leads to an awareness of the possibilities for enriching one's own private life.

Being imprisoned in the limitations of possibilities breeds a boredom more dangerous than rats. Tolerance of limitations manufactures hostility and resistance, promotes rivalry, and encourages class consciousness. Projects should be directed toward a sense of expanding possibilities rather than to an adjustment to limitations. One is static and negative; the other is active and positive.

Fundamental ideas, as opposed to sophisticated ones, encourage curiosity, counteract boredom, and destroy the cultural separation of the neighborhoods from the city as a whole. Some projects which accomplish this are:

1.

To utilize existing available spaces within the neighborhood, such as unused movie houses, supermarkets, drycleaning establishments, and empty lots which can function as tent sites; they should be converted even temporarily into cultural centers, employing local professionals and volunteers for the conversion.

Renovations should profit the economic structure of the neighborhood. A representative from the community can be appointed to manage and coordinate local needs and outside invited activities. Using neighborhood facilities and people will avoid patronization and intimidation. It will also change the residents' attitude toward the neighborhood without rebuilding. Space should be made available for activities of social groups as well as being used for exhibits and performances by either professionals or aspiring locals. These centers could function as a headquarters for future plans and activities which the Committee deigns worthwhile.

2.

In each neighborhood select an outdoor wall site to be whitewashed and utilized as an outdoor slide-projection and movie screen. Projectors can be placed in appropriate spaces in hallways or apartments. Suggested uses are: movies from all sources including home movies; it may also function as a community bulletin board to communicate official and personal information such as church and social events, weddings, births, seasonal events, news, art education, or decorative patterns. It could be possible to work with Kodak, Polaroid, and TV studios to initiate photography, film, and television projects in the neighborhood to be used for wall projection. The variations from evening to evening, transforming the building, will stimulate and provoke a fresh view of the neighborhood.

3.

Trucks containing botanical gardens, creating total environments of a particular region, with the Museum of Natural History cooperating to provide sounds and animal life of the area, can travel from neighborhood to neighborhood. Related activities are:

a. Distribution of seeds, plants, and earth.
b. Door-to-door houseplant calls, giving advice and information on how to cure and care for personal plants and gardens.
c. Investigate the area for the possibility of making and constructing a community garden or gardens and instructing interested people in how to maintain them.

4.

Portable swimming pools, either inflatable or adjusted trucks. Related activities are:

a. Swimming and life-saving lessons, water choreography, and pure pleasure.
b. Hose play with existing fire hydrants and hoses to create spontaneous fountain sculptures.
c. Cooperate with nozzle manufacturers to invent adapters to attach lawn sprinklers and hoses directly to fire hydrants to turn the whole street into a water garden.

5.

Establish a center maintained by technicians to aid, instruct, and supervise local residents in repairing common appliances, such as TV sets, toasters, irons, radios, fans. Inquire in the neighborhood or from outside sources for donations of appliances which are defunct, which become the property of the person who repairs it. This encourages community contact, takes advantage positively of the waste, and promotes voluntary job training.

6.

A truckload of "dress-up" clothes and costumes with musical instruments which can be given away to invite responsive activities. It is suggested that volunteers from theatre, dance, music, and other performance arts accompany the truck and encourage direction when necessary.

a. Parties, plays, performances, and events can be videotaped to be shown after dark.
b. Polaroid photos taken of families, groups, and friends celebrate and document the day.

7.

Animals, domestic and exotic, can be brought into the neighborhood for direct contact and familiarization, such as: cows to be milked, sheep to be shorn, horses to be ridden, snakes to be handled, and, if possible, elephant rides.

Related activities are:

a. House-to-house calls by volunteer veterinarians to give aid, advice, and treatment to animals, birds, and fish.
b. If conditions allow, fence off an area for a local zoo to be maintained by interested volunteers in the neighborhood with supervision by experts from local zoos which would also be responsible for supplying the beasts.

Presented at a meeting of New York City Cultural Commission, Spring 1968
at 381 Lafayette Street, New York City
Published in *TECHNE* 1, no. 1 (April 14, 1969): 12.
Reprinted courtesy of Experiments in Art and Technology.

Robert Rauschenberg (1925–2008) was one of the most important American artists of the twentieth century. Influential in painting, assemblage, sculpture, and installation, he was an inventive cross-disciplinary collaborator who played a key role in the formation of a uniquely American avant-garde originally centered around Black Mountain College. A committed activist, Rauschenberg founded Change, Inc., and the Robert Rauschenberg Foundation to provide resources and support to artists in need.

6.

A truckload of "dress-up" clothes and costumes with musical instruments which can be given away to invite responsive activities. It is suggested that volunteers from theatre, dance, music, and other performance arts accompany the truck and encourage direction when necessary.

a. Parties, plays, performances, and events can be videotaped to be shown after dark.
b. Polaroid photos taken of families, groups, and friends celebrate and document the day.

7.

Animals, domestic and exotic, can be brought into the neighborhood for direct contact and familiarization, such as: cows to be milked, sheep to be shorn, horses to be ridden, snakes to be handled, and, if possible, elephant rides.

Related activities are:

a. House-to-house calls by volunteer veterinarians to give aid, advice, and treatment to animals, birds, and fish.
b. If conditions allow, fence off an area for a local zoo to be maintained by interested volunteers in the neighborhood with supervision by experts from local zoos which would also be responsible for supplying the beasts.

Presented at a meeting of New York City Cultural Commission, Spring 1968
at 381 Lafayette Street, New York City
Published in *TECHNE* 1, no. 1 (April 14, 1969): 12.
Reprinted courtesy of Experiments in Art and Technology.

Robert Rauschenberg (1925–2008) was one of the most important American artists of the twentieth century. Influential in painting, assemblage, sculpture, and installation, he was an inventive cross-disciplinary collaborator who played a key role in the formation of a uniquely American avant-garde originally centered around Black Mountain College. A committed activist, Rauschenberg founded Change, Inc., and the Robert Rauschenberg Foundation to provide resources and support to artists in need.

FIG. 1
Bedford Stuyvesant Superblock, Brooklyn, New York, 1968, designed by M. Paul Friedberg in collaboration with I. M. Pei & Partners. Courtesy of M. Paul Friedberg

PLAY IT AGAIN, MUSEUM

DANIEL BAUMANN

THINK OF THE MUSEUM AS A PLAYGROUND

I know it's difficult. Museums weren't exactly built to play this role, but rather to conserve and construct history—hence their thick walls. Museums still conceive of themselves as spectacular citadels of knowledge, celebrating the triumph and perfection of the educated citizen or the successful self-made man, or both. This is certainly true for Carnegie Museum of Art, founded in 1895 by Andrew Carnegie, a poor boy from Scotland who became one of the richest men of the early twentieth century. Many museums are lasting symbols of this type of individual success, aimed at preserving for posterity a sense of achievement gained through hard work, education, taste, and capitalism (or authoritarianism).

Even as they are built on ambitions of permanence and preservation of the past, museums need to adapt to new times. It is sometimes a painful and challenging process, particularly in the last fifty years, as more and more people started to claim their right to inclusion and pushed museums to acknowledge and adjust to the realities taking place in the larger world outside. Although democratization and the broadening of audiences have always been concerns for museums, institutions sometimes struggle in the face of such pressures to stay relevant in a changing world. Add to this the ever-increasing competition among thousands of museums, galleries, and events globally, all fighting for our attention, not to mention the nonstop demands of the digital era (can we please have museums filled with spectacle, binary codes, and no memory?), and it's a wonder that museums continue to research, conserve, and collect at all.

When Dan Byers, Tina Kukielski, and I began planning the *2013 Carnegie International* in 2010, this was the state of the world we faced. So we embraced our future and decided to build a playground. It had to be outside the museum, next to the entrance on Forbes Avenue, to give a strong message from the street that something exciting was taking place inside and to offer kids a chance to let off steam before having to walk through an exhibition with their parents (Fig. 2). The playground set a tone and led us to adopt play as a model for our behavior and thinking as we figured out how to collaborate among ourselves—and with the institution. Play is generous. It encourages a freedom to invent, change, subvert, and establish rules, and it allowed us to lose control, take a break, and come back again. The playground, on the other hand, presented itself as a precise yet liberating metaphor for the museum itself. Both are imagined locations that empower people to have both physical and intellectual experiences; both are defined spaces in which objects are installed within a given framework; both are important actors within the public space of a city; and both are dedicated to education and building communal moments. And, notably, both cherish the idea of risk, whether it is a transgressive picture or dangerous performance put forward by the avant-garde, or the prospect that somebody might fall from the heights of a jungle gym.

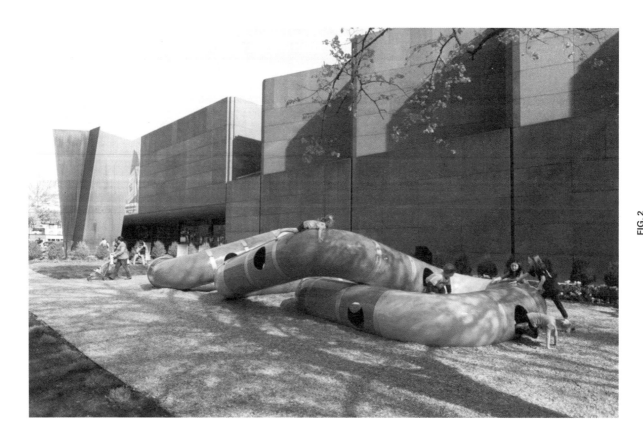

FIG. 2
Lozziwurm play sculpture, 1972, designed by Ivan Pestalozzi, installed at Carnegie Museum of Art, 2013

234

FIG. 3
Alvin Rosensweet, "Sculptor Refuses $1,000," *Pittsburgh Post-Gazette*, November 1, 1961. David Smith rejected his third-place prize in the 1961 *Pittsburgh International*, frustrated with the "archaic system of awards."

Calls Award System 'Archaic'

Sculptor Refuses $1,000

By ALVIN ROSENSWEET
Post-Gazette Staff Writer

David Smith has turned down third prize of $1,000 for his metal sculpture, "Zig IV," in the International art exhibition here because he does not approve of what he calls an archaic system of awards.

"I'm opposed to the system of first, second and third prizes," Smith said yesterday from his home at Bolton Landing, N. Y. "I hope Carnegie Institute will apply the $1,000 toward an art purchase for the Museum."

Smith said he rejected the award in a letter he wrote last Friday when he was at Carnegie Institute for the opening of the International. The letter was addressed to the fine arts committee of the board of trustees of Carnegie Institute.

Sincerity, Not Pique

"I just chose not to accept the prize," Smith said yesterday. "My letter was written in all sincerity, not in pique."

Smith said he had been busy getting ready for three shows, including his one-man show in connection with the International.

He said he had intended placing "Zig IV" in his one-man show, which is not in the competition for awards. But it was too big to go through the doorway of the gallery; so he entered it in the International.

"Then I got busy and forgot to withdraw it," Smith said. "The next time I enter anything at the International I'll indicate that it is not to be for competition."

Smith, 55, a native of Decatur, Ind., has worked as a riveter and as a welder of tanks and locomotives in a defense plant during World War II. He is considered a pioneer and innovator in constructing direct metal sculpture.

Title Origin

The title, "Zig IV," comes from ziggurat, a temple tower of the ancient Babylonians.

"It is presumed to be a shrine, reaching toward the skies, with man elevating himself," Smith explained. "The title has an affectionate reference for me. Zig is a nice, handy little name."

"Zig IV" is priced at $45,000. His ten sculptures in the one-man show are priced at from $21,000 to $50,000 each. None has been sold so far, Smith conceded.

Smith said he had no fuss with the jury for picking Alberto Giacometti's "Man Walking" for the first sculpture prize of $3,000 or George Sugarman's "Six Forms in Pine" for the $1,500 second prize in sculpture.

Wants System Abolished

"I don't acknowledge that one artist is better than another," he said. "It's kind of an arbitrary decision, an old-fashioned idea not in keeping with my ideas of democratic principles. I'd like to see the prize system abolished."

He feels, Smith said, that the costs of jury travel and other expenses of the award machinery can be more honorably extended to the artist by purchase.

DAVID SMITH
He doesn't like awards.

He praised Giacometti as a "master," who should have won a prize 20 years ago.

Smith said it's the prerogative of Carnegie Institute to present cash awards but he said that he feels that so many artists are outstanding they should be given equal awards.

Gordon Bailey Washburn, Carnegie Institute director of fine arts, who selected the works on display at the International, didn't want to say anything about the controversy. Although he had known about Smith's rejection of the award since last Friday, Washburn kept quiet about it.

"We'd rather not have it publicized," he observed.

Opposed for Years

Sculptor Smith said he has been opposed to the idea of first, second, and third prize awards for a number of years. He said he was chairman of a panel of artists and museum directors in Woodstock, N. Y., who held a meeting to discuss prizes and awards for an exhibition.

"The artists were all against the idea of prizes," Smith recalled yesterday. "After they finished, Dr. Henry Francis Taylor, who was then president of the Metropolitan Museum of Art, made an eloquent address in favor of the award system.

"He said it all goes back to the days of ancient Rome when prizes were given for virginity."

Smith said that "everybody laughed like hell." Then Arnold Blanch, the painter, raised his hand and asked:

"Would the last speaker care to qualify conditions for the second and third prizes?' "

"That broke up the meeting," Smith observed.

He's been opposed to awards ever since.

PITTSBURGH POST-GAZETTE: WEDNESDAY, NOVEMBER 1, 1961

This is "Zig IV," which won $1,000 prize, now rejected.

EPISTOLARY AFFECT AND
ROMANCE SCAMS
Letter from an Unkown Woman*
(2011)

HITO STEYERL

Her name was Esperanza. A thirty-five-year-old Puerto Rican woman running a construction business and nurturing a great passion for humanitarian ventures. Sadly, her husband had died two years ago. She sent pictures of herself and her little daughter via the online dating platform Match.com in Feb. 2007.1

At first, Fred responded casually to her letters. But then, he suddenly found himself falling in love with her.

A few months later, he told his family that he was going to leave his wife and their children to live with Esperanza. When his mother asked him if he had ever met her, his answer was no. He'd meet her, in time. By now they were calling each other and chatting. She had canceled their first meeting at the last minute. He had waited at the airport, flowers in hand, trembling more with fear than anticipation.

Looking back, he couldn't understand how he could not have known. She wouldn't turn on her webcam while chatting. One technical problem followed another; communication was ruptured by unannounced sudden meetings. But on the other hand she never asked for money either. Until the day she died.

An official called him from the U.S. embassy in Denmark, where she had traveled on business. She had accidentally been killed in a random shootout between rival gangs.

It was the worst day in Fred's life.

He transferred money to repatriate her body. He was numb with shock. Nothing mattered. None of the multiple problems that arose in the process mattered. He decided that he wouldn't go see her. He couldn't face the idea that their first date would be after her death.

The end of the story was sudden. His friend did research online. No American citizen had been killed in Denmark lately. There had been no shooting. Esperanza had never existed. She was the creature of a group of scammers.

http://www.romancescam.com/forum/viewtopic.php?f=l&:t=19587&start=15-p95537 by dxxx on Fri Jun 05, 2009 12:02 pm
CXX

I hope you realize there is no doubt that this is a scammer. As soon as he sent you a Photoshopped stock photo, it was confirmed beyond a doubt. I will treat it as if you are dealing with a female, but many of these elements may be handled by a male. Although certain elements are always the same with scammers (after all, the ultimate goal is the same—to get your money), there is a variety in other elements. Most scammers we see go for volume and speed—they get their fake profiles out there, approach as many people as possible, and move to the money stage with all of them quickly. This approach is going to lose more people quickly, but since they are (or at least want to be) targeting lots of people at once, they are still making money, even if it is only a couple hundred dollars per victim.

Other scammers opt for a more organized, long-term approach. These are the more skilled scammers, and in my opinion the most dangerous. They will spend lots of time on a

particular victim. (...) These "better" scammers are much more aware of IP-address issues, and are more likely to admit to their location or hide behind a proxy to ensure that they do not lose their victim to that simple mistake. If you watch closely, they do make mistakes— but they are generally much harder to spot. (...) Sending a picture without wiping out the EXIF data that shows it is from 2002 was a much more subtle mistake, and the majority of victims would not catch it. (...)

http://www.romancescam.com/forum/viewtopic.php?f=1&t=19587&sid=17266b953
7f5462100007720al96b4c0 - p95509
by dxxx on Fri Jun 05, 2009 4:57 am

(...)

xmlns:tiff = "http://ns.adobe.com/tiff/l.0/"
xmlns:exif = "http://ns.adobe.com/exif/l.0/"
xap:CreateDate = "2002-05-07T11:00:16+05:30"
xap:ModifyDate = "2002-05-07Tll:00:16+05:30"
xap:MetadataDate = "2002-05-07Tll:00:16+05:30"

See something odd there?

EPISTOLARY AFFECT

On a recent trip to Bangalore, I found myself saying something I didn't fully understand. During a public discussion, Lata Mani, the respected feminist scholar, had asked me about the sensorial, the affective impact of the digital. I answered that the strongest affective address happened on a very unexpected and even old-fashioned level: in the epistolary mode. As a brush with words divorced from actual bodies.

Digital writing—by email or chat—presents a contemporary complication of historical practices of writing. Jacques Derrida has patiently described the conundrum of script: its connection to absence[2] and delay.[3] In this case, the delay is minimized, but the absence stays put. The combination of (almost) real-time communication and physical absence creates something one could call absense, so to speak. The sensual aspect of an absence, which presences itself in (almost) real time. A live and lively absence, to which the lack of a physical body is not an unfortunate coincidence, but necessary.

Its proxy is compressed as message body, translated into rhythm, flow, sounds, and the temporality of both interruption and availability. None of this is "virtual" or "simulated." The absence is real, just as is the communication based on it.

http://www.romancescam.com/forum/viewtopic.php?f=l&t=8784&start=150

Re: scammers with pictures of Mxxxx QT
By axxxxxxs on Wed Jan 26, 2011 8:05 am
This is a private IP address and cannot be traced.Hostname:
10.227.179.xxx
dont see any problem in meeting, i do believe in meeting and seeing is believing, i can change my flight to you if you wish to meet, i dont see any problem changing my flight to

you, tell me how you think we can meet, meeting and seeing is believing to me and id otn
care of age and location, what is the name of your closest airport, i can call the airline now to
ask for flight changing possibility
This is a private IP address and cannot be traced.

Im cool baby, how are you doing today?
Sent from my BlackBerry® wireless device

Do you still want to meet up with me baby?
I dont have msn

do you want to meet me baby?
Whats the name of your airport baby?
Give me like 1hour baby

Baby, do you live alone? Tell me about your travelling experiences baby Sent from my
BlackBerry® wireless device
(...)
Im at the airline getting the ticket done Sent from my BlackBerry® wireless device

Honey, im done with the ticklet and i'll email you in like lhour with the scan copy of the
ticket baby Sent from my BlackBerry® wireless device
sending it nwo now baby
Honey

DIGITAL MELODRAMA

In 1588, a scam with the romantic title "Spanish Prisoner" was launched for the first time.
The scammer approached the victim to tell him he was in touch with a Spanish aristocrat who
needed a lot of money to buy his freedom from jail. Whoever helped him would get rich
recompense, including marrying his daughter. After a first installment was paid, new difficul-
ties kept emerging until the victim ended up broke and impoverished.

In the digital era, this plot has been updated to resonate with contemporary wars and
upheaval. Countless 419 scams—the number refers to the applicable penal-code number
in Nigerian law—rewrite daily catastrophe as entrepreneurial plotline. Shock capitalism
and its consequences—wars over raw materials or privatization—are recast as interactive
romance or adventure novels.

You too may have received a letter from an unknown woman—as Max Ophüls's 1948
classical melodram title had it. In Ophüls's film, a Viennese girl posthumously confesses her
unrequited love in a letter. It recounts every detail of her relentless passion for a concert
pianist who barely noticed her existence.

In the contemporary digital version, letters from unknown women emerge from all over
the globe, afflicted by tragedies personal and political. A cacophony of post-postcolonial
tragedies, diluted with generous servings of telenovela. Widows and orphans get swept up by
financialized hypercapitalism, natural disaster, and assorted crimes against humanity—and
it's you who are destined to sort out their fates.[4]

Basis	%
air crash	35
car accident	13
tsunami/earthquake	3
coup	22
over-invoiced	16
undisclosed	11
Sender	%
lawyer	35
widow	31
child	10
bank officer	24

*Source: http://www.caslon.com.au/419
scamnote.htm*

Romance scams offer windfalls of love and opportunity, casually asking for bank-account numbers and passport copies. Flight schedules are mixed with instructions for transfer of funds and serially sampled professions of love. Modules of sensation are copy-pasted, recycled, ripped. But despite their obvious mass production, these are "the only form(s) of tragedy available to us," as Thomas Elsaesser said about the melodrama.[5] They drop into mailboxes unsolicited, and suddenly expose themselves to the open.

TRAGEDY AS READY-MADE

The genre of melodrama departs from impossibility, delay, submission. It addresses the domestic, feminized sphere. The so-called weepie was a genre that was underrecognized and safely kept apart from cinema-as-art for decades. It was suspected to perpetuate oppression as well as female compliance.

Yet the melodrama also voiced perspectives that were repressed and forbidden, views that couldn't be expressed anywhere else and remained deprecated, shameful, and dismissed. Over-the-top exaggeration and exoticization opened possibilities to imagine something different from the drab repetitiveness of reproductive labor. Melodramas concoct implausible tales of cultural encounter, racial harmony, and happiness narrowly lost in miscommunication. They insist that the political is personal— and thus trace social histories from the point of view of sentiment.[6]

But their new personalized digital versions are produced differently. They are no longer just one-size-fits-all Taylorist studio-based productions, but customized products.

248

These messages are not only posted but perhaps even post-ist. Post-isms are a symptom of a time that considers itself to be posterior and secondary, a leftover of history itself. They assume a general overcoming of everything without anything new to replace worn-out worldviews.

But there is a dialectical twist to this post-dialectical condition. Post-isms conserve the issue they are distancing and claim to have overcome it. Indeed, it is impossible to define any of these terms—post-Marxism, poststructuralism, postmodernism, etc.—without recourse to the terms they claim to have left behind. Distance is achieved despite intimate closeness, or maybe even precisely because of it. The co-presence of proximity and distance is inherent to the structure of the prefix "post" itself. "Post" connotes a past, whose meaning is derived from spatial separation. In their earliest versions, the roots of the prefix refer to "behind, after, afterward," but also "toward, to, near, close by"; "late" but also "away from."[7] Both closeness and separation, absence and presence, form part of the structural aporia of this term.

Romance scams are intimately related to this timescape of simultaneous presence and absence, incongruously bridged by hope and desire. They also perfectly resonate with an undecided temporality, which synchronizes both closeness and separation, past and present, and refuses to let go of worldviews it no longer believes in.

CONCEPTUAL LOVE

This turn to the digital melodrama and epistolary affect comes somewhat unexpectedly. The world of digital feelings had been imagined more robustly before. None of the rather crude initial ideas about cybersex and the merging of the physical and digital worlds has held much sustainable appeal, though. Datagloves, digital dildos, and other equipment deemed suitable for amorous purposes turned out to be cumbersome embarrassments for an age in which data, feelings, and touch travel lightly.

The popularity of the epistolary address is also based on its blatant availability. Text is a makeshift medium, cheap and cost-effective. No complicated engineering is necessary, nor bulky equipment; just basic literary skills and a terminal for hire at an Internet café.

Perhaps the ready-made language of romance scams also expresses a deeper shift in contemporary practices of writing. In parallel to a visual economy of the blurred and raw, an economy of text has developed, which is in many ways as compressed and abstracted as the rags of imagery that crowd the digital realms. Prompted by the legacy of advertising, a Victorian economy of affect merges with the verbal austerity of the tweet message. It is simultaneously blunt and chaste, downsized and delicate, bold and coy. Compressed and evacuated text allows feelings to fill in the blanks. Hollow words bait, retreat, play. Reduction and withdrawal spark intensity.

http://www.romancescam.com/forum/viewtopic.php?f=l&t=19587&start=45#pl09129
Re: GXXX TXXXX
by xxxxxxxxxxxxxxx on Fri Sep 18, 2009 8:20 pm
Gxxxx now has another email address, gxxxx@hotmail.com, I am trying to get a picture off her but its like trying to get blood out of a stone.

She knows I am trying to build up a new relationship and has said she will now leave me alone at last and just wants to be friends and just some one to write to which I am okay with that.
Cxx

to boot. In his project for the *2013 Carnegie International*, Gabriel Sierra speaks to the space around and among the casts, animating the hall's voids: the walls and platforms that create a framework for the display. Tens of thousands of square feet of walls and pedestals are painted purple, creating an abstraction grafted onto an architectural rendering that simultaneously deflates and ennobles these casts of fragments of the Western world's great buildings across millennia.

Smithson's interest in the museum's voids, its "oblivion," and what Sally Yard describes as the "chasm obscured amidst the chaos beyond the pristine walls"[6] imagines the museum without people. Though it's true that not every gallery or public space is consistently animated (I have experienced my fair share of hushed, empty galleries), I do wonder how we are to reconcile this perception of clinical separation from the world with the actual lived-in, worn, warm, patina-covered spaces of museums. There are scars on the floor from now-removed artworks, smudges between galleries where guards lean, or an extinguished lightbulb. Much of the work in the *2013 Carnegie International* is animated by the life that goes on around the works, by the day-to-day humanness that sticks to galleries and lobbies. That series of confrontations—between the perceived order of the building, the order and program within an artwork on view, and the happenstance of a visitor's encounter—instills life and, on good days, energy into the void.

Tobias Madison, for example, siphons off the human activity and small messes of institutions, incorporating that genially lifted and constantly recycled energy into his multimedia and multiauthored installations. Into the mix of ticket takers, docents, custodians, and Central Catholic School students cutting through the museum, Madison added a group of visiting middle school students from Wilkinsburg. Providing various props, images, and sound-making equipment (enormous aluminum mixing bowls from New York's Chinatown), he worked with the students to make a series of abstract passages for a film, which leaves parts of itself in a sound installation dangling in the huge emptiness of the Grand Staircase, far up on the museum's third floor. The sound fragments seep into the heart of the museum from their sculptural containers.

Mark Leckey skips the human stuff and goes straight to the void, elevating it to high art in its own right. As we take in a 360-degree camera sweep around a reflective, impervious Jeff Koons stainless steel bunny, we don't see ourselves or our surrogate, the camera, but only the shiny surface itself (no doubt very evocative of the oblivion that Smithson kept at bay) (Fig. 5). The ghost (in the 16mm machine) hums and flutters through the digital transfer to film, bringing us, through digital image sharpness and the warm authenticity of the coveted analog projection, close to some feeling of "experience," as we float farther away from an actual experience of an art object in space. Situated in the Museum of Natural History's gallery of gemstones, the animated emptiness of Lecky's imagery persists in the reflections of the faceted gems and mirrors that surround it.

Both Leckey and Madison use the texture of the museum's spaces: in one case, to create a sanitized delirium, and in the other, to open them up to a strangely immersive experience.

Smithson associated the pervasive, anonymous white of museum walls with institutional power and uniformity. Mladen Stilinović's *Dictionary–Pain* (2000–2003) suggests those same associations, yet made more complex. Going through an English (the first iteration was Croatian) dictionary, Stilinović painted every page white except for certain words per page, their definitions painted out and replaced with the word "pain." Art historian Branka Stipančić has noted that in this case, "White is not pure white. It is sensitive, changes and attracts dust, ages unusually fast."[7] For Stilinović, white is pain that has dimension and history; it is generative, taking on more than five hundred different forms of meaning, through each whited-out definition, as the artist acquires language from each page and fills the entire book.

This obliterating/generating white, this pain, and the work of its creation find correspondence in Eileen Scarry's writing on pain and literature:

FIG. 6
Children drawing in the Hall of Architecture

6. Ibid.
7. Branka Stipančić, in Igor Zabel, Branka Stipančić, Tihomir Milovac, and

Nada Beroš, *Mladen Stilinović: Pain* (Zagreb: Museum of Contemporary Art, 2003), 12.

That pain and the imagination are each other's missing intentional counterpart ... is perhaps most succinctly suggested by the fact that there is one piece of language used—in many different languages—at once as a near synonym for pain, *and* as a near synonym for created object; and that is the word "work." The deep ambivalence of the meaning of "work" in western civilization has often been commented upon, for it has tended to be perceived at once as pain's twin and as its opposite: ... it has been repeatedly placed by the side of physical suffering yet has, at the same time and almost as often, been placed in the company of pleasure, art, imagination, civilization—phenomena that in varying degrees express man's expansive possibility, the movement out into the world that is the opposite of pain's contractive potential.[8]

This intermingling and interdependency of notions of pain, imagination, and work find further resonance in Stilinović's use of the dictionary itself as an institution, a structure to enforce and represent power (the power of naming, of defining, and of organizing language, and hence culture). He both obliterates it, word by word, and reimagines it as representing only itself, with its power and pain.[9]

In many analyses of the "art world" system, art's meanings in relation to its production, display, sale, and collection have been described as closed systems, with value and meaning determined by internal relationships. In the early 1960s, Arthur Danto differentiated a work of art from, say, a Brillo box, through its display in high culture and institutional contexts, and its movement among the systems of philosophical and economic theory.[10] A few years later, Lawrence Alloway wrote about the art world's system of galleries, museums, publications, artists, collectors, and their networked relationships from the perspective of cybernetics and systems theories popular in the 1960s. (To Alloway, the art world was a "coherent and autonomous thing within a 'negotiated environment.'"[11]) In these instances neither writer concerned himself much with the place in which a public, or a person, receives art. Besides galleries, which have a mostly self-selecting audience, museums are that place. They represent not only a node on the closed system, but a breaking point, the site of a leak into a broader culture where meaning may not in fact be made through reference to Duchamp or Warhol or network theory. Instead, artworks sit as physical entities that are both subject to and in discussion with those who encounter them. The circuit breaks in a museum setting, letting out all sorts of strange energy into a public place, just as it lets in all different kinds of energy.

For the last 120 years, Carnegie Museum of Art (whose galleries of contemporary are no more than a few hundred feet away from the dinosaurs in the adjacent Museum of Natural History) has connected the closed system of the art world to the world at large. Yet the way that a potentially ambivalent public is exposed to contemporary art or experimental culture in such a setting and the effect that setting has on its audience are rarely included in analyses of art's meaning or in critical discussions around the role of "the institution." Most of the people who will view the *2013 Carnegie International* are not part of the "art world," and the potential of that encounter, of this willing confrontation between worlds, was one of our organizing principles.

Which brings me back to the dinner roll. When Sierra paints every non–plaster cast surface of the Hall of Architecture purple, it articulates the forms and patina of the casts, and coaxes out their complex relationships to architecture, representation, nineteenth-century globalization, sculpture making, and industrialized production. It is surreal, perceptually funky, and formally elegant and precise. But it also makes the dust that gathers look dustier. And we notice the cracks in the floor that run past the aging furniture. And art students sit against a purple wall as they sketch. The purple shocks the eyes upon first encounter, but recedes into the background upon repeated viewings. And a dinner roll, left over from a holiday party, sits, sad and obdurate, against a backdrop of royal purple dreamed up in Bogotá. The work is more beautiful, more strange, and more complete when one weighs the sheer gallon count and hours of labor involved against the reality of its eventual aging and the institutional shell.

A HUMAN UNIVERSE

Few large-scale exhibitions in the United States, despite focusing on specific regions or countries, have taken globalization itself as their theme, subject, or agenda, at least on the level that recent iterations of Documenta, Gwangju, Sharjah, and Istanbul have tackled. The *2013 Carnegie International* does not explicity break this trend. However, the exhibition presents an amalgamation—almost an image bank—of projects that directly engage conditions of lived experience or political realities specific to certain parts of the world. There are palpably felt evocations of life in, among other places, the rapidly developing cities of China (He An); the state of Odisha in India (Amar Kanwar); Sendai in Japan (Ei Arakawa/ Henning Bohl); Johannesburg in South Africa (Zenele Muholi); Los Angeles (Henry Taylor) (Fig. 7), Brooklyn (Nicole Eisenman), and Homestead (Zoe Strauss) in the United States; Poland (Paulina Olowska); Croatia (Mladen Stilinović); Iran (Kamran Shirdel); Vietnam (Dinh Q. Lê); Mexico (Pedro Reyes); and an amorphous zone often referred to as "the Middle East" (Bidoun Library).

This collection of images, objects, stories, and histories is not an account of globalization per se (although its effects are present), or of the supposedly easy crossing of borders and instant communication

8. Elaine Scarry, *The Body in Pain: The Making and Unmaking of the World* (New York: Oxford University Press, 1985), 169.
9. "In my dictionary, I would like to abolish, you might say, this kind of ideological sign. I want to abolish it with an emotional, certainly not a rational, gesture, by linking all the words in the dictionary of pain. I simply whited out the meaning of the word, and instead of it wrote the word Pain. Pain for me is the very opposite of power, power actually produces it, it is the consequence of power." Stilinović, in *Mladen Stilinović: Pain.*
10. Arthur C. Danto, *Beyond the Brillo Box: The Visual Arts in Post-Historical Perspective* (Berkeley: University of California Press, 1998).
11. Pamela M. Lee, *Forgetting the Art World* (Cambridge, MA: MIT Press, 2012), 21.

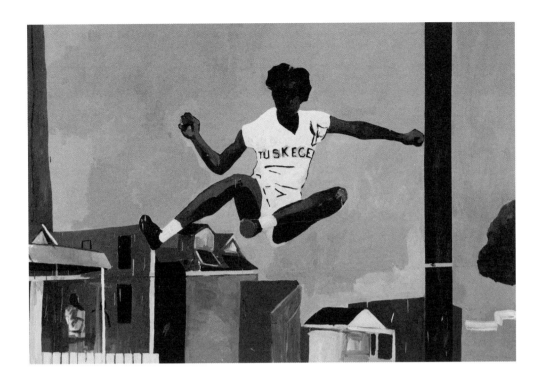

FIG. 7
Henry Taylor, *See Alice Jump*, 2011, cat. no. 247

achieved through globalism. The works, and the places they evoke, maintain a sense of difference, with the gaps between them often exploited in the exhibition itself. Joseph Yoakum's far-out depictions of landscapes from every corner of the world are not the result of frequent-flier miles but of a force that might have emanated from somewhere between his memories, his imagination, and the possibility of pen on paper. The sense of foreign-ness pervades the images equally, making each place seem just as different, strange, and otherworldly as the next. Everything is foreign and other, and in Yoakum's near-abstract world, benignly so.[12]

It was important to us to bring together artworks from different parts of the world, in order to see these works in conversation with one another, with the museum, and with our visitors. Seeing Lê's *Light and Belief: Sketches of Life from the Vietnam War* (2012) in Kassel, where the work was first shown, was affecting. There, Lê's video and the accompanying drawings by Vietnamese artists, made during the war, were displayed in a contemplative pavilion in Karlsaue park. The drawings, depicting heroic or just poignantly human scenes of life during wartime, from the perspective of the United States' enemy in that conflict, brought the quotidian realities of a sometimes forgotten war to a public that, by and large, has not had to encounter these realities (histories) for two or three generations. The work has different resonance in Pittsburgh, where it is likely to be seen by more Vietnam War veterans than would have visited Kassel, thus open-ing up the possibility for types of conversation and

exchange absent in its first showing. Here, the Vietnamese artists speak through the video interviews and through their own works on display not only to visitors but also to other works in the exhibition that likewise illuminate a particular national situation. Muholi's striking portraits of lesbians in South Africa, for example, are both artworks and part of an activist project that addresses the deplor-able conditions of violence and discrimination faced by gay people in her country. Similar conditions exist all over the world, and Muholi's act of representing and chronicling her subjects provides exposure both to the individuals and to the larger community.

This concentration on place, and difference, is further manifested in representations of people and depictions of behavior that are responsive (or in resistance) to that place. Eileen Myles has noted of Eisenman's work:

So much in her oeuvre goes against the grain of whatever museums do. Ending things? Instead she posits a museum, or a school full of holes…. For a significant decade, Nicole Eisenman's been operating within a culture where no one really wants to talk about what's done to women…. Where does aware-ness go in the space of official public blindness of "how it is." Maybe it's perfectly reasonable to corral a space within that same vast American silence and in it make a vivid proposal of what anyone would do, in response, if they could. Wouldn't any-one, everyone? when we look at this work. Didn't we fight back?[13]

12. Marcus Steinweg quotes Adorno: "Foreignness to the world is an ele-ment of art: Whoever perceives it other than as foreign fails to perceive it at all." Steinweg goes on to assert in his

own words that "Art is an assertion of difference. In the zone of familiarity, art appears as something unfamiliar in the domain of established certainties." Steinweg, "Nine Theses on Art," 4.

13. Quoted in Eileen Myles, *The Importance of Being Iceland: Travel Essays in Art* (Los Angeles: Semiotexte, 2009), 67.

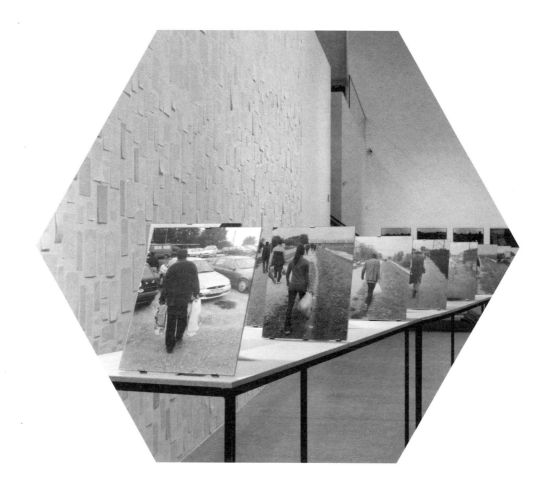

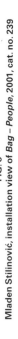

FIG. 8
Mladen Stilinović, installation view of *Bag – People*, 2001, cat. no. 239

Myles evokes both the inurement to trauma through repeated exposure and the desire to picture and experience a response, a resistance. And her questions should be continually asked, now more than ever. The surreal, hyperbolic, and awkwardly expressive valence of Eisenman's work confronts the discomfort of everyday experience: its small humiliations and mistakes as well as its physical and psychological violence. Frank, beautiful, and uncanny passages of painterly, allegorical fragments accumulate in her work, most recently in combination with depictions of the social. Relationships—interpersonal, then those within a larger schema—play out in the canvases, and her plaster sculptures can feel like characters plucked out of these scenes, actualized in a further act of explicit distortion.

Even Eisenman's figures that are pictured alone feel the heat of other people, just outside the frame. Their bodies, like those deployed in group activity, are set into place. And with Eisenman, the representation of people lies always between the corporeality and uneasiness of "body" and the relationally defined, sometimes culturally determined, often exaggerated role of "character." For the robust vein of figurative work that runs through the *2013 Carnegie International*, the idea of "figuration" is helpful only in so much as we consider the figure in relation to its surroundings. The academic category of figurative work (in opposition to "abstract") is mostly irrelevant in

the context of this exhibition. What are central, however, are the means by which artists make explicit the roles and functions of bodies and situate them in place and time.

Marcus Steinweg again helps delineate art's relationship to its cultural context: "More than being a document of its times, the artwork is a corruption of the zeitgeist and the socio-historic texture from which it indeed arises. If a work were nothing other than the result of its conditions and reducible to its determinants, it would not be a work. The essential feature of an artwork is that it inscribes a resistance in the reality to which it belongs by appearing in it as something incommensurable."[14] This last idea is key to the *2013 Carnegie International*. The excess of information, material, form, or mimesis makes itself present in pronounced instances. With many works in the *International*, the "socio-historic texture" is enmeshed in the actions of subjects or bodies. In her relentless indexing and documenting of actresses and objects associated with the James Bond movies, Taryn Simon nearly disfigures our expectations of their roles and functions, having offered them up as interchangeable accessories that simultaneously retain their covetous charge and become neutralized. In their removal from context, these figures (the actresses) become objects, and the objects become characters—each remaining vessels for desire. Similarly, the people in Stilinović's photographs

14. Steinweg, "Nine Theses on Art," 4.

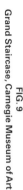

FIG. 9
Grand Staircase, Carnegie Museum of Art

FIG. 10
Erika Verzutti, *Indigentes*, 2008, parallelepiped, bronze, clay, paper and cold porcelain clay, and acrylic, 12 ³/₁₆ x 70 ⅞ x 78 ¾ in. (31 x 180 x 200 cm). Courtesy of the artist and Galeria Fortes Vilaça, São Paulo

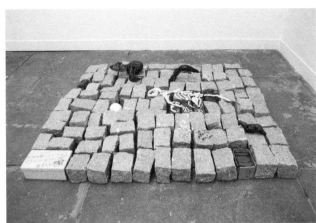

in *Bag–People* (2001) are recognizable types, in this case laborers on their way to a job, lunches packed in those ubiquitous and flimsy plastic bags. In his work, the bags become sad formal gestures, emblematic of whole global systems of consumption, waste, and labor, but also indicative of highly specific individual uses and forming a kind of social sculpture. They are truly "figures in landscape," and there is a dark, playful wisdom to their silent march in two rows down the narrow table on which they are displayed (Fig. 8).

Such works further resonate with Carnegie Museum of Art itself. John White Alexander's famous three-story mural *The Crowning of Labor* (1905–8) shows laborers building the city of Pittsburgh; as the paintings ascend, so does the prestige of the type of work depicted: from the building blocks of physical, industrialized toil emerge more elevated pursuits of art, culture, and knowledge (Fig. 9). Among the marble columns and wrought metal lamps, these figures bring the city inside the Grand Staircase. Likewise, the Hall of Sculpture is watched over by permanently affixed plaster casts of classical figures—seemingly anonymous (they are figures from Greek mythology) and innocuous—which were plucked from the storehouses of plaster workshops at the turn of the twentieth century to become august observers today of weddings, receptions, and major sculpture installations.

Erika Verzutti's new project, shown in the museum's Forum Gallery, off the lobby, takes as its departure her 2008 exhibition *Pet Cemetery*, specifically a floor-bound work called *Indigentes*, a name taken from the graves of unidentified bodies in her native Brazil (Fig. 10). From her own sculptural mistakes and "unwanted results," she has built a multilayered sculpture that contains multiple forms and objects, generating a mass that riffs off of the ultimate synthesis of figure (body) and ground. In this work, and in past projects, body parts, flowers, vases, animals, fruits, vegetables, and other strange fragments are, in the artist's words, "highly deformable."[15] The sculptures spoil their own beauty, a transformation of appearance that is possible precisely because they are identifiable to begin with. Their recognizability enables their deformability—and abstraction—allowing for the creation of meaning through the artist's formal play. There is a built-in resistance to that recognition, a desire to abstract (and in this case "abstracting" means to mess with, through the accumulation of piles, appendages, growths, and humor), which nonetheless has its origins in the world.

15. Rodrigo Moura, *Erika Verzutti*, trans. Sergio Pachá (Rio de Janeiro: Cobogó, 2007), 89.

ABSTRACTION,
OR "… 1 COW BONE, 2 FISH BONES,
1 DRY GOURD, 1 PHOTOGRAPH
BY WALLACE KIRKLAND OF SAND …"

Verzutti's notes on the materials, objects, and spatial relations made for her *International* installation read in part as follows: "Heads and towers … Styrofoam covered by concrete. pedestals. tower. beetroot head. starfruit head. feng shui heads."[16] The inventory reminded me of parts of art historian Katharine Kuh's list of materials for her educational exhibition *Explaining Abstract Art*, which debuted at the Art Institute of Chicago's Gallery of Art Interpretation from July 1, 1947, to January 31, 1948 (Fig. 11), and was subsequently re-created at Carnegie Museum of Art at the behest of director Gordon Bailey Washburn for the 1952 *International*. Kuh combined reproductions of artworks (and some originals) by Picasso, Moholy-Nagy, Duchamp, Kepes, Edgerton, and others, with, for instance, "1 large piece of driftwood, 1 large shell, 1 cow bone, 2 fish bones, 1 dry gourd, 1 photograph by Wallace Kirkland of sand … 4 metal gears … 7 photographs of Tables for Table Series … Mexican toy whistle … 2 rolls of wall paper" (see pages 271–73). Through playful and elegant juxtapositions of cross-disciplinary imagery and with innovative use of exhibition apparatus and formally sophisticated displays (plywood and glass panels, modular shelving units, wallpapers), Kuh created accessible entries into abstraction. Washburn, who had recently arrived from the Albright-Knox Art Gallery in Buffalo, was eager to find an ally in introducing abstraction into the *International*s, late as it was in 1952.

Relevant to the *2013 Carnegie International* for its relationship to institutional history and our use of the collection, Kuh's display, with its energetic and generous approach to complex ideas and artistic movements, resonates with a number of artist projects in the current exhibition. Most important, it provides a model—like the playground—for animating the institution, in this case, to orient it toward an engagement with its visitors and to position it as a medium through which to experience modern life and the world.

Much, though by no means all, of the abstraction in the *2013 Carnegie International* is very much about place. Phyllida Barlow, Lara Favaretto, Wade Guyton, Tobias Madison, and Gabriel Sierra each tweak the standards and motifs of sculptural and painterly abstraction to graft them onto physical and ideological spaces of the museum. Sierra's walk-in painting both cloaks and reveals the historical phantasmagoria that is the Hall of Architecture, making the cast forms more vivid as their surroundings become more abstract, swathed in the deep, rich purple paint. Pedestals and wall fragments become lush Minimalist sculptures as the mechanics of display are highlighted. Guyton provokes the taut relationships between Minimalism, décor, taste, class, and abstraction by transforming the museum's somewhat worn coatroom into a massive abstract painting lounge. Coat hangers and lockers remain, accompanied now by specially selected leather couches from which to enjoy his large inkjet paintings that fill the space. Guyton also added paintings to the museum's elaborate gilded-age Founder's Room, accessible only at limited times to the general public.

Favaretto's confetti cubes seem to address Minimalism head on, but in fact they only momentarily quote that movement's rational cubes before moving on to assert their own irrational identity. The aggressive materiality of a wood or steel cube seems light and pure in the face

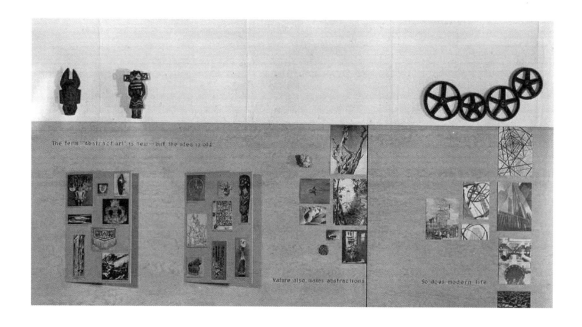

16. Email to Lauren Wetmore,
January 9, 2013.

FIG. 11
Installation view of *Explaining Abstract Art* at the Art Institute of Chicago, 1948

FIG. 12
View of the Forbes Avenue facade of Carnegie Museum of Art, showing sculptures by Henry Moore (left) and Richard Serra (right)

of the thousand pounds of compressed party confetti that make up one of Favaretto's cubes, its weight obscured by the seemingly effervescent material. These cubes will fall apart over the course of the show, instilling a section of the *International* with a sense of festive resignation and aggressive frivolity. Each of her steel road plates— the kind that cover up dangerous holes in the street—lies on top of a similarly shaped piece of colorful silk, visible through holes in the plate, to form a restrained yet visceral sculpture. Installed on the museum floor in a room of Impressionist paintings, they connote danger (a hole in the museum floor?) and reorient visitors' attention as they negotiate the tripping hazard in their path, forcing a new kind of in-gallery awareness and reconsideration and bringing the city into the museum.

Barlow uses abstraction to take on the chaos of the museum's front plaza, and all of the action that surrounds it (school bus parking, public bus stop, four-way intersection, the meeting of two major universities, and at least ten different kinds of architecture). Most present among her barricade-like, snaking construction of wood poles and brightly colored streamers are three other public sculptural offerings, each with a different relationship to the world around it. Richard Serra's three-story-high *Carnegie* (1985) employs the artist's signature material of Corten steel to block the museum's entrance with a forceful walk-in tower. Henry Moore's *Reclining Figure* (1957) is an abstracted bronze body, and aloof to passersby (Fig. 12). Finally, the newly installed Lozziwurm meshes abstract form, bold color, and the anarchic socializing potential of the playground. Barlow's installation acts as a brazen interlocutor, tipping its hat to her English sculptor forbear, fracturing and adding color to the cohesive authority of *Carnegie*, and rhyming the playful foreignness and experimentation of the Lozziwurm. Barlow's abstraction is specific to its surroundings in that it refuses to synthesize, instead gaining identity from the haphazardness around it as it leads people into the museum.

TOWARD THE COLLECTION

And back inside, an otherwise heterogeneous group of artists in the *2013 Carnegie International* takes on aspects of the museum itself, adopting characteristics of an institution or using the strategies and implications of a collection to make work. They are less concerned with Carnegie Museum of Art's (or any other museum's) institutional history, and more attuned to the associative possibilities offered by collections and display in general. In other instances, the artists themselves take on the role of the institution, gathering people, objects, images, and histories through their own methods of research and interpretation as well as outreach and interaction with the public. Dinh Q. Lê has collected drawings by other artists; Taryn Simon has photographed a collection of actors and objects; Paulina Olowska has used puppet collections; Bidoun Library (actually its own institution) brings together books from the Middle East; and Zoe Strauss not only collects portraits but also sets up her own mini-institution portrait studio.

Pierre Leguillon, who has worked with various kinds of mostly photographic collections in previous works, has made a "vivarium" to hold the pots of eccentric ceramic artist George Ohr, conflating the forms of his work with the artist's ambitiously strange self-branding. The pots become personal, like small animals, each with its own personality. Transformazium's project, to create an Art Lending Collection at the Braddock Carnegie Library, perhaps hews most closely to a traditional, institutional conception of a collection. But in many ways, the artworks in this collection might offer the public the most intimate relationships of any works in the exhibition. Library patrons can take works home for a period of time, where they may be displayed in ways neither the artist nor the institution could ever have imagined. This conception of an art collection creates an institutional generosity that functions on a very different level from that of a museum. The public nature of looking at artworks with

THE PLAYGROUND PROJECT

GABRIELA BURKHALTER

The playground is a hidden place, seeming to have little interest for artists, designers, and architects today. Yet it is, just like the museum, a domain in which opinions about education, exploration, aesthetics, and public space abound. *The Playground Project* presents some of the most outstanding and influential achievements in this vein from Europe, the United States, and Japan from the mid-to-late twentieth century in order to prompt a reconsideration of our own time and the way we approach childhood, risk, public space, and education. The project also puts the concept of play into the foreground as an important mode of thinking, one that has considerably influenced the development of the *2013 Carnegie International*. One of the many consequences of this was the decision to install an actual Lozziwurm, a play sculpture from 1972 designed by Ivan Pestalozzi (born 1937), in front of the museum and make it available to the public (see page 234).

Playgrounds are among the few remaining places within the city for nonpurposive, spontaneous, and creative activity as well as for exciting physical challenge and discovery. Yet most playgrounds today are highly standardized and sanitized. By the late 1980s, the era of the custom-designed playground had come to an end because of increased concerns about safety and legal liability. Play-equipment manufacturers established guidelines that dictated materials, heights, slopes, and railings, often resulting in unchallenging or even boring places.[1] Today, fewer children (with the exception of toddlers) use playgrounds, preferring instead to play inside or to participate in organized activities. Maybe playgrounds are simply outdated? Or maybe it is time to reevaluate their role in contemporary society?

A change is needed, but, as history shows, it is possible only if different actors engage in the revitalization both of the playground and of public space in general.

THE HISTORY OF PLAYGROUNDS

The origin of playgrounds needs to be understood in relation to the history of public parks, urban planning, and the "invention" of recreation. Playgrounds emerged out of necessity some one hundred years ago. As urban areas became more densely populated, open spaces were taken over by development, and city streets filled with carriages, cars, trams, and buses. At the beginning of the twentieth century, during the so-called Reform Era,[2]

playgrounds were framed by moral agendas such as social and physical hygiene; they were built to take rough youth off the streets and provide them with a basic civic education. The typical American playground of this time featured custom-made gymnastic equipment, slides, a sandbox, and a wading pool with separate areas for girls and boys. It was fenced in and had a play leader.

After the 1930s, a new approach to childhood, play, and creativity led to a multiplication of forms and concepts around the world. These can be grouped broadly into a number of categories that emerged from the 1940s to the 1970s: adventure playgrounds, landscape playgrounds, play sculptures and environments, and DIY (Do-It-Yourself) playgrounds. Special conditions were required for the development of progressive playgrounds: innovative ideas for such environments needed the support of open-minded city or park officials, the proper funding, and the engagement of the community.

Scandinavia led the way in conceiving a new place for children in society, one rooted in the belief that creative play is a key factor in the development of a child's personality. In the world of playgrounds, these ideas found their most accomplished and sensitive form in the *Skrammellegeplads* (junk playground) imagined by Danish modernist landscape architect Carl Theodor Sørensen starting in 1931. In Scandinavia and the Netherlands, the rise of social democracy and the welfare state after World War II led to an increase in public play spaces in parks and housing projects, away from streets and traffic.[3] Many European city planners and parks officials traveled to Scandinavian countries for inspiration. In the United States playground design responded to the particular changing needs of this country. In California the development was closely linked to the rise of suburbia and the design of suburban parks, while on the East Coast playgrounds were adapted to the constraints of increasingly congested cities.

In the 1960s and 1970s, as society grew more open in general, the playground moved away from being focused exclusively on children to become an open, inclusive space for everybody. Frontiers vanished between indoor and outdoor, and between playground and public space. The DIY movement put the design of playgrounds into the hands of communities themselves. At the same time, this period also saw the emergence of highly designed and structured playgrounds created by designers and artists, and specialized play equipment began to be mass-produced. Many of these intersecting ideas flourished in

1. Michael Gorkin, "The Politics of Play: The Adventure Playground in Central Park," in *Preserving Modern Landscape Architecture: Papers from the Wave Hill–National Park Service Conference*, ed. Charles A. Birnbaum (Cambridge, MA: Spacemaker Press, 1999), 70.
2. Galen Cranz, *The Politics of Park Design: A History of Urban Parks in America* (Cambridge, MA: MIT Press, 1982), 192 ff.
3. Lianne Verstrate and Lia Karsten, "The Creation of Play Spaces in Twentieth-Century Amsterdam: From an Intervention of Civil Actors to a Public Policy," *Landscape Research* 36, no. 1 (2011): 91.

Japan, where the scarcity of land and the lack of open space in the big cities pushed the development of imaginative and space-efficient playground equipment.

The pioneering concepts developed in this period were reviewed widely in international architectural magazines; play and playground design were present in books published for a broad audience interested in modern architecture, design, art, and education. Yet many of these playgrounds have vanished. More highly designed playgrounds in cities were often vandalized and poorly maintained, leading them to be torn down. As new standards of safety evolved, many playgrounds came to be considered dangerous and were either closed or retrofitted in ways that diminish their unique character. The survey that follows traces these major trends in playground design, focusing on particular artists, architects, and designers—both well known and forgotten—who contributed to some of the most exciting conversations about creativity, play, and exploration in the mid-twentieth century.

FIG. 2
Future site of Aldo van Eyck's Dijkstraat Playground. Amsterdam City Archives

THE HUMANIST ROOTS OF PLAYGROUND DESIGN

Before tracing the four major categories that are the focus of *The Playground Project*, it is useful to acknowledge the innovative efforts of <u>ALDO VAN EYCK</u> (1918–1999), a truly singular voice in playground design. The first to envision playgrounds according to a systematic approach in the 1940s, he created neither landscapes nor play sculptures. Van Eyck was a cofounder of Team 10, an influential group of theorists and avant-garde architects in Europe; as former members of CIAM (Congrès internationaux d'architecture moderne), they were opposed to Le Corbusier's functionalism and called for a return to humanism.

As a commitment to this humanist approach, Van Eyck contributed to the idea of the playground as a standard element of urban planning and social responsibility by installing a network of at least seven hundred playgrounds throughout Amsterdam. His design was guided by a broad social conscience and a belief that children must be part of the city and not be fenced within play "ghettos."

As an assistant to the architect Jakoba Mulder (1900–1988), head of design within Amsterdam's town planning department, Van Eyck became involved in a long-term project to provide more play space in the city.[4] He realized his first playground in Amsterdam's Bertelmanplein in 1947, which became a model for the many that followed. The central element of Van Eyck's designs was the sandpit; built in varying geometric shapes, it was combined with concrete blocks of different forms, which could be used for sitting and jumping. He used metal climbing bars along the street side to create a natural barrier, while metal arches, domes, or funnels provided climbing structures for all ages. The distances and connections among the play elements were designed to encourage investigation of a place through play. This became most evident in the Dijkstraat Playground (1954), located in an empty lot between two tall buildings (Figs. 2–3).

Van Eyck developed a range of specific shapes, equipment, and "compositions" that he varied depending on the site. He never gated his playgrounds, which became social hubs of the neighborhood. The design quality of playgrounds in Amsterdam and the way they established a network throughout the city provided a model for numerous other European cities.

FIG. 3
The completed Dijkstraat Playground, 1954. Amsterdam City Archives

4. Francis Strauven, "Wasted Pearls in the Fabric of the City," in Liane Lefaivre, Ingeborg Roode, and Rudolf Herman

Fuchs, *Aldo van Eyck: The Playgrounds and the City* (Amsterdam: Stedelijk Museum, 2002), 66–70.

FIG. 4
Children climbing a wooden tower they constructed at the
Skrammellegeplads in Emdrup, c. 1943. The Royal Library, Copenhagen,
Department of Maps, Prints, and Photographs

FIG. 5
Skrammellegeplads in Emdrup, 1952. The Royal Library, Copenhagen,
Department of Maps, Prints, and Photographs

FROM THE *SKRAMMELLEGEPLADS* TO
THE ADVENTURE PLAYGROUND

From the 1930s to the 1970s, a number of architects and designers explored what has come to be known as the "adventure playground." Although they have taken different forms over time and in different places, such spaces are rooted in the idea of handing design over to children themselves, who build their own houses and play environments. These playgrounds represent in effect the institutionalization of the vacant lot where city children had played unattended for generations. The emphasis was on creativity and social competence rather than on physical and moral education, which had been the focus of the earliest playground reformers. Emerging first in Scandinavia, adventure playgrounds spread throughout Europe, the United States, and Japan. They went through a process of "civilization" over the decades, but continue to function in a similar way and are still popular in many European countries and Japan. The pioneering adventure playgrounds in Emdrup, London, and Zurich are still in operation.

CARL THEODOR SØRENSEN (1893–1979) first imagined this new type of playground in the 1930s. He had worked in the 1920s as a landscape architect in early public housing projects in Denmark, which integrated open spaces into their overall planning and emphasized family-friendly designs. He searched for ways to give city children the same play opportunities that kids in the country enjoyed. Inspired by his observation that children preferred to play on adjoining construction sites rather than on his designed playgrounds, he developed the concept of the

Skrammellegeplads (junk playground): a place where children could build and play with surplus lumber and bricks. He expounded on his concept in his influential 1931 book *Parkpolitik i sogn og købstad* (*Park Policy in Parish and Borough*). Between 1937 and 1943, Sørensen designed the open space of two new housing estates for a Workers' Cooperative Housing Association in Emdrup, on the outskirts of Copenhagen. It was there that he oversaw the creation of the first *Skrammellegeplads* in 1943, a 1.2-acre lot with very few facilities (Figs. 4–5). The available material—in short supply in German-occupied Denmark—was shared by the one hundred children who used the playground daily. The play leader managed a fair allocation; children were then free to build the structures they imagined, following a process of consensus among the group.

In 1945 the British horticulturist, educator, and advocate for children LADY ALLEN OF HURTWOOD (1897–1976) traveled to Denmark, where she visited the *Skrammellegeplads* in Emdrup. The visit was part of her international and pacifistic efforts to cultivate "early child education as the best way of creating peace-loving citizens."[5] Amazed by the concept of the *Skrammellegeplads*, she began to promote it in Great Britain, which was just beginning to recover from the destruction of World War II. She recognized in these playgrounds a meaningful way to provide children a place to play in the bombed-out city. The first *Skrammellegeplads*, which opened in London in 1948, operated with the aid of the International Voluntary Services for Peace (Fig. 6). Lady

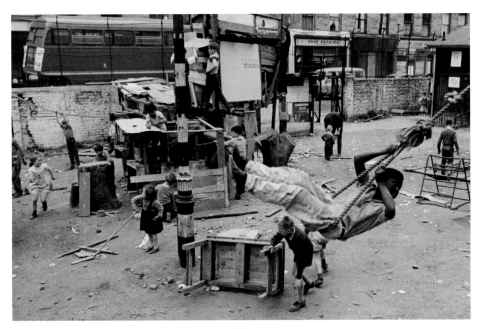

FIG. 6
Notting Hill Adventure Playground, London, c. 1959. Modern Records Centre and the Lady Allen
of Hurtwood Papers, University of Warwick Library, Coventry, England

5. Roy Kozlovsky, "Adventure Playgrounds and Postwar Reconstruction," in Marta Gutman and Ning de Coninck-Smith, *Designing*

Modern Childhoods: History, Space, and the Material Culture of Children (New Brunswick, NJ: Rutgers University Press, 2008), 176–78.

Allen suggested building more of them as a way to involve people in the city's reconstruction process, in opposition to the official approach of large-scale urban renewal. In the 1950s she coined the term "adventure playgrounds" (to replace the use of "junk playgrounds") to give them a more positive connotation. Lady Allen actively promoted her ideas through lectures and books such as *Adventure Playgrounds* (1961), *Design for Play* (1965), and *Planning for Play* (1968).

ALFRED LEDERMANN (born 1919) and ALFRED TRACHSEL (1920–1995) brought the concept of the adventure playground to Switzerland in the 1950s. Ledermann, a lawyer, was first inspired by his experiences on a humanitarian mission to Germany just after World War II, when he saw children who found moments of happiness while playing in the rubble of buildings. He then traveled to Denmark to learn more about Sørensen's junk playground. Back in Zurich, he became the chairman of the powerful Pro Juventute, the Swiss national youth organization. In the 1950s increased leisure time became an important issue in the ever-growing cities, and Ledermann was particularly interested in finding new places and activities for teenagers as well as for children.

In 1953 Ledermann collaborated with Trachsel, an architect responsible for the playground design at Zurich's Public Housing Department, to construct the city's first so-called Robinson playground (after Robinson Crusoe), the Swiss version of the adventure playground. Combining the concept of the adventure playground with a neighborhood's community center, it included crafts, music, and theater, and offered leisure activities for all ages. The concept went on to become popular in other Swiss cities, promoted and financed by Pro Juventute.

In 1959 Ledermann and Trachsel published *Spielplatz und Gemeinschaftszentrum*, published in translation the same year as *Creative Playgrounds and Recreation Centers*. The book was the first substantial overview of the most innovative playgrounds in Europe, the United States, Japan, and Brazil (Fig. 7) and appeared on the list of a publisher with an outstanding reputation in modern art and architecture, highlighting the significance of playgrounds in such fields as urban planning and design.[6]

In the 1960s many cities around the world embarked on massive urban renewal projects that often resulted in the clearance of old neighborhoods and the development of massive suburban housing projects. In 1967, as a critique, Danish artist PALLE NIELSEN (born 1942) built a "guerrilla playground" in Denmark's largest housing estate, near Copenhagen. Nielsen and his group went on to build illegal adventure playgrounds in different neighborhoods in collaboration with their residents. Although these playgrounds didn't endure for long, they often enjoyed wide media coverage.

In August 1968 Nielsen traveled to Stockholm, Sweden, to participate in Aktion Samtal (Action Dialogue), a series of community-based events that questioned the commercialization and destruction of the public space.[7] Nielsen and his collective were invited by Pontus Hultén, legendary director of the Moderna Museet in Stockholm, to transform the museum into an adventure playground (Fig. 8). Their design offered a maximum of freedom: "The frame itself is conceived as being built of wood, including many spatial formations and bridges. The frame will contain no fixed play functions—only the children's use of it will determine its function. The frame is also aimed at making the space more unpredictable."[8] Called *Modellen—en modell för ett kvalitativt samhälle* (*The Model—A Model for a Qualitative Society*), the project was published as an exhibition catalogue in 1968, and has since had a profound impact on the field of museum studies as well as architecture. The success of *Modellen* was immediate; two thousand children visited the exhibition during its brief three-week run.

6. The German edition was published by the young publishing house of Gerd Hatje (now Hatje Cantz Verlag); Praeger published the translation. See Gabriela Burkhalter, "Communication Offensive," in *Paisea: Revista de paisajismo* 22 (September 2012): 97.

7. Aktion Samtal was carried out by anti–Vietnam War activists, members of the National Front for the Liberation of South Vietnam. See Palle Nielsen and Lars Bang Larsen, *The Model: A Model for a Qualitative Society* (1968) (Barcelona: MACBA, 2010), 45.

8. Ibid., 51 (quoted from Nielsen's fund-raising paper, 1968).

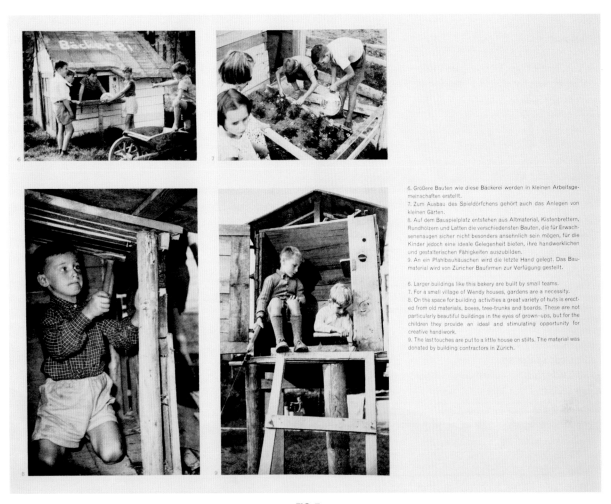

6. Größere Bauten wie diese Bäckerei werden in kleinen Arbeitsgemeinschaften erstellt.
7. Zum Ausbau des Spieldörfchens gehört auch das Anlegen von kleinen Gärten.
8. Auf dem Bauspielplatz entstehen aus Altmaterial, Kistenbrettern, Rundhölzern und Latten die verschiedensten Bauten, die für Erwachsenenaugen sicher nicht besonders ansehnlich sein mögen, für die Kinder jedoch eine ideale Gelegenheit bieten, ihre handwerklichen und gestalterischen Fähigkeiten auszubilden.
9. An ein Pfahlbauhäuschen wird die letzte Hand gelegt. Das Baumaterial wird von Züricher Baufirmen zur Verfügung gestellt.

6. Larger buildings like this bakery are built by small teams.
7. For a small village of Wendy houses, gardens are a necessity.
8. On the space for building activities a great variety of huts is erected from old materials, boxes, tree-trunks and boards. These are not particularly beautiful buildings in the eyes of grown-ups, but for the children they provide an ideal and stimulating opportunity for creative handiwork.
9. The last touches are put to a little house on stilts. The material was donated by building contractors in Zürich.

FIG. 7
Alfred Ledermann and Alfred Trachsel, *Spielplatz und Gemeinschaftszentrum* (Stuttgart: Gerd Hatje, 1959), 122.
Pictured is the first Robinson playground in Zurich-Wipkingen, designed by Alfred Trachsel in 1952.

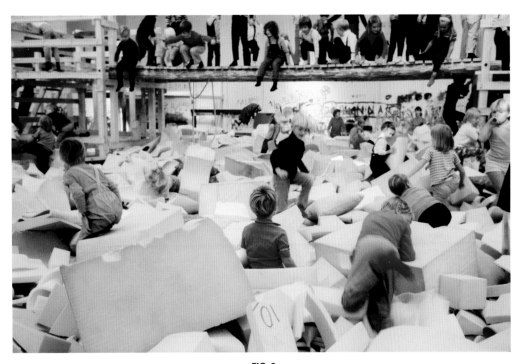

FIG. 8
Children playing in *Modellen*, Moderna Museet, Stockholm, 1968,
created by Palle Nielsen and Aktion Samtal. Museu d'Art Contemporani de Barcelona

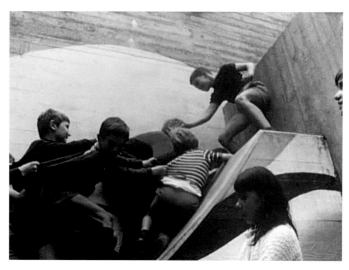

FIG. 9
Playground for Aumatten Primary School in Reinach,
Switzerland, 1967, designed by Michael Grossert. Still from the 1968
film *Pausenhofplastik Reinach*, directed by Georg Radanowicz

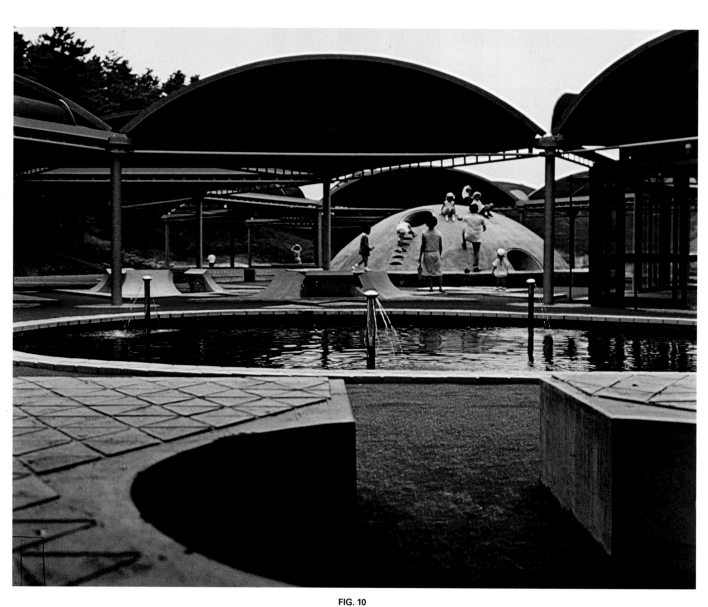

FIG. 10
View of National Children's Land, Yokohama, showing floors and seating platforms under steel shelters by Sachio Otani
and climbing mound by Isamu Noguchi, 1965–67. Noguchi Foundation, Long Island City

LANDSCAPE PLAYGROUNDS

The creators of landscape playgrounds work with topography, earth modulations, wooden or concrete micro-landscapes, water, and sand to enhance the sensation of space and its exploration. The concept encompasses a wide range of projects, from the sculpted, artificial landscapes of Michael Grossert (born 1927), such as the example he created in 1967 for a school yard in Switzerland (Fig. 9), to more natural playscapes integrating trees, shrubs, and ponds. Natural playscapes became popular in the 1970s, related to the rise in environmentalism; they continue to be significant today with a new emphasis on the importance for children of having experiences in nature.

ISAMU NOGUCHI (1904–1988), best known as a sculptor, is the pioneer of the landscape playground. While living in China and Japan in the 1930s, Noguchi began to work on playgrounds and landscapes, creating designs that combined geometric and natural forms inspired by mythology, prehistory, indigenous culture, and traditional Japanese gardens. The idea of play was built into the landscape, not added through objects or equipment. In 1933 he designed *Play Mountain*, a landscape without any play equipment, as a proposal for an unrealized playground in New York.[9] His visionary approach was entirely new and opposed to the typical American playground, with equipment set on flat asphalt.

Noguchi created other playground designs in the 1940s and 1950s, but his first to actually be built was a temporary play area for the National Children's Land in Yokohama, in

1965–67 (Figs. 10–11). The project, constructed on a 240-acre former military site, framed by the master plan of Takashi Asada (1921–1990), was a collaboration with architect Sachio Otani (born 1924), both members of the avant-garde Japanese architecture movement Metabolism.[10] The play area featured umbrella-shaped shelters, a sand area, an ice-skating rink, a wading pool, and a mound with a tunnel. The structures were often composed of parts that seem to grow organically out of each other; the play area thus felt like an extension of nature.

In the playgrounds he designed in New York City from the 1960s to the 1980s, landscape architect M. PAUL FRIEDBERG (born 1931) combined an interest in topography with the boundless possibilities of the adventure playground. Friedberg's first playground commissions in the early 1960s aimed to enhance the quality of life in low-income neighborhoods. These projects were funded by the Astor Foundation, whose president, Brooke Astor, had been deeply influenced by Jane Jacobs's 1961 book *The Death and Life of Great American Cities*, in part a critique of the New York City Housing Authority's policies of slum clearance and large-scale subsidized housing developments.

Initially installing standard equipment in his play environments, Friedberg soon began to incorporate existing topography. He often modeled the terrain with pyramids and terraced steps, which he combined with structures such as climbing arches, slides, stepping columns,

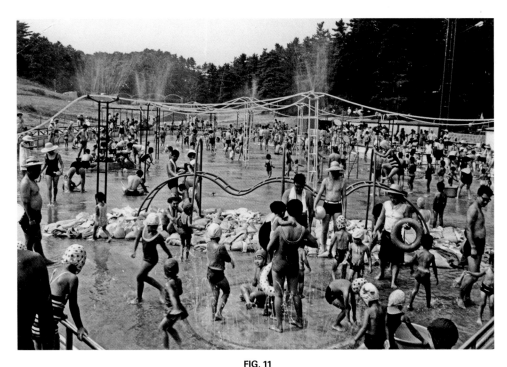

FIG. 11
View of National Children's Land, Yokohama, showing the wading and splashing pool during
Children's Day Celebration, c. 1965. Noguchi Foundation, Long Island City

9. Noguchi conceived four visionary playground projects for New York; none of them was ever built, as powerful parks commissioner Robert Moses banned them and any other modern design.
10. See Kishō Kurokawa, *Metabolism in Architecture* (Boulder, CO: Westview Press, 1977).

and, later, modular units. Friedberg's first "total" play environment, Riis Plaza at Jacob Riis Houses, a housing estate on New York's Lower East Side, opened in 1965 (Fig. 12). It demonstrated his concept of "linked play" through the juxtaposition of different elements and the connections between them.[11] Getting from one piece of equipment to another became part of the play experience itself.[12] He later popularized this groundbreaking concept through his 1970 book *Play and Interplay*. Friedberg went on to create playgrounds in Washington, DC, also under the auspices of the Astor Foundation (Figs. 13–14).

Between 1967 and 1968 Friedberg created a series of vest-pocket parks, which were installed temporarily on vacant lots in areas with few play facilities such as Bedford-Stuyvesant. These were constructed of pipe frames and concrete modules, wood timber, and pipe-and-cable units that did not require foundations.[13] This modular, ready-to-use equipment came close to the DIY playground (see Friedberg's 1975 book *Handcrafted Playgrounds*). Later, TimberForm in Portland, Oregon, commercialized his designs for modular equipment based on wooden poles that could be put together according to a model or combined in new ways designed by the user.

In the mid-1980s Friedberg won a competition to build a "rustic playground" in Central Park: the Billy Johnson Playground at East Sixty-Seventh Street. In this project, Friedberg fostered an experience of play in the landscape through the use of natural materials and existing topography.[14] This playground features the park's most popular slide, which is cut directly into a natural rock outcropping.[15]

Architect <u>RICHARD DATTNER</u> (born 1937) designed several playgrounds for New York's Central Park between 1967 and 1973 (Fig. 15).[16] Replacing old-style asphalt playgrounds, his spaces were dense environments that offered children possibilities for physical experience and space for human interaction. His first project, the Adventure Playground at West Sixty-Seventh Street in Central Park, is memorable both for the design and for the engagement of the local community. It was built at the request of a mothers' committee, supported by a newly elected mayor, and funded by the Estée Lauder Foundation, which was concerned about the exodus of families from the city.

To prepare the project, Dattner immersed himself in the psychology of play and studied child's play in the streets of New York City. His project was inspired not only by Lady Allen's adventure playgrounds, but also by Noguchi's pioneering designs. Dattner created an abstract landscape of concrete and granite forms featuring pyramids, volcanoes, tunnels, wooden climbing structures, and a tree house, set among sand and water. Parents, neighbors, and children participated in the planning process and raised money to hire a play leader to hand out construction materials, art supplies, games, and toys.[17] In his influential 1969 book *Design for Play*, Dattner traced his research into children's play and the history of his playground designs, and presented other major playgrounds in Europe and the United States. In recent years, four of Dattner's remaining Central Park playgrounds have been restored; as they were adapted to new safety standards, some of their signature elements, such as the sand floor and wooden structures, were lost.

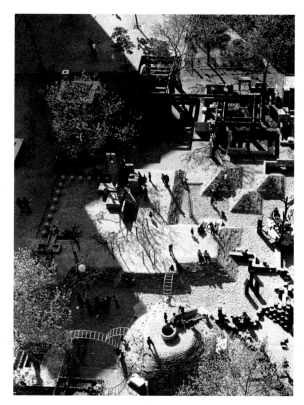

FIG. 12
Riis Plaza, Jacob Riis Houses, New York, 1965, designed by M. Paul Friedberg. Courtesy of M. Paul Friedberg

11. M. Paul Friedberg with Ellen Perry Berkeley, *Play and Interplay: A Manifesto for New Design in the Urban Recreational Environment* (London: Macmillan, 1970), 44.
12. Alison Dalton, "M. Paul Friedberg's Early Playground Designs in New York City," in *Preserving Modern Landscape Architecture*, 58.

13. Ibid., 57.
14. Central Park Conservancy, *Plan for Play: A Framework for Rebuilding and Managing Central Park Playgrounds* (New York, 2011), 57.
15. Michael Gorkin, "The Politics of Play: The Adventure Playground in Central Park," in *Preserving Modern Landscape Architecture*, 70.

16. Playgrounds that still exist today are the Sixty-Seventh Street Adventure Playground (1967), the Seventy-Second Street Playground (1970), the Eighty-Fifth Street Ancient Play Garden (1972), and the Water Playground (1973) on the very south side of Central Park.
17. Gorkin, "The Politics of Play," 64–69.

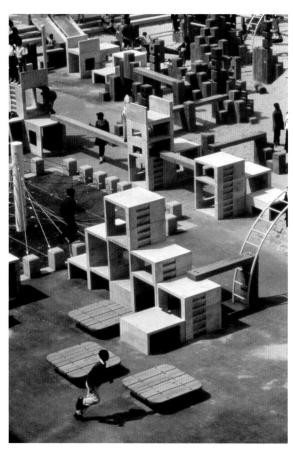

FIGS. 13–14
School yard for Buchanan High School, Washington, DC, 1966, designed by
M. Paul Friedberg. Courtesy of M. Paul Friedberg

FIG. 15
Water Playground, Central Park, New York, 1973, designed by Richard Dattner.
Courtesy of Dattner Architects

FIG. 16
Tuffsen play sculpture, 1949, designed by Egon Møller Nielsen, Humlegården, Stockholm.
Swedish Museum of Architecture

FIG. 17
Swing-Ring, c. 1953–55, designed by Joseph Brown. Special Collections,
University of Tennessee, Knoxville

PLAY SCULPTURES

Play sculptures (or play structures) are autonomous objects that offer multiple play options and accommodate a large number of children within a limited space. The first play sculptures emerged in the 1940s, and over the course of the mid-twentieth century many new forms were developed explicitly for mass production. The history of play structures reveals how new materials invaded the playground. The earliest were made of metal, wood, stone, or concrete, but in the 1960s and 1970s new products such as plastics and fiberglass were introduced. Though still durable, these new materials were lightweight and affordable; easily molded and brightly colored, they allowed for the development of new forms and shapes.

The concept of the singular play sculpture evolved into larger environments in the late 1960s when architects and designers such as Mitsuru Senda and Group Ludic began to make immersive play environments. By connecting numerous elements into a whole or by building large, complex play structures, they in effect created small universes—miniature cities within the city.

EGON MØLLER NIELSEN (1915–1959) is best known for his abstract play sculptures designed to respond to children's most primary desires: jumping, climbing, and sliding (Fig. 16). *Tuffsen* (1949) was his first play sculpture. Installed in Stockholm as part of the city's progressive plans to build a network of parks meant to serve the population as "outdoor living rooms,"[18] this biomorphic sculpture cum island surrounded by sand functions as a spatial labyrinth.

The American toy manufacturer Creative Playthings (est. 1951) believed in the creative potential of abstract play equipment. In 1953 they opened a new division, Play Sculptures, to commercialize playground equipment designed by artists; it produced Nielsen's spiral slide, which was placed in several playgrounds throughout the United States. The slide first appeared in 1959 in Cornelia Hahn Oberlander's Bigler Street Playground in Philadelphia, a city that had some of the most innovative playgrounds in the country at the time.[19]

For playground designer JOSEPH BROWN (1909–1985), "unpredictability—with reasonable limits—is the basis of man's creativity."[20] Brown had a highly unconventional and unpredictable career. Beginning as a professional boxer in 1929 in Philadelphia, he became a boxing coach at Princeton University in 1938 and a resident fellow there in sculpture. In a critique of the play equipment designed by Princeton's architecture graduate students, he proposed his own devices and designs with an open structure shaped by the actions of the user; his innovations soon

came to the attention of architects and landscape architects such as Marcel Breuer and Walter Gropius. Brown believed deeply in play as a preparation for adulthood and in the central importance of balancing and exploring the body's own limits. His frequent use of ropes was based on the belief that "one child's actions affect everyone on the plot, demanding a balancing adjustment."[21]

Brown realized several prototypes for play sculptures, none of which went into full-scale production. By 1957 his sculptures had been installed in Philadelphia, London, Tokyo, and several New Jersey towns (Fig. 17).

Very few architects have dedicated their work and research so thoroughly to children as has MITSURU SENDA (born 1941). His "architecture as play structure" concept—based on the traditional Japanese house with its corridors, passageways, and verandas—allows the house to become an open and porous play space. Senda continues to employ this model today in his designs for kindergartens, childcare centers, and children's museums.

Senda established his own office, the Environment Design Institute, in Tokyo in 1968. Concerned about society's insensitivity toward the unique needs of children, he carried out his first research on play environments in 1974. He observed that for many Japanese children, play structures had become substitutes for "those thrilling experiences in the natural environment; the enjoyment of running around the fields, the intimacy of the streets, the freedom of the scrap yard and the pleasure of the hide out."[22] Envisioning a new type of space that would enable play to develop easily and organically, he invented a circular play system that he believed must have a few key elements: a "thrill experience," shortcuts, and hideouts (Figs. 18–20). An essential feature of Senda's play environments is the sense of vertigo described by French philosopher Roger Callois in his influential book *Man, Play, and Games*: "Ilinx. The last kind of game includes those which are based on the pursuit of vertigo and which consist of an attempt to momentarily destroy the stability of perception and inflict a kind of voluptuous panic upon an otherwise lucid mind."[23]

Senda studied play environments all over the world, but in his opinion, "the place where most effort is being put into the design of play structures is, in fact, Japan, where children have the least amount of time and readily available space to play."[24]

The members of GROUP LUDIC, an interdisciplinary collective founded in 1968 in Paris, worked as playground designers and play facilitators until they dissolved in the 1990s.

18. Thorbjörn Andersson, "To Erase the Garden: Modernity in the Swedish Garden and Landscape," in Marc Treib, *The Architecture of Landscape, 1940–1960* (Philadelphia: University of Pennsylvania Press, 2002), 2.
19. Susan G. Solomon, *American Playgrounds: Revitalizing Community Space* (Hanover, NH: University Press of New England, 2005), 33–34.
20. Joseph Brown, "Unpredictability—Margin for Inspiration," *Architectural Record* 118 (September 1955): 226.
21. Ibid., 228.
22. Mitsuru Senda, "Playground Types in Japan," *Process: Architecture*, no. 30, *Playgrounds and Play Apparatus* (1982): 19–20.
23. Roger Callois, *Man, Play, and Games* (New York: Free Press of Glencoe, 1961), 23; first published in French as *Les jeux et les hommes* (Paris: Librairie Gallimard, 1958).
24. Mitsuru Senda, in "Design of Environment Play Structures," *Process: Architecture*, no. 121, *Environment Architecture* (1994): 76.

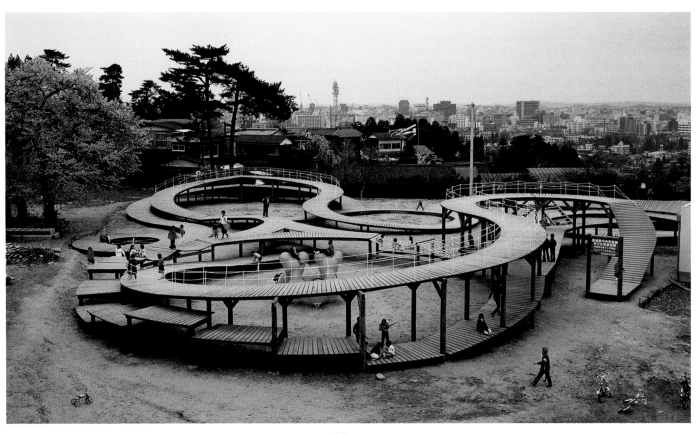

FIG. 18
Running Circuit, at Miyagi Children's Hall, Sendai, Miyagi Prefecture, Japan, 1979, designed by Mitsuru Senda.
Courtesy of Environment Design Institute, Tokyo

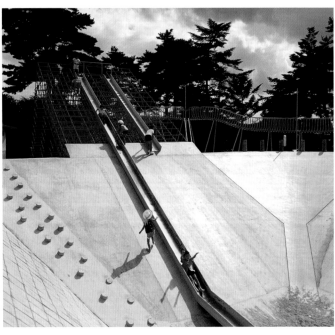

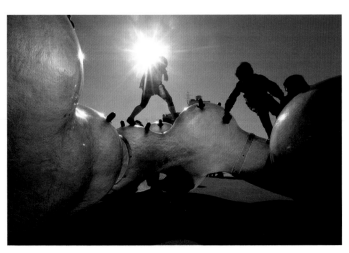

FIG. 20
Ping Pong, 1979, designed by Mitsuru Senda. Courtesy of
Environment Design Institute, Tokyo. Ping Pong, made of semitransparent
fiber-reinforced plastic (FRP), is an example of a so-called community
play structure, designed for mass production.

FIG. 19
Giant Path play structure, Mukoyama Children's Park, Sendai,
Miyagi Prefecture, 1969, designed by Mitsuru Senda.
Courtesy of Environment Design Institute, Tokyo. The long slide
leads to a large hollow from the triangular jungle gym.
Giant Path was Senda's first play structure.

Different tendencies coexisted within the group, which comprised architect Simon Koszel (born 1939), fashion designer David Roditi (born 1937), and sculptor and social scientist Xavier de la Salle (born 1938): the preference for adventure playgrounds and spontaneous creativity; an ambition for good design and form; and an interest in new materials and production techniques. Their so-called *sphères* (polyester globes on stilts), for example, were developed in collaboration with industrial fabricators (Fig. 21).

Group Ludic became known for their unconventional way of working, particularly their practice of involving children in the design process. Their comprehensive approach sometimes led to conflicts with their clients and investors, who expected a standardized ready-made playground. They built numerous projects in France for the *villes nouvelles* (new suburban cities) and *grands ensembles* (large-scale housing estates). Yet Group Ludic's insistence on developing overall concepts for the estates, not just for the playground elements, often alienated the clients and led to their exclusion from competitions.

The group also developed playgrounds for several French family holidays resorts (Village Vacances Familles, or VVF) and were invited to organize temporary play environments for commercial or community events all over France (Figs. 22–23). For these projects Group Ludic offered creative activities, film projections, and spaces for recess and storytelling. They were designed to provide valuable insight into children's play, functioning as instant "play laboratories."

In the 1980s, as the *villes nouvelles* became hot spots of social unrest in France, Group Ludic's comprehensive approach for the design of neighborhood playgrounds became impractical. Play facilities were no longer able to offer substantial solutions for these serious urban problems.

French artist <u>NIKI DE SAINT PHALLE</u> (1930–2002) is best known for her mystical and exuberant sculptures. Often sited outdoors, some of them were large enough to be entered or inhabited and could function as play sculptures.

In 1966 Pontus Hultén, director of the Moderna Museet in Stockholm, invited Saint Phalle to build a monumental indoor sculpture for the museum. Titled *Hon—En katedral* (*She—A Cathedral*), it took the form of a gigantic pregnant goddess. Visitors entered the sculpture through the figure's spread legs and vagina to find inside a bar serving milk, a movie theater, a slide, a planetarium, and an aquarium; a roof terrace was perched on the figure's belly.

In the 1970s Saint Phalle created two more walk-in sculptures in which the contrasting experience of a vibrantly colored exterior and a dark, cavernous interior was both seductive and somewhat uncanny. *Golem*, also called *Mifletzet* (1972), her first architectural project for children, was commissioned by the Jerusalem Foundation for Rabinovich Park in that city (Fig. 24).[25] The three red tongues of the black-and-white monster serve as slides, while the interior functions as a children's playhouse. Saint Phalle built another playhouse, titled *Dragon* (1975), for the family of Roger and Fabiens Nellens in Knokke-le-Zoute, Belgium. It was a fully equipped, cavelike house for children that again had a tongue as a slide into the outside world. In all of these projects, Saint Phalle broke with the "rule" of abstraction that was prevalent among modern play-structure designers who attributed a higher creative value to abstract play sculptures over figurative ones.

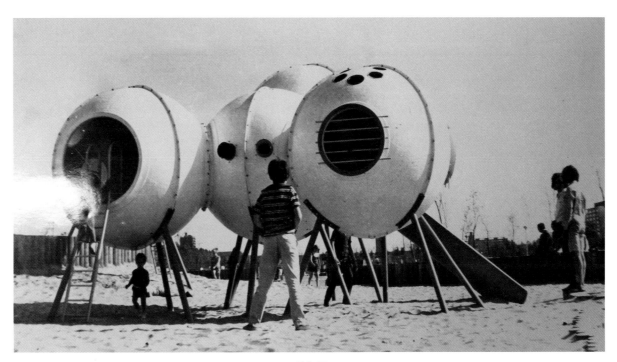

FIG. 21
Sphères on stilts, Rembrandt Park, Amsterdam, c. 1970, designed by Group Ludic. Courtesy of Xavier de la Salle

25.　The Jerusalem Foundation was committed to providing new parks and playgrounds in poor Arab neighborhoods.

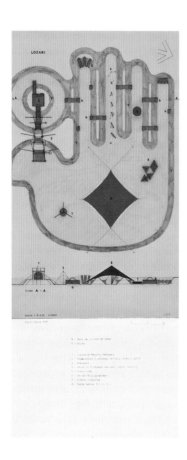

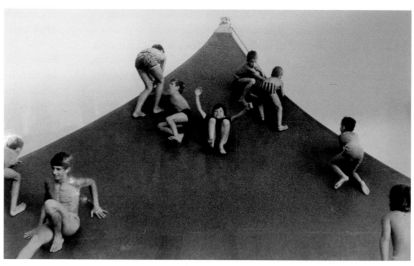

FIG. 22
Site plan for playground for Lozari family
holiday resort (VVF), Corsica, 1970,
designed by Group Ludic. Courtesy of Xavier
de la Salle

FIG. 23
Slide made out of polyester fabric, playground
for Lozari family holiday resort (VVF),
Corsica, 1970, designed by Group Ludic.
Courtesy of Xavier de la Salle

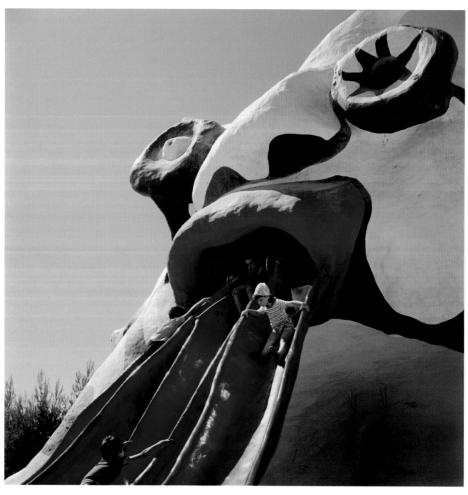

FIG. 24
Views of *Golem (Mifletzet)*, 1972, by Niki de Saint Phalle, in Rabinovich Park, Jerusalem

DIY PLAYGROUNDS

"I used to think that I wanted to build playgrounds *for* people; then I thought that I would build *with* people; but now I see that by far the best—though most difficult—way is to encourage people to build *for themselves.*"

— Paul Hogan, *Playgrounds for Free*

The 1970s launched an era of self-empowerment and self-reliance marked by an emphasis on learning by doing and sharing one's knowledge, often through self-published books. DIY (Do-It-Yourself) initiatives in the public sphere mobilized local communities, particularly in the United States, empowering them to shape their own environment.

Until the early 1980s many playgrounds for schools, nursery schools, and neighborhoods were built through the collaboration of parent-teacher associations or other nonprofit organizations, children, and skilled volunteers. Built with surplus material, such as utility poles, cables, tires, and concrete pipes, these playgrounds were developed quickly and with minimal funding.

In 1961 landscape architect Karl Linn (1923–2005) founded the Neighborhood Renewal Corps in Philadelphia, which assisted members of disadvantaged communities in reclaiming, designing, and rebuilding urban spaces. As director of construction for the Neighborhood Renewal Corps, Paul Hogan supported local communities throughout Pennsylvania in building their own playgrounds; in 1972 he directed the Playgrounds for Free Program, which provided play spaces for the flood victims of Hurricane Agnes. His first book, *Playgrounds for Free*, was published in 1974, illustrating hundreds of playgrounds built with surplus material in Pennsylvania and abroad and introducing the nuts and bolts of the DIY playground (Fig. 25). Such manuals with plans, drawings, and practical instructions started to circulate in the 1970s and served as step-by-step instructions for building playgrounds; they celebrate an accessible and purposely lo-fi aesthetic, and are often accompanied by humorous pictures.

* * *

Playgrounds are transitional spaces for children, places that lie between the familiarity of home and the unfamiliar territory of the city. In allowing children to gain access to a larger community beyond the family, playgrounds and other places for play are crucial both to the city's fabric and to children's lives. This is especially true in a time of seemingly infinite choices in a globally digitized world, where video games and social media compete with local community experiences.

The history of playgrounds shows that innovative concepts frequently evolve out of necessity: the junk/adventure playground responded to the scarcity of materials following World War II; landscape playgrounds, despite their artificiality, provided an urban experience of natural forms; play sculptures created lively and family-friendly places in large and increasingly anonymous housing estates; and DIY emerged as a way for people to create their own play spaces out of nothing.

Today, playground design is almost exclusively in the hands of risk-averse manufacturers who create standardized experiences meeting liability requirements. It seems that once again we have reached a moment that asks for a joyful and courageous remaking of playgrounds led by landscape architects, architects, artists, designers, and users to expand the creative possibilities of these spaces that are so essential to our community life.

FIG. 25
Cover of Paul Hogan, *Playgrounds for Free: The Utilization of Used and Surplus Materials in Playground Construction* (Cambridge, MA: MIT Press, 1974)

THE PARTICULARITIES OF PITTSBURGH
Episodes from a History of Collecting

ROBERT BAILEY

Carnegie Museum of Art and the *Carnegie International* have a singular relationship. It is a rare thing for a museum to host a large-scale, recurring exhibition of current art from around the world, and even rarer for a museum to build so much of its collection of modern and contemporary art through acquisitions of artworks exhibited in one. The result of this special arrangement between the institution and the *International* is an at times surprising and not infrequently uneven collection of art that mirrors the interests, attitudes, and decisions of the directors, curators, and juries involved in the endeavor since its inception in 1896.[1] The museum's collection thus uniquely provides visitors not only with a history of art but also with an idiosyncratic history of art collecting that testifies to the whys and hows by which the museum's permanent collection has come together over the decades. The collection also provides the *International* with a kind of permanence enjoyed by no other temporary exhibition. Whenever a new work is acquired from it, an element of an ephemeral survey of the present moment becomes a part of an enduring gathering of artworks that is rich in history.

The *2013 Carnegie International* is in deeper and more conscious touch with the history of the museum's collection than were previous iterations of the exhibition. The curators drew on themes present in the collection, and they have even gone so far as to include a reinstallation of the contemporary galleries as part of the *International* (a list of the artists represented in the reinstallation is presented on pages 308–9). Usually, large parts of these galleries are temporarily displaced into storage to make room for the exhibition, disconnecting what the *International* presents at a given moment from the exhibition's lengthy and complex past as reflected in the museum's holdings. Such self-reflection is characteristic of recent efforts by arts institutions to become more transparent to their publics and better articulate their mission as civically beneficial. By drawing on the uniquely intertwined histories of Carnegie Museum and the *Carnegie International*, the 2013 iteration of the exhibition makes a case for the broad relevance of what is particular to the history of art in Pittsburgh. This essay highlights selected aspects of this particularity, especially those that informed the current curatorial team's thinking

and enlivened the exhibition they made together. In accordance with this goal, it largely omits areas of strength in the museum's collection—Minimalist sculpture of the 1960s and 1970s, for instance—that are not closely related to the *Carnegie International*.

In 1896 Andrew Carnegie appointed John W. Beatty— Pittsburgh native, artist, and art teacher—to be the first director of the Department of Fine Arts (now the Museum of Art). From his appointment until his retirement in 1921, his duties included overseeing the *Annual Exhibition*, what we now call the *Carnegie International*. Unlike his business partner Henry Clay Frick, Carnegie was never much of an art collector. He hoped the *Annual Exhibition* would gradually provide his new institution with a permanent collection of its own that would both further the educational mission of the Carnegie Institute and make Pittsburgh a cultural hub to rival New York City.[2] Drawing on the 1893 World's Columbian Exposition in Chicago and the Paris Salons as models, the *Annual Exhibition* endeavored to show the best examples of international contemporary art each year. Beatty, aided by a Fine Arts Committee composed largely of Pittsburgh business leaders, was assigned the task of identifying and buying works from the exhibition. This strategy of building the museum's collection of contemporary art from the *International* persists today, although now the museum's curators are responsible for recommending purchases. Beatty's ideas about art, recorded in his 1922 book *The Relation of Art to Nature*, were a good match for Carnegie's belief in scientific progress and well suited to the idea of an annual exhibition building the museum's collection.[3] Believing that art improved incrementally over time, Beatty was an aesthetic conservative who had difficulty admiring works that did not obey this rule of gradual progress. Prizes at early *Annual Exhibition*s were given largely to Americans working in Realist and Impressionist styles, including George Bellows, Thomas Eakins, Childe Hassam, Winslow Homer, and John Sloan. Foundational for the collection were early acquisitions of works by a mixture of prominent Americans and Europeans, including, in addition to Bellows, Hassam, Homer, and Sloan, John White Alexander, Mary Cassatt, Camille Pissarro, Alfred Sisley, Henry O. Tanner, and James Abbott McNeill Whistler. Beatty struggled, however, to keep up with more

1. On the history of the *Carnegie International* generally, see Vicky A. Clark, ed., *International Encounters: The Carnegie International and Contemporary Art, 1896–1996* (Pittsburgh: Carnegie Museum of Art, 1996). On the early history of the exhibition, see Kenneth Neal,

A Wise Extravagance: The Founding of the Carnegie International Exhibitions, 1895–1901 (Pittsburgh: University of Pittsburgh Press, 1996).
2. As further evidence of this, when some works from the Armory Show— the exhibition most responsible for

introducing modernism to America— toured Pittsburgh in 1913, it was shown at Boggs and Buhl Department Store rather than at the Carnegie.
3. John W. Beatty, *The Relation of Art to Nature* (New York: William Edwin Rudge, 1922).

Winslow Homer
The Wreck, 1896, oil on canvas, 30 ⅜ x 48 ⁵⁄₁₆ (77.2 x 122.7 cm)
Purchase, 96.1

Robert Gwathmey
Hoeing, 1943, oil on canvas, 40 x 60 ¼ in. (101.6 x 153 cm)
Patrons Art Fund, 44.2

John Sloan
The Coffee Line, 1905, oil on canvas, 21 ½ x 31 ⅝ in. (54.6 x 80.3 cm)
Fellows of the Museum of Art Fund, 83.29

Rockwell Kent
"Europe" 1947, 1947, lithograph on paper, 15 ⅞ x 12 in. (40.3 x 30.5 cm)
Gift of the artist, 48.16.1

radical artistic movements that were little interested in naturalistic representation, such as Post-Impressionism and Cubism, and the *Annual Exhibition* fell out of step with some of the most exciting developments in art, specifically abstraction. A sign of the museum's discomfort with artistic radicalism was the reaction to Sloan's *The Coffee Line*, which received an honorable mention in 1905. Though the work broke with both Realist and Impressionist traditions, it was not nearly as formally daring as contemporary work from Europe; even so, *The Coffee Line* was deemed too artistically and politically problematic to purchase at the time and entered the museum's collection only in 1983.

It would be some time before the *International* (the modifier, first used in 1901, finally stuck in 1920) found itself at the forefront of new developments in modern art;

as a result, major avant-garde movements from Europe such as Dada, Surrealism, and Constructivism are almost entirely absent from the collection. On the flip side, the museum did strengthen its holdings of American Realists, regionalists, and self-taught artists, including Ivan Albright, Charles Burchfield, Clarence Holbrook Carter, Robert Gwathmey, Edward Hopper, John Kane, Rockwell Kent, and Leon Kroll. Burchfield, a Western New Yorker whose work blends a rural localism with otherworldly visionary qualities, won multiple prizes for his contributions to the *International*. In 1944 Mr. and Mrs. James H. Beal purchased for the museum's permanent collection Burchfield's *The Great Elm* (1939–41), exhibited that year in the *International*. Ever a partisan of the local, Burchfield described the tree that he depicted in the painting, which stood six miles from his home in rural Gardenville outside

Edward Hopper
Cape Cod Afternoon, 1936, oil on canvas, 34 x 50 in. (86.4 x 127 cm)
Patrons Art Fund, 38.2

John Kane
Scene from the Scottish Highlands, c. 1927, oil on canvas,
23 ¼ x 27 ⅛ in. (59.1 x 68.9 cm)
Gift of G. David Thompson, 59.11.1

Charles E. Burchfield
Sun Glitter, 1945, watercolor on paper,
30 x 25 ⅛ in. (76.2 x 63.8 cm)
Gift of Mr. and Mrs. James H. Beal, 46.20.1

Buffalo, as "one of the glories of Western New York." [4]
Kane, a self-taught artist, was, like Carnegie, a Scottish
immigrant. After a career as a laborer on the railroads and
in coke ovens of Western Pennsylvania, Kane made head-
lines when, following failed attempts in 1925 and 1926,
he won the favor of the *International*'s jury and showed
Scene from the Scottish Highlands in the 1927 exhibition
to great media sensation, becoming an artistic success for
the first time at the age of sixty-seven. Collector G. David
Thompson gave the painting to the museum in 1959, and

it is now one of many Kane paintings in the permanent
collection depicting Scottish and Western Pennsylvanian
themes. Kane's breakthrough into the *International* and
the museum's collection anticipates the inclusion of
other so-called self-taught artists in subsequent exhibi-
tions, including Joseph Yoakum and Guo Fengyi in the
2013 Carnegie International. It also, like the acquisition of
Burchfield's *The Great Elm*, helped establish a focus on
the local and artists concerned with place, another theme
that runs deep in the *2013 Carnegie International*.

4. Charles Burchfield, letter to
Mrs. James H. Beal, December 7,
1944, viewable online at http://www.
cmoa.org/searchcollections/details.
aspx?item=1007553.

Marsden Hartley
Sustained Comedy, 1939, oil on board, 28 ⅛ x 22 in. (71.4 x 55.9 cm)
Gift of Mervin Jules in memory of Hudson Walker, 76.64

Thomas Hart Benton
Plantation Road, 1944–45, oil and tempera on canvas mounted
on plywood, 28 ½ x 39 ⅜ in. (72.4 x 100 cm)
Patrons Art Fund, 46.22

Henry Koerner
It Isn't the Heat, It's the Humidity, 1947–48, oil on panel,
36 x 26 ⅜ in. (91.4 x 67 cm)
Purchase: gift of the Judith Rothschild Foundation, 2001.29

Homer Saint-Gaudens, who organized nearly every *International* from 1922 to 1950 as director of the Department of Fine Arts, was more adventurous than Beatty in celebrating European artists like Pablo Picasso and Henri Matisse with prizes, although the museum purchased works by neither at the time. Saint-Gaudens also expanded the exhibition's internationality by introducing the idea of foreign advisors to assist with research and correspondence with artists in Europe. During World War II, borrowing work from overseas proved difficult, so the *International* was temporarily reconfigured as an exhibition about painting in the United States; works by Thomas Hart Benton and Marsden Hartley entered the collection during this period. American painting was also key for Saint-Gaudens's successor, Gordon Bailey Washburn, who finally plunged headlong into the most advanced modern art of the era, which, in the 1950s, was for the first

time being made in the United States. Washburn gave the *International* renewed currency by highlighting American abstract painters, who had begun to appear in the exhibition in greater numbers during the end of Saint-Gaudens's tenure. Washburn oversaw acquisitions of major paintings by Willem de Kooning, Richard Diebenkorn, Sam Francis, Helen Frankenthaler, Ellsworth Kelly, Franz Kline, and Robert Motherwell. A major sculpture by Alberto Giacometti was also acquired under Washburn. Given that Pittsburgh audiences had little experience with abstract art, having been exposed primarily to Realist artists through the *International*, Washburn undertook considerable pedagogical efforts, including lecturing on the subject of abstraction on the local public television station WQED. He also invited Art Institute of Chicago curator Katharine Kuh to organize for the Carnegie a multimedia exhibit designed to aid viewers in the interpretation of abstract art (see pages 269–76).

Willem de Kooning
Woman VI, 1953, oil on canvas, 68 ½ x 58 ½ in. (174 x 148.6 cm)
Gift of G. David Thompson, 55.24.4

Charles "Teenie" Harris
Photographer taking picture of Muhammad Ali (Cassius Clay),
possibly in Carlton House Hotel, Downtown, 1963,
gelatin silver print made from original negative, 2013
Heinz Family Fund, 2001.35.3162

Elliott Erwitt
Storefront of Giant Eagle Market, 1950, gelatin silver print,
8 ¾ x 13 ⅜ in. (22.2 x 34 cm)
Gift of the Carnegie Library of Pittsburgh, 83.6.27

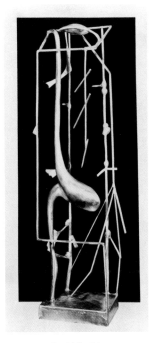

David Smith
All Around the Square, 1951,
stainless steel, 43 ½ x 14 x 9 in. (110.5 x 35.6 x 22.9 cm)
Gift of G. David Thompson, 55.54.2

As Pittsburgh belatedly became acquainted with abstraction, it was also undergoing radical urban transformations that were the subject of a very different aesthetic, which was documentary. Roy Stryker, who played an instrumental role in the careers of photographers Dorothea Lange and Walker Evans as head of the Information Division of the Farm Security Administration during the Great Depression, directed a photographic survey of Pittsburgh from 1950 to 1953. He hired photographers such as Elliott Erwitt, Clyde Hare, and Richard Saunders to document the city before an urban-renewal project known as

"Renaissance" forever changed its appearance by beginning to remove traces of the industrial past.[5] Now known as the Pittsburgh Photographic Library and housed at the Carnegie Library of Pittsburgh—which shares a building with Carnegie Museum of Art—the collection consists of 18,000 photographs showing the city on the cusp of a radical transformation. Photographer Charles "Teenie" Harris was also documenting the changing urban landscape and produced an archive of 80,000 images between the mid-1930s and mid-1970s that record in detail the history of Pittsburgh's African American community.[6] Although these

5. On the Pittsburgh Photographic Library, see Clarke M. Thomas, *Witness to the Fifties: The Pittsburgh Photographic Library, 1950–1953*, ed. Constance B. Schulz and Steven W. Plattner

(Pittsburgh: University of Pittsburgh Press, 1999).
6. On Teenie Harris, see Cheryl Finley, Laurence Glasco, and Joe W. Trotter, *Teenie Harris, Photographer: Image,*

Memory, History (Pittsburgh: Carnegie Museum of Art and University of Pittsburgh Press, 2011).

Mel Bochner
Measurement: Plant (Palm), 1969, live plant and tape on wall,
dimensions variable
Carnegie Mellon Art Gallery Fund, 1997.37

Marcel Broodthaers
Untitled (Les portes du musée) (The Doors of the Museum), 1968–69,
paint on plastic, 74 13/16 x 10 7/8 in. (190 x 180 cm)
A. W. Mellon Acquisition Endowment Fund, Roy O. Mitchell Fund,
Founder Patrons Day Acquisition Fund, and Patrons Art Fund, 90.24

and other documentary photographs were not considered for inclusion in the *International* at that time, such works are now recognized as art; Harris's photographs came into the collection in the 1990s and 2000s.

Washburn's brilliant tenure as director, which coincided with a renaissance for the *International*, was shorter than that of either of his predecessors, lasting from 1950 until 1962. During the decades that followed, the relevance of the exhibition was often in doubt. Museums around the United States had begun hosting their own competing versions, such as the Guggenheim International. Sculptor David Smith, frustrated with the *International*'s "archaic system of awards," famously rejected a third-place prize in 1961 and asked that his prize money be used "toward an art purchase for the Museum."[7] Although major figures such as Jasper Johns,

Robert Rauschenberg, and Paul Thek exhibited in the *International* (known as the *Pittsburgh International* during the 1950s and 1960s), its organizers largely failed to collect works representative of such key developments as Pop, Minimalism, and Conceptual art. Subsequent curators filled these holes in the collection retroactively through acquisitions of works such as Pittsburgh native Mel Bochner's *Measurement: Plant (Palm)* (1969) and Marcel Broodthaers's *Untitled (Les portes du musée)* (*The Doors of the Museum*; 1968–69), the latter following his 1989 exhibition at the museum. Presaging the global sweep of more recent surveys, the exhibition was geographically broader than ever before during this period, and works by artists from Eastern Europe, Asia, and Latin America entered the collection in larger numbers than in the past. Meanwhile, the museum was on the cutting

7. David Smith, quoted in Alvin Rosensweet, "Sculptor Refuses $1,000," *Pittsburgh Post-Gazette*, November 1, 1961. See p. 235, fig. 3.

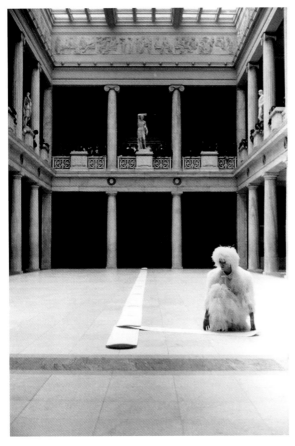

James Lee Byars
Still from *The Mile Long White Paper Walk*, 1965, 16mm film
transferred to video, black-and-white, silent, 9:32 min.
Created by James Lee Byars and performed by Lucinda Childs
at the Museum of Art, Carnegie Institute, October 25, 1965, under
the auspices of the Women's Committee of Carnegie Institute

Frank Stella
Delaware Crossing, 1967, alkyd on canvas, 55 x 55 in. (139.7 x 139.7 cm)
Gift of James H. and Idamae B. Rich, 2007.74

edge in other ways, such as introducing Performance art to Pittsburgh through "Happenings" by James Lee Byars that took place in its Hall of Sculpture in 1964 and 1965. To assess what might be done with the somewhat stagnating *International*, the Mellon Foundation was invited to analyze it. Their report, published in 1972, was severely critical of the format to which the *International* had clung since its earliest days, by which each participating artist contributed only one work.[8]

After the 1970 *International*, the exhibition temporarily ceased altogether. Taking advantage of the new, spacious Heinz and Scaife Galleries designed by Edward Larrabee Barnes and opened in 1974, it was launched anew in 1977 on the recently successful model of the blockbuster exhibition.[9] (*The Treasures of Tutankhamun*, which is

exemplary of this spectacular and entertaining exhibition format, drew eight million visitors as it toured the United States between 1976 and 1979.) In place of the usual group exhibition, director Leon Arkus chose to stage career-spanning retrospectives of Pierre Alechinsky in 1977 and Willem de Kooning and Eduardo Chillida in 1979. The *Pittsburgh International Series*, as the exhibition was dubbed for these shows, largely departed from the *International*'s original mission of building the collection. The museum acquired only two works—one each by Alechinsky and de Kooning—from these exhibitions. Nevertheless, other projects at the museum had been building steam during the 1970s and would supplement the *International*'s shortcomings, particularly concerning the collection. Foremost among them, the Film Section (later the Department of

8. Carolyn Wells, "Report on the Pittsburgh International Exhibition of Contemporary Art: Prepared for the A. W. Mellon Educational and Charitable Trust," transcript, Carnegie Museum of Art, 1-1-2, Appendix A, cited in Clark,

ed., *International Encounters*, 141n11.
9. Pittsburgh newspaper publisher, philanthropist, and heir to the Mellon fortune Richard Mellon Scaife was the key benefactor of the Sarah Scaife Galleries, named in honor of his mother. H. J. Heinz

II, former chief operating officer of the H. J. Heinz Company, and his wife, Drue Heinz, a noted supporter of the literary arts, were the patrons of the Heinz Galleries.

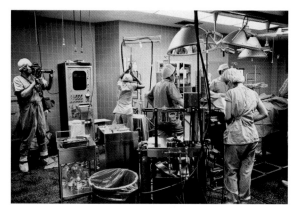

Stan Brakhage
Documentary photograph of production of "The
Pittsburgh Trilogy," 1971

Stephanie Beroes
Still from *Debt Begins at Twenty*, 1980, 16mm film transferred
to video, black-and-white, sound, 40 min.
Pennsylvania Council on the Arts and John D. and Catherine
T. MacArthur Foundation, 91.4.1

Hollis Frampton
Still from *Winter Solstice*, 1975, 16mm film transferred
to video, color, silent, 33 min.
National Endowment for the Arts Purchase Grant for
the Acquisition of Films by Living American Film Makers and
Director's Discretionary Fund, 77.24.28

Film and Video), founded in 1970, began collecting experimental film and thereby became an early institutional supporter of media arts. Its founding curator, Sally Dixon, and her successor, Bill Judson, brought, among many others, Kenneth Anger, Stan Brakhage, Robert Breer, Bruce Conner, Hollis Frampton, Yvonne Rainer, Carolee Schneemann, and Paul Sharits to Pittsburgh to present their work. Some, like Brakhage and Frampton, stayed for extended periods to shoot and edit new films. While in residence, Brakhage filmed what is often called "The Pittsburgh Trilogy," a three-film suite comprising *Eyes*, *Deus Ex*, and *The Act of Seeing with One's Own Eyes* (all 1971), which concerned public institutions in the city, focusing, respectively, on the police, a hospital, and an autopsy. Frampton, too, did work while in residence, filming *Winter Solstice*, part of

his Magellan cycle, at Homestead Steel Works in 1974.[10] Seminal films by these and other experimental filmmakers were acquired by the museum in the 1970s through a grant from the National Endowment of the Arts to support living American artists.

During the 1980s, under the directorship of John R. Lane, the *Carnegie International* acquired its current name, again became a survey, and gradually regained its prominence as a major exhibition of contemporary art. Adopting the now-standard and familiar format of the contemporary art biennial (though not the biannual schedule), the exhibition has since 1982 included work by roughly a few dozen prominent contemporary artists, often grouped around an organizing theme or a set of interests provided by a changing cast of curators. As far as

10. On Magellan and Pittsburgh, see Melissa Ragona, "Hidden Noise: Strategies of Sound Montage in the Films of Hollis Frampton," *October* 109 (Summer 2004): 96–118.

Georg Baselitz
Die Verspottung (The Mocking), 1984, oil on canvas,
118 ¼ x 95 ⅝ in. (300.4 x 242.9 cm)
Gordon Bailey Washburn Memorial Fund, the Women's
Committee Washburn Memorial Fund, and Carnegie International
Acquisition Fund, 85.2

Sigmar Polke
Hochsitz II (Watchtower II), 1984–85, silver, silver oxide,
and synthetic resin on canvas, 119 ⅝ x 88 ¾ in. (303.9 x 225.4 cm)
William R. Scott, Jr. Fund, 85.17

the collection is concerned, the 1980s were a decade for acquiring works by major artists such as Cindy Sherman and Bill Viola who had recently come to prominence. It was also a decade to make amends for having missed key artistic developments of the past. Conceptual artist Sol LeWitt's large *Wall Drawing #450, A wall is divided vertically into four equal parts. All one-, two-, three-, and four-part combinations of four colors* (1985) was acquired, and it remains prominently on view along the main staircase of the museum's 1974 addition. Postminimalist sculptor Richard Serra's *Carnegie* (1985), which won the Carnegie Prize in 1985, stands outside the Museum of Art entrance. Additionally, in 1985 and 1988 German painters, including Georg Baselitz, Günther Förg, Anselm Kiefer, Sigmar Polke, and Gerhard Richter, entered the collection in large numbers. While the collection again began to benefit from

the *International* as it reentered the spotlight of the global art world, Pittsburgh's local art scene was also burgeoning in parallel. Filmmaker Stephanie Beroes chronicled the local punk scene in *Debt Begins at Twenty* (1980), a half-fictional, half-documentary film focused on drummer Bill Bored (played by William von Hagen, who drummed in the Pittsburgh garage rock band The Cynics during the mid-1980s). After the collapse of industry in Pittsburgh, the city and its culture—both institutional and underground—were finding themselves again.

For helping to pioneer the notion of site-specificity and thereby consolidating the exhibition's renewed importance, the 1991 *Carnegie International* is an obvious predecessor to the current one.[11] Organized by Lynne Cooke and Mark Francis, the exhibition included many artists who drew on Pittsburgh, its institutions, and its

11. On site-specificity in contemporary art, see Miwon Kwon, *One Place After* *Another: Site-Specificity and Locational Identity* (Cambridge, MA: MIT Press, 2004).

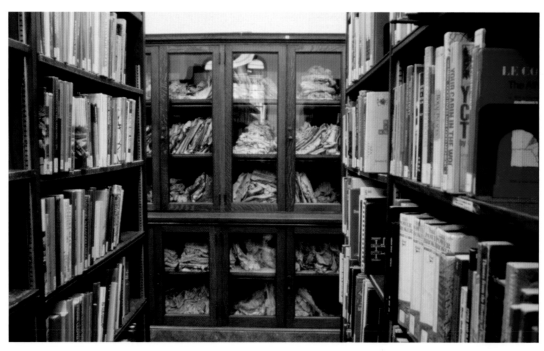

Huang Yong Ping
Installation view of *Unreadable Humidity*, 1991, pulped paper, 90 x 295 ¾ x 28 in.
(228.6 x 751.2 x 71.3 cm), in the 1991 *Carnegie International*
Element of installation: Carnegie International Acquisition Fund, 92.54

surroundings to make work in situ. Huang Yong Ping, Ken Lum, and Tim Rollins + K.O.S. each exemplified the spirit of the local by working with libraries in Pittsburgh to develop connections between art and literature that serve as reminders of the Carnegie Institute's comprehensive and integrated approach to providing Pittsburgh with access to culture and knowledge. Huang pulped a number of disused books about art from the collection of the Carnegie Library and installed them in the music and art section of the library—in rooms that were once used to display the *Carnegie International*—to meditate on use, reuse, and history. Lum donated bilingual poetry anthologies (including Inuit-English, Japanese-English, and Maltese-English) to each Pittsburgh branch of the Carnegie Library as part of his contribution to the exhibition, thereby establishing links between languages, places, and cultural traditions. Rollins + K.O.S., whose collaborative practice draws on books as both material and thematic sources, made unique works of art on the pages of twenty-one books in the collection of the Carnegie Library in the Homewood neighborhood, where they "wait to be discovered always."[12] A portion of Huang's installation and a painting by Rollins + K.O.S. entitled *The Temptation of Saint Anthony—The Forms* (1991), which was produced in collaboration with local teenagers and the museum's education department, are among the many important works acquired from the *International* during this banner year, which also saw pieces by Louise Bourgeois, Robert Gober, On Kawara, and Glenn Ligon entering the collection.

Since the 1991 *International*, the exhibition has continued to take form as a global survey of contemporary art,

and individual curators have brought their unique interests and approaches to it. In 1995 Richard Armstrong organized an *International* strong in sculpture that extended the legacy of Minimalism in aesthetically subtle ways, with works by Richard Artschwager and Doris Salcedo entering the collection that year. Madeleine Grynsztejn organized an ambitious exhibition in 1999 that showed work in a wider range of media than in previous *Internationals*, always strong in painting and sculpture, had tended to offer, and she pressed harder on issues of globalism than had any of her predecessors. Technically innovative photographs and videos by Thomas Demand, William Kentridge, and Jeff Wall—each based on a different continent—were among the works acquired from the exhibition. Laura Hoptman emphasized weighty themes and big questions in the 2004 *International*, and Paul Chan's terrific and terrifying video *Happiness (Finally) after 35,000 Years of Civilization (after Henry Darger and Charles Fourier)* (2000–2003) and Rachel Harrison's *Utopia* (2002) became part of the collection that year. Most recently, Douglas Fogle foregrounded the strangeness, precariousness, and longing of "Life on Mars," the title he gave to the 2008 *International*. Mike Kelley's *Kandor 20* (2007) was among the works acquired from that exhibition. The work draws on the mythos of the comic-book character Superman—specifically, the story of his home city Kandor being shrunken and stolen by the villain Brainiac—to meditate on home, place, and displacement, thereby exemplifying perfectly Fogle's exhibition thematic and certain prevailing conditions of life in the aftermath of globalization.

The *Carnegie International* has, through these curators' efforts, kept pace with a global contemporary art

12. Tim Rollins + K.O.S., untitled statement in *Carnegie International 1991*, vol.

1 (Pittsburgh: Carnegie Museum of Art; New York: Rizzoli, 1991), 122.

Paul Chan
Happiness (Finally) after 35,000 Years of Civilization (after Henry Darger and Charles Fourier), 2000–2003, digital animation and sparkle vellum screen; color, sound
A. W. Mellon Acquisition Endowment Fund, 2005.3

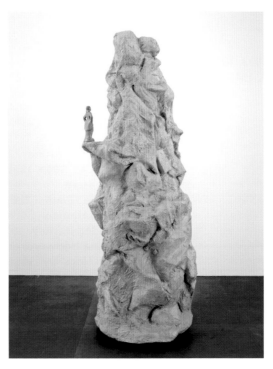

Rachel Harrison
Utopia, 2002, wood, polystyrene, cement,
acrylic, porcelain figurine, and pyrite, 80 x 40 x 38 ½ in.
(203.2 x 101.6 x 97.8 cm)
Oxford Development Fund, 2002.37

world and given Pittsburghers regular reports about and exposure to it; yet it has been somewhat remiss in speaking to what Pittsburgh uniquely offers that world in return. In many ways the *International* has become largely indistinguishable from other exhibitions like it, which now number in the hundreds and take place everywhere from Beijing to Berlin, Sharjah to Sydney. The essential contradiction animating such exhibitions in their current configuration is to produce a picture of art today that is compelling both locally and globally, that satisfies one particular place's curiosity about what is happening elsewhere while simultaneously piquing the curiosity of the world about what is happening in that one particular place. For the *Carnegie International*, that challenge is met when Pittsburgh receives a vision of the world that stirs the world to be curious about Pittsburgh.

So what, finally, follows from the unique relationship that Carnegie Museum of Art, arguably the first

museum of modern art in the United States, maintains with the *Carnegie International*, the oldest recurring exhibition of contemporary art in North America? In a word, history. But that is too simple. To be more precise, the *International* has afforded the museum unique opportunities to tell multiple overlapping histories of modern and contemporary art at once: histories of art, curating, educating, and collecting; local, international, and global histories; histories of an institution, an exhibition, and a collection that is equally telling for inclusions and omissions. Rarely are such histories so densely interwoven with one another and so continuously renewed, much less across a span of time now well exceeding a century. Throughout that time, what has kept these histories in such close proximity is the museum's continuous practice of collecting from the *Carnegie International*. The *2013 Carnegie International* makes these histories visible in all their particularities.

ARTIST LIST

2013 *Carnegie International* Contemporary
Galleries Reinstallation

Artists who were included in past *Carnegie International* exhibitions are indicated by the year(s) of their participation.

Berenice Abbott
John Ahearn (1985)
Doug Aitken (2008)
Ivan Albright (1927, 1928, 1929, 1930, 1933, 1935, 1936, 1937, 1938, 1939, 1940, 1943, 1944, 1945, 1946, 1947, 1948, 1949, 1950, 1964)
Pawel Althamer (2004)
Carl Andre
Kenneth Anger
Cory Arcangel
Robert Arneson
Jean Arp (1958, 1961, 1964)
Richard Artschwager (1988, 1995)
Jo Baer
John Baldessari
Georg Baselitz (1985, 1988, 1995)
Bernd and Hilla Becher
Lynda Benglis
Thomas Hart Benton (1931, 1933, 1934, 1935, 1936, 1937, 1938, 1939, 1940, 1943, 1944, 1945, 1946, 1947, 1948, 1949)
Stephanie Beroes
Dara Birnbaum (1985)
James Blair
Mel Bochner
Ilya Bolotowsky (1945, 1946, 1947)
Michaël Borremans
Louise Bourgeois (1991)
Margaret Bourke-White
Stan Brakhage
Brassaï
Manuel Alvarez Bravo
Robert Breer (2004)
Marcel Broodthaers
Esther Bubley
Matthew Buckingham
Charles Burchfield (1927, 1930, 1931, 1933, 1934, 1935, 1936, 1937, 1938, 1939, 1940, 1943, 1944, 1945, 1946, 1947, 1948, 1949, 1950, 1952, 1955, 1958, 1964)
Chris Burden
James Lee Byars (1964)
Alexander Calder (1958, 1961, 1964, 1967, 1970)
Harry Callahan
Clarence Holbrook Carter (1929, 1938, 1939)
Paul Chan (2004)

Cecelia Condit
Bruce Conner (2008)
John Currin (1999)
Stuart Davis (1931, 1943, 1944, 1945, 1946, 1952, 1955, 1958, 1961, 1964)
Willem de Kooning (1952, 1955, 1958, 1961, 1964, 1970)
Burgoyne Diller (1964)
Arthur G. Dove (1945, 1946)
Jean Dubuffet (1952, 1955, 1958, 1961, 1964, 1967, 1970, 1982)
Elliott Erwitt
Roe Ethridge
Walker Evans
Andreas Feininger
Fischli & Weiss (1988, 2008)
Lucio Fontana (1958, 1961, 1964, 1967)
Hollis Frampton
Robert Frank
Isa Genzken (2004)
Alberto Giacometti (1955, 1958, 1961, 1964)
Robert Gober (1995)
John Graham (1945)
Mark Grotjahn (2004)
Philip Guston (1941, 1943, 1944, 1945, 1947, 1948, 1949, 1950, 1955, 1958, 1964)
Robert Gwathmey (1941, 1943, 1944, 1945, 1946, 1947, 1948, 1949, 1950, 1964)
Clyde Hare
Charles "Teenie" Harris
Rachel Harrison (2004)
Marsden Hartley (1931, 1933, 1943)
Barbara Hepworth (1958, 1961, 1964, 1967)
David Hockney (1967, 1982)
Harry Holtzman
Edward Hopper (1928, 1930, 1931, 1933, 1934, 1935, 1936, 1937, 1938, 1939, 1940, 1943, 1944, 1945, 1946, 1947, 1948, 1949, 1950, 1955, 1967)
Huang Yong Ping (1991)
Richard Hughes (2008)
Peter Hujar
Joan Jonas
John Kane (1927, 1928, 1929, 1930, 1931, 1933, 1934)
Alex Katz (1999)
Craig Kauffman
On Kawara (1991)
Yasuo Kazuki (1952, 1961)
Mike Kelley (1991, 2008)
Ellsworth Kelly (1958, 1961, 1964, 1967, 1985)
Rockwell Kent (1908, 1921, 1922, 1923, 1925, 1926, 1927, 1930, 1931, 1933, 1934, 1935, 1936, 1937, 1938, 1939, 1940, 1943, 1944, 1945, 1946, 1947, 1948, 1949)
Karen Kilimnik
Franz Kline (1952, 1955, 1948, 1961)
Henry Koerner (1948, 1949, 1950, 1955)
Joachim Koester
Leon Kroll (1925, 1933, 1934, 1935, 1936, 1937, 1938, 1939, 1940, 1943, 1944, 1945, 1946, 1947, 1948, 1949, 1950)
George Kuchar
Yayoi Kusama (1961)
George Landow (a.k.a. Owen Land)
Glenn Ligon

Charles Long
René Magritte (1938, 1950, 1958, 1964, 1967)
Mark Manders (2008)
Robert Mapplethorpe
Agnes Martin (1961, 1988, 1995)
Gordon Matta-Clark
John McCracken
Julie Mehretu (2004)
Joan Mitchell (1955, 1958, 1961, 1970, 1995)
Robert Motherwell (1952, 1955, 1958, 1961, 1964, 1967)
Elizabeth Murray (1988)
Elie Nadelman
Bruce Nauman (1985, 1988, 1991)
Robert Nelson (1955)
Senga Nengudi (2004)
Ernesto Neto (1999)
Isamu Noguchi (1958, 1961, 1964, 1967, 1970)
Chris Ofili (1999)
Hélio Oiticica
Georgia O'Keeffe (1933, 1934, 1935, 1940, 1943, 1944, 1946,
 1947, 1948, 1949, 1950, 1952)
Claes Oldenburg (1964, 1967, 1970)
Tony Oursler (1995)
Laura Owens (1999)
Nam June Paik
Eduardo Luigi Paolozzi (1958, 1961, 1964, 1967, 1970)
Lygia Pape
Ed Paschke
Horace Pippin (1943, 1944, 1945)
Lari Pittman
Sigmar Polke (1985)
Jackson Pollock (1952, 1955)
Ken Price
Ad Reinhardt (1955, 1958)
Gerhard Richter (1985, 1988)
Georges Rouault (1937, 1938, 1939, 1950)
Edward Ruscha (1999)
Doris Salcedo (1995)
David Salle (1985)
Peter Saul (1967)
Thomas Schütte (2008)
Paul Sharits
Cindy Sherman (1985, 1995)
Roman Signer (1999)
Raymond Simboli (1925, 1926, 1928, 1934)
David Smith (1958, 1961)
Harry Smith
W. Eugene Smith
Raphael Soyer (1934, 1935, 1937, 1938, 1939, 1940, 1943,
 1944, 1945, 1946, 1947, 1948, 1949, 1950)
Frank Stella (1967, 1970, 1985)
Myron S. Stout (1958)
Luke Swank
Paul Thek (1967, 2008)
Rirkrit Tiravanija (1995)
Rosemarie Trockel (2008)
Richard Tuttle (1995)
Luc Tuymans (1999)
Jeff Wall (1988, 1999)
Franz Erhard Walther
Andy Warhol (1964, 1967, 1988)

William Wegman
Lawrence Weiner
Franz West (1995)
Edward Weston
Cathy Wilkes
Christopher Williams (1991)
Christopher Wool (1991)
Richard Wright (2008)
Haegue Yang (2008)

INSTALLATION VIEWS

Past *Carnegie Internationals*

Installation view of the first *International,* 1896

1896 **1903**

Installation view of the 1903 *International*

Installation view of the 1905 *International*

1905 **1929**

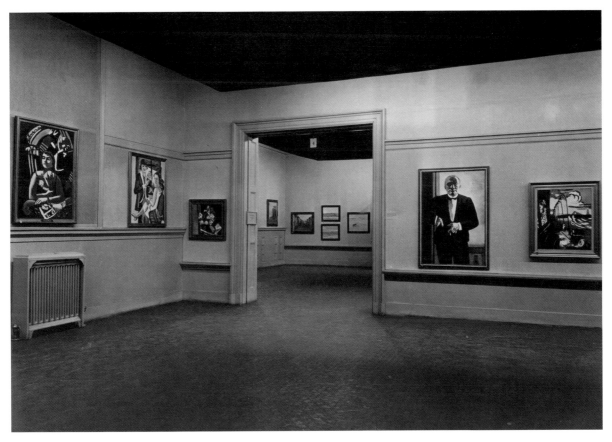

Installation view of the 1929 *International* showing work by Max Beckmann, among others

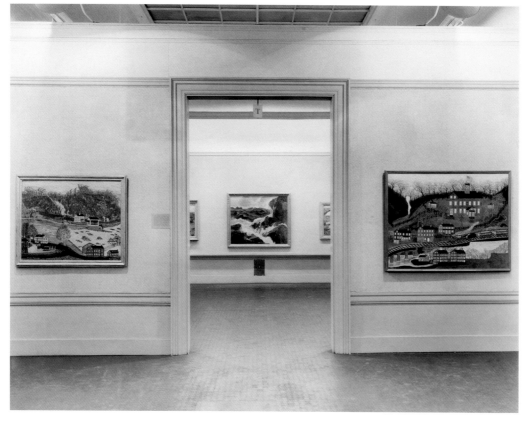

Installation view of the *Survey of American Painting*, 1940

1940

1958

Installation view of the 1958 *International* showing *Painting* (1958) by Antoni Tàpies (far left), which won the Carnegie Prize

Alexander Calder's mobile *Pittsburgh* (1958) installed in the Grand Staircase during the 1958 *International*. The work won first prize for sculpture.

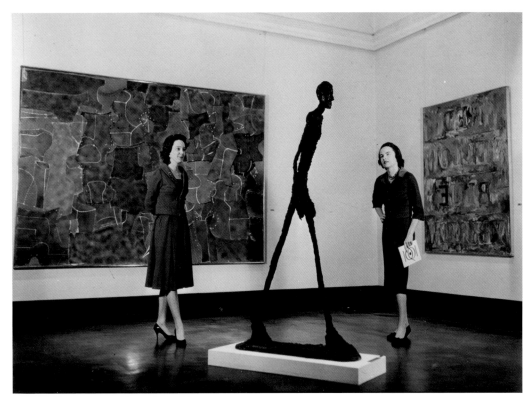

Visitors to the 1961 *International* with Alberto Giacometti's *Walking Man I* (1960)

1961 1964

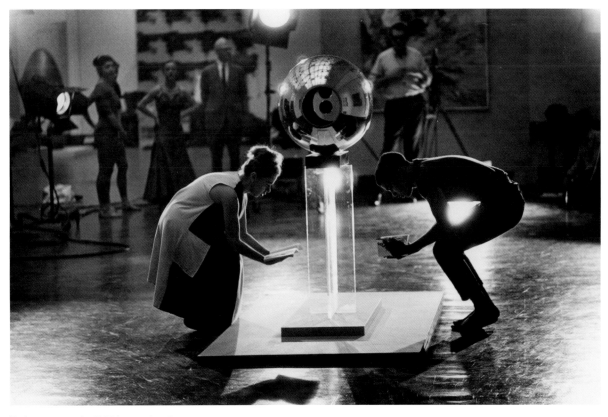

Performance at the 1964 *International*

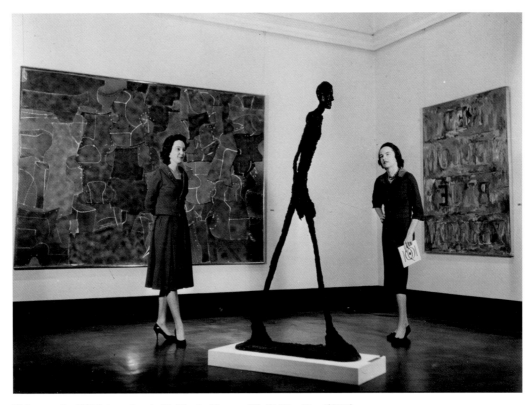

Visitors to the 1961 *International* with Alberto Giacometti's *Walking Man I* (1960)

1961 **1964**

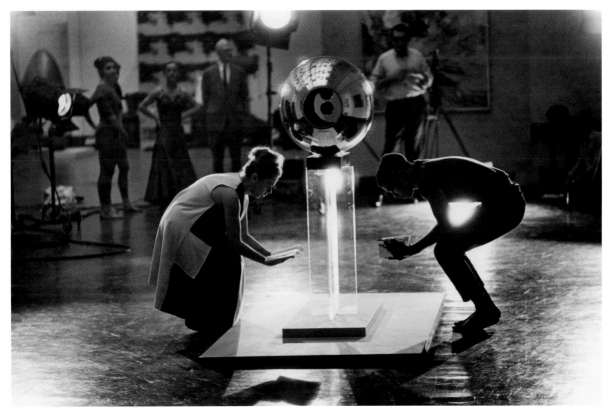

Performance at the 1964 *International*

Otto Piene's *Rapid Red Growth* (1970) in the Grand Staircase
in the 1970 *International*

1970 **1985**

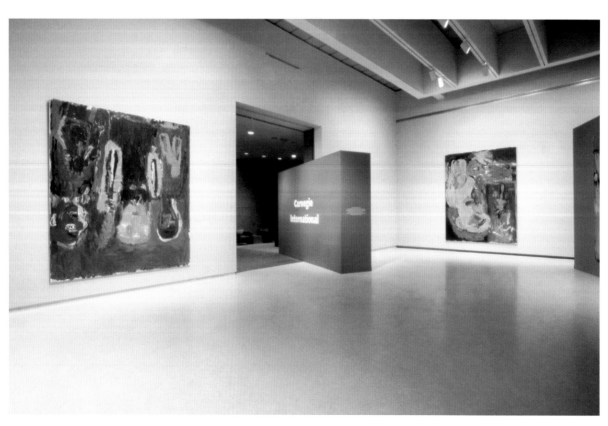

The entrance to the 1985 *International,* showing works by Georg Baselitz

Works by Joseph Beuys (foreground) and Andy Warhol (background)
in the 1988 *International*

1988

1991

Installation by Christian Boltanski in the 1991 *International*

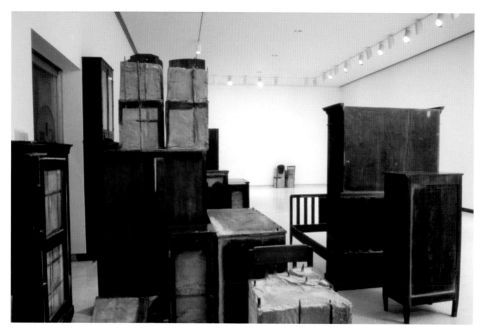

Installation by Doris Salcedo in the 1995 *International*

1995

1999

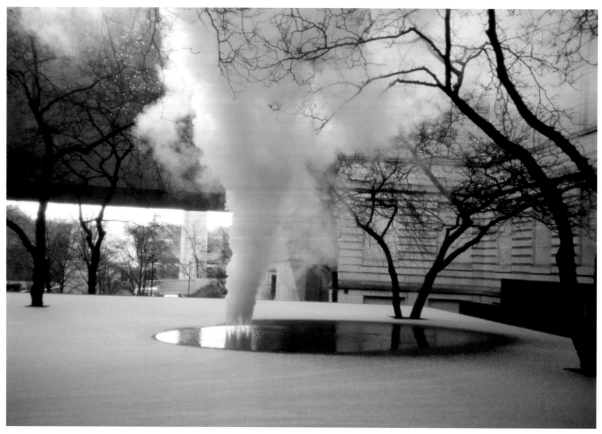

Olafur Eliasson's *Your natural denudation inverted* (1999) in the 1999 *International*

Maurizio Cattelan's *Now* (2004) in the Founder's Room in the 2004 *International*

2004 **2008**

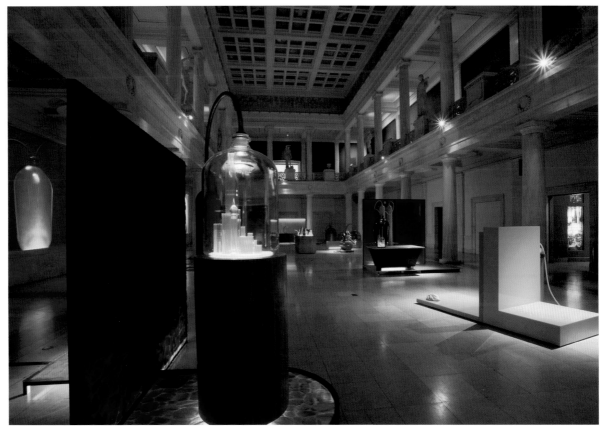

Mike Kelley's *Kandors* (2007) in the 2008 *International*

THE *2013 CARNEGIE INTERNATIONAL* APARTMENT
113 44th Street, Lawrenceville

EVENT LISTINGS AS OF JULY 20, 2013

The apartment, located in Pittsburgh's Lawrenceville neighborhood, was established in 2011 as a satellite space for the *2013 Carnegie International* and the Contemporary Art Department of Carnegie Museum of Art. Used to develop the exhibition in exchange with the city, and to create a new space for art and artists in Pittsburgh, the apartment brought together local and out-of-town writers, artists, scholars, curators, and the public in an informal environment for a series of diverse programs. Events were programmed by each member of the curatorial team, working in collaboration with local organizations and universities.

The Neighborhood Print Shop, run by Transformazium out of the Braddock Carnegie Library, produced a series of posters for selected events. The following listings present a good snapshot of Pittsburgh's current art scene as well as some great collaborations by visitors passing through.

AUGUST 31, 2011
FREDERICK WISEMAN SCREENING
A screening of films by American director Frederick Wiseman was held.

SEPTEMBER 1, 2011
DANIEL BAUMANN
Daniel Baumann presented a summary of his ongoing projects in Tbilisi, Georgia; Basel, Switzerland; and beyond.

 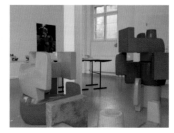

SEPTEMBER 2, 2011
LENKA CLAYTON AND ED STECK
Artist and documentary filmmaker Lenka Clayton and poet Ed Steck, both Pittsburgh-based, presented recent work.

Poster by Nia Hogan, 2011

Ed Steck

Lenka Clayton

OCTOBER 19, 2011
CAROLEE SCHNEEMANN
The evening featured a screening of Carolee Schneemann's films *Americana I Ching Apple Pie* (1972/2007) and *Mysteries of the Pussies* (1998/2010). Schneemann conducted a Q and A and discussion after the films. Hosted with Melissa Ragona in association with Schneemann's participation in Carnegie Mellon University's Artist Lecture series.

Poster by Nia Hogan, 2011

OCTOBER 30, 2011
RICH PELL, CENTER FOR POSTNATURAL HISTORY
Artist Rich Pell presented his work as the founder of the Center for PostNatural History, a cultural outreach center based in Pittsburgh dedicated to the collection and documentation of life forms that have been intentionally altered through selective breeding or genetic engineering.

Poster by Nia Hogan, 2011

319

DECEMBER 6, 2011
JERSTIN CROSBY AND JASDEEP KHAIRA

Interdisciplinary artist Jerstin Crosby and Encyclopedia Destructica co-founder Jasdeep Khaira presented on their work and current projects.

Poster by Nia Hogan, 2011

Jerstin Crosby

Encyclopedia Destructica

FEBRUARY 8, 2012
CORIN HEWITT

Artist Corin Hewitt discussed his work. Hewitt lives and works in Richmond, Virginia, and East Corinth, Vermont.

Poster by Nia Hogan, 2011

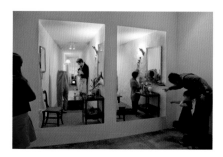

MARCH 13, 2012
JAMIE SKYE BIANCO AND HAAKON FASTE

Jamie Skye Bianco, assistant professor in the Composition: Literacy, Pedagogy, and Rhetoric group at the University of Pittsburgh, discussed her recent projects. Haakon Faste discussed his art practice and his work as visiting assistant professor in the Human-Computer Interaction Institute at Carnegie Mellon University.

Jamie Skye Bianco

Haakon Faste

APRIL 11, 2012
JUSTSEEDS ARTISTS' COOPERATIVE

This evening featured a presentation by Mary Tremonte and Shaun Slifer, core members of the Justseeds Artists'
Cooperative, a decentralized network of twenty-six artists committed to making print and design work
that reflects a radical social, environmental, and political stance. Along with artist and member Bec Young, they run
the Cooperative's distribution center in Pittsburgh.

Nicolas Lampert Roger Peet Santiago Armengod

MAY 14, 2012
STRANGE ATTRACTORS BOOK/DVD PREVIEW

Artist Suzie Silver and writer Ed Steck presented their contributions to *Strange Attractors: Investigations in Non-
Humanoid Extraterrestrial Sexualities*, a collaboration between Encyclopedia Destructica and the Institute of
Extraterrestrial Sexuality. The evening included a screening of work by Scott Andrew, Jacob Ciocci, and Shana Moulton.

Poster by Kijuana D. Cummings, 2012

Shana Moulton

Strange Attractions

MAY 22, 2012
WILLIAM E. JONES SCREENING OF FRED HALSTED'S *L.A. PLAYS ITSELF*

This evening featured a screening of Fred Halsted's *L.A. Plays Itself* (1972), gay porn's first masterpiece: a sexually
explicit, autobiographical, experimental film. In his 2012 Semiotext(e) publication *Halsted Plays Himself*, artist
and filmmaker William E. Jones documents his quest to capture the elusive public and private personas of Halsted.

JUNE 18, 2012
SIX x ATE: SOUND
The apartment hosted an iteration of the themed lecture and dinner series. Curated by Casey Droege, the evening featured presentations by artists David Bernabo; tENTATIVELY, a cONVENIENCE; Becky Slemmons; T. Foley; Nina Sarnelle; and Heather Mull.

Nina Sarnelle

JUNE 21, 2012
SPACES CORNERS PRESENTS RON JUDE AND DANIELLE MERICLE
Founded in 2011, Spaces Corners is Pittsburgh's first book shop and project space dedicated to sharing the photographic book as a contemporary art object. Spaces Corners presented artists Ron Jude and Danielle Mericle from Ithaca, New York, who shared their photographic and video work as well as their experiences as founders of the small publishing house A-Jump Books.

Ron Jude Spaces Corners

JUNE 26, 2012
COMMVLVS II
Curated by Ben Hernstrom of Ambulantic Videoworks, the evening featured presentations by Stephanie Armbruster, Nina Marie Barbuto, David Bernabo, Ben Hernstrom, Justin Hopper, Rob Larson, Bovey Lee, David Montano, Matthew Newton, and Ben Saks. Each artist had five minutes to present her or his work via digital projection, performance, or physical object.

David Montano Ben Saks

JULY 10, 2012
ZOE STRAUSS
2013 Carnegie International artist Zoe Strauss discussed her photo-based installations and projects.

Poster by Tiona
Henderson, 2012

Zoe Strauss at the
Carrie Furnaces

JULY 26, 2012
RILEY HARMON, DANIEL LUCHMAN, AND BEN KINSLEY
This event featured talks by three artists whose work intersects with ideas about performance and media:
Riley Harmon, Daniel Luchman, and Ben Kinsley.

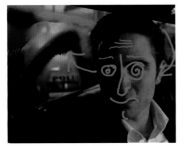

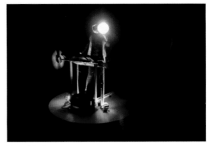

Riley Harmon

Ben Kinsley

Daniel Luchman

SEPTEMBER 29, 2012
ARTISTS FROM *THE CITY & THE CITY: ARTWORK BY LONDON WRITERS*,
IN COLLABORATION WITH THE BRITISH COUNCIL
This lunchtime "long table" discussion featured the artists from *The City & the City: Artwork by London Writers*,
curated by Justin Hopper for Wood Street Galleries, Pittsburgh. Caroline Bergvall, Rod Dickinson,
Rachel Lichtenstein, Tom McCarthy, and Sukhdev Sandhu gave insight to topics related to their work and ideas
surrounding psychogeography.

Rod Dickinson and Tom McCarthy

Caroline Bergvall

OCTOBER 2, 2012
LIGHT PLAY: EXPERIMENTS IN PARACINEMA
This event was programmed by *INCITE Journal of Experimental Media*'s Brett Kashmere for the 2012 VIA Music and New Media Festival. With collaborators Melissa Ragona and Nico Zevallos of Carnegie Mellon University and Jonathan Walley of Denison University, Kashmere presented re-creations of two "non-films" of the 1960s: Hollis Frampton's audio/projection performance *A Lecture*, first performed at Hunter College in New York in 1968, and Takehisa Kosugi's little-known performance *Film and Film #4* of 1966.

DECEMBER 12, 2012
MARVIN HEIFERMAN
Presented in collaboration with the PGH Photo Fair Speaker Series, curator and writer Marvin Heiferman discussed his latest book, *Photography Changes Everything*. Published by Aperture in 2012, Heiferman's book draws from the online Smithsonian Photography Initiative, offering a provocative rethinking of photography's impact on our culture and our lives.

DECEMBER 17, 2012
EMILY NEWMAN AND THE SAXIFRAGE SCHOOL
Artist Emily Newman present her latest work, and Tim Cook and Andrew Heffner from the Saxifrage School discussed ideas for change in higher education.

Saxifrage School

Emily Newman

FEBRUARY 18, 2013
CHRIS BEAUREGARD AND BRANDON BOAN
Artists Chris Beauregard and Brandon Boan, both largely known for their sculptural practices,
presented live temporary installations demonstrating their recent interest in the intersection between
object making and performance.

Brandon Boan Chris Beauregard

MARCH 8, 2013
MARK DION'S VISUAL ARTS MFA STUDENTS FROM COLUMBIA UNIVERSITY
1999 *Carnegie International* alumnus Mark Dion's students from Columbia University, New York, gave brief
presentations on their work as part of a long weekend visit to explore Pittsburgh.

Mira Hunter Laura Miller

MARCH 29, 2013
ALEXIS GIDEON
Alexis Gideon performed *Video Musics III: Floating Oceans*, a thirty-eight-minute stop-motion animation
video opera based on the works of the early twentieth-century Irish writer Lord Dunsany, and inspired
by the time and dream experiments of the Irish physicist John William Dunne. The screening was accompanied
by Gideon's live musical performance.

APRIL 2, 2013
2013 CARNEGIE INTERNATIONAL ARTIST LIST ANNOUNCEMENT
The Friends of the *2013 Carnegie International* were treated to an exclusive unveiling of the list of participating artists.

APRIL 6, 2013
HEATHER GUERTIN AND WILLIAM EARL KOFMEHL III
A performance by New York–based artist and stand-up comedian Heather Guertin was followed by a talk by Pittsburgh-based artist William Earl Kofmehl III.

Heather Guertin

William Earl Kofmehl III

APRIL 15, 2013
SIX x ATE: VEGETABLE
The apartment hosted another iteration of the themed lecture and dinner series. Curated by Casey Droege, the evening featured presentations by artists in CSA PGH, Pittsburgh's first visual arts CSA; Kim Beck; David Bernabo; Lenka Clayton; William Earl Kofmehl III; Alexi Morrisey; and Ed Panar.

Ed Panar

MAY 13, 2013
SHELLSHOCK ROCK SCREENING / GOOD VIBRATIONS VINYL LISTENING PARTY

This evening featured a screening of *Shellshock Rock* (1979), the definitive documentary on Northern Irish punk by John T. Davis, and a Good Vibrations vinyl listening party DJed by John Carson, Head of the Carnegie Mellon University School of Art.

Jason Carson

MAY 21, 2013
CARA ERSKINE AND COREY ESCOTO

This evening featured artist talks by Pittsburgh-based artists Cara Erskine and Corey Escoto.

Corey Escoto

Cara Erskine

JUNE 15, 2013
SCREENING OF *FEMALE FIST* AND *COMMUNITY ACTION CENTER*

To mark Pittsburgh's LGBTQ Pride Festival, artists AK Burns and A. L. Steiner screened their film *Community Action Center* (2010) and Kasja Dahlberg's *Female Fist* (2006). A Q and A with the directors was followed by a DJ set by Ginger Brooks Takahashi.

Community Action Center

JULY 9, 2013
AYANAH MOOR AND GRAHAM SHEARING
Artist Ayanah Moor presented her recent work, and critic and collector Graham Shearing gave a talk titled "Uncertainty and Ironic Dogmatism" to a packed house.

Ayanah Moor

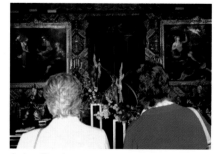

Graham Shearing

JULY 20, 2013
REALIZATION IS BETTER THAN ANTICIPATION
This event highlighted work by artists participating in MOCA Cleveland's summer exhibition *Realization Is Better than Anticipation*, organized by Megan Lykins Reich and Rose Bouthillier. The apartment became a satellite exhibition with work by Jacob Ciocci, Scott Olson, Lauren Yeager, Kevin Beasley, and Lenka Clayton.

Lauren Yeager

Kevin Beasley

RESTRICTED ACTION
(1897)

STÉPHANE MALLARMÉ

Several times the same Comrade, this other, came to me and confided his need to act: what did he have in mind?—especially since his coming to me announced on his part, in his youthfulness, also the occupation of creating or succeeding with words, which would seem to dominate. I say again, what did he have in mind, exactly?

To unclench one's fists, to break out of a sedentary dream, for violent fisticuffs with the idea, like a need for exercise: but the younger generation seems hardly restless, besides being politically disinterested, to stretch or test the body. Except in the monotony of unrolling, between one's ankles, on a track, according to today's most fashionable instrument, the fiction of a dazzling, continuous rail.

To act, otherwise, and for someone who doesn't begin the exercise by smoking, meant, visitor, I understand you, philosophically, to produce on many a movement that gives you the impression that you originated it, and therefore exist: something no one is sure of. This praxis can be understood in two ways: either, by will, unbeknownst to others, to spend a whole life toward a multiple outburst—which would be *thinking*: or else, using the means available now—journals and their whirlwind—to send a force in some direction, *any* direction, which, when countered, gives you immunity from having any result.

At will, according to one's disposition, plenitude, or haste.

Your act is always applied to paper; for meditating without a trace is evanescent, nor is the exalting of an instinct in some vehement, lost gesture what you were seeking.

To write—

The inkwell, crystalline like consciousness, with its drop, at bottom, of shadows relative to letting something be: then, take the lamp away.

As you noted, one doesn't write, luminously, on a dark field; the alphabet of stars alone does that, sketched or interrupted; man writes black upon white.

This fold of dark lace, which holds the infinite, woven by thousands, each according to his own thread or extension, not knowing the secret, assembles distant spacings in which riches yet to be inventoried sleep: vampire, knot, foliage; and our job is to present them.

With the indispensable touch of mystery that always remains, somewhat expressed, nevertheless.

I don't know whether the Guest perspicaciously circumscribes his domain of effort: I would be happy to mark it, along with certain conditions. The right to accomplish anything exceptional, or beyond reach of the vulgar, is paid for by the omission of the doer, and of his death as so-and-so. He will commit exploits only in dreams, so as not to bother anyone, but still, the program is posted for those who don't care.

The writer, with his pains, dragons he has cherished, or with his light-heartedness, must establish himself, in the text, as a spiritual *histrio*.

Stageboards, *lustre*, obnubilation of fabrics and liquefaction of mirrors, in the real, all the way up to excessive leaps of our gauzy form around a still center, on one foot, of virile stature, a Place presents itself, on the stage, the enlargement in front of everyone of the spectacle of the Self; there, because of the intermediaries of light, flesh, and laughter, the sacrifice the inspirer makes relative to his personality, completes itself; or it's the end, in an uncanny resurrection, of so-and-so: his word henceforth vain and echoing through the exhalations of the orchestral chimera.

In a hall, he celebrates himself, anonymous, in the hero.

Everything functions like a festival: a people testifies to its transformation into Truth.

Honor.

Seek, anywhere, something similar—

Will one recognize it in one of those suspect houses that detach themselves, overburdened by the banal, from the common alignment, claiming to synthesize the diverse goings-on of a quarter; or, if some facade, according to the French taste for divination, isolates, in a square, its ghost, I salute. Indifferent to what, here and there, is whispered, as along a gas line the tongues of flame are turned down.

Thus, Action, in the mode we agreed upon—literary action—does not go beyond the Theater; is limited to that, to representation—an immediate disappearance of writing. If it ends up in the street or elsewhere, the mask falls away; we don't have to do with a poet: abjure your poetry—anyway, it doesn't have much power out there—you would prefer to add to the pile of acts committed by individuals. What good would it do to spell out, which you very well know, like me, who kept it through a quality or lack of childhood in exclusivity, this point, that everything, vehicle or placement, which is currently offered to the ideal, is contrary to it—almost a speculation on your lack of externalization, your silence—or defective, not direct and legitimate, in the sense that a moment ago we called for a surge, now tainted. Since a malaise never suffices, I'll clarify, assuredly, with the right number of digressions coming next, this reciprocal contamination of work and means: but first, doesn't it make sense to express oneself spatially? like a cigar tracing circonvolutory patterns, whose vagueness, at the very least, is outlined against the harsh electric light?

A certain delicacy has, I hope, suffered—

Externally, like a cry of distance, the traveler hears the wail of a whistle. "No doubt," he says to himself, "we're going through a tunnel—*our time*—that runs for a long way beneath the city before getting to the all-powerful station of the virginal central palace, which crowns it all." The underground will last as long, O impatient one, as your concentration in preparing to build the crystal palace swiped by a wing of Justice.

Suicide or abstention, why would you choose to do nothing?—This is your only time on earth, and because of an event I'll explain, there's no such thing as a Present, no—a

present doesn't exist.… For lack of the Crowd's declaring itself, for lack of—everything. Uninformed is he who would proclaim himself his own contemporary, deserting or usurping with equal imprudence, when the past seems to cease and the future to stall, in view of masking the gap. Outside of those All-Paris occasions whose job is to propagate faith in the quotidian nothingness, and inexpert if the plague measures its period to a fragment, important or not, of a century.

Therefore, keep yourself, and be there.

Poetry is sacred; some people attempt hidden chaste crises in isolation, while the other gestation takes place.

Publish.

The Book, where the spirit lives satisfied, in cases of misunderstanding, one feels an obligation toward some sort of purity of delight to shake off the dregs of the moment. Impersonified, the volume, to the extent that one separates from it as author, does not demand a reader, either. As such, please note, among human accessories, it takes place all by itself: finished, it exists. Its buried meaning moves and arranges, into a chorus, the pages.

Afar, it dares to forbid, even at celebrations, the present: one notes that chance denies to certain dreams the materials of confrontation; or a special attitude helps them.

You, Friend, whom it's unnecessary to frustrate for years just because there's a parallel with voiceless general labor, will find the case strange: I ask you, without judgment, without sudden factors, to treat my advice as, I admit, a rare kind of folly. Nevertheless, it is tempered by this wisdom, or discernment: that it might be better (than to bet on, at the very least, an incomplete context around you) to risk certain conclusions of extreme art that might burst out, glittering like a cut diamond, now or forever, within the integrity of the Book— to play them, even through a triumphal reversal, with the tacit injunction that nothing, palpitating in the unconscious flank of the hour, shown clear and evident to the pages, will find the hour ready; while nevertheless it may be in another time that it will cast illumination.

Reprinted from Stéphane Mallarmé, *Divagations*, trans. Barbara Johnson (Cambridge, MA: Belknap Press of Harvard University Press, 2007), 215–19. Courtesy of Harvard University Press.

Stéphane Mallarmé (1842–1898) was a French critic and poet, and a major force behind the French Symbolist movement. His work anticipated the revolutionary philosophy behind the transnational twentieth-century artistic movements of Dada, Surrealism, and Futurism.

WORKS IN
THE EXHIBITION

As of July 20, 2013

EI ARAKAWA
AND
HENNING BOHL

1. *Helena and Miwako*, 2013
Video; color, sound; and built structure
Courtesy of the artists
Commissioned by Carnegie Museum of
Art for the *2013 Carnegie International*
Supported by The George Foundation and
The Japan Foundation, New York

2. *Soccer Ball and Figure*, 2013
Performance, October 5, 2013
Courtesy of the artists

3. *Art from the Future*, 2013
A summer art camp for ages 6–7, 8–10, and
11–13
Courtesy of the artists and Children's and
Family Programs, Carnegie Museum of Art

PHYLLIDA BARLOW

4. *untitled:upturnedhouse*, 2012
Timber, plywood, scrim, cement, polysty-
rene, polyfiller, paint, and varnish
138 x 200 x 128 in. (350.5 x 508 x 325.1 cm)
Carnegie Museum of Art, The Henry L.
Hillman Fund

5. *TIP*, 2013
Timber, steel, spray paint, paint, steel
mesh, scrim, cement, fabric, and varnish
275 ⅝ x 472 ½ x 1574 ¾ in. (700 x 1200 x
4000 cm) overall (approx.)
Courtesy of the artist and Hauser & Wirth,
Zurich, London, and New York

6. *untitled: wrecker*, 2013
Polystyrene, cement, polyurethane
foam, steel mesh, paper, fabric, paint,
PVA, and sand
55 ⅛ x 55 ⅛ x 55 ⅛ in. (140 x 140 x 140 cm)
Courtesy of the artist and Hauser & Wirth,
Zurich, London, and New York

YAEL BARTANA

7. *Mary Koszmary* (*Nightmares*), 2007
Super 16mm transferred to video;
color, sound
11 min.
Courtesy of Annet Gelink Gallery,
Amsterdam, and Foksal Gallery
Foundation, Warsaw

8. *Summer Camp*, 2007
Video and sound installation
24 min.
Courtesy of Annet Gelink Gallery,
Amsterdam, and Sommer Contemporary
Art, Tel Aviv
Supported by Artis and The George
Foundation

9. *Mur i wieża* (*Wall and Tower*), 2009
HD video; color, sound
15 min.
Courtesy of Annet Gelink Gallery,
Amsterdam, and Sommer Contemporary
Art, Tel Aviv

10. *Zamach* (*Assassination*), 2011
HD video; color, sound
35 min.
Courtesy of Annet Gelink Gallery,
Amsterdam, and Sommer Contemporary
Art, Tel Aviv

SADIE BENNING

11. *Old Waves (Record one and two)*,
2011
Video; black-and-white, sound
1:02 min.
Courtesy of the artist

12. *Locating Centers*, 2013
40 pieces; casein paint and acrylic paint
on board with plaster
18 x 27 x ¾ in. (45.7 x 68.5 x 1.9 cm) each
Courtesy of the artist
Commissioned by Carnegie Museum of
Art for the *2013 Carnegie International*

BIDOUN LIBRARY

13. *Bidoun Library*
Library and display structure
Dimensions variable
Courtesy of Bidoun Library

NICOLE EISENMAN

14. *Amazon Birthday*, 1993
Oil on canvas
81 x 65 in. (205.7 x 165.1 cm)
Hort Family Collection

15. *Swimmers in the Lap Lane*, 1995
Oil on canvas
51 x 39 in. (129.5 x 99 cm)
Collection of Dianne Wallace, New York

16. *Spring Fling*, 1996
Oil on canvas
65 x 52 ½ in. (165.1 x 133.4 cm)
Collection of Martin and
Rebecca Eisenberg

17. *Portrait of a Lady*, 1998
Oil on canvas with diamond
56 ¼ x 43 ⅛ in. (142.8 x 109.5 cm)
Collection of Richard Gerrig and
Timothy Peterson

18. *Fishing*, 2000
Oil on panel
48 x 56 in. (121.9 x 142.2 cm)
Collection of Craig Robins

19. *I'm with Stupid*, 2001
Oil on canvas
51 x 39 in. (126.5 x 99 cm)
Hall Collection

20. *Commerce Feeds Creativity*, 2004
Oil on canvas
51 x 39 ½ in. (129.5 x 100.3 cm)
Hort Family Collection

21. *From Success to Obscurity*, 2004
Oil on canvas
51 x 40 in. (129.5 x 101.6 cm)
Hall Collection

22. *Inspiration*, 2004
Oil on canvas
50 ¹³⁄₁₆ x 39 ½ in. (129.1 x 100.3 cm)
Collection of Beth Rudin DeWoody

23. *Ketchup & Mustard War*, 2005
Oil on canvas
78 x 60 in. (198.1 x 152.4 cm)
Hall Collection

24. *Little Shaver*, 2005
Oil on canvas
24 x 18 in. (60.9 x 45.7 cm)
Hall Collection

25. *Coping*, 2008
Oil on canvas
65 x 82 in. (165.1 x 208.2 cm)
Collection of Igor M. DaCosta, New York,
courtesy of Galerie Barbara Weiss

26. *Beer Garden with Ash*, 2009
Oil on canvas
65 x 82 in. (165.1 x 208.2 cm)
Private collection, Switzerland

27. *Beer Garden with Ulrike
and Celeste*, 2009
Oil on canvas
65 x 82 in. (165.1 x 208.2 cm)
Hall Collection

28. *Death and the Maiden*, 2009
Oil on canvas
14 ½ x 18 in. (36.8 x 45.7 cm)
Collection of Martin and
Rebecca Eisenberg

29. *The Fag End II*, 2009
Oil on canvas
18 x 14 ½ in. (36.8 x 45.7 cm)
Collection of Martin and Rebecca
Eisenberg

WORKS IN THE EXHIBITION

As of July 20, 2013

EI ARAKAWA AND HENNING BOHL

1. *Helena and Miwako*, 2013
Video; color, sound; and built structure
Courtesy of the artists
Commissioned by Carnegie Museum of
Art for the *2013 Carnegie International*
Supported by The George Foundation and
The Japan Foundation, New York

2. *Soccer Ball and Figure*, 2013
Performance, October 5, 2013
Courtesy of the artists

3. *Art from the Future*, 2013
A summer art camp for ages 6–7, 8–10, and
11–13
Courtesy of the artists and Children's and
Family Programs, Carnegie Museum of Art

PHYLLIDA BARLOW

4. *untitled:upturnedhouse*, 2012
Timber, plywood, scrim, cement, polysty-
rene, polyfiller, paint, and varnish
138 x 200 x 128 in. (350.5 x 508 x 325.1 cm)
Carnegie Museum of Art, The Henry L.
Hillman Fund

5. *TIP*, 2013
Timber, steel, spray paint, paint, steel
mesh, scrim, cement, fabric, and varnish
275 ⅝ x 472 ½ x 1574 ¾ in. (700 x 1200 x
4000 cm) overall (approx.)
Courtesy of the artist and Hauser & Wirth,
Zurich, London, and New York

6. *untitled: wrecker*, 2013
Polystyrene, cement, polyurethane
foam, steel mesh, paper, fabric, paint,
PVA, and sand
55 ⅛ x 55 ⅛ x 55 ⅛ in. (140 x 140 x 140 cm)
Courtesy of the artist and Hauser & Wirth,
Zurich, London, and New York

YAEL BARTANA

7. *Mary Koszmary* (*Nightmares*), 2007
Super 16mm transferred to video;
color, sound
11 min.
Courtesy of Annet Gelink Gallery,
Amsterdam, and Foksal Gallery
Foundation, Warsaw

8. *Summer Camp*, 2007
Video and sound installation
24 min.
Courtesy of Annet Gelink Gallery,
Amsterdam, and Sommer Contemporary
Art, Tel Aviv
Supported by Artis and The George
Foundation

9. *Mur i wieża* (*Wall and Tower*), 2009
HD video; color, sound
15 min.
Courtesy of Annet Gelink Gallery,
Amsterdam, and Sommer Contemporary
Art, Tel Aviv

10. *Zamach* (*Assassination*), 2011
HD video; color, sound
35 min.
Courtesy of Annet Gelink Gallery,
Amsterdam, and Sommer Contemporary
Art, Tel Aviv

SADIE BENNING

11. *Old Waves (Record one and two)*,
2011
Video; black-and-white, sound
1:02 min.
Courtesy of the artist

12. *Locating Centers*, 2013
40 pieces; casein paint and acrylic paint
on board with plaster
18 x 27 x ¾ in. (45.7 x 68.5 x 1.9 cm) each
Courtesy of the artist
Commissioned by Carnegie Museum of
Art for the *2013 Carnegie International*

BIDOUN LIBRARY

13. *Bidoun Library*
Library and display structure
Dimensions variable
Courtesy of Bidoun Library

NICOLE EISENMAN

14. *Amazon Birthday*, 1993
Oil on canvas
81 x 65 in. (205.7 x 165.1 cm)
Hort Family Collection

15. *Swimmers in the Lap Lane*, 1995
Oil on canvas
51 x 39 in. (129.5 x 99 cm)
Collection of Dianne Wallace, New York

16. *Spring Fling*, 1996
Oil on canvas
65 x 52 ½ in. (165.1 x 133.4 cm)
Collection of Martin and
Rebecca Eisenberg

17. *Portrait of a Lady*, 1998
Oil on canvas with diamond
56 ¼ x 43 ⅛ in. (142.8 x 109.5 cm)
Collection of Richard Gerrig and
Timothy Peterson

18. *Fishing*, 2000
Oil on panel
48 x 56 in. (121.9 x 142.2 cm)
Collection of Craig Robins

19. *I'm with Stupid*, 2001
Oil on canvas
51 x 39 in. (126.5 x 99 cm)
Hall Collection

20. *Commerce Feeds Creativity*, 2004
Oil on canvas
51 x 39 ½ in. (129.5 x 100.3 cm)
Hort Family Collection

21. *From Success to Obscurity*, 2004
Oil on canvas
51 x 40 in. (129.5 x 101.6 cm)
Hall Collection

22. *Inspiration*, 2004
Oil on canvas
50 ¹³⁄₁₆ x 39 ½ in. (129.1 x 100.3 cm)
Collection of Beth Rudin DeWoody

23. *Ketchup & Mustard War*, 2005
Oil on canvas
78 x 60 in. (198.1 x 152.4 cm)
Hall Collection

24. *Little Shaver*, 2005
Oil on canvas
24 x 18 in. (60.9 x 45.7 cm)
Hall Collection

25. *Coping*, 2008
Oil on canvas
65 x 82 in. (165.1 x 208.2 cm)
Collection of Igor M. DaCosta, New York,
courtesy of Galerie Barbara Weiss

26. *Beer Garden with Ash*, 2009
Oil on canvas
65 x 82 in. (165.1 x 208.2 cm)
Private collection, Switzerland

27. *Beer Garden with Ulrike
and Celeste*, 2009
Oil on canvas
65 x 82 in. (165.1 x 208.2 cm)
Hall Collection

28. *Death and the Maiden*, 2009
Oil on canvas
14 ½ x 18 in. (36.8 x 45.7 cm)
Collection of Martin and
Rebecca Eisenberg

29. *The Fag End II*, 2009
Oil on canvas
18 x 14 ½ in. (36.8 x 45.7 cm)
Collection of Martin and Rebecca
Eisenberg

30. *Sunday Night Dinner*, 2009
Oil on canvas
42 x 51 in. (106.6 x 129.5 cm)
Collection of Arlene Shechet and
Mark Epstein

31. *Guy Racer*, 2011
Oil on canvas
76 x 60 in. (193 x 152.4 cm)
Collection of The Kimmel Family

32. *Tea Party*, 2011
Oil on canvas
82 x 65 in. (208.2 x 165.1 cm)
Hort Family Collection

33. *Untitled (One of Wands)*, 2012
Plaster and wood
102 ⅜ x 31 ½ x 29 ½ in. (260 x 80 x 75 cm)
Hall Collection

34. *Untitled (Three of Wands)*, 2012
Plaster
104 ⅜ x 35 ⅞ x 25 ⅝ in. (265 x 91 x 65 cm)
Hall Collection

35. *Big Head Sleeping*, 2013
Plaster and graphite
27 x 49 x 36 in. (68.6 x 124.5 x 91.4 cm)
Courtesy of the artist and Koenig
& Clinton, New York
Produced in conversation with
Sam Greenleaf Miller

36. *Couple Kissing*, 2013
Plaster, sage, and mugwort
46 x 23 x 40 in. (116.8 x 58.4 x 101.6 cm)
Courtesy of the artist and Koenig
& Clinton, New York
Produced in conversation with
Sam Greenleaf Miller

37. *Guy with Mugwart
(Water Element)*, 2013
Plaster, indigo, and mugwart
27 x 83 x 42 in. (68.6 x 210.8 x 106.7 cm)
Courtesy of the artist and Koenig
& Clinton, New York
Produced in conversation with
Sam Greenleaf Miller

38. *Inhaling Object Symbol Guy*, 2013
Plaster, ceramic, and cotton
106 x 30 x 40 in. (269.2 x 76.2 x 101.6 cm)
Courtesy of the artist and Koenig
& Clinton, New York
Produced in conversation with
Sam Greenleaf Miller

39. *Prince of Swords*, 2013
Plaster, graphite, and leather
77 x 46 x 27 in. (195.6 x 116.8 x 68.6 cm)
Courtesy of the artist and Koenig
& Clinton, New York
Produced in conversation with
Sam Greenleaf Miller

LARA FAVARETTO

40. *Jestem*, 2013
4 confetti cubes
36 x 36 x 36 in. (90 x 90 x 90 cm) each
Courtesy of the artist and Galleria Franco
Noero, Turin

41. *L'écume des mers, 2013*
Steel road plate and silk; 2,451 lbs.
60 x 144 x 1 in. (152.4 x 365.7 x 2.5 cm)
Courtesy of the artist and Galleria Franco
Noero, Turin

42. *Effluves de Jasmin*, 2013
Steel road plate and silk; 1,225 lbs.
60 x 72 x 1 in. (152.4 x 182.9 x 2.5 cm)
Courtesy of the artist and Galleria Franco
Noero, Turin

43. *Son coup de coeur*, 2013
Steel road plate and silk; 1,429 lbs.
60 x 84 x 1 in. (152.4 x 213.4 x 2.5 cm)
Courtesy of the artist and Galleria Franco
Noero, Turin

44. *Sous les Paletuviers*, 2013
Steel road plate and silk; 1,307 lbs.
48 x 96 x 1 in. (121.9 x 243.8 x 2.5 cm)
Courtesy of the artist and Galleria Franco
Noero, Turin

VINCENT FECTEAU

45. *Untitled*, 2006
Papier-mâché and acrylic paint
13 ⅜ x 35 ⁷⁄₁₆ x 16 ¹⁵⁄₁₆ in. (34 x 90 x 43 cm)
Collection of Barbara Gladstone

46. *Untitled*, 2008
Papier-mâché and acrylic paint
15 ¾ x 28 ½ x 19 in. (40 x 72.3 x 48.2 cm)
Speyer Family Collection, New York

47. *Untitled*, 2008
Papier-mâché and acrylic paint
19 ¾ x 28 ½ x 19 in. (50.1 x 72.3 x 48.2 cm)
Collection of Donna and Howard Stone,
Promised Gift to The Art Institute of
Chicago

48. *Untitled*, 2008
Papier-mâché and acrylic paint
18 x 22 ½ x 30 in. (45.7 x 57.1 x 76.2 cm)
Courtesy of Matthew Marks Gallery,
New York and Los Angeles

49. *Untitled*, 2010
Papier-mâché and acrylic paint
32 x 27 x 18 in. (81.2 x 68.5 x 45.7 cm)
Private collection, New York

50. *Untitled*, 2010
Papier-mâché and acrylic paint
28 x 29 x 19 ½ in. (71.1 x 73.7 x 49.5 cm)
Collection of Carla Emil and Richard
Silverstein, Promised Gift to San
Francisco Museum of Modern Art

51. *Untitled*, 2010
Papier-mâché and acrylic paint
33 x 25 x 16 in. (83.8 x 63.5 x 40.6 cm)
Collection of Judith Neisser, promised
gift to The Art Institute of Chicago

52. *Untitled*, 2012
Papier-mâché and acrylic paint
25 ⁹⁄₁₆ x 35 ⁷⁄₁₆ x 34 ¼ in. (65 x 90 x 87 cm)
Collection of Igor M. DaCosta, New York

53. *Untitled*, 2012
Papier-mâché and acrylic paint
23 ¼ x 48 ⁷⁄₁₆ x 35 ⁷⁄₁₆ in. (59 x 123 x 90 cm)
Collection of Chara Schreyer

54. *Untitled*, 2012
Papier-mâché and acrylic paint
20 ½ x 46 ¾ x 39 in. (52 x 118.7 x 99 cm)
Carnegie Museum of Art, The Henry L.
Hillman Fund, 2013.1

55. *Untitled*, 2012
Papier-mâché and acrylic paint
22 ½ x 40 ½ x 38 ⅛ in.
(57.2 x 102.8 x 96.8 cm)
Private collection

RODNEY GRAHAM

56. *The Green Cinematograph
(Programme I: Pipe smoker and
overflowing sink)*, 2010
16mm film; color, silent, 5:35 min.;
custom film projector with looper, bench
Courtesy of the artist and Lisson
Gallery, London

57. *The Pipe Cleaner Artist,
Amalfi, '61*, 2013
Painted aluminum light box with
transmounted chromogenic transparency
90 ⅝ x 71 ⅝ x 7 in. (230.3 x 181.9 x 17.8 cm)
each panel
90 ⅝ x 146 ¼ x 7 in. (230.3 x 371.5 x
17.8 cm) overall
Courtesy of 303 Gallery, New York

GUO FENGYI

58. *Emperor Xuanyuan*, 1990
Ink on cloth
59 ¹³⁄₁₆ x 24 ⅝ in. (152 x 62.5 cm)
Courtesy of Long March Space, Beijing

59. *Heavenly Dragon*, 1990
Ink on cloth
59 ¹³⁄₁₆ x 24 ¹³⁄₁₆ in. (152 x 63 cm)
Courtesy of Long March Space, Beijing

60. *Huaxu Family,* 1996
Colored ink on rice paper
244 ⅛ x 27 ⁹⁄₁₆ in. (620 x 70 cm)
Courtesy of Long March Space, Beijing

61. *Statue of Liberty*, 2003
Colored ink on rice paper
198 1/16 x 38 3/16 in. (503 x 97 cm)
Courtesy of Long March Space, Beijing

62. *Image of Tortoise and Snake*, 2004
Ink on rice paper mounted on cloth
174 7/16 x 27 9/16 in. (443 x 70 cm)
Courtesy of Long March Space, Beijing

63. *Tang Dynasty Princess Wencheng*, 2004
Colored ink on rice paper
157 1/2 x 27 3/8 in. (400 x 69.5 cm)
Courtesy of Long March Space, Beijing

64. *Fuxi*, 2006
Colored ink on rice paper
157 1/2 x 27 9/16 in. (400 x 70 cm)
Courtesy of Long March Space, Beijing

65. *Shaodian*, 2006
Colored ink on rice paper
178 3/4 x 27 9/16 in. (454 x 70 cm)
Courtesy of Long March Space, Beijing

66. *Di^pam!kara*, 2007
Colored ink on rice paper
151 9/16 x 27 3/16 in. (385 x 69 cm)
Courtesy of Long March Space, Beijing

67. *Suirenshi*, 2007
Colored ink on rice paper
153 9/16 x 27 9/16 in. (390 x 70 cm)
Courtesy of Long March Space, Beijing

WADE GUYTON

68. *Untitled*, 2013
Epson UltraChrome K3 inkjet on linen
128 x 108 x 2 in. (325 x 275 x 5 cm)
Courtesy of the artist and Petzel Gallery, New York

69. *Untitled*, 2013
Epson UltraChrome K3 inkjet on linen
128 x 108 x 2 in. (325 x 275 x 5 cm)
Courtesy of the artist and Petzel Gallery, New York

70. *Untitled*, 2013
Epson UltraChrome K3 inkjet on linen
128 x 108 x 2 in. (325 x 275 x 5 cm)
Courtesy of the artist and Petzel Gallery, New York

71. *Untitled*, 2013
Epson UltraChrome K3 inkjet on linen
128 x 108 x 2 in. (325 x 275 x 5 cm)
Courtesy of the artist and Petzel Gallery, New York

72. *Untitled*, 2013
4 panels; Epson UltraChrome inkjet on linen
192 x 69 in. (487.6 x 175.2 cm) each
Courtesy of the artist and Petzel Gallery, New York

ROKNI HAERIZADEH

73. *Just What Is It that Makes Today's Homes So Different, So Appealing?*, 2010–11
Video; color, silent
4:23 min.
Courtesy of Gallery Isabelle van den Eynde, Dubai, and the artist

74. *Adrenaline Runs in Armpits*, 2011
Gesso, ink, and watercolor on printed paper
Portfolio of 9 works, 8 1/4 x 11 13/16 in. (21 x 30 cm) each
Courtesy of Gallery Isabelle van den Eynde, Dubai, and the artist

75. *Cyrus Sylinder Coming Back Home*, 2011
Gesso, ink, and watercolor on printed paper
Portfolio of 9 works, 8 1/4 x 11 13/16 in. (21 x 30 cm) each
Courtesy of Gallery Isabelle van den Eynde, Dubai, and the artist

76. *Go Find a New Bed*, 2011
Gesso, ink, and watercolor on printed paper
Portfolio of 9 works, 8 1/4 x 11 13/16 in. (21 x 30 cm) each
Courtesy of Gallery Isabelle van den Eynde, Dubai, and the artist

77. *Some Breath Breathes Out of Bombs and Dog Barks*, 2011
Gesso, ink, and watercolor on printed paper
Portfolio of 9 works, 8 1/4 x 11 13/16 in. (21 x 30 cm) each
Courtesy of Gallery Isabelle van den Eynde, Dubai, and the artist

78. *Reign of Winter*, 2012–13
Video; color, silent
6 min.
Courtesy of Gallery Isabelle van den Eynde, Dubai, and the artist

79–103. *My Heart Is Not Here, My Heart's in The Highlands, Chasing The Deers*, 2013
24 gesso, ink, and watercolor drawings on printed paper
11 13/16 x 15 3/4 in. (30 x 40 cm) each
Courtesy of Gallery Isabelle van den Eynde, Dubai, and the artist

HE AN

104. *What Makes Me Understand What I Know?*, 2009
Neon lights
Dimensions variable
Courtesy of Kwong Yee Leong & Alfred Cheong

105. *What Makes Me Understand What I Know?*, 2013
Neon lights
Dimensions variable
Courtesy of Leo Xu Projects, Shanghai

106. *What Makes Me Understand What I Know?*, 2013
Neon lights
Dimensions variable
Courtesy of DSL Collection

AMAR KANWAR

107. *The Scene of Crime*, 2011
HD video installation; color, sound
42 min.
Courtesy of Marian Goodman Gallery, New York and Paris
Presentation supported by the Asian Cultural Council and the George Foundation

108. *A Love Story*, 2010
HD video installation; color, sound
5:37 min.
Courtesy of Marian Goodman Gallery, New York and Paris
Presentation supported by the Asian Cultural Council and The George Foundation

DINH Q. LÊ

In collaboration with Lê Lam, Quách Phong, Huynh Phương Đông, Nguyễn Thụ, Dương Ánh, Vũ Giáng Hương, Nguyễn Toàn Thi, Trương Hiếu, Phan Oánh, Kim Tiến, Minh Phương, Quang Thọ, Nguyễn Thanh Châu

109. *Light and Belief: Sketches of Life from the Vietnam War*, 2012
100 drawings; pencil, watercolor, ink, and oil on paper
Dimensions variable
Video; color, sound
35 min.
Courtesy of the artist and Shoshana Wayne Gallery, Santa Monica
Presentation supported by The George Foundation

MARK LECKEY

110. *Made in 'Eaven*, 2004
16mm film; color, silent
3 min.; looped 20 min.
Courtesy of the artist; Gavin Brown's enterprise, New York; Galerie Daniel Buchholz, Cologne; and Cabinet Gallery, London

111. *Pearl Vision*, 2012
Video; color, sound
3:10 min.
Courtesy of the artist; Gavin Brown's
enterprise, New York; Galerie Daniel
Buchholz, Cologne; and Cabinet
Gallery, London

PIERRE LEGUILLON

112. *Non-Happening after
Ad Reinhardt*, 2010/2013
Performance
Duration variable
Courtesy of the artist

113. *Jean Dubuffet Typographer
(diorama)*, 2013
Installation
Dimensions variable
Courtesy of the artist

114. *A Vivarium for George E. Ohr*, 2013
Installation including 30 ceramics from
the collection of Carolyn and Gene Hecht
Dimensions variable
Courtesy of the artist
Supported by Etant donnés: The French-
American Fund for Contemporary Art

SARAH LUCAS

115. *Ace in The Hole*, 1998
Tights, stockings, 4 chairs, clamps, kapok,
stuffing, and card table
Dimensions variable
Sender Collection

116. *Aunty Jam*, 2005
Steel cage, wire, nylon tights,
and cast concrete
80 x 63 x 94 in. (203 x 160 x 238.7 cm)
Collection of Jeanne Greenberg Rohatyn
and Nicolas Rohatyn

117. *Stars at a glance*, 2007
Concrete shoes, bra, footballs,
and cigarettes
10 ⅝ x 13 x 10 ⅝ in. (26.9 x 33 x 26.9 cm)
Collection of Jeanne Greenberg Rohatyn
and Nicolas Rohatyn

118. *NUD 10*, 2009
Tights, fluff, and wire
12 ⅝ x 14 ⅝ x 14 ⅝ in. (32 x 37 x 37 cm)
Collection of Jeanne Greenberg Rohatyn
and Nicolas Rohatyn

119. *NUD 11*, 2009
Tights, fluff, and wire
13 x 12 ¼ x 13 in. (33 x 31.1 x 33 cm)
Private collection

120. *Loungers #3*, 2011
Tights, fluff, plastic bucket, and
plastic lounger
78 x 24 ⅝ x 22 in. (198.1 x 62.5 x 55.8 cm)
Collection of Jeanne Greenberg
Rohatyn and Nicolas Rohatyn

121. *Dr. Atl*, 2012
Aluminum wire, masking tape, natural
cotton, lycra stockings, and adobe bricks
30 ⅝ x 32 ⁵⁄₁₆ x 21 ¼ in.
(77 x 82 x 54 cm) sculpture
42 ¹⁵⁄₁₆ x 20 ¹⁄₁₆ x 17 ¹¹⁄₁₆ in.
(109 x 51 x 45 cm) plinth
Courtesy of the artist; Sadie Coles HQ,
London; and kurimanzutto, Mexico City

122. *NUD 28*, 2012
Aluminum wire, masking tape, natural
cotton, lycra stockings, and adobe bricks
12 x 15 ¾ x 22 ¹³⁄₁₆ in.
(30.5 x 40 x 58 cm) sculpture
22 ¹⁄₁₆ x 17 ½ x 17 ⁵⁄₁₆ in.
(56 x 44.5 x 44 cm) plinth
Courtesy of the artist; Sadie Coles HQ,
London; and kurimanzutto, Mexico City

123. *B1*, 2013
MDF, 6 breeze blocks
33 ½ x 29 ⅜ x 29 ⅛ in. (85 x 74.6 x 74 cm)
Courtesy of Sadie Coles HQ, London

124. *C1*, 2013
MDF, 8 breeze blocks
20 ⅞ x 76 ½ x 19 ½ in. (53 x 194.4 x 49.5 cm)
Courtesy of Sadie Coles HQ, London

125. *D4*, 2013
MDF, 4 breeze blocks
35 x 9 ½ x 32 ¼ in. (89 x 49.5 x 82 cm)
Courtesy of Sadie Coles HQ, London

126. *E1*, 2013
MDF, 8 breeze blocks
20 ⅞ x 75 x 20 ⅛ in. (53 x 190.5 x 51 cm)
Courtesy of Sadie Coles HQ, London

TOBIAS MADISON

127. *Workshop*, 2013
Video; color, sound; and installation
Duration and dimensions variable
Courtesy of the artist
In collaboration with the Neighborhood
Youth Outreach Program and St.
Stephen's Church, Wilkinsburg, PA
Supported by the Walter A. Bechtler
Foundation and The Swiss Arts
Council Pro Helvetia

ZANELE MUHOLI

Faces and Phases
48 gelatin silver prints
34 ¹⁄₁₆ x 23 ¹³⁄₁₆ in. (86.5 x 60.5 cm) each
Presentation supported by The George
Foundation

128. *Dikeledi Sibanda, Yeoville,
Johannesburg*, 2007
Courtesy of the artist and Stevenson,
Cape Town and Johannesburg

129. *Nosi "Ginga" Marumo, Yeoville,
Johannesburg*, 2007
Courtesy of the artist and Stevenson,
Cape Town and Johannesburg

130. *Nosipho Solundwana, Parktown,
Johannesburg*, 2007
Courtesy of the artist and Stevenson,
Cape Town and Johannesburg

131. *Jordyn Monroe, Toronto*, 2008
Courtesy of the artist and Stevenson,
Cape Town and Johannesburg

132. *Sisipho Ndzuzo, Embekweni, Paarl*,
2009
Courtesy of the artist and Stevenson,
Cape Town and Johannesburg

133. *Betesta Segale, Gaborone,
Botswana*, 2010
Courtesy of the artist and Stevenson,
Cape Town and Johannesburg

134. *Funeka Soldaat, Makhaza,
Khayelitsha, Cape Town*, 2010
Courtesy of the artist and Stevenson,
Cape Town and Johannesburg

135. *Gazi T Zuma, Umlazi, Durban*, 2010
Courtesy of the artist and Stevenson,
Cape Town and Johannesburg

136. *"Makhethi" Sebenzile Ndaba,
Constitution Hill, Johannesburg*, 2010
Courtesy of the artist and Stevenson,
Cape Town and Johannesburg

137. *Thandeka Ndamase, KwaThema,
Springs, Johannesburg*, 2010
Courtesy of the artist and Stevenson,
Cape Town and Johannesburg

138. *Audrey Mary, Harare,
Zimbabwe*, 2011
Carnegie Museum of Art, A. W. Mellon
Acquisition Endowment Fund

139. *Lebo Ntladi, Newtown,
Johannesburg*, 2011
Courtesy of the artist and Stevenson,
Cape Town and Johannesburg
Commissioned by Carnegie Museum of
Art for the *2013 Carnegie International*

140. *Lungile Cleo Dladla, Kwa
Thema Community Hall, Springs,
Johannesburg*, 2011
Carnegie Museum of Art, A. W. Mellon
Acquisition Endowment Fund

141. *Mshini K. Ndzimande, Vosloorus Township, Johannesburg,* 2011
Courtesy of the artist and Stevenson, Cape Town and Johannesburg
Commissioned by Carnegie Museum of Art for the *2013 Carnegie International*

142. *Pearl Mali, Makhaza, Khayelitsha,* 2011
Courtesy of the artist; Yancey Richardson Gallery, New York; and Stevenson, Cape Town and Johannesburg

143. *Sebo Shabalala, Umlazi Township, Durban,* 2011
Courtesy of the artist and Stevenson, Cape Town and Johannesburg
Commissioned by Carnegie Museum of Art for the *2013 Carnegie International*

144. *Sisipho Ndzuzo, District 6, Cape Town,* 2011
Courtesy of the artist and Stevenson, Cape Town and Johannesburg

145. *Tash Dowell, Harare, Zimbabwe,* 2011
Courtesy of the artist; Yancey Richardson Gallery, New York; and Stevenson, Cape Town and Johannesburg

146. *Tinashe Wakapila, Harare, Zimbabwe,* 2011
Carnegie Museum of Art, A.W. Mellon Acquisition Endowment Fund

147. *Vuyelwa Makubetse, KwaThema Community Hall, Springs, Johannesburg,* 2011
Carnegie Museum of Art, A.W. Mellon Acquisition Endowment Fund

148. *Vuyo Mkonwana, Site B, Oliver Tambo Hall, Khayelitsha, Cape Town,* 2011
Carnegie Museum of Art, A.W. Mellon Acquisition Endowment Fund

149. *Xana Nyilenda, Newtown, Johannesburg,* 2011
Courtesy of the artist; Yancey Richardson Gallery, New York; Stevenson, Cape Town and Johannesburg

150. *Zimaseka "Zim" Salusalu Gugulethu, Cape Town,* 2011
Carnegie Museum of Art, A.W. Mellon Acquisition Endowment Fund

151. *Zuki Gaca, Grand Parade, Cape Town,* 2011
Courtesy of the artist and Stevenson, Cape Town and Johannesburg

152. *Amanda Gxwalintloko, Khayelitsha Township, Cape Town,* 2012
Courtesy of the artist and Stevenson, Cape Town and Johannesburg
Commissioned by Carnegie Museum of Art for the *2013 Carnegie International*

153. *Ayanda Magoloza, Kwanele South, Katlehong, Johannesburg,* 2012
Courtesy of the artist; Yancey Richardson Gallery, New York; Stevenson, Cape Town and Johannesburg

154. *Collen Mfazwe, August House, Johannesburg,* 2012
Courtesy of the artist and Stevenson, Cape Town and Johannesburg
Commissioned by Carnegie Museum of Art for the *2013 Carnegie International*

155. *Lithakazi Nomngcongo, Vredehoek, Cape Town,* 2012
Courtesy of the artist and Stevenson, Cape Town and Johannesburg
Commissioned by Carnegie Museum of Art for the *2013 Carnegie International*

156. *Londeka Xulu, Pietermaritzburg, KwaZulu-Natal,* 2012
Courtesy of the artist and Stevenson, Cape Town and Johannesburg
Commissioned by Carnegie Museum of Art for the *2013 Carnegie International*

157. *Nana Nxumalo, Pietermaritzburg, KwaZulu-Natal,* 2012
Courtesy of the artist and Stevenson, Cape Town and Johannesburg
Commissioned by Carnegie Museum of Art for the *2013 Carnegie International*

158. *Nhlanhla Mofokeng, Katlehong Township, Johannesburg,* 2012
Courtesy of the artist and Stevenson, Cape Town and Johannesburg
Commissioned by Carnegie Museum of Art for the *2013 Carnegie International*

159. *Ntobza Mkhwanazi, BB Section, Umlazi Township, Durban,* 2012
Courtesy of the artist; Yancey Richardson Gallery, New York; Stevenson, Cape Town and Johannesburg

160. *Sane, Pietermaritzburg, KwaZulu-Natal,* 2012
Courtesy of the artist and Stevenson, Cape Town and Johannesburg
Commissioned by Carnegie Museum of Art for the *2013 Carnegie International*

161. *Simphiwe Mbatha, August House, Johannesburg,* 2012
Courtesy of the artist and Stevenson, Cape Town and Johannesburg
Commissioned by Carnegie Museum of Art for the *2013 Carnegie International*

162. *Thembela Dick, Vredehoek, Cape Town,* 2012
Courtesy of the artist and Stevenson, Cape Town and Johannesburg
Commissioned by Carnegie Museum of Art for the *2013 Carnegie International*

163. *Thobe Mpulo, Pietermaritzburg, KwaZulu-Natal,* 2012
Courtesy of the artist and Stevenson, Cape Town and Johannesburg
Commissioned by Carnegie Museum of Art for the *2013 Carnegie International*

164. *"TK" Thembi Khumalo, BB Section Umlazi Township, Durban,* 2012
Courtesy of the artist; Yancey Richardson Gallery, New York; and Stevenson, Cape Town and Johannesburg

165. *Bathini Dambuza, Tembisa, Johannesburg,* 2013
Courtesy of the artist and Stevenson, Cape Town and Johannesburg
Commissioned by Carnegie Museum of Art for the *2013 Carnegie International*

166. *Boitumelo Mimie Sepotokele, White City, Soweto, Johannesburg,* 2013
Courtesy of the artist and Stevenson, Cape Town and Johannesburg
Commissioned by Carnegie Museum of Art for the *2013 Carnegie International*

167. *Charmain Carrol, Parktown, Johannesburg,* 2013
Courtesy of the artist and Stevenson, Cape Town and Johannesburg
Commissioned by Carnegie Museum of Art for the *2013 Carnegie International*

168. *Collen Mfazwe, Women's Goal, Constitution Hill, Braamfontein, Johannesburg,* 2013
Courtesy of the artist and Stevenson, Cape Town and Johannesburg
Commissioned by Carnegie Museum of Art for the *2013 Carnegie International*

169. *Jamilla Jade Madingwane, White City, Soweto, Johannesburg,* 2013
Courtesy of the artist and Stevenson, Cape Town and Johannesburg
Commissioned by Carnegie Museum of Art for the, *2013 Carnegie International*

170. *Maureen Velile Majola, Parktown, Johannesburg,* 2013
Courtesy of the artist and Stevenson, Cape Town and Johannesburg
Commissioned by Carnegie Museum of Art for the *2013 Carnegie International*

171. *Noluntu Makalima, Yeoville, Johannesburg,* 2013
Courtesy of the artist and Stevenson, Cape Town and Johannesburg
Commissioned by Carnegie Museum of Art for the *2013 Carnegie International*

172. *Nosiphiwo Kulati, Orlando, Soweto, Johannesburg,* 2013
Courtesy of the artist and Stevenson, Cape Town and Johannesburg
Commissioned by Carnegie Museum of Art for the *2013 Carnegie International*

173. *Ricki Kgositau, Melville,*
Johannesburg, 2013
Courtesy of the artist and Stevenson,
Cape Town and Johannesburg
Commissioned by Carnegie Museum of
Art for the *2013 Carnegie International*

174. *Thekwane Bongi Mpisholo,*
Women's Goal, Constitution Hill,
Braamfontein, Johannesburg, 2013
Courtesy of the artist and Stevenson,
Cape Town and Johannesburg
Commissioned by Carnegie Museum of
Art for the *2013 Carnegie International*

175. *Tumi Nkopane, KwaThema*
Township, Johannesburg, 2013
Courtesy of the artist and Stevenson,
Cape Town and Johannesburg
Commissioned by Carnegie Museum of
Art for the *2013 Carnegie International*

PAULINA OLOWSKA

176. *Cake,* 2010
Oil on canvas
68 ⅞ x 49 ³/₁₆ in. (175 x 124.9 cm)
Private collection

177. *Cardigan Jedrek,* 2010
Oil on canvas
76 ¾ x 55 ⅛ in. (194.9 x 140 cm)
Courtesy of the artist and Metro
Pictures, New York

178. *Chess Player 1,* 2010
Oil on canvas
68 ⅞ x 49 ³/₁₆ in. (175 x 124.9 cm)
Sender Collection

179. *Puppetry in America Is Truly*
a Lonely Craft, 2013
Installation including performance,
collage, built structures, and puppets
from the collection of Tom Sarver
Dimensions variable
Courtesy of the artist and Metro
Pictures, New York
Commissioned by Carnegie Museum of
Art for the *2013 Carnegie International*

PEDRO REYES

180. *Disarm (Mechanized),* 2012–13
Recycled metal
Installation comprising 8 mechanized
instruments:
Harpanet: 77 ³/₁₆ x 36 ¼ x 28 ¾ in.
(196 x 92 x 73 cm)
Cañonófono: 28 ¾ x 72 ¹³/₁₆ x 19 ¹¹/₁₆ in.
(117 x 185 x 50 cm)
Sentinel: 85 ⁷/₁₆ x 50 ⅜ x 32 ¹¹/₁₆ in.
(217 x 128 x 83 cm)
Wind Chime: 65 ⅜ x 25 ⁹/₁₆ x 25 ⁹/₁₆ in.
(166 x 65 x 65 cm)
Kalashniclock: 43 ⁵/₁₆ x 45 ¼ x 45 ¼ in.
(110 x 115 x 115 cm)

Snare Drum: 30 ¹¹/₁₆ x 27 ⁹/₁₆ x 24 in.
(78 x 70 x 61 cm)
Hi-Hat: 39 ⅜ x 26 x 26 in. (100 x 66 x 66 cm)
Bass Drum: 47 ¼ x 44 ⅛ x 39 ⅜ in. and
22 ¹³/₁₆ x 15 ⅜ x 45 ¼ in. (120 x 112 x 100 cm
and 58 x 39 x 115 cm)
Magnetic Cello: 55 ⅛ x 53 ⅛ x 31 ½ in.
(140 x 135 x 80 cm)
Trigger Puller: 46 ⁷/₁₆ x 66 ¹⁵/₁₆ x 66 ¹⁵/₁₆ in.
(118 x 170 x 170 cm)
Courtesy of the artist and Lisson
Gallery, London

181. *Disarm (Double Psaltery),* 2013
Recycled metal
7 ⅞ x 19 ¹¹/₁₆ x 19 ¹¹/₁₆ in. (20 x 50 x 50 cm)
Courtesy of the artist and Lisson
Gallery, London

182. *Disarm (Guitar),* 2013
Metal
33 ⅞ x 11 ¹³/₁₆ x 3 ⅞ in. (86 x 30 x 10 cm)
Courtesy of the artist and Lisson
Gallery, London

KAMRAN SHIRDEL

183. *Nedamatgah* (*Women's Prison*), 1965
35mm film transferred to digital format;
black-and-white, sound
11 min.
Courtesy of the artist
Presentation supported by The George
Foundation

184. *Tehran Paitakhte Iran Ast*
(*Tehran Is the Capital of Iran*), 1966–79
35mm film transferred to digital format;
black-and-white, sound
18 min.
Courtesy of the artist
Presentation supported by The George
Foundation

185. *Qaleh* (*The Women's Quarter*), 1966–80
35mm film transferred to digital format;
black-and-white, sound
18 min.
Courtesy of the artist
Presentation supported by The George
Foundation

186. *An shab ke barun amad*
(*The Night It Rained*), 1967–74
35mm film transferred to digital format;
black-and-white, sound
35 min.
Courtesy of the artist
Presentation supported by The George
Foundation

187. *Pearls of the Persian Gulf:*
Dubai, 1975
35mm film transferred to digital format;
color, sound
43 min.
Courtesy of the artist
Presentation supported by The George
Foundation

188. *Solitude Opus,* 2001–2
Digital video; color, sound
19 min.
Courtesy of the artist
Presentation supported by The George
Foundation

GABRIEL SIERRA

189. *Untitled (111.111.111 x 111.111.111 =*
12345678987654321), 2013
Paint and wood
Dimensions variable
Courtesy of the artist and kurimanzutto,
Mexico City
Commissioned by Carnegie Museum of
Art for the *2013 Carnegie International*
Supported by Nancy and Woody
Ostrow and the Colombia Ministry of
Foreign Affairs

TARYN SIMON

190. *Birds of the West Indies,* 2013
190 archival inkjet prints in boxed mats
and aluminum frames
15 ¾ x 10 ½ in (40 x 26.7 cm) each
and
Single-channel video; color, sound
8:05 min., looped
Courtesy of Gagosian Gallery

　Women
A.1　*Honey Ryder* (Ursula Andress), 1962
A.2　*Sylvia Trench* (Eunice Gayson), 1962
A.3　*Tatiana Romanova* (Daniela Bianchi),
　　1963
A.4　*Sylvia Trench* (Eunice Gayson), 1963
A.5　*Zora* (Martine Beswick), 1963
A.6　*Pussy Galore* (Honor Blackman),
　　1964
A.7　*Jill Masterson* (Shirley Eaton), 1964
A.8　*Tilly Masterson* (Tania Mallet), 1964
A.9　*Paula Caplan* (Martine Beswick),
　　1965
A.10　*Domino Derval* (Claudine Auger),
　　1965
A.11　*Patricia Fearing* (Mollie Peters),
　　1965
A.12　*Fiona Volpe* (Luciana Paluzzi), 1965
A.13　*Aki* (Akiko Wakabayashi), 1967
A.14　*Helga Brandt* (Karin Dor), 1967
A.15　*Ling* (Tsai Chin), 1967
A.16　*Kissy Suzuki* (Mie Hama), 1967
A.17　*Tracy Di Vicenzo* (Diana Rigg), 1969
A.18　*Nancy* (Catherine Schell), 1969
A.19　*Tiffany Case* (Jill St. John), 1971
A.20　*Plenty O'Toole* (Lana Wood), 1971
A.21　*Solitaire* (Jane Seymour), 1973
A.22　*Miss Caruso* (Madeline Smith), 1973
A.23　*Rosie Carver* (Gloria Hendry), 1973
A.24　*Andrea Anders* (Maud Adams), 1974
A.25　*Mary Goodnight* (Britt Ekland), 1974
A.26　*Anya Amasova* (Barbara Bach), 1977
A.27　*Hotel Receptionist* (Valerie Leon),
　　1977
A.28　*Naomi* (Caroline Munro), 1977
A.29　*Holly Goodhead* (Lois Chiles), 1979

A.30 *Corinne Dufour* (Corinne Cléry), 1979
A.31 *Bibi Dahl* (Lynn-Holly Johnson), 1981
A.32 *Melina Havelock* (Carole Bouquet), 1981
A.33 *Magda* (Kristina Wayborn), 1983
A.34 *Octopussy* (Maud Adams), 1983
A.35 *Lady in Bahamas* (Valerie Leon), 1983
A.36 *Fatima Blush* (Barbara Carrera), 1983
A.37 *Domino Petachi* (Kim Basinger), 1983
A.38 *May Day* (Grace Jones), 1985
A.39 *Pola Ivanova* (Fiona Fullerton), 1985
A.40 *Stacey Sutton* (Tanya Roberts), 1985
A.41 *Kara Milovy* (Maryam d'Abo), 1987
A.42 *Miss Moneypenny* (Caroline Secombe), 1987
A.43 *Pam Bouvier* (Carey Lowell), 1989
A.44 *Lupe Lamora* (Talisa Soto), 1989
A.45 *Miss Moneypenny* (Caroline Secombe), 1989
A.46 *Xenia Onatopp* (Famke Janssen), 1995
A.47 *Miss Moneypenny* (Samantha Bond), 1995
A.48 *Natalya Simonova* (Izabella Scorupco), 1995
A.49 *Paris Carver* (Teri Hatcher), 1997
A.50 *Colonel Wai Lin* (Michelle Yeoh), 1997
A.51 *Miss Moneypenny* (Samantha Bond), 1997
A.52 *Dr. Christmas Jones* (Denise Richards), 1999
A.53 *Elektra King* (Sophie Marceau), 1999
A.54 *Miss Moneypenny* (Samantha Bond), 1999
A.55 *Miranda Frost* (Rosamund Pike), 2002
A.56 *Jinx Johnson* (Halle Berry), 2002
A.57 *Miss Moneypenny* (Samantha Bond), 2002
A.58 *Vesper Lynd* (Eva Green), 2006
A.59 *Solange Dimitrios* (Caterina Murino), 2006
A.60 *Madame Wu* (Tsai Chin), 2006
A.61 *Strawberry Fields* (Gemma Arterton), 2008
A.62 *Camille Montes* (Olga Kurylenko), 2008
A.63 *Eve Moneypenny* (Naomie Harris), 2012
A.64 *Séverine* (Bérénice Marlohe), 2012

X.X Nikki van der Zyl

Weapons
B.1 *Dom Pérignon*, 1962
B.2 *Tarantula*, 1962
B.3 *Attaché Case*, 1963
B.4 *Poison Dagger Shoe*, 1963
B.5 *Walther PPK 7.65 mm / .32 ACP*, 1963
B.6 *Piton Gun*, 1964
B.7 *Razor-Edged Bowler Hat*, 1964
B.8 *Spear*, 1965
B.9 *Spear Gun*, 1965
B.10 *Cigarette Rocket*, 1967
B.11 *MB Associates Gyrojet Mark I Model B Pistol*, 1967
B.12 *Armalite AR-7 in Aston Martin DBS Glovebox*, 1969
B.13 *SIG SG 510*, 1969
B.14 *Bombe Surprise Explosive Device*, 1971
B.15 *Piton Gun*, 1971
B.16 *CO2 Bullet*, 1973
B.17 *Mechanical Arm*, 1973
B.18 *Sideview Mirror Dart Gun*, 1973
B.19 *Ceremonial Sword*, 1974
B.20 *Golden Gun*, 1974
B.21 *Ski Pole Rifle*, 1977
B.22 *Steel Teeth*, 1977
B.23 *Laser Pistol*, 1979
B.24 *Laser Rifle*, 1979
B.25 *Barnett Commando Crossbow*, 1981
B.26 *Blasting Detonator*, 1981
B.27 *Walther PPK 7.65 mm / .32 ACP*, 1981
B.28 *Indian Mace*, 1983
B.29 *Nuclear Bomb*, 1983
B.30 *Rapier Missile Launcher*, 1983
B.31 *Yo-yo Saw*, 1983
B.32 *Shark Brain Control Device*, 1983
B.33 *U.S. Air Force AGM-86B ALCM*, 1983
B.34 *XT7B Personal Missile / Rocket Transport*, 1983
B.35 *Fire Axe*, 1985
B.36 *Thermos Bomb*, 1985
B.37 *Plastic Explosives and Timer*, 1987
B.38 *Rolling Pin*, 1987
B.39 *Walther PPK 7.65 mm / .32 ACP*, 1987
B.40 *Dagger*, 1989
B.41 *Dentonite Plastic Explosive*, 1989
B.42 *Exploding Alarm Clock*, 1989
B.43 *General Dynamics FIM-43 Redeye*, 1989
B.44 *Garrote*, 1989
B.45 *Shark*, 1989
B.46 *Hasselblad Camera Signature Gun*, 1989
B.47 *Stingray Tail Whip*, 1989
B.48 *Laser X-ray Polaroid Camera*, 1989
B.49 *Ballpoint Pen Grenade*, 1995
B.50 *Browning BDA with Suppressor*, 1995
B.51 *Piton Gun*, 1995
B.52 *Leg Cast Missile Launcher*, 1995
B.53 *Ericsson Mobile Phone with Stun Gun, Fingerprint Scanner, Lock Pick, and Remote Control System for Operating BMW 750iL*, 1997
B.54 *Modified Sterling Armalite AR-180*, 1997
B.55 *Limpet Mines*, 1997
B.56 *Restraint Fan*, 1997
B.57 *Grenade in Jar Rigged with Remote Detonator*, 1997
B.58 *Chakra Torture Devices*, 1997
B.59 *Walther P99*, 1997
B.60 *Bagpipes with Flamethrower and Machine Gun*, 1999
B.61 *C4 Explosives and Detonator*, 1999
B.62 *Cane Rifle*, 1999
B.63 *Explosive Bills with Magnesium Circuit Detonator*, 1999
B.64 *Nuclear Material Container*, 1999
B.65 *Plutonium Rod and Case*, 1999
B.66 *Beretta 3032 Tomcat*, 2002
B.67 *Beretta 84FS "Cheetah,"* 2002
B.68 *Bikini Hip Knife*, 2002
B.69 *Foil*, 2002
B.70 *Heckler & Koch XM29 OICW (embellished G36K)*, 2002
B.71 *Explosives*, 2006
B.72 *Explosive Key Fob*, 2006
B.73 *Heckler & Koch UMP-9 with Suppressor*, 2006
B.74 *Knotted Rope Whip*, 2006
B.75 *Nail Gun*, 2006
B.76 *Stun Gun*, 2006
B.77 *Fororro Motor Oil Can*, 2008
B.78 *Fingernail Scissors*, 2008
B.79 *Shard of Glass*, 2008
B.80 *Walther PPK 7.65 mm / .32 ACP*, 2008
B.81 *Anderson Wheeler 500 NE Double Rifle*, 2012
B.82 *Custom Bolt Action Sniper Rifle with Suppressor*, 2012
B.83 *Walther PPK/S 9 mm Short*, 2012

Vehicles
C.1 *1961 Sunbeam Alpine Series II*, 1962
C.2 *Fairey Huntress 23*, 1963
C.3 *1963 Aston Martin DB5*, 1964
C.4 *1937 Rolls-Royce Phantom III*, 1964
C.5 *Tow Sled*, 1965
C.6 *Burial-at-Sea Bed*, 1967
C.7 *1967 Wallis Autogyros WA-116 Agile Series 1 " Little Nellie,"* 1967
C.8 *1969 Mercury Cougar XR7*, 1969
C.9 *Bath-O-Sub*, 1971
C.10 *1971 Ford Mustang Mach 1*, 1971
C.11 *1971 Honda ATC*, 1971
C.12 *1973 Glastron Carlson GT-150*, 1973
C.13 *1974 AMC Hornet*, 1974
C.14 *1977 Lotus Esprit S1 " Wet Nellie,"* 1977
C.15 *1977 Spirit Marine Wetbike Prototype*, 1977
C.16 *1978 Glastron Carlson CV-23HT*, 1979
C.17 *1981 Citroën 2CV*, 1981
C.18 *Bede BD-5J " Acrostar,"* 1983
C.19 *Crocodile Mini-Sub*, 1983
C.20 *1983 Honda Tuk Tuk Taxi*, 1983
C.21 *Underwater Tow Sled*, 1983
C.22 *1985 Renault 11 TXE*, 1985
C.23 *1962 Rolls-Royce Silver Cloud II*, 1985
C.24 *1984 Aston Martin V8 Volante*, 1987
C.25 *" PIG" Pipeline Inspection Gauge*, 1987
C.26 *1995 Cagiva 600 W16*, 1995
C.27 *1997 BMW 750iL*, 1997
C.28 *1997 BMW R1200C*, 1997
C.29 *1999 BMW Z8*, 1999
C.30 *1999 Blue Heron Parahawk*, 1999
C.31 *Q Boat*, 1999
C.32 *1977 Rolls-Royce Silver Shadow II*, 1999
C.33 *2002 Aston Martin V12 Vanquish*, 2002
C.34 *Bell Aerosystems Rocket Belt*, 2002
C.35 *2002 Ford Thunderbird*, 2002
C.36 *Ice Dragster*, 2002
C.37 *2002 Jaguar XKR Convertible*, 2002
C.38 *2002 Osprey Hovercraft Osprey 5 MKII*, 2002
C.39 *2006 Aston Martin DBS*, 2006
C.40 *2006 Aston Martin DBS (with roll*

damage), 2006
C.41 *Skyfleet S570*, 2006
C.42 *2008 Aston Martin DBS* (with
continuity damage), 2008
C.43 *1964 Aston Martin DB5*, 2012

FRANCES STARK

191. *Bobby Jesus's Alma Mater b/w
Reading the Book of David and/or Paying
Attention Is Free*, 2013
Inkjet print on paper and multichannel
projection with sound
4:20 min.
Courtesy of the artist; Galerie Daniel
Buchholz, Cologne and Berlin; Gavin
Brown's enterprise, New York; Marc Foxx,
Los Angeles; and Greengrassi, London

JOEL STERNFELD

*Sweet Earth: Experimental
Utopias in America*
C-prints
26 ½ x 33 ¼ in. (67.3 x 84.4 cm) each
Courtesy of the artist and Luhring
Augustine, New York

192. *Scott and Helen Nearing at Forest
Farm, Harborside, Maine, October 1982.*

193. *The General Sherman Tree, Sequoia
National Park, California, January 1994.*

194. *Dome Village, Los Angeles,
California, August 1994.*

195. *Old Economy, Ambrose,
Pennsylvania, August 1995.*

196. *Ruins of Drop City, Trinidad,
Colorado, August 1995.*

197. *Oneida Community Mansion House,
Oneida, New York, August 1996.*

198. *Roofless Church, New Harmony,
Indiana, May 2000.*

199. *Daily Menu, Biosphere 2, Oracle,
Arizona, July 2000.*

200. *Paolo Soleri at Arcosanti, Cordes
Junction, Arizona, August 2000.*

201. *The Farm, Summertown,
Tennessee, March 2003.*

202. *Dacha/Staff Building,
Gesundheit! Institute, Hillsboro,
West Virginia, April 2004.*

203. *Light of Truth Universal Shrine
(LOTUS), Yogaville, Buckingham,
Virginia, April 2004.*

204. *Lost Valley Education Center, Dexter,
Oregon, April 2004.*

205. *Sirius Community during a break
in a Paths of Awakening weekend
retreat with Mirabai Devi, Shutesbury,
Massachusetts, April 2004.*

206. *Jyoti Kori-Bhatt and Seth Williams
at Appel Farm Restoration Project, a
commune in formation, with Huw "Piper"
Wiliams, founder of Tolstoy Farm, Edwall,
Washington, August 2004.*

207. *US Post Office, Seaside, Florida,
December 2004.*

208. *Lake Tuendae, Zzyzx Springs,
California, March 2005.*

209. *Leonard Knight at Salvation
Mountain, Slab City, California,
March 2005.*

210. *N Street Cohousing, Davis,
California, March 2005.*

211. *Queen of the Prom, the Range
Nightclub, Slab City, California,
March 2005.*

212. *An Earthship at Earthaven
Ecovillage, Black Mountain, North
Carolina, April 2005.*

213. *"Learning" by Jean Charlot, Camp
Rockmount, Black Mountain, North
Carolina, April 2005.*

214. *Piedmont Biofuels, Pittsboro,
North Carolina, April 2005.*

215. *Garden Roof, City Hall, Chicago,
May 2005.*

216. *Mormon Temple, Nauvoo, Illinois,
May 2005.*

217. *Liz Christy Garden, Bowery
and Houston Streets, New York City,
June 2005.*

218. *Roosevelt Public School, Roosevelt,
New Jersey, June 2005.*

219. *New Elm Springs Colony, Ethan,
South Dakota, July 2005.*

220. *Surreal Estates, Sacramento,
California, July 2005.*

MLADEN STILINOVIĆ

221. *Exhibition-Action, Group of
Six Artists, the Public Baths on the
River Sava, Zagreb*, 1975
Color inkjet print
5 ⅞ x 8 ¼ in. (15 x 21 cm)
Collection of the artist

222. *Smile from Burda Magazine*, 1975
Black-and-white inkjet print
11 ¹³⁄₁₆ x 8 ¼ in. (30 x 21 cm)
Collection of the artist

223. *Aukcija crvene* (*Auction of Red*), 1976
Colored pen and black-and-white photo-
graph on paper
11 ⁹⁄₁₆ x 7 ⅞ in. (29.3 x 20 cm)
Collection of the artist

224. *Exhibition-Action, Group of Six
Artists, Strolling through Zagreb*, 1976
Color inkjet print
11 ¹³⁄₁₆ x 8 ¼ in. (30 x 21 cm)
Collection of the artist

225. *To Dürer*, 1976
4 black-and-white photographs
19 ¹¹⁄₁₆ x 23 ⅝ in. (50 x 60 cm) each
Collection of the artist

226. *Odnos noga kruh* (*The Foot-Bread
Relationship*), 1977
8 accordion-folded inkjet prints
4 ¾ x 6 ¹¹⁄₁₆ in. (12 x 17 cm) each
Collection of the artist

227. *The Pain Game*, 1977
2 black-and-white inkjet prints
11 ¹³⁄₁₆ x 8 ¼ in. (30 x 21 cm) each
Collection of the artist

228. *Zastava (1), Zastava (2), Zastava (3)*
(*Flag [1], Flag [2], Flag [3]*), 1977
3 color inkjet prints
5 ⅞ x 3 ¹⁵⁄₁₆ in. (15 x 10 cm); 5 ⅞ x 3 ¹⁵⁄₁₆ in.
(15 x 10 cm); 7 ¹⁄₁₆ x 4 ¹⁵⁄₁₆ in. (18 x 12.5 cm)
Collection of the artist

229. *Artist at Work (for Neša Paripović)*,
1978
8 black-and-white photographs
11 ¹³⁄₁₆ x 15 ¹¹⁄₁₆ in. (30 x 39.8 cm) each
Collection of the artist

230. *Pjevaj!* (*Sing!*), 1980
Banknote on black-and-white photograph
on artificial silk
21 ⅝ x 18 ½ in. (55 x 47 cm)
Collection of the artist

231. *Anti-Museum Stand, Cvjetni trg,
Zagreb*, 1981
Black-and-white inkjet print
5 ⅞ x 8 ¼ in. (15 x 21 cm)
Collection of the artist

232. *Rad je bolest (Karl Marx)*
(*Work Is Disease [Karl Marx]*), 1981
Text painted on cardboard
3 ⅛ x 11 ¹³⁄₁₆ in. (8 x 30 cm)
Collection of the artist

233. *Exploitation of the Dead*, 1984–90
126 pieces; various materials
Dimensions variable
Collection of the artist

234. *Threw a Cake at the Painting*, 1988
3 black-and-white photographs
3 ¹⁵/₁₆ x 5 ⁷/₈ (10 x 15 cm) each
Collection of the artist

235. *An Artist Who Cannot Speak English Is No Artist*, 1992
Acrylic on artificial silk
59 x 98 ⁷/₁₆ in. (150 x 250 cm)
Collection of the artist

236. *In Praise of Laziness*, 1993
Artist text

237. *Bread–Tito*, 1996
Black-and-white photograph
9 ⁵/₁₆ x 6 ¹⁵/₁₆ in. (23.7 x 17.6 cm)
Collection of the artist

238. *Dictionary–Pain*, 2000–2003
523 pieces; tempera on printed paper
7 ¹/₁₆ x 5 ¹/₈ in. (18 x 13 cm) each
Collection of the artist

239. *Bag–People*, 2001
80 pieces; black-and-white
photographs on table
11 ¹³/₁₆ x 9 ⁷/₁₆ in. (30 x 24 cm) each
Collection of the artist

240. *Krumpira Krumpira*
(*Potatoes Potatoes*), 2001
Video; color, sound
3 min.
Collection of the artist

241. *Nobody Wants to See*, 2009
3 black-and-white inkjet prints
11 ¹³/₁₆ x 8 ¼ in. (30 x 21 cm) each
Collection of the artist

ZOE STRAUSS

242. *Homesteading*, 2013
Multifaceted collaborative project based
in Homestead, PA, and an installation of
photographic prints and video projections
at Carnegie Museum of Art
Courtesy of the artist
Commissioned by Carnegie Museum of
Art for the *2013 Carnegie International*

HENRY TAYLOR

243. *Eldridge Cleaver*, 2007
Acrylic on canvas
75 ¾ x 94 ¾ in. (192.4 x 240.6 cm)
Collection of David Hoberman,
Los Angeles

244. *Homage to a Brother*, 2007
Acrylic and collage on linen
94 x 63 in. (238.7 x 160 cm)
Promised gift to The Studio Museum
in Harlem, Collection of Martin and
Rebecca Eisenberg

245. *Huey Newton*, 2007
Acrylic and collage on canvas
95 ⅛ x 76 ¼ in. (241.6 x 194.3 cm)
Collection of Martin and
Rebecca Eisenberg

246. *Noah*, 2011
Acrylic on canvas
96 ½ x 76 ¾ in. (245.1 x 194.9 cm)
Carnegie Museum of Art, Gift of
Nancy and Milton Washington, 2013.19

247. *See Alice Jump*, 2011
Acrylic on canvas
76 ½ x 113 in. (193.6 x 287 cm)
Ovitz Family Collection, Los Angeles

248. *Let's Talk About Our Party*, 2012
Acrylic on canvas
73 x 55 in. (185.4 x 139.7 cm)
Kravis Collection

249. *Mary had a little… (that ain't
no lamb)*, 2013
Acrylic on canvas
96 ½ x 71 ¾ x 2 ½ in. (245.1 x
182.2 x 6.4 cm)
Collection of Lonti Ebers

250. *Stand Tall — Y'all*, 2013
Acrylic on canvas
126 x 72 x 2 ½ in. (320 x 182.9 x 6.4 cm)
Collection of Frank Masi and Donna Kolb

251. *That Was Then*, 2013
Acrylic on canvas
95 x 75 x 3 ¼ in. (241.3 x 190.5 x 8.3 cm)
Carnegie Museum of Art, The Henry L.
Hillman Fund. 2013.12

TEZUKA ARCHITECTS

252. *run run run*, 2013
Installation; digital projection, curtain,
floor mat, and balloons
Dimensions variable
Courtesy of Tezuka Architects
Supported by The Japan Foundation, New
York

TRANSFORMAZIUM

253. *Art Lending Collection*, 2013
Art lending collection at the Braddock
Carnegie Library, Braddock, PA, and
viewing area in the Carnegie Museum
of Art Scaife Lobby
The Art Lending Collection is a joint proj-
ect of Transformazium and the Braddock
Carnegie Library Association and is part of
the *2013 Carnegie International*

ERIKA VERZUTTI

254. *Cinco Ovos* (*Five Eggs*), 2013
Bronze, stone, and acrylic
9 ⁷/₁₆ x 5 ½ x 1 ³/₁₆ in. (24 x 14 x 3 cm)
Courtesy of the artist and Galeria
Fortes Vilaça, São Paulo

255. *Egg Tower*, 2013
Bronze, egg shell, concrete, and wax
110 ¼ x 15 ¾ x 15 ¾ in. (280 x 40 x 40 cm)
Courtesy of the artist and Galeria Fortes
Vilaça, São Paulo

256. *Eye Shadow* (*Smokey*), 2013
Concrete and acrylic gouache
9 ⁷/₁₆ x 6 ⁵/₁₆ x 1 ⁹/₁₆ in. (24 x 16 x 4 cm)
Courtesy of the artist and Galeria Fortes
Vilaça, São Paulo

257. *Gerbera*, 2013
Concrete and wax
13 ⅜ x 8 ¹¹/₁₆ x 1 ⁹/₁₆ in. (34 x 22 x 4 cm)
Courtesy of the artist and Galeria Fortes
Vilaça, São Paulo

258. *Livro Incrustado* (*Encrusted Book*),
2013
Bronze and stones
11 ¹³/₁₆ x 8 ¼ x 1 ⁹/₁₆ in. (30 x 21 x 4 cm)
Courtesy of the artist and Galeria Fortes
Vilaça, São Paulo

259. *Lua* (*Moon*), 2013
Bronze
10 ¼ x 7 ½ x 1 ⁹/₁₆ in. (26 x 19 x 4 cm)
Courtesy of the artist and Galeria Fortes
Vilaça, São Paulo

260. *Pink Photo Frame*, 2013
Bronze and wax
8 ¼ x 5 ⅞ x 1 ⁹/₁₆ in. (21 x 15 x 4 cm)
Courtesy of the artist and Galeria Fortes
Vilaça, São Paulo

261. *Swan with Hammer*, 2013
Bronze and sledgehammer
25 ⁹/₁₆ x 27 ⁹/₁₆ x 27 ⁹/₁₆ in. (65 x 70 x 70 cm)
Courtesy of the artist and Galeria Fortes
Vilaça, São Paulo

262. *Text Book*, 2013
Bronze
13 x 8 ¼ x 1 ¹⁵/₁₆ in. (33 x 21 x 5 cm)
Courtesy of the artist and Galeria Fortes
Vilaça, São Paulo

263. *The Book of Gems*, 2013
Concrete and wax
11 ¹³/₁₆ x 8 ¼ x 1 ⁹/₁₆ in (30 x 21 x 4 cm)
Courtesy of the artist and Galeria Fortes
Vilaça, São Paulo

JOSEPH YOAKUM

264. *Foot of Mountain Range Near Madrid Spain,* c. 1963–64
Watercolor and ballpoint pen on brown kraft paper, shellacked
19 x 24 in. (48.3 x 61 cm)
Courtesy of Karen Lennox Gallery, Chicago

265. *English Channel Between Southampton England and Le Havre France,* March 11, 1964
Ballpoint pen and colored pencil on paper
12 x 19 in. (30.5 x 48.3 cm)
Collection of Jim Nutt and Gladys Nilsson

266. *Iron Mountain Near Elk Rapids, Michigan,* May 19, 1964
Colored pencil and ballpoint pen on paper
31 x 25 in. (78.7 x 63.5 cm)
The Museum of Everything, courtesy of Carl Hammer Gallery, Chicago

267. *U.S. Highway #19 From Miami Florida to New York City N.Y.,* June 21, 1964
Ink on brown paper
12 x 17 ⅞ in. (30.5 x 45.4 cm)
The Museum of Everything

268. *Wilderness of Juda near Bethlehem,* November 3, 1964
Ballpoint pen and colored pencil on paper
12 x 18 in. (30.5 x 45.7 cm)
Collection of Jim Nutt and Gladys Nilsson

269. *Columbia Knowles in Hanford Desert, 35 miles North of Pasco, Washington,* December 11, 1964
Colored pen and pencil on paper
12 x 18 in. (30.5 x 45.7 cm)
The Museum of Everything

270. *The Home of Jesse James Near Bonner,* 1964
Colored pencil on paper
12 x 17 ⅞ in. (30.5 x 45.4 cm)
The Museum of Everything

271. *Mt. Kheio 4,167 ft. near Bangkok Thailand of Asia,* January 20, 1965
Ballpoint pen, colored pencil, and graphite on paper
12 x 18 in. (30.5 x 45.7 cm)
Collection of Jim Nutt and Gladys Nilsson

272. *Lake Ponchatrain Near New Orleans Lousiana,* April 12, 1965
Colored pencil, watercolor, and ballpoint pen on brown kraft paper
12 x 18 in. (30.5 x 45.7 cm)
Courtesy of Karen Lennox Gallery, Chicago

273. *In Bitter Root Mtns Montana in Northwestern Montana,* August 21, 1965
Carbon tracing ink, pencil, and ballpoint pen on paper
12 x 18 in. (30.5 x 45.7 cm)
Courtesy of Karen Lennox Gallery, Chicago

274. *Altali Mtn Mongolia Asia,* c. 1965
Colored pencil and ballpoint pen on paper
11 ¾ x 15 ½ in. (35 x 39 cm)
Courtesy of Karen Lennox, Chicago

275. *Under Ground river in Sequiotta Park Springfield Missouri,* c. 1965–69
Ink and colored pencil on paper
12 x 18 ⅞ in. (30.5 x 47.9 cm)
Private collection

276. *Mt National in Grand Canyon National Range in Grand Canyon National Park at Tuweep Arizona U.S.A.,* July 30, 1966
Ballpoint pen, colored pencil, and graphite on paper
24 x 19 in. (61 x 48.3 cm)
Collection of Jim Nutt and Gladys Nilsson

277. *Crater Range near Kingston Jamaica, W.9.,* September 4, 1966
Ballpoint pen, colored pencil, and graphite on paper
12 x 17 ¾ in. (30.5 x 45.1 cm)
Collection of Jim Nutt and Gladys Nilsson

278. *The Home of Cole Younger Bonner Springs Missouri,* October 25, 1966
Ballpoint pen and colored pencil on paper
12 x 17 ¾ in. (30.5 x 45.1 cm)
Collection of Jim Nutt and Gladys Nilsson

279. *Bay of Fundy near Middlenton Nova Scotia,* 1966
Colored pencil and ballpoint pen on paper
18 x 24 in. (45.7 x 61.0 cm)
Collection of Christian and Michelle Daniel

280. *Kathy Poillian, 1st Strip Dancer in 1893,* July 23, 1966
Pen and colored pencil on paper
18 x 11 ½ in. (45.7 x 29.2 cm)
The Museum of Everything, courtesy of Carl Hammer Gallery, Chicago

281. *Mt Haig near Alberta Canada,* c. 1966
Colored pencil and ballpoint pen on paper
12 x 18 in. (30.5 x 45.7 cm)
Courtesy of Karen Lennox Gallery, Chicago

282. *Mt. Holmes in Gablatin Mtn Range and Yellow stone National park near Canyon Wyoming,* c. 1966
Colored pencil and ballpoint pen on paper
12 x 19 in. (30.5 x 48.3 cm)
Courtesy of Karen Lennox Gallery, Chicago

283. *Mt. Horeb of Mt. Sini Range of Canaan Asia on Palestine,* c. 1966
Crayon, ink, and watercolor on paper
12 x 18 in. (30.5 x 45.7 cm)
The Museum of Everything

284. *Fay King wife of Batling Nelson Light Weight Pugelist Champion in year 1911,* January 26, 1967
Ballpoint pen, colored pencil, and graphite on paper
17 ¾ x 11 ¾ in. (45.1 x 29.8 cm)
Collection of Jim Nutt and Gladys Nilsson

285. *Mt. Purula of Baykal Mtn. Range in Siberan Era up Land near Bodaybo in USSR,* September 7, 1967
Ballpoint pen and colored pencil on paper
12 x 19 in. (30.5 x 48.3 cm)
Collection of Jim Nutt and Gladys Nilsson

286. *Goldhopiggan of Hardangenviddo Glacier near Dombas Norway N.E.E.,* November 1, 1967
Colored pencil and ballpoint pen on paper
11 ⅞ x 17 ¾ in. (30.2 x 45.1 cm)
Courtesy of Karen Lennox Gallery, Chicago

287. *Gum Tree on Amazon,* 1967
Colored pencil and pen on paper
12 x 18 in. (30.5 x 45.7 cm)
Private collection, courtesy of Fleisher/ Ollman Gallery, Philadelphia

288. *Baywood Park San Luis Obispo County California, Los Osos. Valley, Cal,* August 25, 1968
Ballpoint pen and watercolor on paper
8 x 11 in. (20.3 x 27.9 cm)
Collection of Jim Nutt and Gladys Nilsson

289. *Kathy Poillian, 1st Strip Dancer in 1893,* October 30, 1968
Ballpoint pen, colored pencil, and graphite on paper
15 ½ x 11 ¾ in. (39.4 x 29.8 cm)
Collection of Jim Nutt and Gladys Nilsson

290. *Mt. Sinaii at Seaport on Gulf of Aquaba near Dhant Haii of Saudi Arabia in Asia,* December 27, 1968
Ballpoint pen and colored pencil on paper
12 x 19 in. (30.5 x 48.3 cm)
Collection of Jim Nutt and Gladys Nilsson

291. *Horse Shoe Falls,* c. 1968
Ink and colored pencil on paper
12 ½ x 19 in. (31.8 x 48.3 cm)
Private collection

292. *The Valley of the Moon in Big Horn Mtn. Rang, Sheridan Wyoming,* c. 1968–70
Colored pencil and ballpoint pen on paper
12 x 18 in. (30.5 x 45.7 cm)
The Museum of Everything, courtesy of Carl Hammer Gallery, Chicago

293. *The dolomites in North Italy,* January 17, 1969
Ink and pencil on paper
8 ½ x 11 ¼ in. (21.6 x 28.6 cm)
The Museum of Everything

294. *An Alaskan Passenger Sail Boat while in Vancouver British Columbia Canada,* May 3, 1969
Ballpoint pen and colored pencil on paper
12 x 19 in. (30.5 x 48.3 cm)
Collection of Jim Nutt and Gladys Nilsson

295. *Mt. Victoria in Arakan Mtn. Range near Paletwa of Pakestan Sector of India on Bengal Bay E. Asia,* July 30, 1969
Ballpoint pen and colored pencil on paper
12 ³/₁₆ x 19 in. (31 x 48.3 cm)
Collection of Jim Nutt and Gladys Nilsson

296. *Mt. Baykal of Yablonvy Mtn. Range near Ulan-ude near lake Baykal of lower Siberia Russia E. Asia,* August 14, 1969
Ballpoint pen and colored pencil on paper
19 x 12 in. (48.3 x 30.5 cm)
Collection of Jim Nutt and Gladys Nilsson

297. *Central Mounds of Kansas State near Twin Oaks Western Kansas,* October 8, 1969
Ballpoint pen and colored pencil on paper
12 x 19 in. (30.5 x 48.3 cm)
Collection of Jim Nutt and Gladys Nilsson

298. *Wilks Land in East sector of Antartica Continents on Rose Sea & Ice Shellf Cliffe of the two sectors: Discovery since Australia and New Zealand,* November 24, 1969
Felt-tip pen, ballpoint pen, and colored pencil on paper
12 x 19 in. (30.5 x 48.3 cm)
Collection of Jim Nutt and Gladys Nilsson

299. *Jessie Willard 2nd. Challange to Champion Fight with Jack Johnson for worlds heavy weight prize fighting championship in year 1917 and in 1921,* December 15, 1969
Ballpoint pen, colored pencil, and graphite on paper
12 ¼ x 19 in. (31.1 x 48.3 cm)
Collection of Jim Nutt and Gladys Nilsson

300. *Mt. Magazine of Blue Range,* 1969
Ink, crayon, and pencil on paper
19 x 12 ¼ in. (48.3 x 31.1 cm)
The Museum of Everything

301. *The Cyclone that Struck Susanville California in Year of 1903,* January 22, 1970
Felt-tip pen, ballpoint pen, and colored pencil on paper
12 x 19 in. (30.5 x 48.3 cm)
Collection of Jim Nutt and Gladys Nilsson

302. *Mt. Kanchen in Himilaya mtn Range near Lhasa China East asia,* August 30, 1970
Pen and colored pencil on paper
19 x 11 ¾ in. (48.3 x 29.8 cm)
Private collection, courtesy of Fleisher/ Ollman Gallery, Philadelphia

303. *Mt. Bifelo in Velibet Range in Montenegro Sector of Yugoslavia,* October 16, 1970
Colored pencil and ink on paper
12 x 19 in. (30.5 x 48.3 cm)
Private collection

304. *Grazing Range,* October 29, 1970
Colored pencil and ballpoint pen on paper
12 x 19 in. (30.5 x 48.3 cm)
Courtesy of Fleisher/Ollman Gallery, Philadelphia

305. *Mt* [title faded], December 5, 1970
Ballpoint pen and colored pencil on paper
19 x 12 in. (30.5 x 48.3 cm)
Private collection, courtesy of Fleisher/ Ollman Gallery

306. *Mohava Brook Near Riverside California,* 1970
Colored pencil and ballpoint pen on paper
31 x 25 in. (78.7 x 63.5 cm)
The Museum of Everything, courtesy of Carl Hammer Gallery, Chicago

307. *Major route from New York to New Haven and Hartford Connecticut,* 1971
Colored pencil and ballpoint pen on paper
11 x 39 ¾ in. (27.9 x 101 cm)
Collection of Robert Weinstock, New York

308. *Crater Head Mtn. in Andes Mtn. Range near Santiag Chile South America,* n.d.
Ballpoint pen, colored pencil, graphite, and watercolor on paper
18 x 24 in. (45.7 x 61 cm)
Collection of Jim Nutt and Gladys Nilsson

309. *Mt. Cross Pate in Long Range, Mt. Range near Damals Harber New Foudland,* n.d.
Ballpoint pen and colored pencil on paper
11 ¾ x 17 ¾ in. (29.8 x 45.1 cm)
Courtesy of Karen Lennox Gallery, Chicago

310. *Mt Demavend,* n.d.
Colored pencil and ballpoint on paper
12 x 19 in. (30.5 x 48.3 cm)
The Museum of Everything

311. *Mt. Gerizim near Arumah Samaria and close to Mt. Ephram,* n.d.
Pen and colored pencil on paper
12 x 19 in. (30.5 x 45.7 cm)
The Museum of Everything, courtesy of Carl Hammer Gallery, Chicago

312. *Mt Mckinley Highest Point in North America 20320 FE Near Town of Curry! Anchorage Seetor Alaska, USA,* n.d.
Ballpoint pen and colored pencil on paper
12 x 17 ⅝ in. (30.5 x 44.8 cm)
Private collection, courtesy of Fleisher/ Ollman Gallery, Philadelphia

313. *Mt Pena Royo,* n.d.
Colored pencil and ballpoint pen on paper
12 x 19 in. (30.5 x 48.3 cm)
Collection of Christian and Michelle Daniel

314. *Mt. Phu-las-leng in Plateau De Jean near Xieng Laos East Asia,* n.d.
Ballpoint pen and colored pencil on paper
19 x 12 in. (48.3 x 30.5 cm)
Collection of Jim Nutt and Gladys Nilsson

315. *Mt. Raelene near town, of Perth Australia,* n.d.
Ballpoint pen and colored pencil on paper
22 x 14 in. (55.9 x 35.6 cm)
Private collection

316. *Mt. Woolbee of Many,* n.d.
Colored pencil on paper
14 x 11 in. (35.6 x 27.9 cm)
The Museum of Everything

317. *North tip of Brenner Pass between Sweeden and Italys alps,* n.d.
Ballpoint pen and colored pencil on paper
18 ⅞ x 24 in. (47.9 x 61 cm)
Private collection, courtesy of Fleisher/ Ollman Gallery, Philadelphia

318. *San Jaquan Valley of San-Luis Obispo Country near San Luis Obispo California,* n.d.
Ballpoint pen and colored pencil on paper
19 x 12 in. (48.3 x 30.5 cm)
Collection of Jim Nutt and Gladys Nilsson

319. *Sheep Mtn. Range near Las Vegas, Nevad,* n.d.
Ballpoint pen and colored pencil on paper
12 x 19 in. (30.5 x 48.3 cm)
Collection of Jim Nutt and Gladys Nilsson

320. *Untitled (orange),* n.d.
Colored pencil on paper
14 x 11 in. (35.6 x 27.9 cm)
The Museum of Everything

CONTRIBUTORS

DANIEL BAUMANN

Daniel Bauman, co-curator of the *2013 Carnegie International,* is a Swiss art historian, critic, and curator who currently lives in Pittsburgh. He writes for magazines such as *Artforum, Mousse, Parkett, Spike Art,* and others. He is the director of the Adolf Wölfli Foundation at the Museum of Fine Arts in Bern, Switzerland; co-founder of New Jerseyy, an exhibition space in Basel; and, since 2004, curator of an ongoing exhibition series in Tbilisi, Georgia.

DAN BYERS

Dan Byers, co-curator of the *2013 Carnegie International,* is The Richard Armstrong Curator of Modern and Contemporary Art at Carnegie Museum of Art. Recent projects include solo exhibitions of Cathy Wilkes (2011), Ragnar Kjartansson (2011), and James Lee Byars (2010), and the group exhibitions *Reanimation: Jones Koester, Nashashibi/Skaer* (2010) and *Ordinary Madness* (2010). Previously, he was curatorial fellow at the Walker Art Center in Minneapolis, and assistant to the directors at the Fabric Workshop and Museum in Philadelphia.

TINA KUKIELSKI

Tina Kukielski is co-curator of the *2013 Carnegie International* and curator of the Hillman Photography Initiative at Carnegie Museum of Art. She was formerly at the Whitney Museum of American Art in New York where she organized contemporary project series exhibitions with Taryn Simon (2007), Sadie Benning (2009), Omer Fast (2009), and Sara VanDerBeek (2010). Her publications include catalogue essays on William Eggleston and Gordon Matta-Clark. She is a contributor to *Mousse* and *The Exhibitionist.*

ROBERT BAILEY

Robert Bailey is assistant professor of art history in the School of Art and Art History at the University of Oklahoma. His essay "Unknown Knowns: Jenny Holzer's Redaction Paintings and the History of the War on Terror" recently appeared in *October.* A co-founder of the journal *Contemporaneity,* Bailey now serves on its advisory board. His current book project *Conceptual Art International: Art & Language and Others* examines the importance of internationality to the development of the Conceptual art movement.

GABRIELA BURKHALTER

Gabriela Burkhalter is a guest curator for *The Playground Project* of the *2013 Carnegie International.* Since 2008 she has documented the history of playgrounds on the website www.architektur-fuerkinder.ch. A trained political scientist and urban planner, she worked as a writer and editor at the Institute of Technology in Zurich and Lausanne and as an advisor for the renovation of historic playgrounds and the revitalization of community playgrounds. Based in Basel, she currently lives in Pittsburgh and Basel.

AMANDA DONNAN

Amanda Donnan is assistant curator of contemporary art at Carnegie Museum of Art, where she has been closely involved with projects such as *Paul Thek, Diver: A Retrospective* (2011), *Ragnar Kjartansson: Song* (2011), and *Ordinary Madness* (2010). She has worked extensively both programming and researching the museum's time-based media collection. In 2012 she organized the exhibition *Duncan Campbell,* and in 2010 inaugurated the museum's annual Two-Minute Film Festival. Previously, Donnan was production coordinator at Art21 in New York.

KLOEPFER-RAMSEY STUDIO

Founded in 2010 by Chad Kloepfer and Jeff Ramsey, Kloepfer-Ramsey Studio is a New York–based graphic design practice with a focus on design and art direction for clients within the fields of art and architecture, culture, and retail. The studio works on projects of varying scales and complexities, including the design of visual identities, books and other printed matter, exhibitions, signage systems, and websites. Recent commissioners include the Dia Art Foundation, the Whitney Museum of American Art, Schaulager, MoMA PS1, and the Yale School of Architecture.

RAYMUND RYAN

Raymund Ryan has been curator of the Heinz Architectural Center at Carnegie Museum of Art since 2003. His exhibitions at the museum include *White Cube, Green Maze: New Art Landscapes* (2012), *Laboratory of Architecture/Fernando Romero* (2009), *Gritty Brits: New London Architecture* (2007), *Frank Lloyd Wright: Renewing the Legacy* (2005), *Michael Maltzan: Alternate Ground* (2005), and *Pittsburgh Platforms: New Projects in Architecture and Environmental Design* (2003). Author of *Cool Construction* (2001) and co-author of *Building Tate Modern* (2000), Ryan was Irish Commissioner for the Venice Architecture Biennale in 2000 and 2002.

LAUREN WETMORE

Lauren Wetmore is the curatorial assistant for the *2013 Carnegie International.* She previously worked at the Banff Centre, Alberta, programming creative residencies in the visual arts. She was the exhibition and project assistant for *Laurie Anderson, Trisha Brown, Gordon Matta-Clark: Pioneers of the Downtown Scene, New York 1970s,* at the Barbican Art Gallery, London (2011), and participated in Raimundas Malašauskas's *Repetition Island* at the Centre Georges Pompidou, Paris (2010). She has contributed to *C Magazine* and *Spike Art.*

ACKNOWLEDGMENTS

The *2013 Carnegie International* was years in the making, an ambitious project that could only have been possible with the support of many individuals and organizations both close to Pittsburgh and from around the world. The A. W. Mellon Charitable and Educational Fund, The Fine Foundation, the Jill and Peter Kraus Endowment for Contemporary Art, and The Henry L. Hillman Fund continued to provide essential and generous support to the *International*. Key as always to the success of the exhibition was the support of The Friends of the *2013 Carnegie International*. We are deeply grateful for the major contributions provided by The Andy Warhol Foundation for the Visual Arts (with special thanks to Joel Wachs), Jill and Peter Kraus, Maja Oeri and Hans Bodenmann, Ritchie Battle, The Fellows of Carnegie Museum of Art, Marcia M. Gumberg, the National Endowment for the Arts, The Pittsburgh Foundation, Juliet Lea Hillman Simonds Foundation, Bessie F. Anathan Charitable Trust of The Pittsburgh Foundation, George Foundation, Huntington Bank, Wendy Mackenzie, Betty and Brack Duker, BNY Mellon, The Broad Art Foundation, and Nancy and Woody Ostrow. Additional thanks also go to Pittsburgh Audi Dealers; GlaxoSmithKline Consumer Healthcare; Bernita Buncher; Peter J. Kalis and Mary O'Day; Daniel and Beverlee Simboli McFadden; Walter A. Bechtler Foundation; the Tillie and Alexander Speyer Fund; Fort Pitt Capital Group; The Japan Foundation, New York; EQT Corporation; Lee and Isabel Foster; K&L Gates, LLP; Sueyun and Gene Locks; Schneider Downs Wealth Management Advisors; Tata Consultancy Services; and Wells Fargo Advisors.

The co-chairs of The Friends of the *2013 Carnegie International* have our utmost admiration and thanks. Sheila and Milton Fine, Jill and Peter Kraus, and Maja Oeri and Hans Bodenmann have been supporters, advisors, and generous funders. Each has contributed considerable experience with artists and institutions, and individual histories with the *Carnegie International*. Milt and Sheila were important Pittsburgh anchors who pushed us to consider the various contexts of the exhibition and institution; Jill and Peter were generous hosts, opening up their homes more than once, allowing us to spend a fruitful long weekend retreat in Upstate New York where much of the show was conceived; and Maja and Hans opened their home to us in Basel, where our plans for the exhibition were finalized. Their level of commitment is rare. Each has given generously to our exhibition; we particularly thank Maja and Hans for their support of the Lozziwurm playground. The co-chairs helped assemble The Friends of the *2013 Carnegie International*, a group of ninety-one patrons from around the world who have supported the exhibition over the past three years (and are listed on page 350). We are deeply grateful to this group for all they have done; without them this exhibition would not be possible.

We are grateful for the ongoing support of William B. Hunt and Martin G. McGuinn, former and current chairs of the Carnegie Museum of Art Board, whose commitment to the exhibition was crucial. In addition, we thank Marty and Anne McGuinn for opening their home to us and hosting the group on a visit to New York.

Lea Simonds and Harley Trice deserve thanks for their special brand of generosity and friendship. Their warm and lengthy dinners provided essential refueling and recharging during the exhibition's organization. We furthermore thank the Juliet Lea Hillman Simonds Foundation for its funding of this exhibition catalogue.

We are enormously grateful to the lenders, both public and private, who made works of art available for the exhibition. Their names are listed on page 349, and we thank them for their generosity, which allows a large public to enjoy the work of these artists.

Lynn Zelevansky, The Henry J. Heinz II Director of Carnegie Museum of Art, deserves our thanks and admiration. Having brought us together as a team, and having shared her enthusiasm and interest in the meaning of museums and the potential of institutions, she supported us at every turn. We thank her for being a leader, interlocutor, and friend. This exhibition, in many ways, grew out of a nearly three-year conversation among the four of us and benefited immensely from Lynn's intellectual generosity. We also appreciate the efforts of YeonHee Stanley, executive assistant to the director, who assisted in countless ways.

Maureen Rolla, deputy director, provided counsel and profoundly useful advice throughout the exhibition's development. Among her crucial contributions was a dinner party she held right after the three of us had met together for the first time. The evening ended with the four us dancing in our socks (Maureen's were Steelers, naturally), an experience that set the tone for the next three years of our curatorial collaboration.

Gabriela Burkhalter's deep knowledge of the history of artist- and architect-designed playgrounds inspired the *2013 Carnegie International*'s *Playground Project*, for which she served as guest curator. Her extensive work on the subject has shed light on an understudied chapter of architecture, urbanism, and art history. Gaby was an essential collaborator throughout, and we thank her for sharing so generously. For their roles in bringing the Lozziwurm play sculpture to life at the museum's front entrance, we thank Terra Design Studios, Technique Architectural Products, and Plantscape; Tony Young, vice president of facilities, planning, and operations for Carnegie Museums of Pittsburgh, John Lyon, manager of maintenance and operations, and Cynthia McCormack, associate vice president for government affairs; and, at the City of Pittsburgh, city councilman Bill Peduto, chief of staff Dan Gilman, and director of public works Robert Kaczorowski.

We reserve our most lavish thanks and praise for the collaboration, assistance, and unswerving commitment of Amanda Donnan, assistant curator of contemporary art, and Lauren Wetmore, curatorial assistant for the *2013 Carnegie International*. Their hard work, intelligence, professionalism, and dedication are present throughout the exhibition and the catalogue, and in ways that may be invisible to the outside world. It is not easy to work with three curators, thirty-five artists, and an uncountable number of logistical, organizational, curatorial, and institutional complexities. Amanda and Lauren's engagement with art and artists helped shape the most fundamental aspects of the exhibition. And their original, excellent texts in this catalogue contribute greatly to the field. Additional thanks go to Amanda for her ongoing dedication to the department of contemporary art's other initiatives while also working on the *International*.

Led by Sarah Minnaert, director of exhibitions, the exhibitions department deserves special thanks. Sarah's fortitude in spearheading the Lozziworm and all our other crazy ideas got the show done on time and on budget (as of this writing!). Exhibitions coordinator Hannah Silbert and construction and facilities coordinator Jeff Lovett were the *2013 Carnegie International*'s MVPs. Frighteningly organized, unfailingly good-natured, unflagging, and thoroughly effective in all of their tasks, this department was responsible not only for keeping the big ship afloat, but for sending it out into the world, full steam ahead. We could not have done it without them. Scott Langill, former director of finance, kept us on budget and helped in ways large and small.

Deep gratitude goes to the entire art preparation and installation department under the expert leadership of Kurt Christian, who joined the museum in the middle of this exhibition and contributed to it mightily. For working with the show's artists and making the artworks' presen-

tation and the museum's galleries look perfect, we thank Craig Barron, Ramon Camacho, Rob Capaldi, Matt Cummings, Dale Luce, Steve Russ, and all of the part-time contributors to the department.

We thank the museum's registrar's office, led by registrar Monika Tomko, for all of their assistance: associate registrar Elizabeth Tufts-Brown (especially for her archival research), former associate registrar Allison Revello, assistant registrar Gabriella di Donna, and departmental assistant Bianca Ruthven (especially for her help with apartment events). Our gratitude goes to Tara Eckert, contract registrar for the *2013 Carnegie International*, who expertly arranged the complex shipping and transport necessary for an exhibition with loans coming from all over the world. Her kind assistance was crucial. Ellen Baxter, chief conservator, Michael Belman, objects conservator, and Rachel Jacobson, technician, were vigilant guardians of all of the exhibition's artworks. Philip Leers, senior research associate for the time-based media collection, helped us prepare for the reinstallation of the collection galleries and tolerated our war-room meetings in his office.

In many moments over the last three years, curator and chair of education Marilyn Russell was a shining light. Her humor, intelligence, and deep care for art, people, and education inspired us. Lucy Stewart, associate curator of education, forever unflappable, worked closely with the exhibition's artists and organized a dynamic program of artist talks, screenings, and performances, partnering with a number of local groups. Assistant curator Ashley Andrykovitch and program coordinator Juliet Pusateri deserve special thanks for their work on *The Playground Project*. Thanks go as well to assistant curator Becky Gaugler and former docent program coordinator Mary Ann Perkins, as well as all of the museum docents who talk with our visitors daily.

In a large field of special acknowledgments, Katie Reilly, director of publications, deserves especially special thanks. From labels, signage, press releases, and funder credits to this very publication — just about everything written for and about this exhibition has been edited or keenly overseen by Katie. Her guidance, organization, smarts, and good humor were absolutely essential to the project. She was more than ably assisted by the dedicated publications staff of Ian Finch (without whom our blog would be nothing), Melinda Harkiewicz, Laurel Mitchell, and Norene Walworth. Michelle Piranio was an ideal editor working closely with each of us on the texts in this catalogue. Our gratitude also goes to Tom Little for his photography of the collection and *The Playground Project*, and to Greenhouse Media's Aaron Igler and Matt Suib for their beautiful installation photography.

The 56th edition of the *Carnegie International* coincides with radical changes in our digital lives. We have been lucky to have the new media and digital manifestations of the exhibition guided by web and digital media manager Jeffrey Inscho and multimedia producer David D'Agostino. Both contributed new and exciting approaches to websites, video, and social media. We thank them. Our appreciation goes as well to Bearded Studio for their work creating the exhibition's website.

Former director of development Matt Hackler helped enormously with fundraising, working with many constituencies to organize an effective campaign that kept us financially solvent. Thanks go as well to his predecessor Lenora Vesio. Rosemary Burk assisted both of them and graciously and capably bridged the gap between. Current director of development James R. McMahon has just come on board, and we appreciate his efforts in taking over the reins, and we are thankful as well to development assistant Sara Ryan. In central development, we thank Dolly Ellenberg, vice president; Barbara Tucker, director of individual giving; Alanna Muir, assistant manager of individual giving; Bernie Caplan, director of sponsorship; Daryl Cross, assistant director of sponsorship; and Arlene Sanderson, development writer, for her expert work on grant applications. We are also grateful to Jodi McLaughlin, development research associate; and Mary Navarro, independent nonprofit consultant, for their help with grant applications. Nancy-Rose Netchi, director of marketing; Jonathan Gaugler, media relations manager; and Dacia Massengill, communications specialist, made sure the exhibition would have a robust life out in the world. Thanks as well to former director of marketing Kitty Julian and marketing department members Susan Geyer and Lauren Buches.

Despite the number of our curatorial team for the *2013 Carnegie International*, we could not have pulled this off without the support, encouragement, and collegiality of the museum's curatorial staff. Gratitude goes, in the Heinz Architectural Center, to Tracy Myers, Raymund Ryan (especially for his collaboration with Tezuka Architects), and Alyssum Skjeie (especially for her work on *The Playground Project*); in the department of decorative arts and design, to chief curator Jason Busch, Rachel Delphia, and Dawn Reid; in the department of fine arts, to Lulu Lippincott (who graciously collaborated with us in extending the exhibition into the permanent collection galleries), Amanda Zehnder, and Akemi May; and in the department of photography, to Linda Benedict-Jones and Adam Ryan.

Former departmental assistant Jen Lue helped with the exhibition's early stages. We are also grateful for the assistance offered by a group of talented interns over the past three years: Kelsey Eckert, Kelly Englert, Stephen Joyce, Josephine Landback, Virginia Mulky, HeeJin Park, Aaron Regal, Hannah Sams, Craig Scheuer, Tyler Shine, Matthew Showman, Henry Skerritt, and Carolyn Supinka. Nicola Schroeder did extensive research with the museum's archive and contributed greatly to the archival section of the collection reinstallation.

The Women's Committee of Carnegie Museum of Art, under the leadership of Susan Block, deserves special recognition. We are grateful to gala co-chairs Nancy Byrnes, Kitty Hillman, and Jessica O'Brien, and the entire committee, for planning a beautiful opening evening. Thanks go to Dorie Taylor and Katie Jones for their work on the gala and with museum groups, and to the large contingent of helpers for that evening. Our opening event is equally indebted to the VIA Festival, whose collaboration on a special performance we will never forget. Thank you Edgar Um Buchholtz, Lauren Goshinski, and Quinn Leonowicz.

A big thank-you goes to the Sprout Fund (especially Matt Hanigan, Mac Howison, and David English) for their generous support of the opening weekend's Sunday brunch at the Braddock Carnegie Library.

We are appreciative of the collaborative approach and design solutions of the architecture firm Edge Studio. Ann Chen, Gary Carlough, and Amanda Markovic added greatly to the exhibition's design and layout.

The book you are holding in your hands was designed by the exceptionally talented Brooklyn-based design studio Kloepfer-Ramsey. Working with Chad Kloepfer and Jeff Ramsey has been a true pleasure. More important, their beautiful, thoughtful design for the graphic identity and catalogue helped shape the conceptual structure of the exhibition itself. We cannot thank them enough, and will miss their trips to Pittsburgh and our walks along the Allegheny. Art historian Robert Bailey wrote the catalogue's informative and engaging text on the relationship between the *Carnegie International* and the museum's collection, and we are grateful for his contribution. We also acknowledge with respect and appreciation the artists and writers whose republished works enrich the catalogue: Roger Callois, Katharine Kuh, Stéphane Mallarmé, Robert Rauschenberg, Hito Steyerl, Mladen Stilinović, and Gordon Bailey Washburn.

Sincere thanks go to Carnegie Museums of Pittsburgh president David Hillenbrand for his leadership, and to his executive assistant Linda Perkins. Our colleagues at Carnegie Museum of Natural History, with whom we share a grand and idiosyncratic building, have gener-

ously welcomed the *International* into several of their galleries (not to mention public spaces such as the coatroom). We are particularly grateful to acting directors Ron Baillie and Ann Metzger; former director Sam Taylor; Sarah Cole and John Van de Grift in the exhibits department; Debra Wilson and Marc Wilson, managers of the gems and minerals collection; and Cynthia Morton, curator in the botany department. Other colleagues at CMP helped make projects possible: Trish Whitehall, director of finance administration, auxiliary services; Eileen Twigger, manager, auxiliary services; Bill Jones, director of catering, Parkhurst; and John Levi, manager of food services, Parkhurst.

Atticus Adams and Garry Pyles, our generous landlords upstairs at 113 44th Street, have been kind and enthusiastic supporters from the very beginning, before we even knew what we were doing. So many thoughtful speakers, participants, and guests at the apartment talks were willing to be part of our experiment, and we thank them. Special appreciation goes to Carnegie Mellon University's School of Art and School of Architecture for their collaboration on several artist talks.

Numerous individuals and colleagues at several galleries, museums, and organizations provided essential assistance with loans and other logistics:

Lisa Spellman, Katy Erdman, Peter Owsiany at 303 Gallery, New York; Sarah Aibel; Nora Ricio at the Art Institute of Chicago; Stephanie Biron; Tim Blum, Jeff Poe, Matt Bangser, and Sam Kahn at Blum & Poe, Los Angeles; Gavin Brown, Lucy Chadwick, Bridget Donahue, and Jamie Kenyon at Gavin Brown's enterprise, New York; Daniel Buchholz, Christopher Müller, and Friederike Gratz at Galerie Daniel Buchholz, Cologne and Berlin; Martin McGeown and Andrew Wheatley at Cabinet Gallery, London; Photios Giovanis at Callicoon Fine Arts, New York; Gisela Capitain and Regina Fiorito at Gisela Capitain, Cologne; Catalina Casas, Paula Bossa, and Cesar González at Casas Riegner, Bogotá; Tiffany Chestler; Jane Werner and Penny Lodge at Children's Museum, Pittsburgh; Sadie Coles and Pauline Daly at Sadie Coles HQ, London; Isabelle van den Eynde at Gallery Isabelle van den Eynde, Dubai; John Ollman, Alex Baker, and Claire Iltis at Fleisher/Ollman Gallery, Philadelphia; Andrzej Przywara and Joanna Diem at Foksal Gallery Foundation, Warsaw; Alessandra d'Aloia, Márcia Fortes, Alexandre Gabriel, and Amanda Rodriques Alves at Galeria Fortes Vilaça, São Paulo; Marc Foxx and Rodney Hill at Marc Foxx, Los Angeles; Larry Gagosian, Valerie Blair, and James McKee at Gagosian Gallery, New York and London; Barbara Gladstone and Lauren Murphy at Gladstone Gallery, New York; Marian Goodman, Leslie Nolen, Brian

Loftus, and Catherine Belloy at Marian Goodman Gallery, New York and Paris; Cornelia Grassi at Greengrassi, London; Stephen Gribbin; Wendy Grogan; Carl Hammer at Carl Hammer Gallery, Chicago; Iwan and Manuela Wirth, Marc Payot, Sarah Harrison, Melissa MacRobert, and Steph Gonzalez-Turne at Hauser & Wirth, Zurich, London, and New York; Alexander Haviland; Martin Janda at Galerie Martin Janda, Vienna; Peter Kilchmann and Annemarie Reichen at Peter Kilchmann, Zurich; Leo Koenig and Maggie Clinton Koenig at Koenig & Clinton, New York; Jose Kuri, Monica Manzutto, and Manola Samaniego at kurimanzutto, Mexico City; Pamela Echeverría at Labor, Mexico City; Simon Lee at Simon Lee, London; Nicholas Logsdail, Alex Logsdail, Kim Klehmet, Silvia Sgualdini, and Johanna Thornberry at Lisson Gallery, London; Lu Jie and Theresa Liang at Long March Space, Beijing; Emily Luce; Roland Augustine, Lawrence Luhring, and Natalia Sacasa at Luhring Augustine, New York; Matthew Marks, Helen Brown, Jeffrey Peabody, and Adrian Rosenfeld at Matthew Marks Gallery, New York and Los Angeles; Janelle Reiring, Helene Winer, Tom Heman, and Manuela Mozo at Metro Pictures, New York; Franco Noero, Matteo Consonni, and Elisa Facchin at Galleria Franco Noero, Turin; Friedrich Petzel and Samantha Tsao at Petzel Gallery, New York; Francesca Pia at Galerie Francesca Pia, Zurich; Yancey Richardson at Yancey Richardson Gallery, New York; Irit Sommer and Inbal Ammar at Sommer Contemporary Art, Tel Aviv; Federica Angelucci, Marc Barben, and Raphaelle Jehan at Stevenson, Cape Town and Johannesburg; Luisa Strina at Galeria Luisa Strina, São Paulo; Joel Mesler at Untitled, New York; Susanne Vielmetter at Susanne Vielmetter Los Angeles Projects; Johannes Vogt at Vogt Gallery, New York; Shoshana Wayne and Marichris Ty at Shoshana Wayne Gallery, Santa Barbara; Barbara Weiss at Galerie Barbara Weiss, Berlin; Michael Wilson and Polly Fleury at the Wilson Centre for Photography; Leo Xu and Kim Wu at Leo Xu Projects, Shanghai; and Emily Letourneau at Donald Young Gallery, Chicago.

Colleagues and friends from Pittsburgh and around the world helped in numerous ways during the research and organization of the *2013 Carnegie International*. Are deepest thanks to:

Cecilia Alemani, Grace Ambrose, Markús Þór Andrésson, Max Andrews, Miwako Arakawa, Tomo Arakawa, Cory Arcangel, Richard Armstrong, George Awde, Angie Baecker, Lars Bang Larsen, Monica Barkley, Michael Barnicle, Christopher Beauregard, Ruedi Bechtler, Jay Beckwith, Vincenzo de Bellis, Sam Berkowitz, Ian Berry, Leonardo Bezzola, Andrew Blauvelt, Helena Bohl, Tanya Bonakdar, Edoardo Bonaspetti, Ted Bonin,

HMS Bounty, Rose Bouthillier, James Brett, Cecilia Brunson, Adam Burge, Marianne Burki, Butterjoint, James Cahn, Andrianna Campbell, James Campbell, Karin Campbell, Özkan Cangüven, Betsy Carpenter, Gary Carrion-Murayari, John Carson, Melissa Catanese, Cattivo, Stefano Cernuschi, Nicholas Chambers, Fang-Wei Chang, Colin Chinnery, Doryun Chong, Thomas Christensen, Biljana Ciric, Vicky Clarke, Heidi B. Coleman, Stuart Comer, Lynne Cooke, Lauren Cornell, Richard Dattner, Rob and Barbara Davis, Sarah Demeuse, Donna DeSalvo, Liu Ding, Apsara DiQuinzio, Casey Droege, Tom Eccles, James Elaine, Peter Eleey, Anne Ellegood, Alicia Escobio Alonso, Monica Novaes Esmanhotto, Jeb Feldman, Áron Fenyvesi, John Fetterman, Douglas Fogle, Dan Fox, Mark Francis, M. Paul Friedberg, Sarah Gavlak, Nazli Ghassemi, Larry Giacoletti, Gooski's, Simon Gowing, Michael Grossert, Madeleine Grynsztejn, Don Gummer, Gina Guy, Bruce Hainley, Andrew Hamilton, Andreas Hanslin, Ben Harrison, Jane Haskell, Dora Hegyi, Eric Heijselaar, Josef Helfenstein, Sofía Hernández Chong Cuy, Andria Hickey, Matthew Higgs, Kiêu Hoang, Paul Hogan, Laura Hoptman, Kyle Hovious, Sarah Humphrey, Terry Irwin, Heidi Zuckerman Jacobson, Martin Jäggi, Ana Janevski, Karin Bonde Johansen, Paige Johnson, Casey Kaplan, Ruba Katrib, Sepideh Khosrowjah, Clara Kim, James King, Carol Kino, Ben Kinsley, Dorothée Kirch, Matt Kirsch, Ragnar Kjartansson, Josh Kline, Mark Knobil, Vasif Kortun, Chad Laird, John R. Lane, Brian Lang, Jessica Langley, Xavier de la Salle, Larry Lebowitz, Alfred Ledermann, Scott Livingstone, Cathy Lewis Long, Thom Loubet, Margo Lovelace, Carol Yinghua Lu, Barbara Luderowski, Mariana Cánepa Luna, Ramona MacDuffie, John MacDuffie Woodburn, Melissa MacRobert, Takayuki Mashiyama, Richard Massey, HG Masters, LaTasha Mayes, Megan McCready, Fionn Meade, Bekezela Mguni, Miami Beach Veterans of Foreign Wars, Sam Greenleaf Miller, Evan Mirapaul, Núria Montclús Carazo, Ayanah Moor, Patrick Moore, John Morace, Julianna Morris, Rodrigo Moura, Julianna Morris, Museum of Everything, Diana Nawi, Palle Nielsen, David Norr, Yuki Okumura, Michael Olynick, Virginia Overton, Paddy Reilly's Music Bar, Dan Palmer, Panther Hollow Inn, Adriano Pedrosa, Lucienne Peiry, Heather Pesanti, Monique Peters, Georg Radanowicz, Melissa Ragona, Mehrdad Rahsepar, John Rasmussen, Yasmil Raymond, Yael Reinharz, João Ribas, Larry Rinder, Hilary Robinson, David Roditi, Jeanne Greenberg Rohatyn, Andrea Rollefson, Jeffrey Rosen and Misako Rosen, Michelle Rosenberg, Emanuel Rossetti, Scott Rothkopf, Beatrix Ruf, Bart Ryan, Yumi Saito, Rivka Saker, Jay Sanders, Tom Sarver, Ingrid Schaffner, Asha Schechter,

Christoph Schifferli, Jenny Schlenzka, Sydney Schrader, John Schulman and Caliban Books, Stephanie Schumann, Ko Senda, Mitsuru Senda, Amanda Sharp, Graham Shearing, Elisabeth Sherman, Eric Shiner, Suzie Silver, Henry Simonds, Debra Singer, Matthew Slotover, Terry Smith, Dan Solbach, Susan Solomon, Hajnalka Somogyi, Mari Spirito, Tijana Stepanovic, Branka Stipančić, Marion Boulton Stroud, Ali Subotnik, Astria Suparak, Elisabeth Sussman, Ginger Brooks Takahashi, Mary Anne Talotta, Mia Henry Tarducci, Annika Tengstrand, Elizabeth Thomas, James Merle Thomas, Sam Thorne, Brina Thurston, Philip Tinari, Nilani Trent, Vicki Vargo, Allyson Vieira, Olga Viso, Sheena Wagstaff, Curtis Wallen, Marie Warsh, James Way, Toby Webster, Adam Weinberg, Adam Welch, Jane Werner, Kaelen Wilson-Goldie, Ruth Wurster, Alicja Wysocka, Wendy Yao, Juan Yarur, Paul Zelevansky, and Tirdad Zolghadr.

Personally, Daniel is thankful to Gabriela Burkhalter and Hanna and Jacob Baumann for having had the courage to dive into this adventure! For their ongoing support, Dan thanks his family, with a special note to his ninety-five-year-old grandmother and role model, Sarah Isenberg. Tina gives her most heartfelt thanks to Josh Weinstein for his brave and inspiring embrace of this wild escapade.

Finally, we are indebted to the artists who form the foundation of the *2013 Carnegie International*: Ei Arakawa/Henning Bohl, Phyllida Barlow, Yael Bartana, Sadie Benning, Bidoun Library (Negar Azimi, Nelson Harst, and Babak Radboy), Nicole Eisenman, Lara Favaretto, Vincent Fecteau, Rodney Graham, Guo Fengyi, Wade Guyton, Rokni Haerizadeh, He An, Amar Kanwar, Dinh Q. Lê, Mark Leckey, Pierre Leguillon, Sarah Lucas, Tobias Madison, Zanele Muholi, Paulina Olowska, Pedro Reyes, Kamran Shirdel, Gabriel Sierra, Taryn Simon, Frances Stark, Joel Sternfeld, Mladen Stilinović, Zoe Strauss, Henry Taylor, Tezuka Architects (Takaharu Tezuka and Yui Tezuka), Transformazium (Dana Bishop-Root, Leslie Stem, and Ruthie Stringer), Erika Verzutti, and Joseph Yoakum.

— Daniel Baumann,
 Dan Byers,
 Tina Kukielski

LENDERS

303 Gallery, New York
Blum & Poe, Los Angeles
Gavin Brown's enterprise, New York
Galerie Daniel Buchholz, Cologne
 and Berlin
Cabinet Gallery, London
Sadie Coles HQ, London
Igor M. DaCosta, New York
Christian and Michelle Daniel
Beth Rudin DeWoody
DSL Collection
Lonti Ebers
Martin and Rebecca Eisenberg
Carla Emil and Richard Silverstein
Gallery Isabelle van den Eynde, Dubai
Fleisher/Ollman Gallery, Philadelphia
Foksal Gallery Foundation, Warsaw
Galeria Fortes Vilaça, São Paulo
Marc Foxx, Los Angeles
Gagosian Gallery
Annet Gelink Gallery, Amsterdam
Richard Gerrig and Timothy Peterson
Barbara Gladstone
Marian Goodman Gallery, New York
 and Paris
Greengrassi, London
Hall Collection
Carl Hammer Gallery, Chicago
Hauser & Wirth, Zurich, London,
 and New York
Carolyn and Gene Hecht
David Hoberman, Los Angeles
Hort Family Collection
The Kimmel Family
Koenig & Clinton, New York
Kravis Collection
kurimanzutto, Mexico City
Karen Lennox Gallery, Chicago
Kwong Yee Leong & Alfred Cheong
Lisson Gallery, London
Long March Space, Beijing
Luhring Augustine, New York
Matthew Marks Gallery, New York and
 Los Angeles
Frank Masi and Donna Kolb
Metro Pictures, New York
The Museum of Everything
Judith Neisser
Galleria Franco Noero, Turin
Jim Nutt and Gladys Nilsson
Ovitz Family Collection, Los Angeles
Petzel Gallery, New York
Private collection (6)
Private collection, New York
Private collection, Switzerland
Yancey Richardson Gallery, New York
Craig Robins

Jeanne Greenberg Rohatyn and
 Nicolas Rohatyn
Tom Sarver
Chara Schreyer
Sender Collection
Arlene Shechet and Mark Epstein
Sommer Contemporary Art, Tel Aviv
Speyer Family Collection, New York
Stevenson, Cape Town and Johannesburg
Donna and Howard Stone
Dianne Wallace, New York
Shoshana Wayne Gallery, Santa Monica
Robert Weinstock, New York
Leo Xu Projects, Shanghai

FRIENDS OF THE
2013
CARNEGIE
INTERNATIONAL

CO-CHAIRS
Milton and Sheila Fine, *Pittsburgh, Pennsylvania*
Jill and Peter Kraus, *New York, New York*
Maja Oeri and Hans Bodenmann, *Basel, Switzerland*

Alan and Barbara Ackerman, *Pittsburgh, Pennsylvania*
Richard Armstrong, *New York, New York*
Ritchie Battle, *Pittsburgh, Pennsylvania*
Bill and Vivian Benter, *Pittsburgh, Pennsylvania*
Jo and Bill Brandt, *Scottsdale, Arizona*
James Brett, *London, England*
Edythe and Eli Broad, *Los Angeles, California*
James Keith Brown and Eric Diefenbach, *New York, New York*
Bernita Buncher, *Pittsburgh, Pennsylvania*
Cees and Inge de Bruin-Heijn, *Wassenaar, The Netherlands*
Elizabeth and Brack Duker, *Pasadena, California*
Stefan Edlis and Gael Neeson, *Chicago, Illinois*
Mark and Tracy Evans, *Tiburon, California*
Christopher and Dawn Fleischner, *Pittsburgh, Pennsylvania*
Lee B. and Isabel Foster, *Pittsburgh, Pennsylvania*
Jerry and Carolyn Friedman, *Newton, Massachusetts*
Ira and Nanette Gordon, *Pittsburgh, Pennsylvania*
Daniel Greenberg and Susan Steinhauser, *Van Nuys, California*
Marcia M. Gumberg, *Pittsburgh, Pennsylvania*
Agnes Gund, *New York, New York*
Henry L. and Elsie Hillman, *Pittsburgh, Pennsylvania*
William E. and Janet Hunt, *Pittsburgh, Pennsylvania*
James R. and Karen Johnson, *Pittsburgh, Pennsylvania*
Peter J. Kalis and Mary O'Day, *Gibsonia, Pennsylvania*
Marshall P. and Wallis Katz, *Pittsburgh, Pennsylvania*
Ellen P. and Jack Kessler, *Pittsburgh, Pennsylvania*
Sybil Fine King, *Poole, England*

Marie-Josée and Henry Kravis, *New York, New York*
Alice and Nahum Lainer, *Beverly Hills, California*
Sarah and Eric Lane, *New York, New York*
Sueyun and Gene Locks, *Philadelphia, Pennsylvania*
Wendy Mackenzie, *New York, New York*
Richard Massey, *Miami, Florida*
Daniel and Beverlee McFadden, *Berkeley, California*
Martin G. and Ann McGuinn, *Pittsburgh, Pennsylvania*
Jeffrey and Jacqueline Morby, *Pittsburgh, Pennsylvania*
Gordon and Kennedy B. Nelson, *Stahlstown, Pennsylvania*
Nancy and Woody Ostrow, *Pittsburgh, Pennsylvania*
Jim and Kathe Patrinos, *Pittsburgh, Pennsylvania*
David and Gabriela Porges, *Pittsburgh, Pennsylvania*
John J. Reilly and Lise Woodard, *Pittsburgh, Pennsylvania*
James H. Rich, *Pittsburgh, Pennsylvania*
Juliet Lea H. Simonds, *Pittsburgh, Pennsylvania*
Patricia and William P. Snyder III, *Sewickley, Pennsylvania*
Teri and R. Damian Soffer, *Pittsburgh, Pennsylvania*
Jerry Speyer and Katherine Farley, *New York, New York*
David Teiger, *Bernardsville, New Jersey*
Judith Evans Thomas, *Sewickley, Pennsylvania*
Jane A. and Harry Thompson, *Pittsburgh, Pennsylvania*
Nancy and Milton A. Washington, *Pittsburgh, Pennsylvania*
Konrad M. and Gisela Weis, *Pittsburgh, Pennsylvania*
Cecilia Wong, *Los Angeles, California*

CARNEGIE MUSEUM OF ART BOARD

AS OF JULY 20, 2013

REPRODUCTION CREDITS

Many of the images in this publication are protected by copyright and may not be available for further reproduction without permission of the copyright holder. Every reasonable attempt has been made to identify owners of copyright.

Introduction
p. 21: Photos: Tom Little for Carnegie Museum of Art; p. 22: Carnegie Museum of Art; p. 23: Photos: Tom Little for Carnegie Museum of Art; p. 24 (left): photo: Joshua Franzos for Carnegie Museum of Art; p. 24 (right): Photo: Daniel Baumann; p. 25: Courtesy of Daniel Baumann; p. 26: Courtesy of Zoe Strauss.

Arakawa/Bohl, pp. 34–37
pp. 34–36: Courtesy of Ei Arakawa. Photos: Ei Arakawa; p. 37: Courtesy of Ei Arakawa © Ei Arakawa and Henning Bohl.

Barlow, pp. 38–41
All images © Phyllida Barlow. Courtesy of the artist and Hauser & Wirth; p. 39: Photo: Stephan Minx; p. 40: Photo: Fabian Peake.

Bartana, pp. 42–45
All images courtesy of the artist; Annet Gelink Gallery, Amsterdam; Sommer Contemporary Art, Tel Aviv; Petzel Gallery, New York.

Benning, pp. 50–53
All images courtesy of the artist. Photos: Chris Austin.

Bidoun Library, pp. 54–57
All images courtesy of Bidoun Library.

Eisenman, pp. 58–61
pp. 58–59: Courtesy of the artist and Koenig & Clinton, New York; p. 60: Courtesy of Susanne Vielmetter Los Angeles Projects. Photo: Robert Wedemeyr; p. 61 (left): Courtesy of the artist and Studio Voltaire, London; Galerie Barbara Weiss, Berlin; Koenig & Clinton, New York; and Susanne Vielmetter Los Angeles Projects; p. 61 (right): Courtesy of the artist and Koenig & Clinton, New York.

Favaretto, pp. 66–69
All images courtesy of the artist and Galleria Franco Noero, Turin; p. 66: Photo: Vipul Sangoi; p. 67: Photo: Everton Ballardin; p. 68 (bottom): Photo: Delfino Sisto Legnani; p. 69: Photo: Sebastiano Pellion di Persano.

Fecteau, pp. 70–73
p. 70: © Vincent Fecteau. Courtesy of Matthew Marks Gallery; p. 71: Courtesy of greengrassi, London. Photo: Marcus Leith; p. 72 (top): Courtesy Galerie Daniel Buchholz, Berlin and Cologne; p. 72 (bottom): © 2012 Vincent Fecteau; p. 73: Courtesy of greengrassi, London. Photo: Marcus Leith.

Graham, pp. 74–77
All images courtesy of 303 Gallery, New York.

Guo, pp. 78–81
All images courtesy of Long March Space.

Guyton, pp. 86–89
All images courtesy of the artist; pp. 86–87: Photos: Ron Amstutz; pp. 88–89: Photos: Gunnar Meier.

Haerizadeh, pp. 90–93
All images courtesy of the artist and Gallery Isabelle van den Eynde, Dubai.

He, pp. 94–97
All images courtesy of Leo Xu, DSL Collection, and Mr. Kwong Yee Leong.

Kanwar, pp. 102–5
All images courtesy of Marian Goodman Gallery.

Lê, pp. 106–9
All images courtesy of the artist and Shoshana Wayne Gallery, Santa Monica, California.

Leckey, pp. 110–13
All images courtesy of the artist; Gavin Brown's enterprise, New York; Galerie Daniel Buchholz, Cologne; and Cabinet Gallery, London.

Leguillon, pp. 118–21
All images courtesy of the artist.

Lucas, pp. 122–25
All images © Sarah Lucas. Courtesy of Sadie Coles HQ, London.

Madison, pp. 126–29
All images © Carnegie Museum of Art; Photos: stills from video by David D'Agostino.

Muholi, pp. 134–37
© Zanele Muholi. Courtesy of Stevenson, Cape Town and Johannesburg.

Olowska, pp. 138–41
All images courtesy of the artist, Metro Pictures, New York, and Foksal Gallery Foundation, Warsaw.

Reyes, pp. 142–45
pp. 142, 145: © Pedro Reyes. Courtesy of Lisson Gallery, London; pp. 143, 144: Courtesy of Lisson Gallery, London; Alumnos 47 Foundation; and the artist.

Shirdel, pp. 150–53
All images courtesy of the artist.

Sierra, pp. 154–57
All images courtesy of the artist and kurimanzutto, Mexico City.

Simon, pp. 158–61
All images courtesy of the artist.

Stark, pp. 166–69
All images © Frances Stark. Courtesy of the artist and Gavin Brown's enterprise, London.

Sternfeld, pp. 170–73
All images courtesy of the artist and Luhring Augustine, New York.

Stilinović, pp. 174–77
All images courtesy of the artist, Zagreb.

Strauss, pp. 182–85
All images courtesy of the artist.

Taylor, pp. 186–89
p. 186: Courtesy of the artist; Blum & Poe, Los Angeles; and UNTITLED, New York; pp. 187–89: Courtesy of the artist and Blum & Poe, Los Angeles.

Tezuka, pp. 190–93
p. 190 (top and bottom left): Photos: Kasuhisa Kida/FOTOTECA; p. 190 (bottom right): Courtesy of Tezuka Architects; p. 191: Courtesy of Tezuka Architects; pp. 192–93: Photos: Kasuhisa Kida/FOTOTECA.

Transformazium, pp. 198–201
All images courtesy of Transformazium.

Verzutti, pp. 202–5
All images courtesy the artist and Galeria Fortes Vilaça, São Paulo; pp. 202–3: Photos: Eduardo Ortega Studio.

Yoakum, pp. 206–11
pp. 206–7: Courtesy of Gladys Nilsson and Jim Nutt. Photos: Tom van Eynde; pp. 208–11: Courtesy of Fleisher/Ollman Gallery, Philadelphia

Kukielski, *An Open Function*, pp. 217–28
p. 217: Amsterdam City Archives; p. 218: Carnegie Museum of Art. Photo: Bryan Conley; p. 220: Photos: Renee Rosensteel; p. 221: Carnegie Museum of Art; p. 222: Courtesy of Fleisher/Ollman Gallery, Philadelphia; p. 223 (top): © Mark Leckey. Courtesy of the artist and Gavin Brown's enterprise, New York. Photo: Jon Barraclough; p. 223 (bottom): © Frances Stark. Courtesy of the artist and

COLOPHON

2013 Carnegie International
October 5, 2013–March 16, 2014

© 2013 Carnegie Museum of Art, Carnegie Institute. All rights reserved.

Produced by the Publications Department
Carnegie Museum of Art
Pittsburgh, Pennsylvania
4400 Forbes Avenue
Pittsburgh, Pennsylvania 15213-4080
www.cmoa.org

Katie Reilly, Director of Publications
Ian Finch, Associate Editor
Melinda Harkiewicz, Publications
 Associate
Laurel Mitchell, Coordinator of Rights
 and Reproductions
Norene Walworth, Production Coordinator

Available through D.A.P./Distributed Art
 Publishers
155 Sixth Avenue, 2nd Floor
New York, New York 10013
Tel.: 212.627.1999 Fax.: 212.627.9484
www.artbook.com

Editors: Michelle Piranio, Katie Reilly
Design: Kloepfer-Ramsey Studio
Printer: The Avery Group at Shapco
 Printing, Inc., Minneapolis
Paper: Carolina C1S; 60lb Cougar Opaque
 Smooth Text; 80lb Mohawk Via
 Vellum Cool White Text; 60lb
 Astrobrights Text, Rocket Red; 60lb
 Springhill Opaque Offset Colors,
 Pink; 60lb Astrobrights Text, Cosmic
 Orange; 60lb Springhill Opaque
 Offset Colors, Green; 60lb Springhill
 Opaque Offset Colors, Tan; 70lb
 French, Construction Safety Orange;
 60lb Astrobrights Text, Venus Violet;
 80lb Gusto Satin
Typefaces: Univers Bold, Times Ten,
 and Bookman BT

ISBN: 978-088039056-9
ISSN: 1084-4341

CARNEGIE MUSEUM
OF **ART**

ONE OF THE FOUR CARNEGIE MUSEUMS OF PITTSBURGH